THE
BIBLE
AND
THE
IMAGE

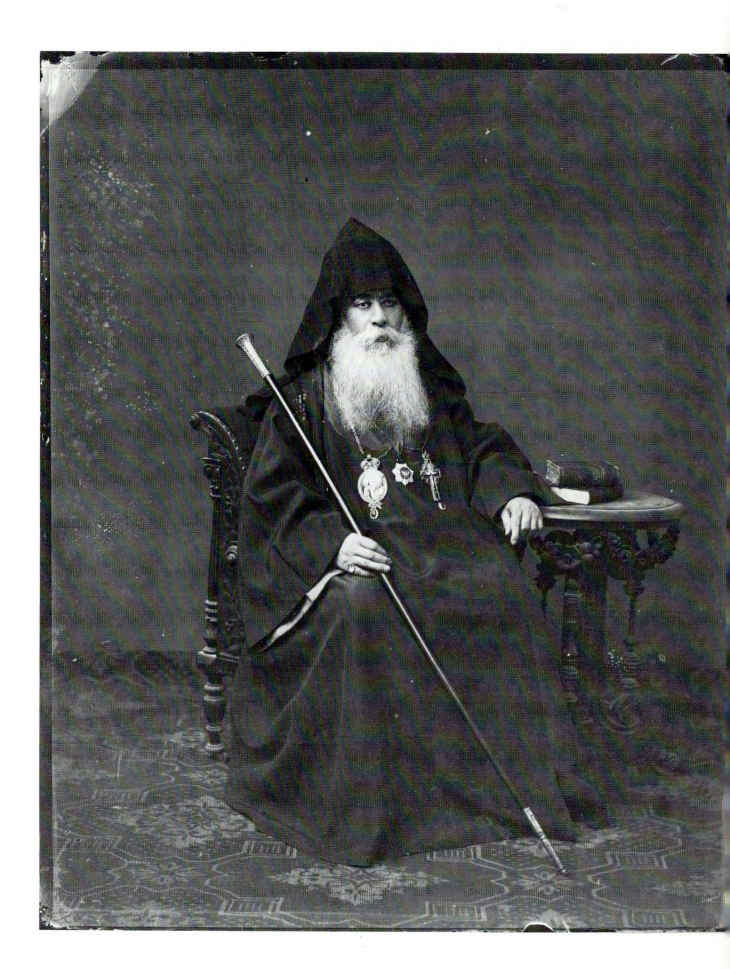

THE BIBLE AND THE IMAGE

The History
of Photography
in the Holy Land
1839–1899
by Yeshayahu Nir

UNIVERSITY OF PENNSYLVANIA PRESS • PHILADELPHIA

upp

Design: ADRIANNE ONDERDONK DUDDEN

Library of Congress Cataloging in Publication Data

Nir, Yeshayahu, 1930–
The Bible and the image.

 Bibliography: p.
 Includes index.
 1. Photography—Palestine—History. I. Title.
TR113.I75N57 1985 770'.95694 84–21997
ISBN 0-8122-7981-6

Printed in the United States of America

To my mother, who perished in Bergen Belsen,
and to my father, lost in Buchenwald,
to my wife, Chava, and my daughter, Yael,
and to those who believe with us
that one day we all, Israelis and Palestinians,
will live in this country
in peace and mutual respect.

Contents

Illustrations

Main Events
in Holy Land Photography
1839–1899

1839 Dr. Alexander Keith makes an unsuccessful attempt to produce photographs on paper (June). Frédéric Goupil-Fesquet takes the first daguerreotypes (December).

1843–44 Joseph Philibert Girault de Prangey takes about one hundred daguerreotypes, the only collection to survive.

1844 George Skene Keith takes daguerreotypes (published in 1847) to support an idea, the first such use of photography in the world.

1849–50 First calotypes taken by C. M. Wheelhouse (private album) and George Bridges (published 1858; precursor of photographic reporting).

1850 Maxime Du Camp, accompanied by novelist Gustave Flaubert, takes six calotypes of Jerusalem, the first original photographs to be published (in 1851).

1853 James Graham settles in Jerusalem for three years; becomes the first "local-resident" photographer.

1854 American missionary James Turner Barclay and French calotypist Auguste Salzmann take photographs for exploratory use.

1857 James Robertson and/or Felice Beato open the era of traveling landscape photographers.

1858 Francis Frith's single stay in the country.

1859 Earliest written reference to a local photographer, Deniss. Photographs unknown.
 Earliest written reference to stereoscopic pictures.

1859–60 Louis de Clercq produces first album on delimited subject: the Via Dolorosa.

1859　Beginnings of photography in the Armenian Convent.

1862　Francis Bedford is photographer of Prince of Wales's tour.

1864　L. Vignes and James McDonald are photographers of exploration parties.

1865　First publication of photographs taken by a local photographer, Peter Bergheim (in *Ordnance Survey of Jerusalem*).

1866–67　H. Phillips engages in "ethnographic" photography.

1867　Félix Bonfils settles in Beirut and takes his first photographs in Jerusalem (perhaps early 1868).

1870　Birth of Charles A. Hornstein, the only local photographer (amateur) born in the country.

1874　Posthumous publication of Duc de Luynes's volume of photomechanically reproduced steel engravings made after L. Vignes's photographs by Charles Nègre.
Frank Mason Good and Lieutenant H. H. Kitchener produce last series of wet-plate photographs.

1876　First local book includes photograph; printed at the Greek Press in Jerusalem, photograph reproduced in Vienna.

1878　Last album of tipped-in, original wet-plate photographs is published.

1882　Abbé Raboisson takes first (documented) dry-gelatin negatives.

1884　Garabed Krikorian establishes independent studio in Jerusalem.
French amateur photographer Jules Ruffier, White Father, settles in Jerusalem.

1887　F. and M. Thévoz of Switzerland produce largest photographic work of the 1880s; some formal innovations.

1890　Chalil Raad, first local Arab photographer, settles in Jerusalem.

1891　B. Warshawski of Poltava, Russia, takes photographs of new Jewish villages, which appear in the Hebrew yearbook *Achiassaf*, published in Warsaw; beginnings of Jewish photography.
First photograph of new Jewish village published in halftone reproduction in the December issue of *Jewish Missionary Intelligence*.

1892　First Arab photographer in Jaffa, Dawid Sabounji, photographs nearby agricultural school, Mikve Israel.

1893 G. R. Lees publishes first album of photographs produced in the Holy Land; albumen prints pasted in.

1895 Visit of Willy Bambus, first Jewish writer-photographer. Yeshayahu Raffalovich, first local Jewish photographer, advertises in the local Hebrew press.
First publication of photographs by Charles A. Hornstein.
First written reference to a (amateur) Moslem photographer of Damascus.

1896 *Album de la Terre Sainte*, most voluminous nineteenth-century publication, compiled and published in Paris.

1897 Chalil Raad advertises own studio in local Hebrew press.

1898 Elijah Meyers starts photography at the American Colony in Jerusalem.

1899 Yeshayahu Raffalovich publishes *Views of Palestine and Its Jewish Colonies*, the first locally produced album of halftone reproductions; plates prepared and album printed in Frankfurt, Germany.

Preface and Acknowledgments

The structure of this book reflects three major lines of interest: the establishment of a precise chronology and a fundamental history of early photography in the Holy Land; the analysis of cultural, social, economic, and political biases that have informed photographic production; and the detection of characteristic trends in photography within the preindustrial context of an underdeveloped country. The particular conditions under which photography was introduced into such contexts demand a shift in focus—one offered here, I believe, for the first time—a shift that entails taking into account the special sociocultural and economic factors prevalent in these environments.

Part One, "The Land, Holy and Profane," constitutes a survey of early landscape work from 1839 to 1878. It covers the collections and albums produced by the three early processes—daguerreotype, calotype, and wet-collodion photography. Emphasis is placed on the cultural and aesthetic attitudes that influenced the work of mostly well-known traveling landscape photographers. Their differing ways of depicting the country are investigated in the first four chapters.

Part Two, "Photography and Local Society," covers the period from 1859 to the end of the century. The three chapters represent the subject from different and even opposing points of view. Chapter 5 concentrates on biographical data and types of production of the earliest local photographers. These constitute important evidence of the status of photography within the local population and culture. Moslem and Jewish religious texts and traditions pertaining to photography are also examined here. Chapter 6 investigates the ways in which foreign photographers shaped the image of the local population and communicated it to the outside world. Chapter 7 traces the responses of local inhabitants to the photographers' attempts to portray them, a point of view that histories of photography have neglected.

Part Three, "Photography in Print," expands on both previous parts. Photographic works produced

during the last decades of the century are examined in terms of their continuity with earlier trends, their new biases, and the influence of new photographic technologies.

Both local and foreign publications of photographs underwent unprecedented growth in the 1890s followed by a decline in the early 1900s. In addition, after the turn of the century, new trends in the treatment of subject matter were introduced by a new generation of visiting and local photographers. Consequently, the first period in the history of Holy Land photography can be said to have ended together with the nineteenth century.

Two main difficulties emerged during the research. First, there was no relevant conceptual framework applicable to the work, since existing histories of photography relate exclusively to industrial countries and have little bearing on the present case. Second, the extreme scarcity and dispersion of relevant information had to be overcome. This paucity of material made it even more necessary to place equal weight upon each and every bit of photographic material that could be gathered or uncovered, no matter how poorly executed or reproduced and no matter how lacking in prestige. Analysis of this corpus made it possible to highlight recurrent patterns and the factors that shaped them. The photographs reproduced in the book illustrate this approach.

Illustrated travelers' literature on the Holy Land contributed complementary pieces to the puzzle. Here, too, the study of emerging patterns made it possible to draw up a relatively coherent account. Many texts are extensively quoted. Some of the photographs provide evidence of the state of the Holy Land and of its Arab and Jewish populations before the advent of Zionism. They constitute a concise first chapter in the photographic history of the country.

To gather and examine photographs and information from so many disparate sources was a strenuous and time-consuming task that necessitated the assistance of many people.

I wish to acknowledge, first of all, the generous assistance provided by the research funds of the Eshkol Institute and the Faculty of Social Sciences at the Hebrew University of Jerusalem. I am especially grateful to Professor Yehoshua Ben-Arieh, dean of Humanities and former chairman of the Department of Geography at the Hebrew University, for his help. I deeply appreciate the warm personal interest of Arthur J. Rosenthal, director of Harvard University Press. It was especially encouraging in the early stages of my work.

To write the story of this research would mean describing not only sleepless nights, but also exciting discoveries and meetings with remarkable people. Many of them were to me more than providers of access

to photographs and information; their passionate interest and unselfish help were sources of inspiration. I wish to express my gratitude to Shlomo Shva of Tel Aviv, Daliah and Eliahu Hacohen of Ramat Gan, Natan Schur of Tsahala, Yaacov Lehman of Jerusalem, Professors Alex Carmel and Ilan Blech of Haifa, Rabbi S. Gorr of Jerusalem, and ethnographers Zohar Wilbush and Ziva Amir. I would like to sincerely thank Canon Adeney of Jerusalem and Reverend Barker of London, the Church's Ministry among the Jews; Kevork Hintlian, Armenian Patriarchate, Jerusalem; and P. Augustin Arce, O.F.M., Latin Convent, Jerusalem. The friendly assistance of Sir Sa'ad Eddin El-Alami, mufti of Jerusalem, is greatly appreciated. Friends I cannot mention without emotion are Dr. Carney E. S. Gavin and his collaborators Ingeborg O'Reilly, Elizabeth Carella, and William Corsetti at the Harvard Semitic Museum in Cambridge, Mass. This is the place to acknowledge all participants of F.O.C.U.S. conference at the Harvard Semitic Museum in 1978, especially Dr. Adnan Hadidi, director-general of Antiquities, Jordan, and Khaled Maoz of Damascus.

The Harvard Semitic Museum team, as well as Gérard Lévy of Paris, Nachum Tim Gidal of Jerusalem, and Shoshana Ballhorn of Tiberias, were extremely helpful by providing access to photographs and offering their own expertise. The daily work and sustained efforts of many curators and librarians—among them Menachem Levin, City Archives of Jerusalem; Adina Haran, Central Zionist Archives, Jerusalem; Bernard Marbot, Bibliothèque Nationale, Paris; Gillian Webster, executive secretary of the Palestine Exploration Fund, London; Moshe Shilo, the Labor History Archive, Tel Aviv; Irene Levitt, Israel Museum, Jerusalem; George Hobart, curator of photography, Library of Congress; Joe Coltharp, curator, Humanities Research Center, Gernsheim Collection, University of Texas—made the research possible. Hana Dagani, along with David Raanan, Abraham Hauser, and David Harris, produced excellent reproductions. I also wish to acknowledge the assistance of Itshak Rishin, Rachel Shilo, Natan Ben Ari, and Shaul Paz.

It is impossible to mention all those who volunteered their help and expertise and sometimes a badly needed word of support: among them, Vivian Gornick of New York, Avner Giladi of Jerusalem, and William B. Goodman of Boston deserve special thanks. I also wish to thank my colleagues, Shaul Katz, Hanah Segal, Professor Brenda Danet, Dr. Judith Elitsur, Professor Elihu Katz, and Alan Rosenthal, who read parts of the manuscript and offered critical comments. I must also acknowledge my debt to Helmut Gernsheim, the eminent historian of photography. His work, as well as that of Beaumont Newhall and others who cleared the way, constitutes the starting point for studies done by my generation.

I am deeply grateful to Mary Heathcote and Helene Hogri for their extremely careful work. They not only improved upon my English, but also helped turn research into a book.

Ingalill Hjelm, Managing Editor of the University of Pennsylvania Press, editor Lee Ann Draud, and designer Adrianne Onderdonk Dudden deserve my fullest gratitude for their warm involvement in the last stages of the book's production.

The longest and deepest involvement was that of my wife, Chava. Over the years she has shared the joys of discovery and the pains of disappointment. Even more important, she has always managed to harmonize critical remarks with steady confidence in the work's progress. In many ways, it is her book, too.

Jerusalem, 1984

THE
BIBLE
AND
THE
IMAGE

Introduction

In October 1833 William Henry Fox Talbot, the future inventor of photography as we know it today, spent a holiday in Italy. The region of Lake Como attracted him, and he decided to make a drawing. He used a camera lucida, a device that projected the image on a sheet of paper, so that he had only to copy the lines. He was nevertheless unhappy with the result. It occurred to him that he had made better drawings in the past with a different device used in a similar way, the camera obscura. It was at this very moment that he began reflecting on "the inimitable beauty of the pictures of Nature's painting which the glass lens of the camera throws upon the paper in its focus" and that the idea of photography first occurred to him:

How charming it would be if it were possible to cause these natural images to imprint themselves durably and remain fixed upon the paper! . . . and since, according to chemical writers, the nitrate of silver is a substance peculiarly sensitive to the action of light, I resolved to make a trial of it in the first instance.[1]

Many more trials were necessary, but today innumerable clicks of many millions of cameras keep proving that Talbot had chosen the right direction 150 years ago.

At the same time, also in October 1833, the first visitor to the Holy Land with a camera lucida arrived in Jerusalem. On October 24 of that year, the English architect and explorer Frederic Catherwood set his instrument on the roof of the governor's house overlooking the celebrated Temple Esplanade and sketched the outline of the city.

Unlike Talbot, Catherwood was specifically interested in exploring the architecture of the Moslem shrines on the Esplanade and wanted to draw them from close range. His wish was hampered, however, by a strict prohibition against access to non-Moslems. Finally, having gained the confidence of the gov-

ernor, Catherwood, dressed as an Egyptian officer, arranged his camera on the Esplanade itself. He reported,

some of the Mussulmans . . . more fanatic than the rest began to think all could not be right. . . . I was completely surrounded by a mob of two hundred people who seemed screwing up their courage for a sudden rush upon me. . . . Suleyman, my servant . . . threatened to inform the governor, . . . and raising his whip, commenced a summary attack upon them, and knocked off the cap of one of the holy dervishes.[2]

An unexpected appearance of the governor, who explained to the crowd that Catherwood's work was needed for repairs of the dilapidated mosque, calmed the spirits; Catherwood could continue to draw. To be sure, he had previously outwitted the governor himself, pretending to have been sent by Ibrahim Pasha, who then ruled the country, temporarily under Egyptian control. When Ibrahim Pasha approached Jerusalem on a visit six weeks later, Catherwood had to stop his work and to flee.

The stories of Talbot and Catherwood reflect the differences between the two cultures in which they took place. In Europe the imprecision of drawing by hand led Talbot to pursue a solution through scientific means that would make image making available to all. In contrast, in the Holy Land the first precise drawing was just being made—by a foreigner—and it met with local opposition. These two events point to the striking gap between the two cultures, which were on the verge of broadening contact. They indicate how differently photography would be received and perceived in different sociocultural environments.

Underlying Talbot's deliberations about capturing an image on paper was the desire to produce an accurate representation of a beautiful landscape. Herein lay the tradition of the visual arts. Implied was a romantically mystified nature and the belief in science. Clearly, at the time of its invention, photography was firmly anchored in the artistic and philosophical trends of Talbot's period and country. Catherwood's story, on the other hand, tells of the mapping of unexplored territory, the penetration of a foreign power, local opposition, the feudal whip of an officer's servant. The story does not lack the colorful ingredients typical of a tale or a comedy: disguise, deceit, danger, sudden deliverance, flight from disclosure. On a deeper level it points to a clash between cultures; it recounts the introduction of an unknown instrument and procedure brought by a stranger into a closed society.

While the clash between photography and traditional society in the Holy Land, foreshadowed in the incident between Catherwood and the local population, was unique in its religious significance, it evolved

out of the economic, social, and cultural situation characteristic of underdeveloped areas. The people of the Holy Land were not the only ones to resist the making of images, as is clear from the following two examples.

In 1873, a British expedition to Turkestan reported an "initial resistance of the Muslim population against having photographs taken" that was "gradually overcome through the liberal intervention of the Amir."[3] In 1877, American explorer F. V. Hayden, introducing the volume *600 Portraits of American Indians*, wrote that "The American Indian is extremely superstitious, and every attempt to take his picture is rendered difficult if not entirely frustrated by his deeply rooted belief that the process places some portion of himself in the power of the white man, and such control may be used to his injury."[4] In the Third World, one may infer, the history of photography was to take a different course than that in London and Paris.

The established history of photography seems to have overlooked the significance of the clash between European photographers and their colonial subjects. At the very least, it has been presented as undeserved animosity directed toward a harmless device. In fact, the industrial world provided the maker of pictures with a technology that enabled him to dominate his subject. Photography enhanced his paternalistic mentality and led the photographer to perceive and depict the local population in Third World countries exclusively in Western terms. Twentieth-century historiography and aesthetics of photography were to follow the same path.[5] Seen from a less prejudiced perspective, local reticence toward photography—in its various manifestations—is an expression of the depicted culture, reflecting the gap between foreign photographers and local inhabitants and the patterns of communication between them. In many countries photography almost exclusively meant a foreigner's intrusion—the exposure of local people to the gaze of an intruder who was unaware of their social and cultural codes. The making of photographs implied a complex interaction in which factors more diverse than backwardness versus progress or art versus iconoclasm played decisive roles. This interaction is paradigmatic in the history of photography in the Holy Land and probably in other former colonies of Western nations as well.

In one area, however, European and American photographers visiting the Holy Land could hardly be accused of ignorance: the biblical landscapes, including the historical and religious significance of such sites, were familiar to them. Thus both the predisposition and itineraries of Catherwood and others who followed were well shaped long before arrival.

To them, both landscape and population were symbols of their own past, and their work was per-

meated both by Christian and by Western bourgeois attitudes and ideologies. Photographic genres and stereotypes that developed reflected those attitudes more than they did local realities. These attitudes were also paradigmatic in the history of photography in the Holy Land, which is not a history of an invention and its technical and artistic conquests, but of a sociocultural interaction and imported modes of representation.

The role of the Holy Land in early photography was prominent and a natural consequence of its importance to European cultures. The frequency with which nineteenth-century photographers sought out the Holy Land as a subject points to deep roots in Western thought and feeling. And the fact that so many of photography's early achievements occurred in this region shows us much about how both the medium and the Holy Land were perceived at that time. Clearly, the new medium of photography, the sociocultural environment in which it flourished, and the eastern Mediterranean region suited each other.

THE SOURCES OF PHOTOGRAPHERS' ATTITUDES

France's attention to the Levant, dormant since the Crusades, reawakened as early as 1798, when Napoleon conquered and explored Egypt. The emperor then tried to conquer the Holy Land and appealed to Jews all over the world to join him in Jerusalem. This flamboyant gesture did not prevent a British naval squadron from helping the Ottoman Turks who ruled the country to defeat the French in 1799, at the port of Acre, on what is now the Bay of Haifa. When Egypt briefly took control of the country in the 1830s, the British troops again helped the Ottoman rulers to drive out the new invaders. The Crimean War (1853–56), in which one of the diplomatic issues was control of Jerusalem's ancient holy places, Napoleon III's expedition to Lebanon (1860), and British financing of the French-built Suez Canal (opened in 1869) represented a deepening rivalry in colonialist penetration of the region. American and German settlers, Russian and French ecclesiastic institutions, and diplomatic missions from many countries increased foreign influence in the Holy Land throughout the later decades of the century. Finally, after their joint victory over Germany and Turkey in World War I, England and France drew the first international borders of the Holy Land and called the country Palestine.

Photographers often arrived in the wake of these developments and were sometimes their precursors. James Robertson and Felice Beato, known for their Crimean War pictures of 1856, produced an album of

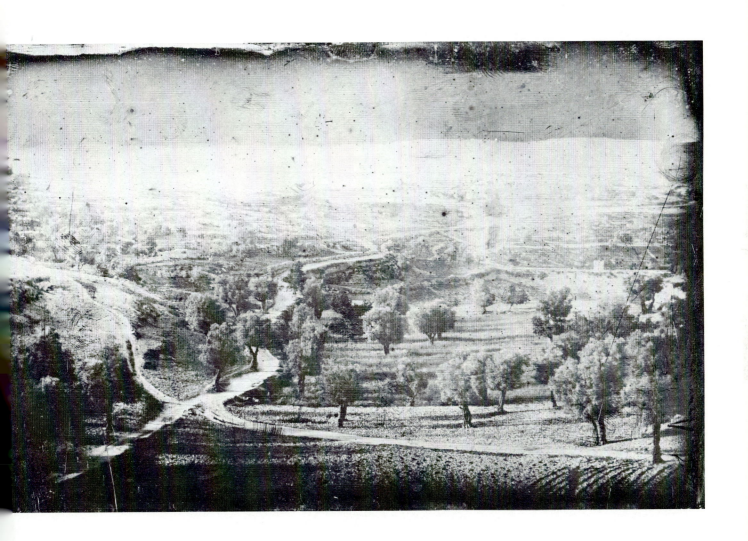

Girault de Prangey (1844), daguerreotype. Jerusalem, the way to Bethlehem. View laterally reversed. For orientation, see the small square structure (a fountain) in the right background. (Private collection)

photographs they took in Jerusalem, probably in 1857, focusing on the holy places recently in dispute. In 1862, Francis Bedford accompanied the Prince of Wales on his Near Eastern tour. Félix Bonfils was the first French photographer to settle in the region, making his home in Beirut, Lebanon. Bonfils first came there as a soldier in Napoleon III's expeditionary corps in 1860. He founded his regionwide enterprise in 1867, when fellow Frenchman Ferdinand de Lesseps had nearly finished digging the Suez Canal. British army photographers Sergeants James McDonald and H. Phillips and Lieutenant H. H. Kitchener (the latter a famous figure in colonial history) took exploratory photographs in the 1860s and 1870s. In 1898, the "American Colony" photographers launched their activity in Jerusalem by covering German Emperor Wilhelm II's "pilgrimage" to the country. Local Armenian and Arab photographers also seized this opportunity to widen their connections and enlarge their businesses.

These were important events in Holy Land photography, examples of direct links between political processes and photographic work. Even more important, and more exciting to trace, are the varied indirect links between colonialism and the development of photography. These include the large Western audiences for photographs of the region and the development of photography as a local trade.

The gradual pull of the Levant into the orbit of European politics was paralleled by the growth of

Auguste Salzmann (1854), calotype. "The way to Bethlehem." Rear center, the fountain; city walls of Jerusalem. (E. Hacohen, Ramat Gan)

: James McDonald (1864), albumen print. "Valley of Hinnom. Looking south from the Gate." At left, city walls of Jerusalem; Mishkenot Shaananim quarter and the windmill n 1858 at right. (Israel Department of Antiquities and Museums)

ABOVE: *Félix Bonfils (1867–68), albumen print. "Jewish Hospice." A closer view of Mish Shaananim. (G. Lévy, Paris)*

RIGHT: *C. A. Hornstein (ca. 1890), dry-gelatin glass negative, modern print. Mish Shaananim, and, to the right, Yemin Moshe quarter. (Israel Trust of the Anglican Church*

Western spiritual and theological attitudes that emphasized exploration and missionary work. These two developments in the same historical period were more than coincidence, less than a well-engineered conspiracy. After all, ever since the Crusades, religious attachment to the Holy Land had generated wayfarer and pilgrim traffic from the West. The new missionary and exploratory activity of the nineteenth century would certainly have been less extensive had the political interest been absent and vice-versa, because ecclesiastical and ideological involvement assisted the political activity.[6] But there was a marked difference between the two movements. Ecclesiastics and intellectuals were attracted by the religious significance of the Holy Land to their respective churches. The broadening contact with the region that resulted furthered the aims of the Western churches in their home countries. Nineteenth-century missionary societies, exploration organizations, and pilgrim associations were motivated by a crisis in the churches in the industrializing West. They all wanted to counter the influence of rationalism, the Encyclopedists, and later the sciences and the Industrial Revolution on the very foundations of Christian belief.

The American response to this challenge is perhaps a purer case to study than those of European countries. At that time the United States was devoid of colonialist interests in the eastern Mediterranean basin, so we can consider this religious phenomenon in isolation from concrete political aims. The American historian Herbert Hovenkamp sums up the American attitude clearly and concisely: "Religious Americans were almost as fascinated by Palestine as they were by their own land. Those faraway countries, with a strange climate, an alien culture, and buried artifacts older than the ruins of Rome, were as important to many evangelicals as their own church buildings." The effect on these travelers was profound:

The places described by the Bible awed them, and they were equally awed by the men who had been there. Every clergyman yearned to visit the Holy Lands and to tell his congregation about them. Three years at Princeton Seminary provided one kind of education, but a visit to Jerusalem provided another, equally important. Scholarly American Protestants naturally believed that by studying Palestine they could authenticate the Bible. . . . To the Western Christian a journey to Palestine was a telescope with which he could bring the remotest places into his viewing room. The Holy Land explorer moved not only through space but through time as well—and when he arrived he found his discoveries immensely satisfying. Things in the Holy Land still appeared very much as the Bible described them. To go there was not to discover conclusive evidence that the Bible was infallible, but it *was* sufficient to demonstrate that the Bible was not an elaborate hoax.[7]

This description of the general religious-scholarly atmosphere in America applies equally well to the special group of American visitors who added the unwieldy new toy, the camera, to their explorer's kit.

Among the many such scholars was James Turner Barclay, possibly the first American to photograph in Jerusalem in the 1850s. Barclay was assisted by the English photographer James Graham, who was on the staff of the Anglican mission called the London Jews' Society. By the 1890s L.J.S. members had acted as one of the first, though nonprofessional, photojournalistic agencies, while reflecting the society's primary aim of ministering to the local Jewish population. American Bishop John Heyl Vincent, one of the founders of the influential religious-educational-recreational Chautauqua movement, who visited the Holy Land in 1863, 1887, and 1893, inspired and wrote an introduction to the largest American album of Holy Land photographs, *Earthly Footsteps of the Man of Galilee and the Journeys of His Apostles*. Many photographers working between 1839 and 1899 were ecclesiasts.

The religious-theological attitude, as a source of the renewed interest in the Holy Land, carried with it two inevitable predispositions. First, the Bible was a hypothesis that the country as explored, as photographed, had to support and validate. This had to be done by providing a set of rediscovered ancient

sites and historical referents. Photography could depict them. Second, the biblical description of the country and its way of life provided the explorer or missionary not only with inspiration but also with detailed knowledge. The Bible as travel guide was not a hypothesis but a catalogue that photographs could illustrate, and explorers, travelers, and pilgrims could check off the extant items. Which items were selected reflected different interpretations of the biblical catalogue. These interpretations led to partial and distorted perceptions and thus to partial and distorted images.

No one was more conscious of these distortions than Mark Twain, the "Innocent Abroad" who toured the country in 1867.

I am sure, from the tenor of the books I have read, that many who have visited this land in years gone by, were Presbyterians, and came seeking evidence in support of their particular creed; they found a Presbyterian Palestine, and they had already made up their minds to find no other, though possibly they did not know it, being blinded by their zeal. Others were Baptists, seeking Baptist evidences and a Baptist Palestine. Others were Catholics, Methodists, Episcopalians, seeking evidences indorsing their several creeds, and a Catholic, a Methodist, an Episcopalian Palestine. Honest as these men's intentions may have been, they were full of partialities and prejudices, they entered the country with their verdicts already prepared, and they could no more write dispassionately and impartially about it than they could about their own wives and children.[8]

Mark Twain did not intend to be a pilgrim or a religious scholar (though he in fact was the latter),[9] but to fulfill his itinerary's "seductive program . . . with its Paris, its Constantinople, Smyrna, Jerusalem, Jericho. . . ."[10]

Though Mark Twain's traveling companions were apparently devout—"I can almost tell, in set phrases, what they will say when they see Tabor, Nazareth, Jericho, and Jerusalem because I have the books they will 'smouch' their ideas from"[11]—tourism was often quite independent of the religious movement. It was a manifestation of attraction to the Holy Land as one of the exotic countries, and this exoticism was another factor in the development of travelers' photography, local photography, and the acculturation of local populations to the new medium.

How the Holy Land, a prominent feature of the "Eastern Tour," was seen depended upon the various preconceptions of the secular travelers. One traveled to see other countries and to compare them to one's own; one compared the newly seen to old memories of other places. Generally the comparison was not in favor of the Holy Land. It was predictable that a photographer arriving from Egypt would find Jerusalem's famous sites disappointing, as the French traveling photographer Maxime Du Camp and British

Francis Frith showed in their work. The more secular the traveler, the less likely he was to "find his discoveries immensely satisfying" (see p. 12). Constantinople, Greece, and Rome—also in the Eastern Tour—successfully competed for the traveler's attention.

Another traveler, Herman Melville, noted in his diary of 1856:

No country will more quickly dissipate romantic expectations than Palestine—particularly Jerusalem. To some the disappointment is heart sickening. . . . Is the desolation of the land the result of the fatal embrace of the Deity? Hapless are the favorites of heaven. In the emptiness of the lifeless antiquity of Jerusalem the emigrant Jews are like flies that have taken up their abode in a skull.[12]

Elsewhere he wrote, "No moss as in other ruins—no grace of decay—no ivy—the unleavened nakedness of desolation."[13]

Melville's sensibilities were perhaps both romantic and melancholy, but he had, before boarding the ship, high hopes of this expedition. "I am full (just now) of this glorious *Eastern* jaunt. Think of it! Jerusalem & the Pyramids—Constantinople, the Aegean, & old Athens!"[14] Now, however, he resented almost everything he saw. In the entrance to the Church of the Holy Sepulchre in Jerusalem he noticed "a divan for Turkish policemen, where they sit cross-legged & smoking, scornfully observing the continuous troops of pilgrims. . . ."[15] Was he unaware of his own scorn? Like Mark Twain, Melville was not

Engravings published in 1884 under various titles: a: "Types of Palestine"; b: "Israelites from Beyrouth"; c: "A Jew of Algiers." (Israel Trust of the Anglican Church)

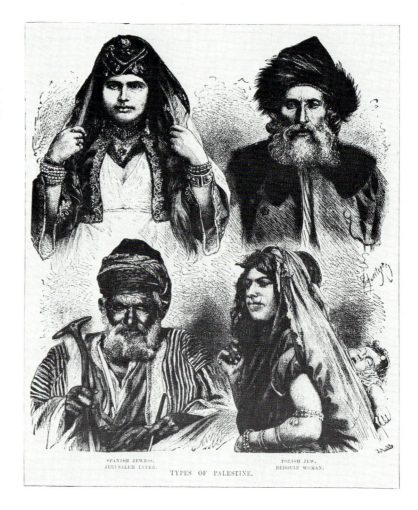

SPANISH JEWESS.
JERUSALEM LEPER.
POLISH JEW.
BEDOUIN WOMAN.
TYPES OF PALESTINE.

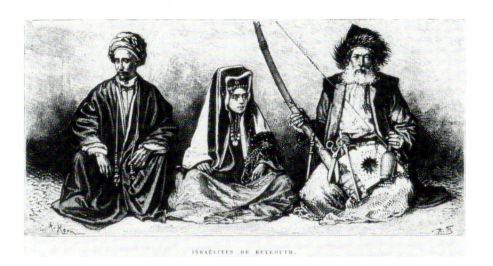

ISRAÉLITES DE BEYROUTH.

A JEW OF ALGIERS.

"innocent" of criteria that had no more to do with the country before him than those of the "troops of pilgrims." Nor was the French writer Lamartine, who saw at the same place "five or six venerable faces of Turks, with long white beards; they saluted us with dignity and grace. . . . I saw nothing in their faces, attitudes, and gestures of that irreverence of which they are usually accused."[16] But for Lamartine the experience of visiting the Holy Sepulchre was of a very different order. As Mark Twain might have said, his was a Catholic traveler's Holy Sepulchre. What he had read on the faces of the Turks was influenced by his perception of the place and of himself as a Catholic. Indeed, Lamartine had positive impressions throughout most of his journey, which began in the northern part of the country, the plain behind Acre. He wrote in his diary on October 12, 1832, that he had expected "naked, rocky, sterile soil," as described by other writers and travelers. "For a short time, their description," he admitted, could fit the road between Jerusalem and Jaffa, and "deceived by them, I did not expect but what they described, a country without trees, and without water." But this was not what he saw on the slopes of Nazareth and Carmel. Here was a green country, "great, agreeable, and deep."[17]

As a matter of fact, the country looks at least as dry in mid-October as in early January, the season of Melville's visit, and it certainly was not endowed with a richer agriculture in 1832 than in 1856. It was a matter of attitude rather than seasons.

The traveling photographers—ecclesiasts and laymen, amateurs and professional—gave evidence of their predispositions, their religious, literary, and political attitudes, in ways specific to the medium: in the number of photographs devoted to a particular site, in the angle from which they depicted it, in precise framing that included or excluded more or less of the surrounding area, and in captions. Within the confines of an unsophisticated medium, they expressed their attitude—or the attitude they perceived as that of their buyers. Catholic and Protestant perceptions were there, less clearly expressed than in written texts, but quite traceable. They dominated early Holy Land photography. There were no Moslem photographers to record an Arabic Palestine, Filastin, and until the 1890s there were no Jewish photographers to portray the Jewish Palestine, Eretz Israel. These two Palestines were not on even Mark Twain's list.

The Viscount de Vogüé, a French explorer of the Holy Land, wrote the entire introduction to his little book *Syrie, Palestine, Mont Athos, Voyage aux pays du passé* without ever using the words "Bible," "Holy Land," "Christianity," or any related terms. To him, the importance of the Orient was that it let historian and traveler come in touch with the world of the past. The "immobile present," he wrote, the

F. and M. Thévoz (1887), phototype reproduction. "A Jew of Jerusalem." Published in Original albumen print by Félix Bonfils not credited. (Jewish National and University L Jerusalem)

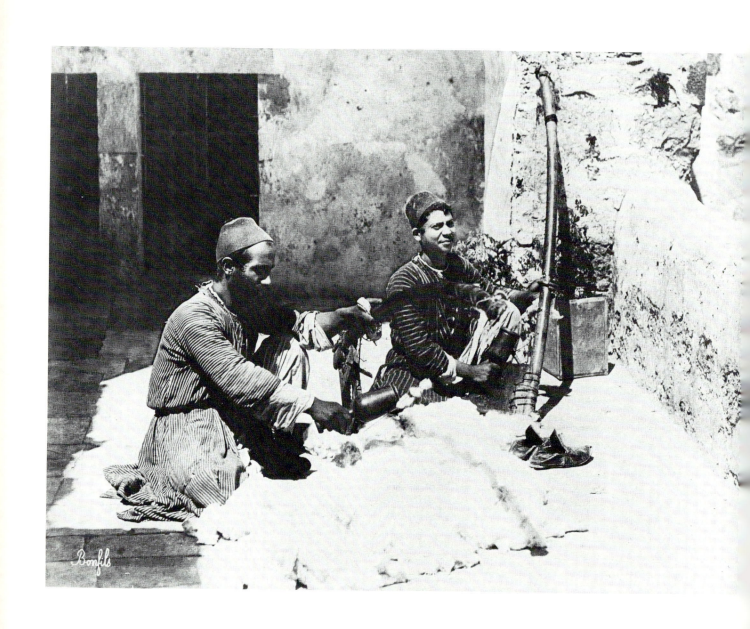

ABOVE: *Bonfils Company (ca. 1890), albumen print. "Jewish cotton carders in Jerusa[...]
Outdoor photograph, pose being held. (A. Carmel, Haifa)*

RIGHT: *C. A. Hornstein (ca. 1900), dry-gelatin glass negative, modern print. Cotton c[...]
(Israel Trust of the Anglican Church)*

"Immutable Orient," reproduced with fidelity the state of occidental societies in certain periods of their development, and "the historian can always find in the retarded races the living types of disappeared societies."[18]

De Vogüé's attitude was typical of those who related to the region in terms of universal history. Such travelers sometimes considered the Orient synonymous with the Holy Land(s), sometimes distinct from it, and sometimes overlapping. They too put the country into the realm of the imaginary, were condescending to the present inhabitants of the country, and projected elements from the past into their analysis of the present. To borrow Mark Twain's definition, they found an orientalist's Palestine.

The modern scholar Edward Said writes that

the French and the British—less so the Germans, Russians, Spanish, Portuguese, Italians and Swiss—have had a long tradition of . . . *Orientalism*, a way of coming to terms with the Orient that is based on the Orient's special place in European Western experience. . . . Orientalism is a Western style for dominating, restructuring, and having authority over the Orient. . . . All pilgrimages to the Orient passed through, or had to pass through, the

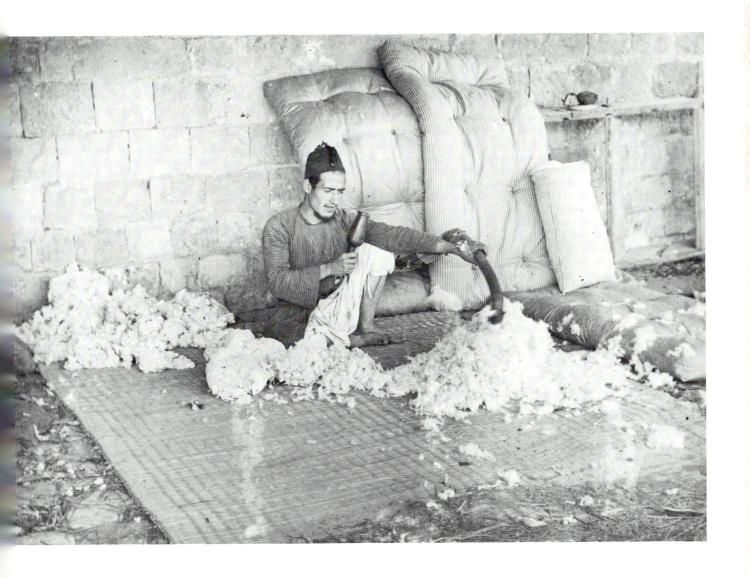

Biblical lands; most of them in fact were attempts either to relive or liberate from the large, incredibly fecund Orient some portion of Judeo-Christian/Greco-Roman actuality.[19]

Some photographers too were attracted to the region for this very reason. Their work was meant specifically to please the orientalist traveler. Formulas applied by orientalist and popular painters when depicting biblical events could be adapted to photography, and sometimes photographs not only resembled paintings but even served as models for them. Historian of photography Aaron Scharf has pointed out that the French painter Jean Gérôme's "city scenes, landscapes, and his mildly erotic pictures, glimpses into Oriental baths and harems, grand white eunuchs and Arab slave markets, with their splendid decorative architectural settings, are recorded with the rigorous objectivity of the camera." Scharf adds that "Gérôme indeed painted with the help of photographs throughout his career. He too had his own camera in Egypt in 1868 (if not earlier), when he both painted and took photographs."[20] Following the traditions of genre paintings, photographers looked in Jerusalem or Jaffa, or for that matter Beirut or Tiberias, for scenes and costumes, faces and landscapes, that would fit painting conventions and yet convey "on location" immediacy. While the home folks might not know the semiauthentic from the altogether spurious, the tourists could not be fooled totally. Still, most travelers preferred to take back the picturesque rather than the real, and all a photographer had to do was avoid the "nonpicturesque" views of actual contemporary life.

Romanticism, too, inspired Holy Land photography. It went hand in hand with orientalism, as it had in other arts as well. Baron A. J. Gros's *Les Pestiférés de Jaffa*, a popular painting of 1806 depicting Napoleon's expedition, is one example of this link.[21] The dream of the Orient likewise infused the work of Delacroix, the major artist of the genre, as well as that of lesser artists like Vernet. Awareness of history, a heightened feeling for nature, fascination with exotic lands and ruins, fondness for church and monarchy are hallmarks of romanticism. Many of the photographs reproduced in this volume portray that very romantic mood and mode of nineteenth-century Holy Land photography.

The desert of Judaea, Crusader ruins along the Mediterranean shore, the walls and gates of Jerusalem, tourist guides in embroidered dresses, Bedouins, camels, beggars—all these were romantic, yet exotic, "oriental" subjects. Jerusalem offered to the traveler, the photographer, and their armchair-traveler clientele not only the devotional associations of the Church of the Holy Sepulchre but also the imposing Moslem architecture of the city gates and the symmetric beauty of the Dome of the Rock, the Moslem shrine on the Temple Esplanade. Though these edifices in fact glorified the Islamic past, the

pervasive aura of romanticism and medievalism captivated Christian photographers, particularly since they stood on biblical sites. The beauty and spirit of these buildings made photographs of them compatible with other objects in the Victorian and bourgeois salon. Their appeal was so strong that photographers and publishers did not hesitate to use them to illustrate biblical and Christian theological texts. There were other buildings and other local inhabitants that could have been photographed, but they were ignored or misrepresented for the most part. Ruins and shrines, camels and tourist guides were not wholly representative of the region. Photography, called at the time the *Pencil of Nature* and the "faithful witness," distorted reality to suit its imaginary mold. Thus, there was also a "photographer's Palestine."

THE LOCAL ENVIRONMENT

Not only did the preconceptions of photographers and the expectations of European audiences shape the history of photography in the Holy Land; actual conditions in nineteenth-century Palestine also had no small effect on photographic output. The small, impoverished country, barely inhabited, with which photographers and travelers of the eighteenth and nineteenth centuries were confronted was a far cry from the Land of Milk and Honey they had expected to see. Instead, they found themselves in a roadless, desolate territory, with a population generally hostile to strangers, and with most of its historical sites in ruins. Even access to the Temple Mount in Jerusalem, the focal point of biblical Palestine, was denied to them as non-Moslems. Their options—the ways they could move, the places they could photograph, the sights that offered themselves to the cameras—were to be as influential as their preconceptions.

A trip to the Holy Land in the nineteenth century involved, first of all, a sea voyage to Jaffa on the Mediterranean coast. From there it was a one-and-a-half day ride up the mountains to Jerusalem, a distance of some fifty miles. From Jerusalem, the traveler generally went six miles south to Bethlehem; on to Hebron, a little farther south; as well as to Jericho in the Jordan Valley, close to the Dead Sea, about twenty-five miles east of Jerusalem. This was the usual tour of the central section of the country. From there, travelers and pilgrims usually continued north through the Moslem town of Nablus, in the mountainous central region, to Nazareth, some seventy miles from Jerusalem. Many of them left the country through nearby Tiberias, on the Sea of Galilee, and stopped in Damascus before returning to Europe. Thus the Holy Land proper, referred to by nineteenth-century explorers as Western Palestine, was the country bordered by the Mediterranean Sea to the west, the Sea of Galilee to the north, the Jordan River and the Dead Sea to the east. It corresponds to the present state of Israel, except for the

Negev Desert in the south and the addition of the West Bank of Jordan. A nineteenth-century American Bible atlas gave the area as 6,600 square miles—1,200 square miles less than the state of Massachusetts.[22]

The Holy Land did not have political or ethnic borders or even a contemporary name of its own. Administered as two provinces or *pashaliks* from the distant capitals of Damascus and Sidon, and considered part of Syria, it was an isolated part of the Ottoman Empire, the notorious "sick man of Europe."

As for the size of the population, Yehoshua Ben-Arieh, Israeli geographer and historian, provides some information:

Today, we have no exacting data which establishes the size of the populace found in what nineteenth-century geographers called "Western Palestine." However, if we were to specify the number of 200,000–300,000 residents at the beginning of the century, our conjecture would not be far from the mark. Yet it is important to emphasize that the population distribution among the different regions was unequal. Most of the residents were in the mountainous regions—Galilee, Samaria, and Judea—while the coastal plains, the valleys, and the Negev were nearly void of any fixed population. The city population was scanty. In the three prominent cities of that day, Jerusalem, Acre, and Gaza, the number of residents was less than ten thousand per city. In the three additional cities, Safed, Nablus, and Hebron, definable as district towns, the population vacillated between five and six thousand. In a number of other cities, historical ones such as Jaffa, Ramleh, and Tiberias, the population was only two to three thousand. And three others, Nazareth, Haifa, and Bethlehem each had less than a thousand residents. In addition to these twelve cities, with a total of approximately 55,000 persons, there were hundreds of villages in the mountainous region, but most of these were small, and their population varied from one or two small families to a few hundred people.[23]

This population was not only small and poor, but also subject to a retrograde, feudal Ottoman administration. This situation changed during the 1830s, when Muhammad Ali, the pasha of Egypt, rebelled against his master, the Turkish sultan. As a result, the Holy Land and Syria were conquered and ruled by the Egyptians for nine years. "The Egyptian power was more liberal and progressive than its predecessor, the Turkish government," Ben-Arieh writes, and

the minority groups—the Christians and the Jews—were given rights they hadn't had for hundreds of years. The Egyptian government was also a strong one, and it enforced law and order. The nomadic Bedouins were in part forced into permanent settlements. Robbery on the roads became less frequent and security conditions improved, but this rule was short-lived. . . . When the Turkish government returned to rule the land in 1840, however, the changes that had begun during the period of the Egyptian government were continued and intensified. The Ottoman government began a campaign of legislative reforms, and its dependence on the European powers which had assisted it in repelling the Egyptian rebellion heightened. The period 1839–1856 is known in the Ottoman Empire as the years of reforms.[24]

This was the period in which the early photographic processes were developed; it also marked the beginning of Western penetration. In 1838, Great Britain opened the first European consulate in Jerusalem, and American Edward Robinson, known as the "father of research in the Holy Land," traveled in the country working on his *Biblical Explorations*. In 1839, the Anglican Mission, which was to become an important source of British influence, began providing medical services (and the son of the first pharmacist was to become one of the country's first local photographers). In the same year, famous Jewish philanthropist Sir Moses Montefiore visited the country and engaged in activities that ultimately generated a social and economic revival within the Jewish community. The French consulate opened in 1843; Prussian, Austrian, Russian, and American diplomats followed. In 1846, the Roman Catholic patriarchate was reestablished in Jerusalem, and in 1849, the Anglicans opened the first Protestant church in the city.

The effects of these changes were not visible for some years, however. Since the Renaissance, Europe had outstripped the Orient socially and economically. In the eighteenth and nineteenth centuries, the region as a whole became a source of raw materials and a market for modern commodities for the growing European powers. The textile production of earlier centuries had been curtailed severely by the Industrial Revolution in Europe in the eighteenth century. The region's town economy was limited to that of colonial outposts exporting a little cotton and importing a few manufactured goods.

Shmuel Avitsur distinguishes three stages of Western technological influence on the economy of Palestine. The first, occurring during the mid-nineteenth century, had a negative effect upon the textile industry. In the second stage, which began after the Crimean War in 1856 and lasted through the 1870s, Avitsur recognizes both positive and negative aspects in the integration with the world market. In the final stage, during the last quarter of the century, Western technology began to take root.[25]

Gabriel Baer is more skeptical:

Only in the oil and soap industry and the production of alcoholic drinks was Palestine's share considerable. . . . Jerusalem and vicinity specialized in inferior *objets de piété*. On the other hand, the number of modern plants established before World War I by Europeans (mainly some mechanical workshops owned by Germans and Jews) was so small that their impact on the local economy and society was negligible.[26]

Transportation and local infrastructure were also primitive compared to the West. Ben-Arieh remarks that the only means of transport within the country until the second half of the century was animals: mules, horses, donkeys, and camels. "Wheeled vehicles appeared only after the Jaffa-Jerusalem road was

paved in 1869, and the first seems to have been the carriage of the Austrian Emperor Franz Joseph, who came to visit the holy places in Jerusalem after the ceremonial opening of the Suez Canal." In addition, "lighting and illumination were the most simple possible. Kerosene reached the region only at the end of the century, and electricity was not used until the beginning of the twentieth century." Modern postal delivery did not begin until near the end of the century, and there was no train service until 1892, when a railroad between Jaffa and Jerusalem was opened.[27]

Socioeconomic conditions, which made it difficult for photographers to provide a true picture of all parts of the country, were complemented by the closedness of the society and by its cultural traditions. While Arab medieval science may have made the earliest contribution to the invention of photography— Ibn al-Haitham (Alhazen) was the first to describe the camera obscura—Moslem tradition itself was opposed to the making of images. The Koranic restriction applied to the overwhelming majority of the population in the Holy Land, who were Sunni Moslems. This, together with other cultural and socioeconomic factors, may explain why Arab photographers practicing in the Holy Land in the 1890s were probably all Christians.

The Jewish population of the Holy Land, mainly living in Jerusalem, Hebron, Safed, and Tiberias, was equally unreceptive to photography, even though Jews were town dwellers and therefore perhaps more exposed to technical innovations. Even in Jerusalem, the city most often frequented by foreigners, where Jews had been the majority since the 1850s, no Jewish photographers emerged until the 1890s. Certainly, the biblical prohibition against image making was one factor. Most Jewish inhabitants were religious and bound by tradition. However, the direct influence of religious prohibitions on the practice of photography was perhaps less decisive, both in Jewish and Moslem societies, than its indirect influence, which generated opposition to modernization in general and photography in particular.

The impact of Western technology and culture on traditional society in nineteenth-century Palestine was gradual and of limited importance in the beginning. It is Jacob Landau's impression that "whatever Western culture was embodied in educational innovations in nineteenth-century Palestine had very limited *immediate* impact on traditional society."[28] Since most of the educational effort was conducted by Christian organizations, Landau thinks the Moslem community in Palestine was aroused, if at all, by "fears that the Christians were proselytizing their children," while "the Jewish traditional community was aroused to fight against the dangers of secular education."[29] The *kutab* and the *heder*, the traditional Moslem and Jewish religious schools, offered no secular opportunities, no education that would encourage

modern development and industrialization. Lack of secular education, which persisted until the last decades of the century, limited access to outside information.

The printing press entered Jerusalem in the 1830s. Secular publications were rare until late in the century. Perhaps the two most important exceptions were the Hebrew periodicals *Halevanon* and *Havazelet*, which started to appear in the 1860s. As to the Arabic press, Shimon Shamir writes that "copies of newspapers in Arabic [printed elsewhere] reached Palestine towns in the 1860's; periodicals in Turkish may have arrived as early as the 1840's."[30] Shamir also believes that "these developments, important as they may have been for the general process of Westernization, could not, by themselves, have transformed the outlook of a traditional society."[31]

This was the environment photographers entered and in which photography was introduced. The development of the medium was therefore slower and took a different course than in the industrialized centers, where it was an instant success.

Conditions in the Holy Land were so different, in fact, that even the question of where to begin its history of photography presents a problem. If we were to assume that the history of Holy Land photography began with local work, we might choose 1859 as the starting point, when the earliest written evidence pointed to the existence of a local photographer, or 1865, when a published photograph was first credited to a local person. But these dates did not mark a revolution in photographic approaches. Foreigners continued to produce the greater part of the important and influential photographic work, and even the local photographers were themselves born abroad. The modern cultural history of a "colonial" country begins before its own cultural production becomes independent of foreign material and ideological influences. To disregard the two decades between 1839 and 1859 would be as much of an error as to ignore the influence of foreign photographers on local work from 1865 onward.

The fact that prototypes of photographic imagery were not created by and for local people is a significant part of the history of Holy Land photography. That is not to say, of course, that the socioeconomic state and traditional culture of the country did not exert their own influence. It is the interaction between two factors—foreign attitudes and local realities—that shaped the history of Holy Land photography. Problems arising from the different cultural predispositions of foreign photographers and local subjects, problems of physical and social access to local sites and peoples, and, in fact, all of social interaction affected the photographs that were ultimately taken. And all these made their mark upon photography in the Holy Land.

THE LAND, Part One HOLY AND PROFANE

Art, Propaganda, and "Remarkable Views": Daguerreotypes, 1839–1844

On December 11, 1839, less than four months after L. J. M. Daguerre's invention of photography was publicly announced in Paris, two painters, Horace Vernet and Frédéric Goupil-Fesquet, arrived in Jerusalem.[1] They were part of a group of photographers, or daguerreotypists, dispatched all over the world by N. M. P. Lerebours to photograph outstanding views. Lerebours, a Paris optician, published the resulting pictures between 1840 and 1842 in a series of albums entitled *Excursions Daguerriennes* and subtitled "The Most Remarkable Views of the World."[2] One of these albums contained reproductions of more than a hundred daguerreotypes taken in various countries, including three from the Holy Land credited to Goupil-Fesquet and Vernet. These were the first photographs ever taken (and published) of Jerusalem, the Holy City; Nazareth, linked to the story of Christ's childhood; and the Crusaders' fortress of Acre. The important genre of travel photography was launched.

Though the introduction to *Excursions Daguerriennes* credits both Vernet and Goupil-Fesquet with the photographs from their Near Eastern tour, the daguerreotypes actually were taken only by the latter. There is, of course, a much-quoted letter of Vernet, written from Alexandria, where he says, "we are daguerreotyping like lions,"[3] but in his diary Goupil-Fesquet used only the first-person singular whenever he described taking the pictures. In addition, two passages included an obvious reference to himself as the only one to use the camera, though he extolled Vernet as a superior artist:

Due to Horace Vernet's prestige and reputation I dare to hope, dear reader, that you will have the patience or curiosity to read these lines. Even though I am neither learned nor an experienced writer, but simply a humble artist of good cheer equipped with pencils and daguerreotype and the desire to enrich my memory and imagination with new sights, my resolve to be sincere and truthful should be sufficient to win your pardon.[4]

H. Vernet sketches very little whilst traveling; his memory is phenomenal . . . whilst painting he recalls from memory precious details. As more ordinary painters browse through an album to select a subject he sees his subject

as if in a dream, sustaining by will the image in his mind's eye for as long as necessary. One is tempted to believe that there is some inner daguerreotype in this mysterious and extraordinary capacity. . . . Not being personally endowed with anything that approaches the talents of this great master I humbly place myself at the mercy of the sketches and the daguerreotype like one rescued at sea on a lifeboat.[5]

Within a few years, other daguerreotypists followed Goupil-Fesquet. The first British daguerreotypist, medical doctor George Skene Keith from Edinburgh, arrived in the Holy Land in 1844.[6] His daguerreotypes were used by his father, Dr. Alexander Keith, to illustrate his book. The elder Keith himself was possibly the first person to attempt to photograph in the Holy Land. The preface to the 1847 edition of his book, which has been passed over by historians of photography, mentioned his possession in 1839 of some "calotype" photographic paper that failed, upon arrival in the country, to register an image (see p. 35).[7] Since Alexander Keith arrived in the country for his first visit on June 2, 1839, on a mission of inquiry set up by the Church of Scotland, and left some four weeks later,[8] it appears that he made his attempt almost six months before Goupil-Fesquet arrived in the Holy Land, that is, even before the invention of photography became generally known.

When Keith left Britain for Palestine on April 12, 1839, photographic processes were known only to inventors and very narrow circles of interested specialists and friends. No links are known between Keith and W. H. Fox Talbot, the inventor of the process later known as calotype. However, another early experimenter with photography, Dr. Andrew Fyfe, was closer to Keith's own circles.[9] Fyfe had already announced his success at obtaining photographs on paper to the Society of Arts of Scotland in Edinburgh on April 17, 1839.[10] Although we do not know whether the two were acquainted, the possibility that Keith knew of Fyfe's invention or, through him, of Talbot's cannot be ruled out. There is as yet no complementary source to confirm the information and to account for Keith's access to one of the processes. Still, the comment in Keith's preface might be accurate, which would make the Holy Land the first and only place outside France and Great Britain where photography was attempted at such an early date.

In 1844, the year of Keith's second tour, Joseph Philibert Girault de Prangey, a French nobleman with a strong interest in Moslem art and architecture, visited the Holy Land. De Prangey's daguerreotypes were mostly of Jerusalem, but occasionally he photographed other parts of the country. The greater part of de Prangey's work, which shows that he had the eye of an artist, was devoted to views of beautiful landmarks and shrines.

De Prangey's collection includes the only extant original daguerreotypes from the Holy Land. About one hundred in number, they have never before been examined in detail. Historians of photography usually refer to de Prangey's Near East reproductions in his album, *Monuments arabes d'Egypte, Syrie et Asie Mineure*. This includes, however, only one picture from the Holy Land, a lithograph of a view of the Temple Esplanade in Jerusalem.[11] Its source—probably a daguerreotype—is not indicated, contrary to current practice. Another album includes two color lithographs made after de Prangey's water colors.[12]

De Prangey's collection of original daguerreotypes seems to be complete. It was not submitted to a publisher and thus is the only one to fully account for a daguerreotypist's own choices and decisions, his personal interests and orientation.

Together, these three collections of Goupil-Fesquet, Keith, and de Prangey constitute the first phase—that of the daguerreotypists—in the history of Holy Land photography. They also show us that, from the very beginning, photographers have approached the Holy Land with well-established preconceptions and with differing aims.

The quality of the daguerreotype was considered excellent at the time and is fine even by today's standards. The process consisted of loading a wooden camera, somewhat smaller than a shoebox, with a specially prepared copper plate, polished with silver; focusing the lens on a well-illuminated object; exposing the plate; and then developing the captured image. There was no separate negative as in modern photography; the image on the plate was a positive. After it was developed, the daguerreotype resembled a mirror on which fine gray tones were imprinted, and, as in all mirror images, the picture was laterally reversed. Dark or black shadows were of darker gray (and sometimes reflected the onlooker); bright areas were whitish-gray.

Though the pictures were precise and rich in details and nuances, the process had several serious limitations. Only one person at a time could inspect a daguerreotype, and then only by holding it at just the right angle to the light. Daguerreotypes could not be reprinted directly.[13] To reproduce them, engravings had to be made by hand, just as works of art had been copied previously. The exposure time was counted in minutes, not fractions of seconds, and could be as long as a quarter hour or more.[14] Thus, the process was perfectly suitable for recording the landscape, but not for photographing people, unless they posed especially for the camera.

The same limited options, determined by geographical and social conditions in the Holy Land, and the same limited equipment might have led to very similar results. But photographers' predispositions

were different, and so were the circumstances of their visits and personal backgrounds, so that, indeed, different results could be expected. A Parisian painter financed by an optician-turned-publisher, a Scottish doctor working for his theologian father, and a French aristocrat devoting his leisure time to research in Moslem art history: these were three daguerreotypists working for different purposes—essentially commerce, theological propaganda, and art history, respectively.

According to Goupil-Fesquet's diary, published in 1843 as *Voyage en Orient avec Horace Vernet*, he and Vernet arrived in Jerusalem on December 11 and shortly thereafter visited the Church of the Holy Sepulchre; they went to the church again on December 14, but no picture of this undoubtedly remarkable place appeared in their album. The two travelers visited Bethlehem and Hebron, but, again, published no view of either town. Between December 11 and 14, Goupil-Fesquet took a daguerreotype (never published) of David's Tower, a prominent Jerusalem landmark, and one of the city of Jerusalem as seen from the Mount of Olives, which did appear in *Excursions Daguerriennes*. The mount provided a superb

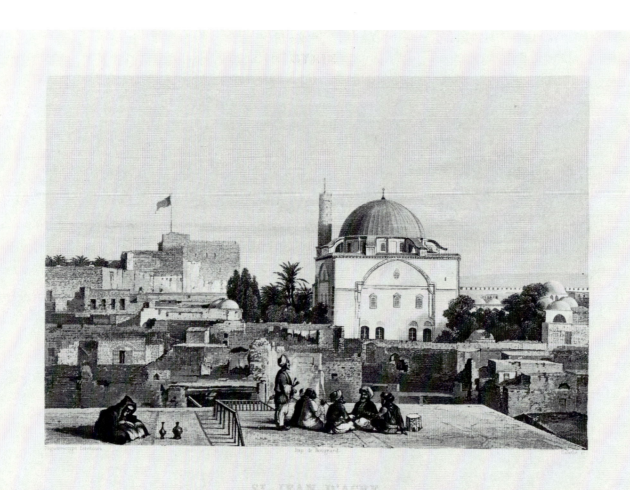

view of the city's impressive domes, walls, and towers, saturated with historical and biblical associations. The vantage point is excellent, and almost everyone who has since photographed the city has confirmed the wisdom of Goupil-Fesquet's original choice. Here is Jerusalem as seen by countless pilgrims and travelers over the centuries.[15]

The travelers continued to the north of the country, where Goupil-Fesquet took a daguerreotype of Nazareth, with its modest, simply built Church of the Annunciation. Although they visited these places just before Christmas, they did not stay for the holiday but departed for Acre, the Crusaders' fortress on the shore of the Mediterranean, of which he also took a daguerreotype. The absence of any mention of Christmas in Goupil-Fesquet's diary reinforces the impression that he did not see himself as a pilgrim to holy places but as an artist on assignment. Acre had no biblical history but had its place in French colonial history. Napoleon's attempt to conquer the Holy Land had failed there in 1799. The city's mosque and ramparts added a romantic oriental touch to a historical site. French photographers who followed Goupil-Fesquet would also photograph Acre, while the British would not.

Vernet and Goupil-Fesquet traveled the twenty miles from Nazareth to Acre the day before Christmas. As reproduced, the picture focuses on the city's mosque, with the tower not yet complete (and with human figures drawn by the engraver). But the flattering view was somewhat belied by part of Goupil-Fesquet's accompanying text:

In short periods between bouts of cholera, typhus, the plague, an earthquake and other calamities, which in turn devastate this unfortunate country, the inhabitants raise their ramparts; but it does not occur to anybody to restore the monuments that once glorified St. John of Acre any more than any thought is ever given to tilling the soil where thorns and thistles thrive unhindered.[16]

With just three daguerreotypes, it is impossible to tell whether Goupil-Fesquet's (or Lerebours's) selection of views was intended to be representative of the Holy Land, either as it actually was in 1839 or as the daguerreotypist envisioned it. The discrepancy between the impressive view of Acre and the more realistic report in the text suggests that a photographer's visual impression was not yet expressed— as it often is today—by the pictures taken. The same person had two different responses. Though interested in local conditions and inhabitants, his realistic observations were expressed only in his writings, never pictorially.

The publisher's choice of two painters for this first photographic assignment was natural. Horace

*ric Goupil-Fesquet (1839), engraving after daguerreotype. "Syrie. St. Jean d'Acre"
). (G. Lévy, Paris)*

Vernet was a famous painter of biblical scenes, noted for precise reproduction of minute details. Goupil-Fesquet, Vernet's nephew, was a minor artist, a teacher of art, and the author of a series of textbooks on drawing.[17] Lerebours regarded the daguerreotype as an improvement upon traditional artistic techniques, not as a new medium. He made this clear in the introduction to *Excursions Daguerriennes*:

These extraordinary feats cannot fail to interest lovers of art, for they are indisputably extensions of the engraving . . . making it possible to become acquainted with monuments and with unique and rare works of art presently hidden away in the studies of collectors and connoisseurs. The etched view will be enlivened with figures when prints of certain places lack them. . . . As a result of the newly found precision of the daguerreotype, sites will no longer be reproduced from drawings of the artist, whose taste and imagination invariably modified reality.[18]

Goupil-Fesquet himself perceived the daguerreotype as a tool in the service of an artist. He writes in his diary:

Heavy rain accompanies us everywhere but does not prevent making daguerreotypes. The view of the ramparts taken from one side of David's Tower seems to warrant a photograph, so enwrapped in my heavy greatcoat I proceed to the nearest mountain. After examining the site and scouting around for a few small stones to prop up my camera, I focus my camera obscura on the object of my choice. . . . The Tower of David looks majestic, casting its geometrical shadows at the sky above the undulating ground; the contrast of straight and curved lines is pleasant to the eye and the parallel vertical lines add to the severity of the scene.[19]

In contrast to Goupil-Fesquet, George Keith regarded the new medium of photography as a means of promoting a cause. To him the camera was a tool that could be used to support his father's thesis. Keith became the first photographer in the world to bolster ideological argument with visual reinforcement. His purpose was the dominant factor governing composition and selection of subjects.

The content of the book Keith was to illustrate is nicely summarized by its title and subtitle: *Evidence of the Truth of the Christian Religion Derived from the Literal Fulfillment of Prophecy Particularly as Illustrated by the History of the Jews and the Discoveries of Modern Travellers.*[20] Such evidence was to be provided by comparing scriptural passages (from Isaiah, Micah, Luke, and others) prophesying the destruction of Israel and Judah with the present desolate state of the Holy Land as observed by the elder Keith. The following passage from his book is characteristic:

Having recently visited the land of Judea, the writer may confidently affirm that it sets before the eyes of every beholder, who knows the Bible and can exercise his reason, a three-fold illustration of the truth of Scripture, in respect to its past, present, and yet destined state . . . it exhibits even among the barren but terraced mountains of

Israel such proofs of ancient cultivation as show to a demonstration that the ancient fertility and glory of the land were not inferior to what Scripture represents. Looking on it as it is, the whole land now bears the burden of the word of the Lord. And yet it shows as clearly whenever that burden shall be removed and the Lord shall in mercy remember the land, that, it yet retains the capability, as if it had never been laid waste, of blowing forth anew in all its beauty.[21]

The first edition of *Evidence* (1823) was illustrated by drawings obviously made from the artist's imagination. Some of these were replaced in the thirty-sixth edition in 1847 by nine engravings made after some of the younger Keith's daguerreotypes (one half of his output in the Holy Land).[22]

The elder Keith clearly appreciated the use to which daguerreotypes could be put in authenticating his text and hence his argument. According to the unsigned preface to the thirty-sixth edition, written in December 1847:

As soon as photography began to take its place among the wonderful arts or inventions of the present day, Keith anticipated a mode of demonstration that could neither be questioned or surpassed; as without the need of any testimony, or the aid of either pen or pencil, the rays of the sun would thus depict what the prophets saw. With this intent, on his first visit to the East, he took with him some calotype paper, the mode of preparing which was then secret, but on reaching Syria it was wholly useless. Then engaged in another object, he passed within an hour of Ashkelon and another of Tyre without seeing either. A second visit to Syria, accompanied by one of his sons, Dr. G. S. Keith, Edinburgh, by whom the daguerreotype views were taken, enables him now to adduce said proof; and has led besides to such an enlargement of the evidence from manifold additional facts, as he again hopes may impart that lesson to others with which his own mind has been impressed—a still deeper conviction of the defined precision of the *sure word*.[23]

It is not known whether the elder Keith formulated strict guidelines for his son on the selection of subjects or specific angles of the views, nor do we know who was responsible for the ultimate choice of scenes that were published. Most likely the father merely asked his son to go along and photograph what he could to strengthen the thesis of his book by means of realistic illustrations.

Certainly the selection of subjects was not due to a rapidly planned or carelessly followed itinerary or to lack of time. The Keiths spent five months in the region covering some thousand miles in the Holy Land and the Near East. They traveled along the Mediterranean coast where Keith photographed ruins of Crusader castles and also saw much of the country's interior, detouring inland to Jerusalem and its environs—Hebron to the south and Samaria to the north—and visiting Tiberias, Chorazin, Capernaum near the Sea of Galilee, Zimrin, Ramleh, and other towns in the interior plains. They even crossed the Jordan River to go to Petra, the ancient Nabatean capital.

Of the nine views of the Holy Land in *Evidence*, four are of ruined Crusader sites of secondary importance to biblical history; two are of Jerusalem; one is of Hebron; and the others are of Ashdod, a small village on the Mediterranean shore, and of olive groves near ancient Samaria. Conspicuously absent from the selection are such well-known places as the biblical towns of Bethlehem and Nazareth and the Church of the Holy Sepulchre.

The overall impression of the Holy Land in Keith's nine views is entirely different from that in Goupil-Fesquet's three. Keith juxtaposed the remains of the ancient glory of Israel with the current desolation of the land, which looked much more barren than in Goupil-Fesquet's and de Prangey's daguerreotypes.

Keith's photograph of Samaria is typical. Here he could have shown the rows of ancient columns just outside the village—and probably would have, if his interests had been aesthetic, romantic, or historical, like those later photographers. Keith chose a view of the neighboring hills, covered with olive groves (perhaps coached by his father), to fit the accompanying quotation from Micah 1:6: "I will make Samaria as an heap of the field, and as plantings of a vineyard. . . ."[24]

One of Keith's pictures of Jerusalem is a panorama of the Temple Mount similar to Goupil-Fesquet's

Engraved by W. Miller, from Daguerreotype by G. S. Keith MD

view. It shows the city in all its majesty—fortified and walled, with a great array of buildings. But Keith's second view of Jerusalem is in sharp contrast. Centering on Mount Zion, adjacent to the Temple Mount, it shows the open countryside with a few small houses on the crest of the mount. Yet the daguerreotypes of the Temple Mount and Mount Zion were taken from a very similar vantage point. If he had wished, Keith could have made a single, continuous panorama of the city from this spot easily. However, when he photographed Mount Zion, his angle of view omitted as much as possible of the impressive Old City; only the southeastern tip of the city walls appeared in the upper-right-hand section. No other nineteenth-century photographer used this angle; no one else was interested in isolating Mount Zion from the city. But this view supports the elder Keith's point, and the caption reinforces it: "Zion shall be plowed as a field" (Jer. 26:18; Mic. 3:12). The accompanying text recalled that "the abomination of desolation was set up in the Holy Place. A ploughshare was drawn over the consecrated ground. . . ."[25]

The senior Keith's use of "Zion" is inaccurate as well as tendentious. In the Bible, as well as in modern Hebrew, Zion is simply another name for the city of Jerusalem. Today the hill is called Mount Zion; in the nineteenth century, the precise location of Mount Zion was a hotly disputed issue. George Keith interpreted the biblical text in line with his father's instructions, using the daguerreotype to make it appear that his father's argument was verified by the landscape.

The correlation between visual and written elements in Keith's book contrasts with the discrepancy between Goupil-Fesquet's written and visual images of Acre. Unlike Goupil-Fesquet and de Prangey, Keith did not look for the most beautiful and impressive buildings, but showed a cross-section of the country: a town, a village, vineyards and olive groves, ruins, and two contradictory views of Jerusalem. The overall view of the country was essentially correct and, even considering the small selection of pictures, gave a reasonably realistic idea of its contemporary state.[26]

Thus, the daguerreotype was employed by Keith to convey the religious connotations of towns, ruins, villages, and hills that fed beliefs, theology, and myths. The elder Keith's argument about the "evidence of the prophecy" was inherent in the landscape itself. Keith the daguerreotypist did not have to superimpose his own views on what the camera could capture to foster his father's propagandistic approach. In his own words, Alexander Keith wanted to submit "to the unbeliever . . . the positive evidence of Christianity [that] convinces the unprejudiced inquirer or rational and sincere believer, that it is impossible that his faith can be false."[27]

Keith's work was thus quite different from that of other early photographers. His employment of

e Skene Keith (1844), engraving after daguerreotype. "Hebron." (N. Schur, Tsahala)

photographs to propagate an idea is the earliest case in the world of the conscious exploitation of the medium's persuasive power. Obviously, Keith had to settle for engraved reproductions; daguerreotypes were suitable for individual viewers, but Keith was addressing a large audience. The book was the first and only British publication in which daguerreotypes were the basis of illustration.

Though the Keith book was highly successful, the idea of using Holy Land photographs as a means of persuasion was not repeated until the 1890s. In general, nineteenth-century photographers followed in the footsteps of de Prangey. His daguerreotypes, though they remained unpublished, could easily have been the model for subsequent generations, who tended to select the very same views.

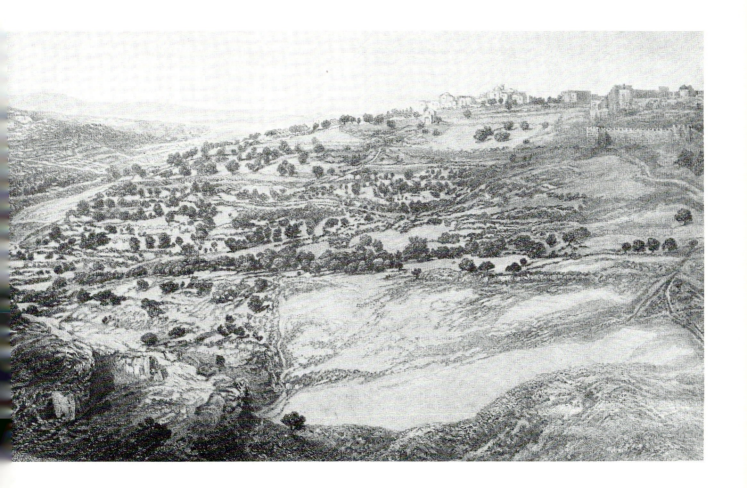

FT: *Anonymous drawing from the imagination, used until 1846. "Zion will be plowed as*
.—Jer. 26; Mic. 3:12," in Alexander Keith, "Evidence of the Truth of the Christian
n." (Jewish National and University Library, Jerusalem)

M LEFT: *Jules Ruffier des Aimes (ca. 1900), dry-gelatin glass negative, modern print.*
em from the Mount of Olives. The Temple Esplanade and the city as depicted by Goupil-
t and Keith, except the section at left, which includes Mount Zion and the upper section
city walls. (White Fathers, St. Anne's Convent, Jerusalem)

George Skene Keith (1844), engraving after daguerreotype. Beginning in 1847, re-
the drawing on p. 38, the same caption being kept. To locate Mount Zion in relation to
, see Ruffier's photograph (p. 38), left section. (N. Schur, Tsahala)

De Prangey made several hundred daguerreotypes during his tour of the Near East, including about a hundred of the Holy Land, which he visited in the same year as George Keith. The whole collection has been preserved virtually intact in the French chateau in which he lived.[28] Its completeness provides a rare example of a daguerreotypist's own approach, since the bulk of Keith's and Goupil-Fesquet's work has been lost and the remainder survives only in engravings carefully selected by the publisher, who was using yet another set of criteria. The de Prangey collection is also the largest of the three (about eight times the number of Goupil-Fesquet's and Keith's engravings combined) that has survived and is therefore comparable to the larger collections made later in the century.

Girault de Prangey's trip to the Near East was an extension of his research into Moslem architecture in Seville and Granada in Spain. Starting in 1832, he made sketches of various buildings in Spain, paying particular attention to the measurement of architectural details and even casting models of sculptural details. He published albums on the subjects in 1836 and 1841. In 1842 he departed from Marseilles for the Near East with several cameras and lenses. Labels on his plates indicate that the earliest ones were made in 1843 in Egypt and the latest ones in 1844 in Baalbek and Constantinople.[29]

Girault de Prangey (1844), daguerreotype. Absalom's Tomb. Laterally reversed view; in the background, Mount Scopus. (Private collection)

Of his daguerreotypes of the Holy Land, a number needed to be restored, and some were so faded that the locals could not be identified definitively—a coastline, a group of mud houses. But seventy-seven of them were in reasonable condition and were identifiable. Of these, thirty-three portrayed Moslem architecture, twenty-one being views of the Temple Mount, focusing on the venerated Dome of the Rock, the outstanding example of Moslem architecture in the Holy City. Sites of Christian interest were the photographer's second priority, with twenty-seven views in this category, including ten of the Holy Sepulchre. About a dozen views were of tombs and villages outside the city walls. The remaining seventeen were of landmarks outside Jerusalem: the Church of the Nativity in Bethlehem; the Church of the Annunciation in Nazareth; convents and Christian sites at Mar Saba (in the Kidron Valley, between Jerusalem and the Dead Sea, an area already traversed by Goupil-Fesquet); in Ramleh, between Jerusalem and Jaffa; on Mount Carmel; and in Samaria, where he made a daguerreotype that closely resembled Keith's.

De Prangey used long-focal lenses for many subjects that otherwise would have been impossible to photograph to the same scale. Thirteen daguerreotypes show the Temple Mount from relatively long range and eight from middle range. The latter had to be taken from a remote vantage point using long-focal lenses, because entry to the Esplanade itself was strictly prohibited to non-Moslems. Judging from his approach to comparable sites, such as the Church of the Holy Sepulchre, we can be reasonably sure he would have taken close-up views of the Dome of the Rock and of the nearby Mosque of El Aksa if this had been possible. De Prangey was the first to appreciate the possibilities of close-ups, probably because of his casting experience; a daguerreotype would be the closest possible replacement of a cast replica, both being imprinted by the model itself. He was a versatile daguerreotypist who used his equipment to the best advantage. He not only photographed the buildings he was interested in from many vantage points; he sometimes cut his rectangular plates into two or even four longitudinal sections to use them more efficiently.[30] For example, he would show towers in narrow, vertically placed plates and ramparts in narrow, horizontally placed ones. In one extraordinary moment, however, he produced a horizontal composition using a vertical subject with an unusual result. In his view of Absalom's tomb it seems as if he consciously paid as much attention to the landscape as to the tomb itself. De Prangey was not only an art historian but also a man of aesthetic sensitivity. Ten years later, Auguste Salzmann, another Frenchman interested in Jerusalem landmarks, would follow him; though Salzmann was a painter, it was de Prangey who had a better eye for composition and light.

Twice de Prangey tried to photograph local people. Taking his picture of Robinson's arch, an important subject of archeological research, he placed (hired? asked a passerby?) a local figure next to the subject to indicate the scale. But that person could not stand still long enough, or did not understand that he was supposed to do so, and thus appears in the daguerreotype as a "ghost figure," semitransparent. In another smaller plate a faded image can barely be discerned. A handwritten caption, most likely done by the daguerreotypist himself, reads "Beggar in Jerusalem." Possibly the image was underexposed to begin with; de Prangey may have been trying to cut the time of exposure and thus of the pose.

Such failures are as significant as de Prangey's many successes. They reflect the technical inadequacy of the daguerreotype in settings in which communication between photographer and model was limited or nonexistent, especially in countries in which modern inventions as well as artistic traditions of posing for a portrait were unknown and without precedent. The daguerreotype process was adequate in other settings, as millions of portraits prove. It was the cultural gap between a Western traveler and his equipment on the one hand, and the local environment on the other hand, that prevented de Prangey from succeeding with these pictures.

ABOVE: *Girault de Prangey (1844), daguerreotype. Robinson's Arch. Detail of ancient arc-
ture. Figure posed to indicate scale, appears transparent ("ghost figure"). (Private collecti*

RIGHT: *Girault de Prangey (1844), daguerreotype. The Dome of the Rock and the W
Wall. Laterally reversed view. (Private collection)*

De Prangey published almost none of his views from the Holy Land. His album, *Monuments arabes d'Egypte, Syrie et Asie Mineure*, which he published himself in 1846, includes only one lithograph of the Holy Land, possibly made after a daguerreotype. It shows the Dome of the Rock on the Temple Esplanade from the roof of the governor's house, the closest and best point of view overlooking the forbidden area.[31]

Lack of commercial success may have discouraged him from further publishing. De Prangey worked alone all his life; he did his own research, wrote his own reports, made his own sketches, castings, measurements, and daguerreotypes, and he published all his work himself. We cannot know whether it was lack of time or lack of commercial success that kept him from publishing the rest of his photographs of the Holy Land. We can only guess from his Spanish albums that he would have printed large-format plates with engravings of both full views of each subject and close-ups showing their architectural details. He also could have easily produced an "Album of Views from the Holy Land," very marketable as later photographic work would prove; he had ample material of the "traveler" kind. But he preferred the solitude of his chateau, and for the rest of his life devoted himself to his interests in botany and in the archeology of his own region.

De Prangey saw the sites in the Holy Land through the eyes of an art historian, a Christian, and an artist. The art historian demanded complete coverage of Moslem architecture; hence his views of the same subject from different vantage points and at varying distances. Since access was barred, these studies had to be limited to general views. As a Christian he wanted to record numerous views of the Holy Sepulchre. He also photographed convents and villages of historical significance outside Jerusalem. The path he took, which was the typical pilgrim and tourist route commonly followed even before the advent of photography, covered the best-known biblical sites. De Prangey had not come to the Holy Land to reveal unknown places, make archeological excavations, or discover hidden treasures of beauty: photography was new, and every single view was a novelty. The topographical features of the path also helped

to determine the vantage points from which the landscape views were taken. Some spots were the only ones accessible, others the best accessible; still others offered the most complete view. Comparing de Prangey's work in retrospect to that of the calotypists of the 1850s, the wet-plate photographers of 1857–78, and the dry-plate photographers in the last part of the century, we find that de Prangey's was, in fact, the overlooked prototype of Holy Land photography. Though unknown, his work also was a precursor of the rather French-Catholic tradition of emphasis on the photography of architecture.

Goupil-Fesquet, Keith, and de Prangey all came to the Holy Land within the same five years. As far as we know, no other daguerreotypist followed them in the next five years. In the meantime, the calotype process, more similar to today's photography, matured. Photographers who arrived in the following decade used the calotype and, somewhat later, the wet-plate process. By 1844, the day of the daguerreotype in the Holy Land had come to an end.

Jerusalem in Beautiful Prints:
Calotypes, 1849–1864

Ten years after the first daguerreotypists, a new wave of photographers reached the eastern shores of the Mediterranean Sea. Late in 1849 or early in 1850, two Englishmen, the Reverend George Bridges and C. M. Wheelhouse, photographed Jerusalem and its environs, using a new process. They were followed in 1850 by the Frenchman Maxime Du Camp, traveling with the novelist Gustave Flaubert. In 1854, another Frenchman, Auguste Salzmann, produced the most voluminous nineteenth-century collection of photographs of Jerusalem. By this time, the process these travelers used—the calotype—was being replaced by the superior wet-plate collodion process. Nevertheless, still another Frenchman, Louis de Clercq, and a German, A. J. Lorent, took calotypes of Jerusalem and other parts of the country as late as 1859–60 and 1863–64.

The word "calotype" comes from the Greek *kalos*, meaning beautiful. It designates the photographic process invented about 1835 by the English nobleman William Henry Fox Talbot. In use soon after the daguerreotype (1839), the calotype was considerably closer to the present-day photograph: it was a print, a sheet of paper.

Unlike Daguerre, Talbot produced "negatives" in his camera obscura, the intermediary pictures that are employed in photography today. The negative served as a template from which unlimited numbers of "positive" calotypes could be printed. Thus copies were not manually engraved, instead appearing unmistakably as photographs. The process also restored the lateral inversion of the daguerreotype.

While the invention of the daguerreotype was said to have brought about the "death" of painting, the calotype now destroyed the concept of the picture as an original work of art. Thousands of identical prints could now be produced, each an "original." Because the finished picture could be reproduced through a self-contained process, Talbot's invention has been the basis for modern photography and derived media.

Unlike the daguerreotype, calotypes, as negatives and positives, were paper. Consequently, the photographic process was cheaper and the visual effect was different—a grainy picture with greater contrasts was produced. Many artists and critics considered this picture closer to art than the sharp, mirrorlike daguerreotype.

The invention of the calotype was crucial not only in the development of photographic technique but also in the production of albums and illustrated books. The finished calotype, a sheet of paper, was suitable for insertion in a book, whereas its predecessor had to be protected with glass and so required a frame. In fact, Talbot himself produced the first book illustrated solely by photographic prints: *Pencil of Nature*, published in 1844.

As these developments were occurring, the process of inserting photographs into books was improving. Calotypes and later photographs were glued into books on separate pages. (Still later text and photograph would be printed together.) Travel accounts of the Near East were among the first products of the merger between photography and the book, and Jerusalem held a place of honor in this production.

Authentic biblical remains, untouched by later conquests, were rare in Jerusalem. One major exception was the Western or Wailing Wall, traditionally considered part of Solomon's Temple and now known to be part of the temple's outer enclosure. It has been the religious and historical focus of Jewish faith and tradition and the symbol of Jewish national independence. While later archeological excavations were to disclose remains of city walls, buildings, and dwellings dating from before the biblical period, most of the ancient structures intact and visible in the 1840s and 1850s were remains from the time of the Romans, the Moslems, the Byzantines, and the Crusaders. Those sites in the region between the Valley of Nilus and Baalbek in Lebanon considered the most beautiful and photographed most often were the Moslem shrines on the Temple Mount—the Dome of the Rock and the Al Aksa Mosque—and the Nabatean shrine of Petra, east of Jordan. Together with the Jerusalem city gates and that part of the walls built in the sixteenth century (which sometimes were visible above older layers of wall), the Moslem and Nabatean shrines attracted photographers no less than places holy to Christianity or relevant to biblical archeology.

Another subject of interest was contemporary Jerusalem itself, its streets, and its dwelling places. Jerusalem in the mid-nineteenth century was still a small medieval town. It was not even the capital of the province to which it belonged and, in fact, had no political status as a municipality. It lacked modern administration as well as modern buildings, and most of its inhabitants were poor. The gates of the city closed at sunset and opened at sunrise, a practice that would be followed until the turn of the century.

Large areas inside the city walls lay in ruins, visible in photographs of nearby historical and religious sites. The population of Jerusalem was estimated at close to 13,000 in 1840: 5,000 Jews, 4,000 Moslems, and 2,750 Christians.[1]

It is not difficult to understand the attraction Jerusalem held for photographers. As the embodiment of biblical times and events, it was the Holy City for Judeo-Christian civilization. Here was the capital of the Judaean judges, kings, and prophets. Here too was the focal point of the Gospels. The Church of the Holy Sepulchre, which had attracted Christian pilgrims for centuries, was photographed first in detail by Girault de Prangey, then by calotypists (and especially Salzmann), and, in fact, by almost every photographer who came to the Holy Land. The way of the cross, the Via Dolorosa, became the subject of one of de Clercq's albums. Many other places inside the city walls or just outside—the Mount of Olives, the Tomb of the Kings, the Valley of Jehoshaphat—and others farther away—Bethlehem, Hebron, Jericho—were on the traveling photographer's main circuit.

The first and most famous photographic account of the Near East was Maxime Du Camp's *Egypte, Nubie, Palestine, et Syrie*, published after his travels of 1849–50. In the middle of the next decade, when the calotype was already becoming obsolete, the most voluminous nineteenth-century album of Holy Land calotypes was produced: Auguste Salzmann's *Jerusalem*, containing some 180 views.

French calotypists were the foremost producers of such accounts for several reasons. First, Louis Désiré Blanquart-Evrard introduced significant improvements in the calotype process in France during the 1840s and 1850s,[2] including the use of albumen paper (i.e., covered with eggwhite) for the positive print. The resulting pictures were less grainy and more on the surface of the sheet of paper. Thanks to their superior quality, albumen prints survived the calotype process by decades. Second, such travel accounts were sponsored by the French Ministry of Public Instruction. Third, the idea of photographing historical landmarks was raised in France as early as 1839. It was then that the Commission for Historical Monuments decided that the daguerreotype could be utilized in the services of archeology. Famous French architect Viollet-le-Duc had the cathedral of Notre-Dame daguerreotyped in 1842.[3] During the summer of 1851 photographers were sent to French provinces to photograph important historical sites. In comparison, the first English publication to use photography in a similar fashion dates from 1855.[4]

Frenchmen, however, by no means monopolized photographic travel accounts of the Near East during this period. At least three British, one Irish, and two German calotypists traveled to the Holy Land,[5] and further research may well discover others.

Reverend George Bridges of Britain was most likely the first calotypist to reach the country. He

produced a voluminous book of calotypes taken in 1849 and published in 1858.[6] He apparently published more than a hundred calotypes, most of which have been lost or are inaccessible. These extant only hint at his true vision of the Holy Land. His perception of the role of photography in the Holy Land is evident from the title of his series of albums, which echoes Keith's thesis: *Palestine as It Is: In a Series of Photographic Views by the Rev. George W. Bridges. Illustrating the Bible.* It is also described in the introduction, which Bridges himself probably wrote:

The Photographs contained in this work were taken several years ago, in the infancy of this astounding Art—when chemistry and science had not developed the wonders since arrived at. Other travellers have devoted their thoughts and learning to investigation into the topography of this Sacred Land, while artists and amateurs have attempted to exhibit to the eye sketches of its most picturesque localities, assisted with all the adventitious embellishments of artistic imagination; but hitherto no one has thought of presenting to the student of Sacred History *fac-similes* of these scenes, satisfying at once the requirements of *truth*, and the delight connected with a display of the beauties of Nature.

The Notes, containing Scripture References, are but the obvious impressions made by the spot described and which must occur to the mind of every traveller in the Holy Land, irrespective of all controversy upon the identity of these places; and it is hoped that, while they escape criticism from the supporters of mere topographical theories, they may tend rather as an additional inducement to search into the pages of the very best of all Guides to Palestine—The Book which cannot err.[7]

Like Keith, Bridges saw the photograph as an instrument of documentation to support ideology. Bridges's claim to primacy may be justified, because Salzmann's book, which had been published two years earlier, was limited to Jerusalem and may have been unknown in London in 1858; also Bridges's visit preceded Salzmann's by five years.

Bridges was also the first to include human figures in his pictures successfully, most likely his own or that of one of his European companions. One of the figures is quite close to the camera, the face recognizable. The other is small, far from the camera, and was probably meant to indicate the scale.

Bridges's interest lay not only in biblical and medieval history, but also in sites of contemporary significance for his native England. This is clear from his calotypes showing "The Protestant Church in Jerusalem" and "The Entrance to Jerusalem, with the Residence of the Anglican Bishop." The church was consecrated in 1849, the year of Bridges's visit and eleven years after the establishment of the British consulate. It was the only Christian place of worship that had been built in Jerusalem since the Middle Ages. As Bridges explained and his pictures testified,

on the North, stands the recently built Protestant Church, within its spacious area; yet sadly defaced and disfigured it appears, if not desecrated, by a Mansion and domestic offices lately in the occupation of the British Consul, built into the angle of its Latin Cross, while the Bishop is left to seek shelter in a confined and hired hovel in the Town. . . . Nor was the excuse for thus attaching a secular Building to the consecrated walls at all a valid one; for the Powers of England and Prussia amply sufficed for the protection of their Church from Moslem insult, without the ordinary Protectorate of their flags waving over its roof.[8]

Bridges's words relate directly to the interrelation of ecclesiastic and diplomatic activity. Although the importance the Church of England held for British diplomacy must have been clear to Bridges, as a clergyman he was opposed to its exploitation. This may have been the first time in the world that photography was used for political reporting, expressing the photographer's own position.

Like Girault de Prangey before him, Bridges photographed a number of buildings several times from different perspectives. The Church of the Holy Sepulchre, which also held a fascination for de Prangey, was one such subject. Bridges photographed it from afar, behind an open field, in one plate (no. 1) and portrayed its entranceway in another (no. 3). Another unavailable plate—plate 2—no doubt also depicted this edifice. Although he was the only photographer throughout the century to open his album with this subject, Bridges had ambiguous feelings toward the church, as is evident from the contrast between the texts accompanying each of the two published photographs:

[Plate 1] Let the snarling caviller, or learned critic who regards the precise spot which was moistened by his Saviour's blood as of the utmost importance to discover—let even the devout inquirer for the only grave which will not yield up its dead at the general Resurrection,—listen only to these solemn words of the Angel of Calvary, and rest satisfied with the assurance that if this wide-spread sanctuary cover not the exact ground he seeks, it is marvellously near it.—A heartless speculator alone would require more to inspire feelings of overwhelming interest and awe.

[Plate 3] Gratifying though it would be to know that in this most interesting spot our affections were taught to flow in the language of truth, yet, sad to say, it is not so. The very first sight of these venerable Gates is mingled with sorrow and disgust at the vulgar deceptions practised by the usual guides—by the importunate vendors of superstitious relics—by the squalid misery of the noisy crows—and by the fables which almost overwhelm all serious feelings.

Ironically, it is the view of the entrance, the best preserved part of the church, that has the denigrating text. The distant view, with an open, barren space in the foreground, touched Bridges more: this is the past. The closing paragraph for plate 1 has a Keithian tone:

The Latin Convent, the usual resort of Frank travellers, and Roman pilgrims, is here seen on the left, and in the foreground of the wide grass-grown level in front of the Church,—a field which covers more than thirty feet of accumulated ruins—is observable a deep dark fosse, the only opening which admits light to the sunken street below, where are the bazaars—the broken ground rising thus on either side of it, being, in fact, the ruined "heaps" of eighteen centuries. So Jerusalem *is* indeed "become heaps, and the mountain of the house as the high places of the forest." (Mic. 3:112)

"The scene of devastation around is but too true a picture of what every where meets the eye in Jerusalem," he wrote in another caption, ". . . and above the perplexing confusion of broken walls, is visible the distant dome which covers 'The Sepulchre of Christ.'"[9]

Bridges's attitude, as far as the album shows, was close to Keith's in many respects. Bridges captured many views of ruined and rundown sections of Jerusalem. When he traveled to other places he took calotypes of the open landscape, and his warmest texts relate to these pictures. To him, nature itself and small mud houses represented biblical scenes and figures and truly reflected the holiness of the land.

The second British calotypist, C. M. Wheelhouse, was a medical officer who accompanied a yachting party on a cruise around the Mediterranean in 1849–50. His party included Lord Lincoln, who, as British war minister during the Crimean War, would become the first statesman to authorize the photo-

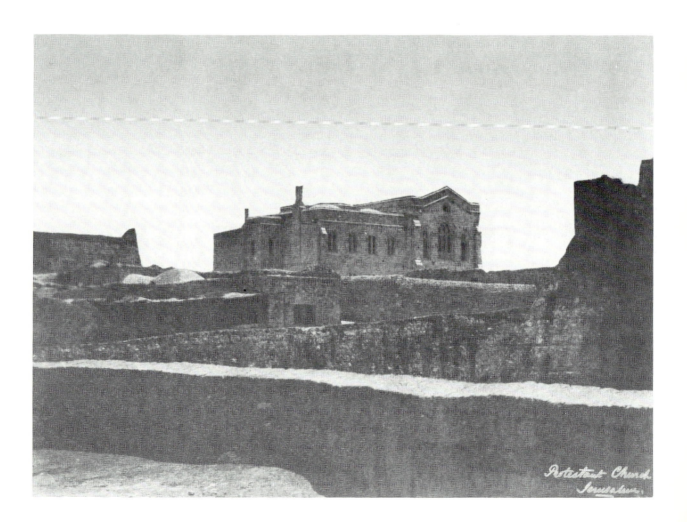

graphic coverage of a war.[10] Wheelhouse's album, of which only one copy exists, contained photographs of a journey beginning in Spain, then Portugal, moving through to Jerusalem, and to Baalbek, Lebanon.[11] Most likely Wheelhouse photographed Jerusalem in early 1850.

Six of his seven Jerusalem calotypes were devoted to well-known sites, including David's Tower, the city wall, and the entrance to the Church of the Holy Sepulchre. His photograph of the Dome of the Rock was taken from a relatively great distance and a unique angle, indicating a personal touch. The caption reads "From my Bedroom Roof," and the photograph was taken from within the Old City. Apparently the picture had souvenir value for Wheelhouse. The seventh calotype, which may have been taken for personal reasons, is captioned "Bishop Gobat's Anglican Church," and was also photographed by Bridges. This new church near the Jaffa Gate, one of Jerusalem's busiest thoroughfares, lacked the historical or architectural interest of older and larger edifices. Wheelhouse probably included it in his album as a political or personal memento. Perhaps he and his party had been well received by the bishop and his staff; perhaps they were simply impressed by the church as a symbol of British influence in Jerusalem. But Wheelhouse preferred landscapes over edifices, as is clear from his composition. His view of the Garden of Gethsemane was taken from a distance and included trees in the foreground and the Mount of Olives in the background; his calotype of David's Tower and the city wall featured a field and trees in the foreground, and his view of the famous tombs in the Valley of Jehoshaphat was taken from a great distance and included the steep slopes on either side.

Wheelhouse, possibly aware of the shortcomings of the calotype—the coarse grain, the lack of fine shades, the somewhat soft lines—carefully emphasized the skyline in his prints. He may have been attempting to compensate for his quite unaccomplished, unskillful photographic technique.

Maxime Du Camp and Gustave Flaubert arrived in Jerusalem shortly after Wheelhouse. Because Du Camp and Wheelhouse produced a similar number of pictures of the city, as well as the fact that both included these calotypes in a book that covered several countries, there is a solid basis for comparing their work.

Du Camp published his calotypes in 1850 in his book *Egypte, Nubie, Palestine et Syrie*.[12] Three of his pictures of historical landmarks in Jerusalem portray impressive sites also photographed by Wheelhouse: the entrance to the Church of the Holy Sepulchre, David's Tower, and the Dome of the Rock. However, Du Camp approached these subjects from closer range in order to isolate and emphasize their architectural beauty and power. Without doubt, he would have taken an even closer view of the Dome of

Wheelhouse (1849–50), calotype. "Protestant Church, Jerusalem." See Bridges's com- about the left (closest) part of the building, p. 49. (Royal Photographic Society, London)

the Rock than he did had he not been barred, like other visitors, from the temple enclosure itself. Many years later, in 1868, he wrote, "Today, in Jerusalem, it is permitted to visit the Haram al Sherif, the Mosque of Omar [the Dome of the Rock], the access to which had been absolutely sealed off to *giaours* (I personally underwent this unpleasant experience in 1850)."[13] A fourth calotype of his shows the beautiful Golden Gate, which he also photographed in such a way as to fill the frame. Nothing in Du Camp's calotypes suggests the greenery and open spaces that surround Wheelhouse's Jerusalem and its buildings. Subjects like the Garden of Gethsemane and the Valley of Jehoshaphat apparently did not attract him. Unlike Wheelhouse, Du Camp photographed architecture in Jerusalem.

This is not to say that Du Camp was interested solely in architectural beauty. In fact, his single written reference to Jerusalem (and the Holy Land) in his book is less than flattering: "I will not say anything about the monuments of Jerusalem and of Baalbek, of which the historical importance is almost none, and which are today too known to talk about."[14] This attitude is understandable for someone who had just left the impressive sites of Egypt.

Flaubert, who accompanied Du Camp to Jerusalem, expressed his unflattering impressions of the city in his diary (entry of August 9, one day after their arrival): "Jerusalem stands as a fortress; here the old religions silently rot away. One treads on dung; ruins surround you wherever your eyes wander—a very sad and sorry picture."[15] A few days later, Flaubert described his impressions of the city in a more detailed letter to his friends. Again his emphasis was on the city's degeneration: its poverty, filth, lack of elementary sanitation and hygiene, and the infighting and mutual recriminations of representatives of the rival Christian sects:

The sky was pale blue with a few scattered clouds, though it was very hot. The white glare of the light was very powerful and piercing and I had to think of a wintry day. Maxime overtook me with the luggage as we entered the Old City through Jaffa Gate. We dined at six in the evening. Jerusalem is a house of bones surrounded by walls. Everything is rotting there—in the streets dead dogs, in the churches the religions. There are many ruins. The Polish Jew in his fur cap steals silently by the decrepit walls, whilst in its shadows a Turkish soldier sleepily fingers his beads and puffs on his pipe. The Armenians curse the Greeks, who in turn despise the Latins, who excommunicate the Copts! The situation is more sad than grotesque, or possibly is it more grotesque than sad? It all depends on the way you look at it, but let us not anticipate details. Firstly we noticed that the slaughterhouse was in the street—an open area amid some houses where you see blood, intestines and urine in a pit, a mass of warm shades which painters could well use. The stench was deathly . . . the animals were killed and offered for sale on this spot. The young Du Camp was on the verge of fainting. Yes, sir, there is no slaughterhouse. The local newspapers should take the city managers to task. . . .[16]

These words were not paralleled by Du Camp's calotypes. Even his two pictures showing small unimpressive rows of houses in residential quarters do not seem to make as explicit a statement. Monumental sites are not contrasted with secular contemporary ones. More likely Du Camp saw the city not through the eyes of a reporter but through those of an urban dweller, finding Jerusalem characteristically oriental.

Du Camp apparently did not take any calotypes outside Jerusalem; if he did, they were never published or mentioned by Flaubert.[17] Nevertheless the two saw a great deal of the country during their month's trip. They entered from the north at Acre and visited Haifa and many localities in the central part of the country en route to Jerusalem. They also traveled to the Dead Sea, the convent of Mar Saba, and Jericho, and were attacked by robbers on their return trip to Jerusalem (they fired back and escaped unhurt). On August 23 they left Jerusalem for Nablus, Nazareth, Tiberias, and Safed. Their Near Eastern trip and work were sponsored by the French Ministry of Public Instruction. The book that resulted was the first publication of original calotypes and turned out to be a considerable commercial success.

As most visits to the Holy Land were a part of excursions through the Near East and along the Mediterranean, early photographers, with the exception of Bridges, included few pictures of it in their published works. This situation changed in 1854, when Auguste Salzmann, French archeologist and painter, visited Jerusalem.

Salzmann was the first photographer to devote a major work entirely to the Holy City, where he spent four months and would have remained longer had he not contracted fever. During that time he produced the largest individual collection of photographs of that city done in the nineteenth century: two volumes of 180 calotypes and one of text and drawings, together entitled *Jerusalem—Photographic Studies and Reproductions of the Holy City from the Judaean Period until Today*.[18] Salzmann's project was also sponsored by the French Ministry of Public Instruction, and the volumes were published by Blanquart-Evrard, who later issued an abridged edition containing forty calotypes.

Salzmann undertook this work because of a French academic controversy during the 1850s. Félicien de Saulcy, a well-known explorer of the Holy Land and a friend of Salzmann's, had proclaimed that some Jerusalem landmarks attributed to the Greeks or Romans actually dated back to the ancient Judaean or Israelite period. In 1852 de Saulcy claimed that a carved stone found in the Tomb of the Kings near Jerusalem and on exhibit in the Louvre dated from the time of King David. Salzmann believed that the new art of photography could help settle this and other academic disputes. In the introduction to this work, Salzmann candidly explained the background to his Jerusalem visit:

De Saulcy in his knowledgeable article wreaked havoc with quite a number of commonly held opinions. It had been generally believed that not a single trace of Judaic architecture remained in Jerusalem. With Bible and history book in hand, de Saulcy was trying to prove that monuments previously thought to belong to the Greek and Roman decline were of Judaic origin. In view of these circumstances I decided . . . that I would be performing a true service to Science by studying and especially photographing the monuments of Jerusalem, particularly those whose origin had been questioned. I left France on December 20, arrived in Jerusalem twenty days later, and began working very soon after my arrival. . . . Once I had collected these documents, I turned my attention to Christian and Arab landmarks. After four months of unceasing toil I assembled about 150 plates, but that is not all. Mr. Durheim, my assistant, who continued in the Holy City after fever had compelled me to leave, will add fifty more plates. . . . Photographs are not reports, but rather conclusive brute facts. . . .[19]

Salzmann's book on Jerusalem was his only venture into photography, but it became so widely known that there has hardly been a book on calotypes or nineteenth-century photographers in which Salzmann has not been represented. The carefully chosen reproductions in such books have created the impression that photographic quality was Salzmann's main achievement. The complete collection, however, which presumably contains every picture he took, is disappointing in this respect. While some of his calotypes do attain the standard of those chosen as examples, many others lack the aesthetic quality one would expect of a painter.

Salzmann's approach and achievement can be better appreciated by considering his entire book rather than selected examples. His specific interest was the relics of the ancient Judaean and Israelite civilizations, although in the course of his work he also photographed Moslem and Christian sites inside and outside Jerusalem. He valued subject matter and details of intrinsic interest more than aesthetic considerations. Moreover, he was not particularly concerned with using the calotype to the best technical advantage. His perspective was not one of single photographs but of complete sequences, so that his album presented a well-organized pictorial survey of the city. Its sequences seem structured, almost as in a present-day television documentary, often beginning with some opening long shots and continuing through medium shots to close-ups of buildings and antiquities. His views were static, but his camera moved and moved.

Part One of the album, "Judaic Monuments," shows the Temple Mount in its opening sequence, beginning with a view of the Western (Wailing) Wall. This is the only nineteenth-century book to open with this view. As an archeologist Salzmann described the wall's construction, relating it to both biblical texts and recent exploration. As an observer of present times, he was deeply touched by the spectacle of the mourning Jews he met there.[20] With his camera Salzmann led the viewer eastward around the wall

TOP RIGHT: *Auguste Salzmann (1854), calotype. "Tomb of the Judean Kings, entrance." S* *view in the sequence. (E. Hacohen, Ramat Gan)*

BOTTOM RIGHT: *Auguste Salzmann (1854), "Fragment of the stone entrance." Sevent* *last view in the sequence. (E. Hacohen, Ramat Gan)*

of the Temple Mount and concluded with three calotypes taken from the Mount of Olives. These showed adjacent sections of the Eastern Wall and completed what was really the earliest panorama of Jerusalem.

The second sequence was of the Tomb of the Kings of Judaea (or so de Saulcy and Salzmann believed—as it happened, subsequent research disproved de Saulcy's thesis). Salzmann's structured sequence presented (a) the exterior courtyard of the tomb; (b) the interior courtyard; (c) a closer view of the decorated upper part of the tomb; (d) a close-up of a relief of fruits and leaves; (e) a close view of the fragments of the sarcophagus; (f) a still closer view of its cover; and (g) a close view of a fragment of a stone door.

The last photograph was intended to provide evidence of the tomb's Judaean origin. That was the way Salzmann worked, proceeding step by step toward his finding, moving from the whole to the significant part. It was the equivalent of today's cinematic "zoom-in" or "dolly-in."

The third and last sequence of the first volume consists largely of single pictures of tombs and other antiquities, general views of water cisterns and fountains, and two views of the walls and the citadel near the Jaffa Gate (the western corner of the city wall).

Part Two of Salzmann's work, entitled "Christian Monuments," opens with a detailed description and twenty-one calotypes of the Church of the Holy Sepulchre. The sequence commences with a general frontal view, zooming in to the entrance, to details of the capitals on the door, and finally to two close-ups of traditional gifts, the sword of Godefroy de Bouillon and a silver cross of Louis XIII.

Though the Church of the Holy Sepulchre was irrelevant to the controversy over de Saulcy's findings, as it was definitely not constructed during the Judaean period, Salzmann photographed it in greater detail than any other historic site, thereby revealing the Christian pilgrim within the archeologist and photographer: "This venerable façade mutilated by the Turks, calcinated by the fire of 1808; this bell-tower mute today evokes striking memories and its message still powerfully reverberates. . . ."[21]

Other Christian sites depicted in this volume include the remains of the Church of St. Mary la Grande (four views), other churches, convents, and chapels of various sects and religious orders, and a few views of Bethlehem, including one of a mosaic within the Church of the Nativity—the only picture taken inside a building.

Part Three, entitled "Arab Monuments," was the least coherent of Salzmann's work, possibly because the inaccessibility of the Temple Esplanade kept him from producing a more complete survey. It included four views of the Dome of the Rock, two of each of the city gates, decorated fountains, streets in the

ste Salzmann (1854), calotype. "Detail of the Dome of the Church of the Holy Sepulchre."
13 in a sequence of twenty-one views. (E. Hacohen, Ramat Gan)

Arab quarter, and decorations on buildings and windows. The volume closed with general landscapes, including views of the Holy City and of the roads leading to Nablus and Bethlehem, taken from a distance.

Salzmann progressively widened the scope of his enterprise as his interest moved from ancient remains to early and late medieval buildings and finally to topographical details. Though one might expect a painter to seek out the most beautiful views or the most aesthetic composition for his subject, this was not Salzmann's method. He did not avoid less attractive views or subjects badly lit or otherwise unsuitable to photography. Drawn to subjects that attracted his interest even when they were far beyond the requirements of his original plan, he remained true to his primary calling, seeing all aspects of the Holy City through the eyes of an archeologist. His published work, apparently intended for an audience with archeological interests, was the first publication of factual or topographical photographs, a vision that probably evolved on location. A few years later Salzmann returned to Jerusalem, accompanying his friend Félicien de Saulcy, but he produced no more photographs of the city, possibly discouraged by the commercial failure of his first set of albums.

The last and least-known French calotypist in the Holy Land was Louis de Clercq, who arrived in Jerusalem in 1859. By that time the calotype process had already become obsolete, having been replaced by the superior wet-plate collodion process. Still, many of his prints are technically superior to Du Camp's and Salzmann's.

De Clercq came to Jerusalem as a member of Guillaume Rey's archeological expedition, sponsored by the French Ministry of Public Instruction. Rey welcomed de Clercq enthusiastically because of his reputation as a successful photographer.[22] The members of the expedition left Paris in August 1859 and arrived in Syria on September 11. They reached Jerusalem on November 28. The party moved on after a week's stay, but de Clercq remained behind for some weeks or months. On his return to Paris, he published four albums of calotypes, entitled *Voyage en Orient*.[23] Volumes 1 and 2 include photographs taken in Syria, Lebanon, and east of the Jordan, as well as nine views of northwestern Palestine, mostly taken along the Mediterranean coast. These nine topographic views include two of Acre—one of them somewhat similar to Goupil-Fesquet's and the other of Napoleon's gun emplacements—and three views of Haifa: the little town itself; the governor's palace; and the convent on Mount Carmel, also photographed by de Prangey. Acre and Haifa attracted French photographers only.

The last two volumes deal exclusively with Jerusalem. Volume 3, *Jerusalem*, contains twenty-eight

Louis de Clercq (1859–60), calotype. "Jewish Synagogue and Environs." The Hurva agogue before its inauguration. (Bibliothèque Nationale, Paris)

photographs. Volume 4 is novel in its conception: fourteen pictures depict each of the traditional stations of the cross on the Via Dolorosa. The last five stations, being interior views in the Church of the Holy Sepulchre, are represented by calotypes of drawings.

De Clercq's approach and photographic technique were a blend of the conventional and the innovative. While it may be an overstatement to claim that his work represented a novelty in style, several of his photographs are clearly composed in a manner unusual for the period. Light and shadow as well as camera angles allowing oblique compositions are sometimes manipulated to dramatize the subject.

De Clercq's subjects were common to most photographic albums of Jerusalem. In addition to the well-known sites, he included a large panorama of the Holy City from the Mount of Olives and views of the Convent of St. Anne (newly given to France by the sultan), an Austrian hospice for pilgrims, a

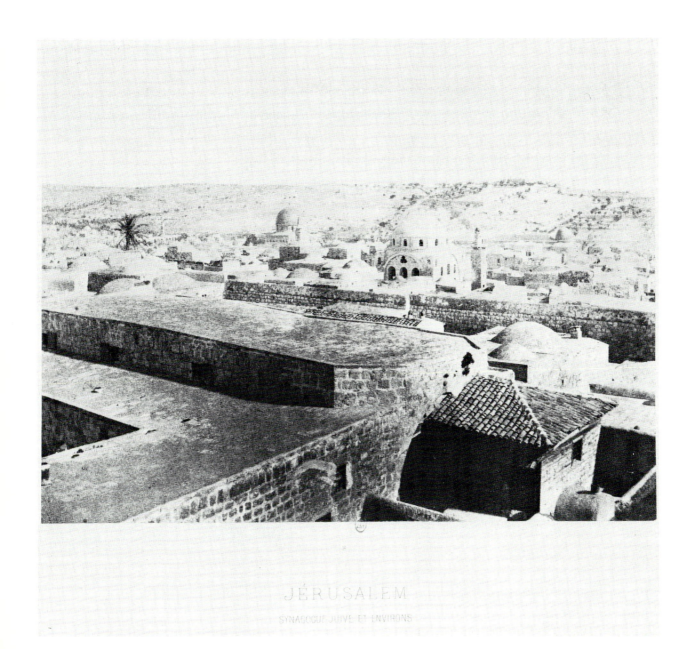

JÉRUSALEM
SYNAGOGUE JUIVE ET ENVIRONS

Protestant chapel, and the Hurva synagogue, the last three of which were of recent construction. His caption for the rear view of the Church of the Holy Sepulchre read: "The actual state of the dome." Obviously de Clercq was concerned with new buildings and with the state of preservation of older ones.

The last album, depicting the Via Dolorosa, was a remarkable and unique enterprise. Most of the stations are houses rudimentarily built of local stone, typical of Jerusalem and the surrounding villages. Their unimpressive appearance and lack of archeological interest did not deter de Clercq. While Salzmann sought documentation, de Clercq looked for symbols. The continuity of the book format encouraged both of them to structure sequences of photographs connected by a common theme. Salzmann's themes were single edifices; de Clercq's photographs in volume 4 followed the central drama of the New Testament.

Following the way of the cross station by station was a new departure; here a sequence of pictures related a story. No other calotypist produced a similarly structured collection. Neither did the early wet-plate photographers, de Clercq's contemporaries and followers. De Clercq was ahead of his time; the fourteen stations of the Via Dolorosa were not again presented as a coherent photographic subject until the 1890s.

The very last photographer to visit Jerusalem and make use of Talbot's already obsolete process was Dr. August Jacob Lorent from Mannheim, Germany, who had exhibited earlier work on the Mediterranean region (Venice, Egypt, Athens) in London and Brussels in 1861 and 1862.[24] In the winter of 1863–64 Lorent visited Syria and Palestine accompanied by writer Professor Fickler, and in 1865 his album *Jerusalem und seine Umgebung* was published in his hometown.[25] Judging by the captions, it originally contained fifty-seven pictures, but only thirty-six have survived. The album was a systematic survey of the city's historical buildings, starting with the temple enclosure and Christian structures and ending with a few views of the city's surroundings and some of Bethany and Bethlehem. Lorent was attracted by architecture, which he approached in mostly frontal views. His plates are remarkably sharp and show fine detail. In terms of subject matter, Lorent had little to add to the work of his predecessors. Nevertheless, one exceptional plate (no. 15) is of special interest: it shows a series of arched apertures in the ruins of St. John's Hospice as seen through an arch in the foreground. No photographer before him had been inspired to use this type of composition.

Lorent's work closes the history of the calotype long after the newer wet-plate process came into general use. Even in the Holy Land Lorent had been preceded by four famous wet-plate photographers.

Early Traveling Landscape Photographers: Wet-Plate Photography 1857–1862

3

Salaam!—Peace be with thee, oh, thou pleasant Buyer of my book.

It is my intention, should my life be spared, and should the present undertaking prove successful, to present to the public, from time to time, my impressions of foreign lands, illustrated by photographic views.

I have chosen as a beginning of my labours, the two most interesting lands of the globe—Egypt and Palestine. Were but the character of the Pen for severe truthfulness, as unimpeachable as that of the Camera, what graphic pictures might they together paint! But we scarcely expect from a traveller "the truth, the whole truth, and nothing but the truth." I am all too deeply enamoured of the gorgeous, sunny East, to feign that my insipid, colourless pictures are by any means *just* to her spiritual charms. But, indeed, I hold it to be impossible, by any means, fully and truthfully to inform the mind of scenes which are wholly foreign to the eye. There is no effectual substitute for actual travel; but it is my ambition to provide for those to whom circumstances forbid that luxury, faithful representations of the scenes I have witnessed and I shall endeavor to make the simple truthfulness of the Camera a guide for my Pen.[1]

—From Francis Frith's introduction to *Egypt and Palestine*

Francis Frith's appeal to the "pleasant Buyer," the "armchair traveller" in a Victorian salon, expresses the new relationship that emerged between photographer and audience in the late 1850s. This changed relationship had great impact on the type of photography produced in the Holy Land. Beginning in the late 1850s the traveling photographer in the Levant began to provide brilliant landscapes to a steadily growing audience in Europe and America. They were made from the new wet-plate process, invented in England in 1851 by Frederick Archer. Frith produced one of the great collections of this period, as did James Robertson and Felice Beato who preceded him and Francis Bedford who succeeded him. Several lesser-known traveling photographers, such as A. Ostheim, John Cramb, John Anthony, A. Beato, and W. Hammerschmidt produced less ambitious works.[2] J. T. Barclay and James Graham, who also photographed during this period, will be discussed later (see chaps. 4 and 5).

The new wet-plate process combined the advantages of the daguerreotype and the calotype, providing the fine definition of the former and the reproducibility of the latter. As wet-plate pictures became part of middle-class culture, the growing demand for photograph albums and books made it possible for the new wave of traveling photographers to support themselves by selling their pictures. Whereas daguerreotypists Keith and de Prangey and calotypists Bridges, Salzmann, Du Camp, and Wheelhouse had been amateurs, the new photographers were professionals. Several years of practical experience had developed their capacity, critical judgment, and technical know-how. James Robertson, Felice Beato, Francis Frith, and Francis Bedford had all made and sold photographs before they went to the Holy Land.

The superior quality of pictures made using the wet-plate process was obtained by using a glass plate as support for the negative in lieu of the paper used in the calotype process. Unlike paper, glass was a transparent and smooth support; its texture left no grain imprinted in the positive albumen print. The new, more light-sensitive emulsion, collodion based, was superior in quality and speed, and, when it was properly used, the result was a finer picture.

At the same time the photographer's task became even more complex and arduous. The negative plates had to be kept wet during preparation, exposure, and development. In a darkroom the glass plate was covered by a film of wet collodion and the sensitive emulsion. The plate was then quickly transferred in a closed wooden container to the camera, exposed, and immediately returned to the darkroom and developed before it dried.

Landscape photographers wanted to produce large pictures; since photographs at that time could not be enlarged as they are today, these photographers had to work with cumbersome cameras and plates. Large plates required a long exposure time—about ten to forty seconds—and were, of course, difficult to handle. The usual procedure was to erect a darkroom adjacent to the vantage point from which the picture would be taken. The difficulties of working in dark tents in the hot and dusty countries of the Near East must have been immense; even the transportation of equipment—cameras, lenses, bottles of chemicals, big glass plates—was no small feat in a underdeveloped country like Palestine. For their contemporaries (as well as for us today) such physical hardships enhanced both the value of the photographs and the glory of those who produced them.

The obstacles these visitors had to contend with obviously affected the creative process, but not always for the worse. The limited quantity of materials that could be transported feasibly, the long journey, the strenuous work on the spot, and practical restrictions on the number of photographs that could be taken compelled the photographer to concentrate on the subjects he judged most important and to

select his vantage point carefully. Also, having to develop the wet plate immediately after exposure allowed the photographer to judge then and there whether his negative was successful. If he was dissatisfied, he could remove the collodion film from the glass plate and reuse the plate. The wet-plate photographer was in this respect in more immediate control of his negative than many of his late-century successors. For these reasons the relatively small number of photographs of the Holy Land produced and published by each of the early traveling photographers—two or three dozen on the average—can be considered fairly representative of their individual approaches.

The conditions that early wet-plate photographers encountered in the country had not changed much since the arrival of the daguerreotypists. Photographers who came in the late 1850s faced many of the same geographical and cultural obstacles. Western Palestine by and large lived on its subsistence agriculture, and even this was conducted on a limited scale in the less fertile regions. The fellahs, the sedentary villagers, were constantly menaced by the Bedouin nomads, who attacked them and plundered their harvests. The fellahs responded by building their villages on the less accessible hills, which were more secure and defensible. This condemned them, however, to stony, mountainous terrains. Consequently, photographers of this period could not reach and depict most of the country's population easily, and there are few signs that they were really interested in doing so.

Towns in the Holy Land were no more than centers for a rural area. Local crafts were few and insubstantial; the towns had to rely on their own meager resources—oil, olive wood, Holy Land souvenirs, pilgrimage, and tourism—which were hardly foundations for the emergence of a local middle class that could serve as a photographer's clientele.

The earliest advancements in the country were in the area of transportation. In 1846 the second British consul in Jerusalem had taken sixty-two days to travel from London to Jaffa. In the 1850s steamers began to arrive on a regular, more frequent schedule. This was an important factor in fighting piracy, still a powerful element in the eastern Mediterranean area, and in increasing foreign commerce. In the interior of the country, however, goods and passengers were still transported by camel and donkey. Photographer Francis Frith was the first traveler to report, in 1858, having seen a carriage "like those used in Balaclava."

Means of communication came late. News of the Crimean War's end in 1856 took a month to reach Jerusalem, where it was announced by the firing of a canon. Mail service, a novelty, was slow and irregular.

Arriving before the major economic and political developments that were to change its face in the

last decades of the century, early landscape photographers captured the medieval look of the Holy Land. Thus, following their work is tantamount to tracing the photographic history of Ottoman Palestine. Many of their pictures are primary documents of the country's history, although this was certainly not the main objective of their makers.

The first known wet-plate photographs of the Holy Land are signed jointly by James Robertson and Felice A. Beato. The pictures, published in their album *Jerusalem*,[3] were probably taken by Beato, who is known to have traveled to India in 1857 and presumably visited Jerusalem on the way. Nothing is known about Robertson's and Beato's trip, but the quality of their large, beautifully executed, and impressively composed photographs is beyond doubt. Their subjects were the most important holy places in and near Jerusalem, photographed from the most impressive angles. This was a work of glorification. Except for one or two pictures, these visitors avoided the city's ruins and its poor neighborhoods.

Jerusalem opens with a panorama of the city, followed by pictures of the Wailing Wall, the Church of the Holy Sepulchre, and the Temple Esplanade. Such an opening sequence was appropriate for this album devoted to the city holy to three religions. It was both timeless and topical. In 1857 the struggle between the European powers for control over Jerusalem's Christian holy places reflected the larger confrontation of the 1853–56 Crimean War. Robertson and Beato arrived in Jerusalem just after a photographic assignment in the Crimea. It was there that Englishman Roger Fenton had produced the first voluminous collection of war photographs in history. Fellow Englishman Robertson and Beato, a naturalized British subject born in Venice, arrived in the Crimea soon after Fenton, in time to photograph the fall of Sebastopol in 1855. This may explain their interest in Jerusalem and its holy places.

"Jerusalem and Its Holy Places" would have been an apt title for their new album, for though some of the photographs were of less important sites, they still had historical and religious relevance. The album ends with three sites near Jerusalem: Bethany, mentioned frequently in the New Testament; Bethlehem; and Mar Saba monastery in the east, in the Judaean desert on the way to Jericho. The photographs were of places often visited, most accessible to travelers and pilgrims, and most attractive to buyers.

Also appearing in their album was the first Holy Land photograph to integrate human figures into the surrounding scenery successfully. The site is the Wailing Wall and the people standing by it are engaged in the ritual of prayer. They are shown from the side, small silhouettes against a brighter background. The silhouettes are sharp; the subjects must have been standing still. (A photograph of Damascus

James Robertson and Felice Beato (1857), albumen print. The Wailing Wall. (N. T. (Jerusalem)

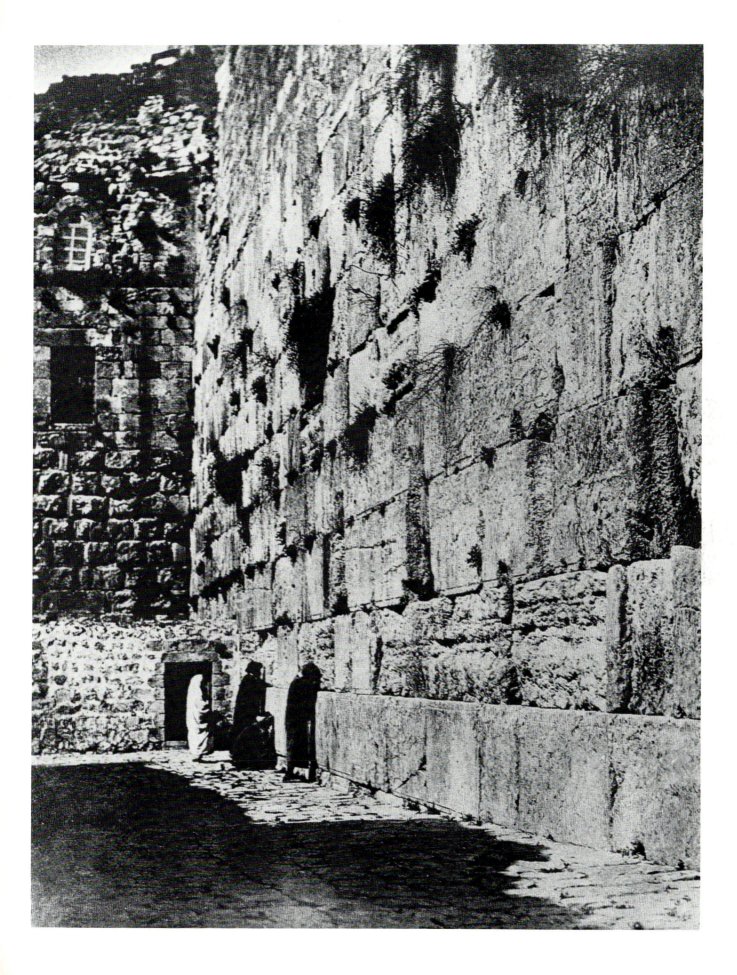

Gate includes smaller human figures; one of these is a "ghost-figure," partly transparent and blurred.) The possibility that the photographers asked Jews praying at the Wailing Wall to pose cannot be ruled out, nor can we dismiss the possibility that the captured figures were European visitors, to whom photography was less of a novelty. Their view of the wall was by no means a group portrait of the type they had taken in the Crimea, where they had photographed soldiers and officers in a number of staged scenes.

Prior to their Crimean War assignment, Robertson and Beato had published large, beautifully composed landscape views of Mediterranean cities such as Constantinople, Cairo, Athens, and the island of Malta, occasionally including very small figures in the middle foreground. They evidently wished to make their album of Jerusalem in the same spirit and thus focused on architecture rather than local inhabitants.

Commercial and tourist-minded photographers were to follow closely in the footsteps of Robertson and Beato. Many later albums of similar scope show identical places from similar vantage points, although not all of them were as successful in accenting Jerusalem's impressiveness.

Jerusalem was seen from a different perspective by Francis Frith, who also had a growing reputation as a professional photographer. Frith visited the Holy Land in the spring of 1858. A small businessman, his career in photography had begun in 1850, and his work in 1856–57 during an assignment in the Nile Valley led his London publishers, Negretti and Zambra, to hire him to cover the area from Cairo eastward.[4] Frith's Quaker background, together with his experience as a photographer and Near East traveler, made him a good candidate for the assignment. His *Sinai and Palestine*, an album of text and photographs, contained six views of the Sinai peninsula; two of Hebron and Gaza, Palestine's southernmost towns; a section on Jerusalem; sites to the east, to Mar Saba and the Dead Sea, and north to Nablus, Nazareth, and Tiberias; and finally Damascus and Baalbek. It was very successful and was published in several editions in England.[5] Frith's were the first original wet-plate photographs of Jerusalem and the Holy Land to reach a wide English-speaking audience, and his pictures of the small Palestinian towns were most likely the first published anywhere.

Frith's journey was laden with hardships. In Jerusalem he developed many of his pictures in tombs "to save myself the trouble of pitching my dark tent and also for the sake of their greater coolness." It was also in Jerusalem that he had to defend himself "against bandits who had recently murdered or carried off a European or two (one of them a lady) for ransom" and who eventually stole his ammunition while he was on a field trip. En route to Nazareth he was "once again set upon by robbers," and near Tiberias, a leopard carried away a lamb from his tent, while "the tent was carried off by still more robbers. . . ."[6]

In spite of his religious upbringing, Frith's Palestine was not only a biblical land of ancient glory but also a desolate country. His album was more a factual photographic travel account than a glorification of holy sites. Perhaps the straightforward title of his album was meant to reflect such a topographical emphasis. Some of the sites he chose had only minor historical or biblical significance; for example, he included two photographs of Gaza in his album (and a third in a supplementary volume) and none of Bethlehem. This rather unusual approach is also evident in Frith's Jerusalem, which is considerably less grandiose than that of Robertson and Beato. Ruins often predominate, while the impressive gates of the Old City, David's Tower, and the Citadel—popular subjects among most early photographers—do not appear at all.

In his text Frith explained why he did not include a photograph of Bethlehem. Arriving there via a mule track from Jerusalem, he said, "I spent the best of my time galloping frantically about the town in the vain search for a point of view from which I might convey to the British public something like a truthful idea of this interesting place."[7] Frith's explanation of his search for a vantage point seems reasonable. The topography of Bethlehem offered no obvious elevation from which one could photograph both the entire town and the Church of the Nativity. Nevertheless, he could have taken a photograph of the church by itself, as Girault de Prangey had done, or of the church with a part of the village, as in Bridges's calotype. In fact, Frith apparently did find his vantage point after all, since his picture of the church and town appeared in an illustrated edition of the Bible published in 1862.[8] He must have remained dissatisfied with the result but realized that he could not possibly exclude such an important site. Using the same picture in another album, entitled *Egypt and Palestine*, Frith wrote:

The position of Bethlehem is so high, and the Convent of the Nativity, which forms an essential part of the general view, is so much isolated, that for some time I vainly rode round and round the town in search of a point from which I might convey, in a single picture, any comprehensive and satisfactory idea of the place. Perhaps the one which I eventually chose is the best; it is about half a mile from the town as one descends towards Mar-Saba. . . . Externally there is nothing to command attention beyond its size, the more imposing from the meanness and smallness of the village, which hangs as it were on its western skirts. . . .

Concluding, he noted that

the women of Bethlehem are, by consent of all travellers, very beautiful—I think I never saw so large a proportion of beauty as amongst the girls and younger women—which no doubt strikes the traveller the more forcibly, from

the absence of the odious Moslem veil, to which he has probably been long accustomed. I could hardly suppress a fanciful idea that this gift of beauty to the women of the place of Christ's Nativity was a sort of heir-loom, a lasting and delightful memento of the saintly Virgin, his mother.[9]

Frith did not, however, photograph any of the Bethlehem women. He took no portraits there, although among the Christian inhabitants of this town, so used to pilgrims and travelers, it would not have been difficult—or, it seems, unrewarding. The single portrait he made during his entire journey was of himself in Turkish dress. While human figures do appear in a picture of Ramleh, a town in the coastal plain, they are not the main subject of the photograph. They seem to belong to Frith's party: they are shown next to a dark tent planted under an arch, probably Frith's darkroom tent. Though small, the figures are clear and sharp; his equipment was adequate for photographing people, but apparently he was not interested in doing so. Like his contemporaries, Frith considered himself a landscape photographer.

The section on the Holy Land in *Sinai and Palestine* opens with views of Hebron, the city of Abraham, where, according to tradition, the biblical patriarchs and matriarchs (except Rachel) were buried in the Cave of Macpelah. Of the pair of pictures he took, one shows the central section of the town with the mosque over the site of the patriarchs' tombs, while the other is of the more distant western quarter.

Frith's photographs of Gaza show the old town and Samson's Gate. The former is a well-composed, well-lit, conventional "eastern" view showing a mosque surrounded by palms, fields, and stone-walled houses, accompanied by a text describing the town's ancient history. Samson's Gate includes a typical stone house in the foreground and a small mosque, palms, and other trees in the background. Frith also photographed the new town, publishing the picture in another of his many albums. This view and its accompanying text were clearly complementary to the one of the old town, focusing primarily on the new section with its long rows of mud houses. This picture was technically the weakest of Frith's published photographs, but he justified its publication in the text:

This view of Gaza gives an excellent idea of the appearance of a town in Palestine. The rude city-walls, the low half-ruined houses, surmounted by many little domes, with small gardens and courts holding a few trees, mainly palms; nearer, without the walls, a thick growth of the cactus, which bears the prickly pear; on the other side, a low hill, with fields and plantations on its slope; all these are common features of such towns and the country around them. In architecture there is little of high interest; the mosques, like that in the view, are usually mean, and the buildings raised by the Crusaders have generally been nearly demolished.[10]

*Francis Frith (1858), albumen print. Ramleh. Under the broken arch, probably Frith's dark-
room tent. People are most likely his (local) staff. (Jewish National and University Library,
Jerusalem)*

ABOVE: *Francis Frith (1858), albumen print. "Church of the Holy Sepulchre." Front* similarly depicted by virtually all nineteenth-century photographers. (Jewish National and versity Library, Jerusalem)

RIGHT: *Francis Frith (1858), albumen print. "Street view, with the Church of the Holy* chre (rear view)." (Jewish National and University Library, Jerusalem)

Frith saw and photographed the contrasts, but only the text and caption indicate that both pictures were of the same town.

Frith's photographic description of Jerusalem opens with two long-range, general views of the city and the surrounding hills, followed by three views of historic sites and two panoramic views from the Mount of Olives. This opening sequence is followed by two pictures of the Church of the Holy Sepulchre. The frontal view was taken at close range and occupies the whole frame—the "classical" view taken throughout the century; there was no technical possibility of photographing the church entrance and front from a greater distance. Like many others, Frith seriously doubted the authenticity of the church but considered its façade a "good example of Byzantine architecture." He also mentioned that "the dilapidated [larger] dome of the church proclaims its present condition. . . . The dome was destroyed in the fire of 1808 and had not been repaired fifty years later."[11] To prove his point, Frith obtained a rear view of the church, which also included the neighboring street and quarter. He did not mince words in conveying his feelings:

The ruined state of Modern Jerusalem is strikingly brought before us by this view. The Church of the Holy Sepulchre has outside the aspect of a place long deserted, so that we could not imagine, did we not know, that it is still the

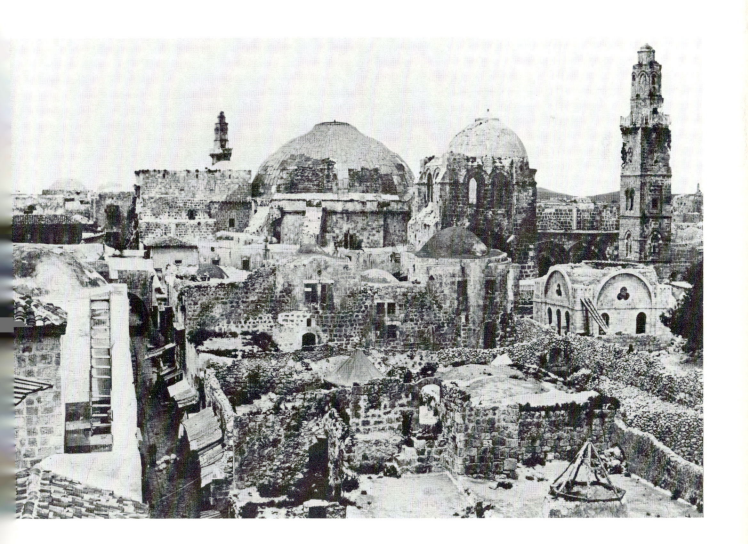

object of pilgrimages and in the hands of rich Christian communities. The great square tower is seen to have partly fallen, the smaller, but loftier, towers to be decayed, and the chief dome to have lost half its outer covering. The street to the left, with its pavement sloping to the middle and the ragged awnings of the shops, is harmonious in its wretchedness. Everything looks as though the city had been sacked and was almost or entirely uninhabited.[12]

The remaining views of Jerusalem, apart from a photograph of Absalom's tomb, were of large sections of the landscape taken from medium and long range and showing different parts of the city. Few of them emphasized the grandeur of the city walls or its well-known structures.

From Jerusalem on, Frith followed the well-trodden tourist path—a brief trip to the Dead Sea, which he was the first to photograph, to the monastery at Mar Saba, and then northward. Frith's Nazareth so closely resembles Goupil-Fesquet's and Girault de Prangey's daguerreotypes that at first one suspects he was familiar with *Excursions Daguerriennes.* More likely he too searched for the most advantageous angle,

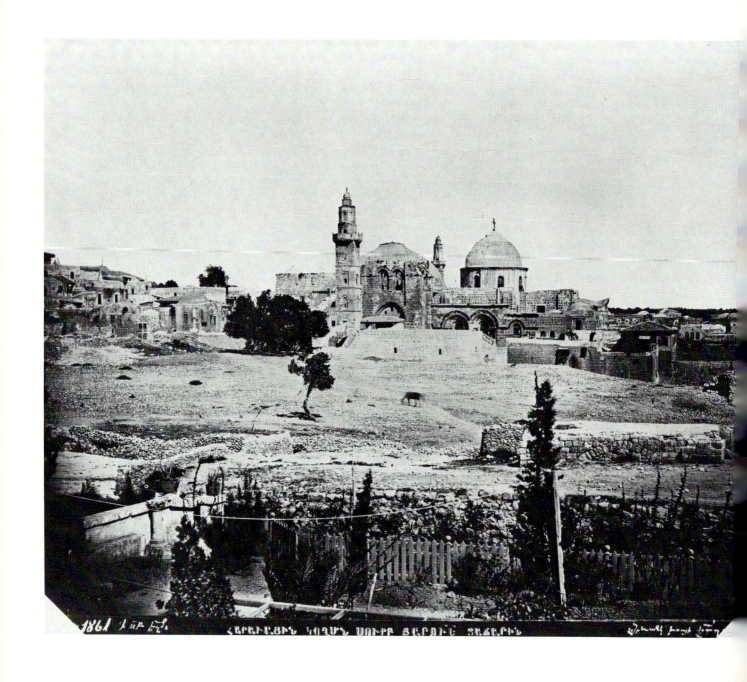

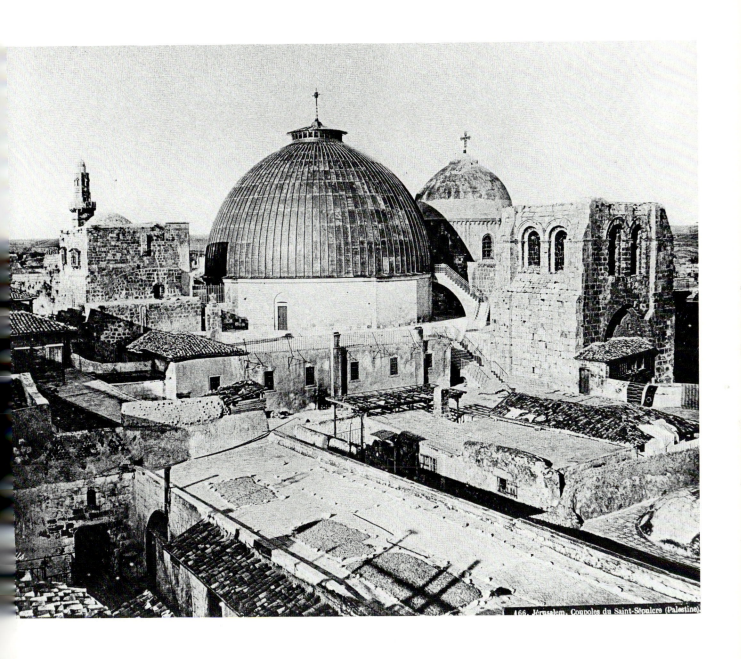

166. Jérusalem. Coupoles du Saint-Sépulcre (Palestine).

Yessayi Garabedian (1861), albumen print. "Church of the Holy Sepulchre." Composi‐
milar to Bridges's distant view. (Armenian Patriarchy, Jerusalem)

: Félix Bonfils (ca. 1870), albumen print. "Jerusalem. Domes of the Holy Sepulchre
tine)." (Jewish National and University Library, Jerusalem)

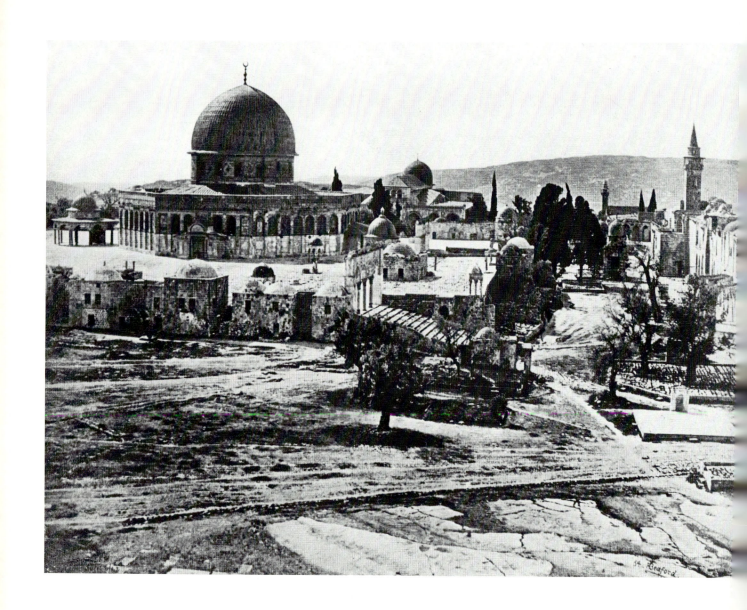

ABOVE: *Francis Bedford (1862), albumen print. "The Mosk of the Dome of the Rock, fro[m] Governor's House." Partly overlaps with next view. The Dome of the Rock is not a mo[sque,] this is a common error. The Mosque of El Aksa is in the background. Bedford did not thi[nk in] terms of a panorama; this view carries catalogue no. 54 (following the next view). (J[ewish] National and University Library, Jerusalem)*

RIGHT: *Francis Bedford (1862), albumen print. "Mount Zion, from the Governor's H[ouse,] showing the West Side of the Enclosure." View no. 53 in catalogue. At far right, the [?] synagogue in the Jewish quarter. (Jewish National and University Library, Jerusalem)*

unintentionally confirming Goupil-Fesquet's and de Prangey's judgment. But characteristically, Frith also took one picture from farther away to include the whole town, using it in another album.

Tiberias, on the shores of the Sea of Galilee, was Frith's final subject in Palestine. Again there are two views, from the north and south. In his own words,

The town itself is a most wretchedly forlorn and dirty-looking assemblage of houses or hovels of ultra-oriental character. It suffered greatly by an earthquake on New Year's Day, 1837, when almost every building, with the exception of the walls and the castle, was levelled to the ground; and up to the present time—such are the poverty and indolence of the inhabitants—scarcely any repairs have taken place.[13]

Frith knew that "there probably existed no town upon this identical spot in the days of Our Savior," but he liked the landscape around the town:

. . . a calm, lovely, sacred landscape. The fields of ripe corn, stretching from my feet to the shores of the lake, were very rich and yellow; the lake was very still and very blue; the Mountains of Moab, although monotonous in their

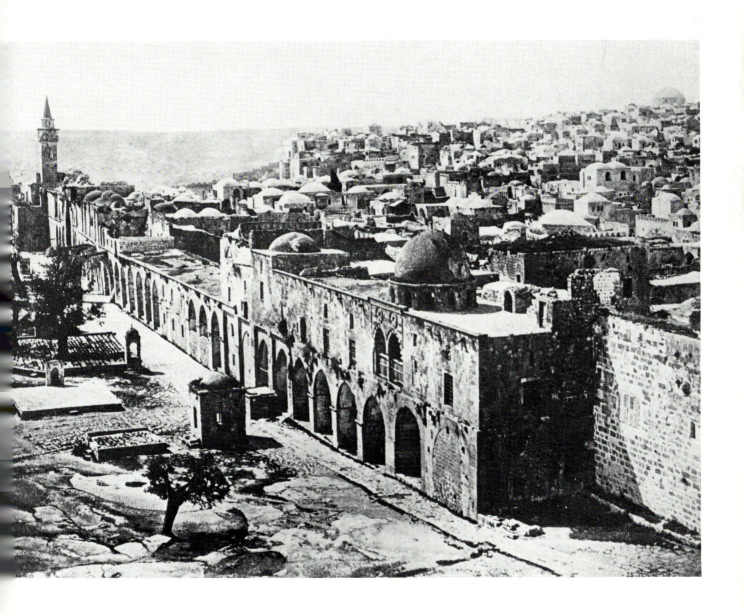

outline, were soft and mellow in their colouring, and in the far north, over the purple hills of Galilee, at a distance of some forty miles, rises the snowy head of Mount Hermon. . . .[14]

Frith did not photograph the scene he described so lyrically. He preferred to concentrate on the town's present-day state.

Throughout his work, Frith juxtaposed topography, historical aspects, and contemporary views. Because he did not restrict himself to impressive views of the most beautiful landmarks but captured less flattering aspects of the country as well, his photography sometimes reflected contemporary social conditions.

Though he took a matter-of-fact approach, Frith's pictures were not topical reports like, for example, Bridges's calotypes of the Anglican bishop's residence and the British consulate annexed to Christ Church. Nor were they purely topographical records like those taken by photographer-explorers in the 1860s. In both pictures and text, Frith commented on the general state of the country during the period, as far as his technique and approach permitted. In this sense, he can be considered the precursor of documentary photography.

Frith is said to have produced 400 stereoscopic pictures during his 1857–58 trip to the Near East. Although no details about the pictures are available, there is reason to believe that they included views from the Holy Land. The American writer Oliver Wendell Holmes referred in 1859 to stereoscopic pictures of the Pool of David in Hebron, a ford of the Jordan River, and Jerusalem from the Mount of Olives, which he personally examined in detail.[15] Since there is no information whatsoever about any other photographer having taken stereoscopic pictures before that year, it can be assumed that the photographs referred to were Frith's.

Francis Bedford visited the Holy Land in the spring of 1862, only four years after Frith but under vastly different circumstances. Since both published about the same number of photographs, some of identical places taken from similar angles, and since no significant changes had occurred in the country or in photographic technique during these four years, a comparison of the work of these two Englishmen gives a good idea of the effect a photographer's personal background and circumstances of travel can have on the resulting photographs.

Bedford, a well-known painter and gentleman of leisure, was the official photographer in the entourage of the Prince of Wales (later Edward VII) when he made a royal tour of Egypt, the Holy Land, Syria, and Greece.[16] He was a true traveling landscape photographer, except that he did not have to worry

RIGHT: *Francis Bedford (1862), albumen print. "Minbar, or Pulpit, in the Enclosure Mosk of the Dome of the Rock." The three persons are, most likely, the guardian of the a servant or guide, and a European—perhaps Bedford himself. (Jewish National and Uni- Library, Jerusalem)*

FAR RIGHT: *Francis Bedford (1862), halftone reproduction. "The late King, Edward VII, Prince of Wales, under the Great Pine Tree North East of Jerusalem where Godefroy de B[o] pitched his tent A.D. 1066. Taken by Mr. Bedford, April 1862, and given to Elisabeth A. (wife of the British consul in Jerusalem). (Jewish National and University Library, Jerus[*

about selling his work. London's aristocratic and intellectual elite would see it on exhibition, and with court patronage its sale would be assured.[17] In many ways Bedford's working conditions were ideal, in comparison with those of Frith and other nineteenth-century photographers. He had access to places forbidden to other Europeans and the protection of the royal bodyguard, comprising fifty soldiers.[18]

Bedford was the first well-known photographer to make and sell a series of photographs taken on the Temple Mount. Although the site became accessible to Christians following the Crimean War, photography was not permitted there until after 1860. Apparently Bedford's royal connections gained him access to the site. His collection includes seven pictures of the most beautiful works of Islamic architecture, some photographed in fine detail. Bedford apparently contented himself with such privileges, because he took very few photographs of other places in the Holy City.

Members of the royal party were also the first Christian visitors authorized to enter the mosque above the Cave of Macpelah at Hebron, but either for technical reasons or, more likely, because of a specific prohibition against photographing inside the mosque, there is no visual record of this visit. At Nablus, a pious Moslem city, Bedford did take a photograph in semidarkness inside a mosque, showing the porch and two people. A technical achievement, it is evidence of privileged access, not only to the shrine but also to its guardians. A picture taken on the Temple Esplanade also includes its Moslem guardian together with a westerner, possibly the photographer himself. In addition, Bedford took a portrait of the royal party near the Sea of Galilee and one of the Prince of Wales "under the Great Pine Tree northeast of Jerusalem where Godfrey de Bouillon pitched his tent A.D. 1066,"[19] though he did not sell the latter.

A few of his photographs show villages surrounded by the open countryside. En route to Jerusalem, Bedford photographed Beit Horon and Gibeon. His collection also includes a view of Safed, in the Galilee, never photographed before and very rarely afterward. The picture shows the ruins of a Crusader fortress and a few small houses on the slopes of the hill.

In general Bedford emphasized the countryside more than Frith did, and in views common to both of their collections he invariably offered more of the surrounding rural landscape. Moreover, he exploited to the full the characteristic lines and structures of the open landscape to produce the most pleasing compositions. In Bethlehem he photographed the biblical Shepherds' Field, showing it as a beautiful terraced hillside and carefully excluding the houses of the nearby village, Bet Sahur.[20] No doubt this choice was an act of interpretation.

The difference between Bedford and Frith is also evident in their photographs of Tiberias. Frith produced two views of the town as it was, shabby and half-destroyed. In Bedford's photograph the Lake

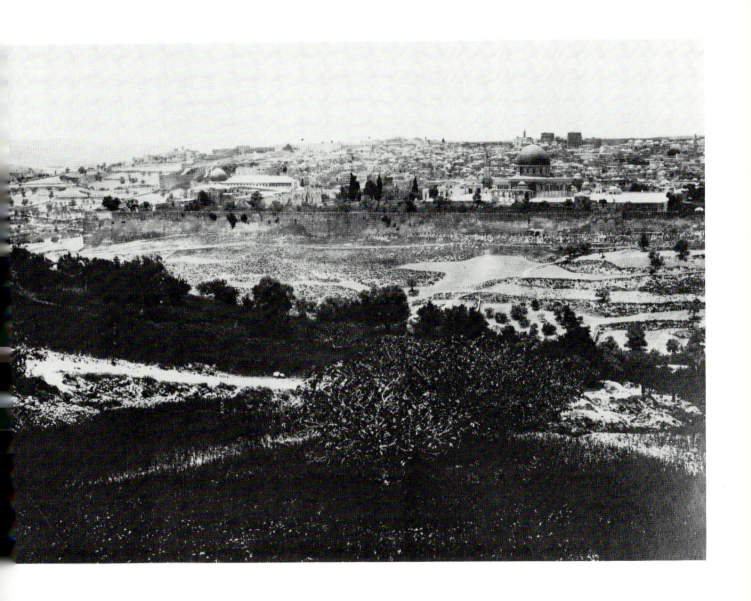

Francis Bedford (1862), albumen print. "General view from the Mount of Olives." (Jewish National and University Library, Jerusalem)

Francis Frith (1858), albumen print. "Jerusalem from the Mount of Olives." This was preferred view of the city. (Jewish National and University Library, Jerusalem)

of Tiberias (Sea of Galilee) predominates. Taken from the south of the town and aiming farther southward, his picture includes a ruin and a few graves in the foreground, hills and the lake in the center and background. Bedford left the walled town itself behind his back.

There was a similar contrast in their treatment of the Church of the Holy Sepulchre in Jerusalem. While both photographers took an almost identical frontal view, nothing in Bedford's collection recalls the wretched quarters at the rear that Frith showed.

ABOVE: *Francis Frith (1858), albumen print. "Tiberias from the South." (Jewish Nationa̶ University Library, Jerusalem)*

TOP RIGHT: *Photographer unknown (ca. 1870), albumen print. (Jewish National and Uni̶ Library, Jerusalem)*

BOTTOM RIGHT: *Lars Larsson (prior to 1916), halftone reproduction. Probably the best po̶ view repeatedly used. The likelihood that photographers knew each others' work is extr̶ doubtful. (Jewish National and University Library, Jerusalem)*

Three factors could account for these contrasting approaches. For one thing, the royal presence was a pervasive influence. The preface to W. H. Thompson's book commemorating the royal tour implies that Bedford, himself an aristocrat, had to avoid unflattering views, to present the material with royal dignity, and to act upon royal suggestions for subjects:

Signally honoured by the Prince's selection of him as the artist to whom so interesting and important a task should be entrusted, he was deeply anxious to justify the choice by the production of a large number of pictures worthy of the scenes he thus visited and of the reputation he had already achieved . . . while His Royal Highness not seldom himself proposed subjects for pictures.[21]

Second, the same royal presence provided Bedford with set photographic subjects, such as the otherwise forbidden mosques, but probably led him to ignore others he might have preferred to explore. Third, and equally important, was the background and taste of the photographer. Bedford was a painter and a member of the Royal Academy, where he exhibited in the 1830s and 1840s. His aptitude for composition and his love of picturesque landscapes were all part of his background as an artist.

The image of the biblical landscape perceived by the prince's entourage was expressed in the introduction to Thompson's book:

. . . if in any class of subjects we may occasionally prefer the stern real to the loveliest ideal it must be in that class which presents us with sites and scenes closely connected with the historical facts of our holy religion. But how much the more indignantly we reprobate the pseudo shrines and sham relics which superstition and greed of gain have constructed and preserve, by so much the more keenly do we appreciate and with more profound reverence gaze on those natural features of the country, the outlines of the everlasting hills, these deep ravines. . . .

It remained only that some such artist as Mr. Bedford should, by means of photography, present us with the hard stern realities of Palestine and the Valley of the Nile . . . it needed but the plain prose of photography in all its simplicity and literalness, to make us perfectly acquainted with the physical characteristics of the Land of Promise. . . .[22]

Bedford's "simplicity and literalness" was not remote from Frith's "simple truthfulness," but it was different. Both photographers avoided "pseudo shrines" and "sham relics," but Frith recorded more of the contemporary scene, while Bedford preferred timelessness. Frith was more interested in facts, Bedford in pictorial values.

Frith, Bedford, and Robertson and Beato could not have known of each other's when they produced their own collections. Though Robertson and Beato were the first in the Holy Land (1857), they pub-

Francis Bedford (1862), albumen print. "Bethlehem. —The Shepherds' Field." (Jewish National and University Library, Jerusalem)

lished their photographs in 1864; Frith published his work in 1858, 1859, and 1862. Bedford is the exception. He surely knew Frith's work, although certainly not Robertson's and Beato's.

The differences are remarkable. Robertson's and Beato's Jerusalem was a magnificent subject of grandiose structures, as Frith's certainly was not. Frith's photographs—in and outside of Jerusalem—although not mere records such as those produced a few years later by photographers trained as explorers, are more factual than picturesque, perhaps a consequence of the matter-of-fact, businesslike spirit of a small entrepreneur. Apparently, Frith's motives were not entirely aesthetic or religious-historical but also encompassed an interest in the region as a potential area of colonial penetration. Frith's photography was of a documentary nature. Notwithstanding the similarity between his work and Frith's, Bedford's portrait of the Holy Land is more pastoral. He preferred subjects in which his artistic sensibilities could be utilized. Perhaps this is what made him reject views of documentary or traditional significance that lacked artistic interest. Bedford also had to live up to the expectations of his royal patron on a royal tour. This tour was, of course, more than a carefree sightseeing excursion. The Prince of Wales's visit in 1862 presaged a sustained English effort to gain a foothold in and explore the Holy Land during the 1860s and 1870s. This task was assigned to the Royal Engineers of the British Army, trained in both topography and photography.

Exploratory Reports and Travelers' Pictures, 1864–1878:

Protestant and Catholic Nuances in Holy Land Photography

Beginning in the 1860s wet-plate photography in the Holy Land could be categorized into two main types: the continuation of landscape photography pursued for commercial reasons, and the beginning of photography for the purpose of scientific exploration. While earlier photographers, such as Salzmann and de Prangey, had in fact used their cameras as tools of exploration, the exploration photographers of the 1860s and 1870s were part of a large enterprise in which photography actually played a secondary role; in fact, the photographer was chosen from among the members of the exploration team, made up of soldiers. The last series of exploratory wet-plate photographs and their accompanying texts were published in the framework of the British-funded survey of western Palestine in 1877 and 1878.

Two exceptional photographers represent the last stage of wet-plate landscape photography produced for commercial purposes: Frank Mason Good and Félix Bonfils. Good, a respected member of the Royal Photographic Society in Great Britain, toured the Holy Land in 1867 and again in 1874. Bonfils, a Frenchman, settled in Beirut, Lebanon, in 1867. His work culminated with his *Souvenirs d'Orient*, a series of albums published in 1877 and 1878. These years marked the close of the period of wet-plate photography.

Bonfils was the tourist's photographer par excellence, his views of famous sites and portraits of local "types" being the perfect souvenirs. He had shops established throughout the region, one of them in Jerusalem. Good was also a tourist's photographer but was more attuned to the landscape. Thus, notwithstanding the similarities between their work, there is a difference in nuance, with respect to their preference of subject matter and composition. A careful comparison between them invites an examination of possible influences upon their work. In fact, a distinction between a preference for nature and one for

architecture can be traced all the way back to the daguerreotypists, pointing to two distinct nuances in Holy Land photography: one British-Protestant, the other French-Catholic. This difference held even for exploration photography to some extent. Photographers were not consciously aware of such influences nor were these influences subsequently identified by historians of photography.

EXPLORATORY PHOTOGRAPHY

A wave of exploratory teams that included photographers left Britain and France for the Holy Land in 1864. Exploratory photography, including the work of precursors such as de Prangey and Salzmann, generally had five basic characteristics. First, it involved repeated representation of subjects from several different angles without emphasis on the most impressive one. Second, the subject matter was confined to the topic of the exploration, of no particular interest to the photographer and of little visual appeal to the lay audience. Third, the commercial motive was either absent or subordinated to the aims of the exploratory enterprise. In most cases, the photographer would not be authorized to sell the pictures for his own profit. Fourth, the photographs were only one part of a larger description of the subject, which included drawings, texts, and maps that were often necessary for interpretation of the photographs. And fifth, as a rule, the work demanded more photographs and a longer stay in the country than were common for the traveling landscape photographers.

The explorers' approach, which focused on less-popular subjects intended for a specific audience, is foreshadowed by that of Dr. James T. Barclay, the first American photographer in Jerusalem. In the introduction to his book, *The City of the Great King*, Barclay wrote:

Many beautiful photographs are withheld from publication simply because the public is already furnished with elegant and correct representations of the subjects alluded to, from the portfolios of Bartlett, Tipping, Catherwood, Roberts and others supplying them, however, by others perhaps equally attractive and more subservient to the special ends in view.[1]

Reading between the lines, Barclay seems to be apologizing for the "exploratory" character of his own pictures and his decision to exclude illustrations of the best-known holy places, which, in fact, filled the portfolios he mentions. That these illustrations were engravings and lithographs, rather than photographs, did not seem significant to him.

None of Barclay's photographs is known. His illustrations are engraved reproductions, and, as he explains in his introduction, they

are almost entirely original; and not only so but owing to a fortunate circumstance that placed the Author in possession of an excellent French photographic apparatus, are nearly all from photographs taken in special reference to topographical illustration. To his excellent friend Mr. Graham of the English Mission, he is also deeply indebted for valuable contributions of this character. . . . To insure greatest accuracy, duplicates of many of these originals were also drawn in a large camera (or when lenses were unavailable by a skillful pencil) and, being satisfactorily verified in comparison with the objects portrayed, they may be regarded as facsimiles of nature.[2]

Arriving in Jerusalem in the early 1850s, Barclay was on good terms with the local authorities. He had access to the Temple Esplanade for months. Whether he was authorized to take photographs there is not known.

Barclay personified the resident photographer, neither a short-time visitor-traveler nor an indigenous local inhabitant. A missionary and writer-explorer,[3] he was—with Graham—the first such photographer in Jerusalem. There were many to follow toward the end of the century.

Ermete Pierotti, an Italian civil engineer hired by the Ottoman authorities in the late 1850s to explore the Holy City, used many photographs, perhaps not ones taken by himself. The second volume of his *Jerusalem Explored* contained lithographs made after some thirty photographs, drawings, and maps.[4] A few pictures show figures—most likely the explorers at work. Most of the subjects reproduced were among Jerusalem's best-known landmarks, to which Pierotti often had privileged access. Dates within the text suggest that Pierotti did most of his work between January 1857 and April 1863. Although the two volumes were published in London in English, Pierotti dedicated them to French Emperor Napoleon III in 1861, apparently seeking additional financial aid and publicity.

Thirteen albumen prints have survived in Pierotti's unpublished diary, together with numerous drawings, engravings, and watercolors produced by a number of artists. Two of the drawings, depicting mosaic patterns, were published in *Jerusalem Explored*. All the photographs were unsigned and accompanied by notes and captions in Pierotti's handwriting. Nine of the prints were apparently taken by a single photographer. They show localities outside Jerusalem. The view of the biblical site of Shilo shows a group of villagers seated in the foreground facing the camera. There were also four very small photographs of other localities.

Pierotti did not limit his interests to buildings. In 1864 he published a study in ethnography, *Customs*

and Traditions of Palestine, Illustrating the Manners of the Ancient Hebrews.[5] While there are no illustrations in this book, a number of original photographs portraying local life in the Holy Land are found in his personal journal. These are captioned "Fishermen of Tiberias," "A Porter of Tiberias," "Odalisque and Arab woman of Gaza," "An Arab coffee-house," and "A Jewish woman of Algier"(?). No exclusively local elements are observable in the portraits, and, were it not for the captions, they could just as well have been taken in any capital of the region and purchased there or in Jerusalem. These were all taken by one unidentified photographer and are the earliest-known portraits of inhabitants. That Pierotti left the Holy Land in 1864 testifies to the existence of this genre in the region before that date. As a whole, the small collection is reminiscent of the later work undertaken by exploratory photographers, particularly Sergeant Phillips of the British Royal Engineers (see chap. 6).

On March 8, 1864, just before the British Royal Engineers came on the scene, a French exploratory

party headed by the Duc de Luynes arrived in Jerusalem. This party designated one of its members, L. Vignes, as photographer, in a division of labor that the British were also to use. From now on, one member of an exploration team would be entrusted with photographic work in addition to other duties. Commercial attractiveness was not the aim, and the director of the project, rather than the photographer himself, would usually determine the subject.[6]

The French group planned to explore the Dead Sea, Petra, and east of the Jordan, and on June 7 the expedition left the Holy City. Vignes, described as a "brilliant marine officer," was unfortunately not as skillful in photographic technique. Many of his negatives could not be developed at all, and the published collection was hardly representative of a major exploratory work. But his materials, ready-made dry-collodion negatives prepared in Paris, were also at fault. There was an obvious need for something simpler than the laborious wet-plate process, but attempts to produce a dry replacement were apparently not yet successful.

Vignes's photographs of the desert east and northeast of Jerusalem showed large open spaces, stony hills and mounds, the mountains beyond the Dead Sea, and details of the natural landscape and ruins. Some sites east of the Jordan were shown from several points of view. The publication of these photographs in 1874 by the grandsons of the Duc de Luynes constituted another innovation. They were among the earliest photomechanical reproductions of photographs from the Holy Land, prepared in Paris by the well-known artist and photographer Charles Nègre. The Duc de Luynes had supported experiments with photomechanical reproduction processes, and this interest led him to include photography in his expedition.[7]

Another team, composed of British clergyman and naturalist H. B. Tristram, one of the more important explorers of the Holy Land, and his photographer, H. T. Bowman, met the Duc de Luynes and his party in Jerusalem and at the shores of the Jordan near the Dead Sea. It was in this latter region that the duke and Tristram did a substantial part of their exploring. Almost nothing is known of Bowman's work. Tristram credited him with photographs from which two engravings in his book, *Land of Israel*, were made.[8]

In the same year (1864) the British Army's Royal Engineers Corps, headed by Captain Wilson, began its work in western Palestine. A total of 550 photographs were taken between then and 1877. Some of these were published in four installments over this period. This is the most voluminous and important collection of photographs taken in the nineteenth century in the Holy Land. Later changes in the terrain

gnes (1864), photomechanical reproduction on steel plate, by Charles Nègre, Paris 1874.
oah." (Israel Department of Antiquities and Museums)

and the disappearance of interesting objects from various sites made these photographs especially valuable. Tristram noted this already in 1881, referring to the ancient synagogue in Birim, in upper Galilee:

Outside the village in an open field there stood a few years ago the gateway and foundations of another Synagogue with very fine sculptures over the doorway, and two lambs supporting a wreath inscription beneath. This, when I visited it in 1864, was one of the finest bits of Jewish work in existence. Last year I was appalled to find it had utterly disappeared, though happily not before it had been photographed by Sir C. Wilson. Within the last few months this almost unique building had been utterly demolished for the sake of its stones, to build cottages.[9]

James McDonald (1864–65), albumen print. "Private houses standing on the west edge of the Tyropean Valley (opposite Robinson's Arch)." Typical frontal view as used in topographical photography. The houses stand today, not far from the Wailing Wall. (Israel Department of Antiquities and Museums)

Charles Wilson was probably the driving force behind the decision of the Royal Engineers to undertake such a large-scale photographic project. In 1858, while exploring the Oregon Territory to draw the Canada-U.S. border, he had become familiar with photography and probably even then recognized its potential value in exploratory work.[10] He headed the first of the British teams, which arrived in Jerusalem in June 1864, with Sergeant James McDonald as photographer. The well-executed album of Jerusalem, accompanied by maps and text, was published by the Ordnance Survey in 1865. In that year Wilson returned to head an exploration party under the auspices of the Palestine Exploration Fund (P.E.F.), newly founded and encouraged by the British government. This time his photographer was Corporal H. Phillips, also of the Royal Engineers. Additional series of photographs were taken for the P.E.F. in 1874 and 1877 by Lieutenant H. H. Kitchener, R.E., who was to become an outstanding figure in British colonial history as Lord Kitchener, earl of Khartoum. A complete catalogue of the photographs taken in the Holy Land by the Royal Engineers for the P.E.F. was published in the 1890s.[11] The collection is still carefully preserved in the P.E.F. London offices. The photographs show sites explored and views relevant to topography and archeology. They were distributed through the P.E.F. network to subscribers.

James McDonald (1864–65), albumen print. "General view of the city from the North." Five-plate panorama. In center, Damascus Gate. (Israel Department of Antiquities and Museums)

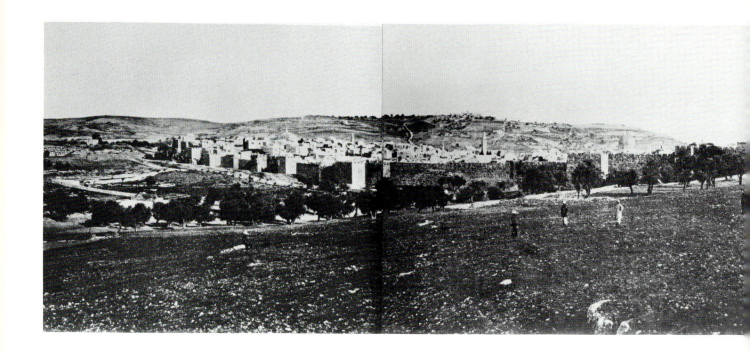

The first work of a Royal Engineer photographer was published in 1865. The photographic volume of the *Ordnance Survey of Jerusalem* displays outstanding topographical work, even though photographs were not considered essential to the survey, and Sergeant McDonald, a surveyor in Captain Wilson's party, was asked only "to take views at spare moments that were intended to illustrate as far as possible the masonry of the walls and architectural details of different buildings."[12] McDonald's choice of subject and angle was guided by topographical or functional considerations. Thus, he would photograph the masonry of the city walls from close range, or houses of no historical or artistic significance to exemplify the city's dwellings. His distant views of the city focus on topographical features, minimizing "interesting" or "magnificent" structures or, at the most, using them as points of orientation. Many of the buildings are presented in flat, almost frontal views. The captions include such precise details as the direction from which the photograph was taken or that which the depicted object was facing. No attempt was made to record the everyday life of the city, though some of the photographs represent it implicitly. A few pictures taken from medium or long range include human figures, some of them blurred; these were British soldiers or local inhabitants who happened to be present. The Ordnance Survey was oriented toward topography

and architecture, so much so that a photograph showing two women at the Wailing Wall (taken by local photographer Peter Bergheim and purchased by the explorers) was captioned "Details of Masonry at the Wailing Wall."

Large panoramic views composed of two, three, and in one case five single photographs mounted together were an exceptional feature of the McDonald album. These panoramas, in the true spirit of the assignment, were of singular interest to a scientific or military observer.

This is not to say that McDonald failed to capture the beauty inherent in the architecture—some of his photographs of buildings were very well made. In fact, most of the pictures were of excellent quality, confirming his capabilities as a photographer.[13]

McDonald also produced stereoscopic pictures of Jerusalem. None of the originals, which are always in pairs, have been found, but a selection of individual unpaired views appears in a small French album.[14]

Captain Wilson's 1866 P.E.F. team included Corporal Phillips as photographer. His work, though technically inferior to that of McDonald, was much more extensive. It constitutes the largest collection produced by a single photographer in the nineteenth century. The expeditions in which Phillips served

as photographer concentrated on topography and archeology, two of the five areas of interest mentioned as declared aims in the initial P.E.F. prospectus (the other three were manners and customs, geology, and natural sciences). A selection of Phillips's photographs appeared in a P.E.F. portfolio published in 1867, although only the heads of the parties, Wilson and Warren, are mentioned on the front page.[15]

The 1866 P.E.F. party blazed the trail for subsequent expeditions that carried out a complete survey of western Palestine during the next decades. Arriving in Palestine on January 1, the team began work near the sources of the Jordan in the north of the country and continued to the ancient synagogues of the later biblical period in the Galilee, which Wilson considered important for exploration; his expedition furnished the first complete account of this subject. The party then proceeded southward to the Plain of Esdraelon (Ezreel), then on to the Nablus region, and finally to Jerusalem in April 1866, returning to England from there. Phillips managed to take 166 photographs of sites, architectural details, and inscriptions and a few views of flora in about four months. Though both the Turkish authorities and the local population were well disposed to the expedition, Phillips had some bad moments, especially when the villagers at Haran stole his developing tent.[16]

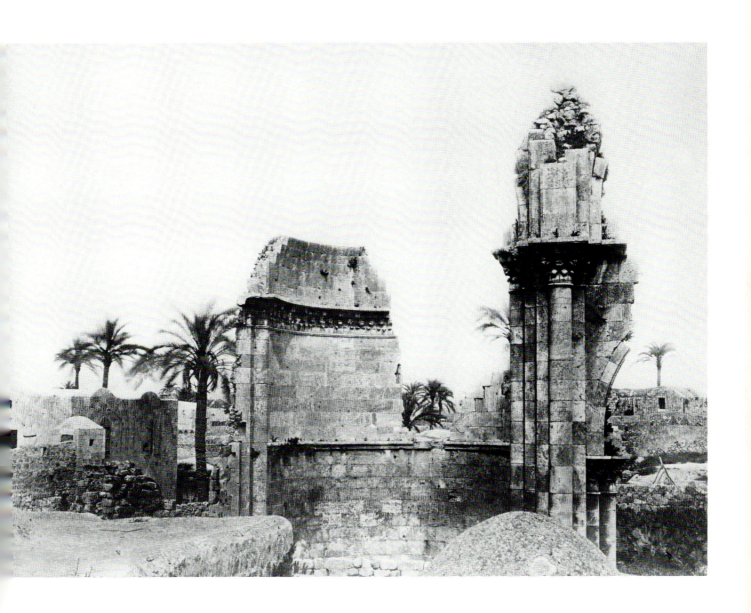

H. Phillips (1866), albumen print. "The Church of St. George. Lod, Lydda, or Diospolis. 1 Chron. 8:12; Ezra 2:33; Neh. 11:35; Acts 9:32–39. The ruins which are now standing here are of a church built about 1150 A.D. It has been partly rebuilt, and converted into a Greek church." (Jewish National and University Library, Jerusalem)

The second expedition, under Lieutenant Warren, arrived in February 1867 and worked until April 1870, concentrating mainly on Jerusalem. Warren described his work in *Underground Jerusalem*, published in 1876, which contained three photographic reproductions: "Group of Jews in Jerusalem," "Jews Praying at the Wailing Wall," and "Group of Samaritans on Mount Gerizim," near Nablus.[17] The first and third photographs were by Phillips; the second, by the local photographer Bergheim, was the one that

H. Phillips (1867), albumen print. "The view from the Jaffa Road (North-West corner of the city). Russian buildings on the left." Taken from today's center of downtown Jerusalem. In the background, Jaffa Gate, David's Tower, city walls. (Jewish National and University Library, Jerusalem)

had already appeared in McDonald's album of Jerusalem, captioned "Detail of Masonry." Warren interrupted his work in Jerusalem several times, and in May 1867 explored Philistia (Gaza Strip) and the Jordan Valley. Phillips, who accompanied Warren on these trips, took 200 photographs, among them the first views ever taken of Masada, and then left for home. Quantity and novelty of subject matter alone distinguish Phillips's collection. There are, for the first time, photographs of trees, bushes, and canyons, as well as of excavations and ruins. This collection is also remarkable in that it includes the first ethnographic portraits ever taken in the Holy Land (see chap. 6).

The Jewish scholar Emanuel Deutsch, writing to the P.E.F. in 1869, provides an extraordinary example of the specific uses and values of exploratory photography:

I have, in the course of my journey, frequently had occasion to feel grateful for the series of photographs taken under your auspices by Captain Wilson and Lieutenant Warren. Thus, to allude to one fact only; when two years ago I was enabled by one of your photographs fully to decipher the probably oldest Samarian stone in existence, now immured upside down in the ruined mosque of Nablus, I could not but be surprised at the fact that no investigator, however competent, even among those who had copied the stone on the spot, should have been able to decipher it fully, and without conjectures, before. When on the spot myself I soon perceived that the photograph showed what the stone itself did not show, at least from the position in which the decipherer is necessarily placed; hanging as he does, at some height in the middle of a ruined tower, over an unstable ledge, and straining towards some blurred and indistinct Samaritan letters standing as it were on their heads. In the same way I have found it much easier to read the Hebrew inscription on the lintel of the ruined synagogue at Kefr Birim ("Peace be upon this dwelling-place," etc.) in the photographs than at the place itself. And let me add another rather melancholy advantage these photographs offer; they record what magnificent remains there were in the land two years ago.[18]

The photographic activity of the Palestine Exploration Fund party, headed since 1872 by Lieutenant Conder, was renewed in November 1874, when Lieutenant H. H. Kitchener, R.E., arrived in Palestine. Kitchener had little time for photography and had taken only fifty pictures by June 1875, when some inhabitants of Safed attacked the party and wounded him and others. His photographs did not reveal any new aspects of exploration or testify to any new approach. On his return to England he published a portfolio of twelve views of his own selection entitled *Photographs of Biblical Sites*.[19]

Conder's party, including Kitchener, renewed its work after the resolution of the tension following the Safed incident, finishing in September 1877. Kitchener published detailed notes on the photographs in the *Palestine Exploration Fund Quarterly Statement* of 1878.[20] The portfolio, the accompanying notes, and detailed scientific texts accompanying the second series show no evidence of any new photographic approach or achievement.

In the 1880s the P.E.F. photographs were mostly of eastern Palestine (Transjordan). Lieutenant Mantell, R.E., and Dr. Gordon Hull were the photographers, although the latter's work was unsuccessful. The last photographs taken in the Holy Land before World War I were made by another officer of the Royal Engineers, a famous figure in the history of the British Empire and of the region, T. E. Lawrence (Lawrence of Arabia).

COMMERCIAL LANDSCAPE PHOTOGRAPHY

Along with the exploration parties, individual wet-plate photographers continued to work in the Holy Land for commercial purposes. The difference between these two types of photography is clear even from the titles of the published work. Both volume 3 of Bonfils's *Souvenirs d'Orient* and the photographic volume of the *Ordnance Survey of Jerusalem* are albums that depict the same city but from strikingly different perspectives. Exploratory teams tended to include photographs of subjects attractive only to the scientifically oriented, while landscape photographers tended to cater to their growing general audiences.

Many buyers frequented the already existing shops in Jerusalem in which landscape photographs could be purchased. These travelers, as well as the photographers of this period, came to the region when the Suez Canal opened in 1869. The first paved road, from Jaffa to Jerusalem, was opened in connection with this event, and the first carriage service begun. These and other developments encouraged more Europeans to visit the area, creating an even larger market. Despite changes in the landscape, however, commercial photographers continued to produce work similar to that of their predecessors for almost two decades.

The work of Frank Mason Good showed similarities to Bedford's approach. Photographs of his were first mentioned in an article published in London in January 1868. It praised his stereoscopic views, which unfortunately seem not to have survived.[21]

Good's photographs from the Holy Land were referred to in a review from London in August 1875.[22] The reference is most likely to Good's portfolio, *Photo-Pictures of the Holy Land*.[23] H. B. Tristram used another selection of the same photographs to illustrate his *Pathways in Palestine* (1881–82).[24] Tristram, an authority on scientific research in the Holy Land, considered Good's photographs the best available. *Pathways*, beautifully produced, was not a work about exploration, like Tristram's other books, but was addressed to a general audience. Tristram invited his reader to follow the unbeaten paths, off the conven-

tional tourist-pilgrim track. Good's photographs were indeed the best available illustration for this purpose. Photographs of mountains, fields, trees, and villages are more numerous in his work than in Frith's or Bedford's.[25]

Good's photography may have been inspired by a personal or artistic sensitivity to the natural landscape and to the people who were part of it (see chap. 6). There may have been a religious motivation as well, a wish to represent those elements of the Holy Land that had withstood time and remained as they had been in the biblical period. A preference for these more ancient features over Moslem, Byzantine, or later medieval architecture is understandable in such a context and would testify to a sophisticated discrimination. Good also may have realized that his predecessors had saturated the market with views of the Church of the Holy Sepulchre, the Dome of the Rock, the city gates, and so on, and had the wisdom to offer additional views—as well as portraits—that earlier had seemed marginal or less attractive. Good's photographs of the tilled fields of the Plain of Esdraelon, of olive trees near the brook of Kidron, of Mount Gerizim and Mount Ebal near Nablus, and of Gilgal in the Jordan Valley provided a fresh new look.

Good's landscapes were well composed and distinguished by flat, undramatic light, which he used frontally in order to leave the depicted subject without contrasting shadows. He often captured the outline of the landscape in its own nuances, lines, and textures. This same London reviewer of his stereoscopic pictures wrote about "the degree of tenderness and delicacy, of vigor and brilliance imparted to each picture as the nature of the subject may have rendered desirable." The same could be said of these photographs. Good's style was already crystallized and established. An excellent technician, he considered the wet process superior for landscapes and continued to use it despite its ongoing replacement by dry plates.

The photograph made at Capernaum is an excellent example of Good's approach. The ruins of the synagogue there were explored by the P.E.F. shortly before Good's first visit, and six P.E.F. photographs of the site were available throughout England. Photographs of the ruins were also taken by Bonfils, who had focused on the ruins and carved stones and included posed figures of seated monks. Good, in contrast, turned his back on the ruins, so that his "Site of Capernaum" shows part of the rocky shore of the Sea of Galilee. Here we have the same place, shared historical-religious associations, and entirely different photographs.

While Good was redefining biblical landscape photography, Félix Bonfils was becoming the chief

supplier of photographs for pilgrims and travelers, as well as for writers and publishers.[26] From the 1870s to the end of the century, Bonfils and Company produced landscapes, biblical scenes, and portraits of all kinds. His work represented a bridge spanning the transition from wet-plate to dry-plate negatives and from single, loose albumen prints to mass-produced reproductions in books, magazines, and newspapers. The voluminous output provides tangible evidence of changing genres, styles, subjects, and techniques.[27]

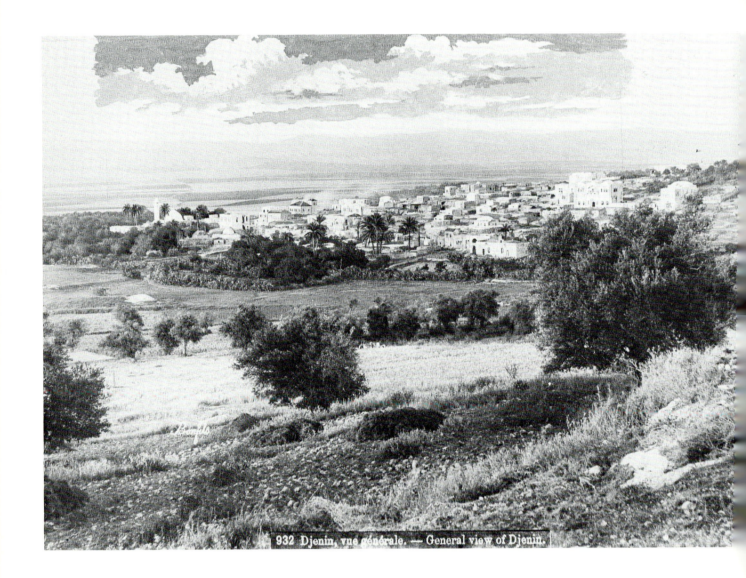

Félix Bonfils (187?), albumen print, clouds drawn in for reproduction. "General view of Djenin." (Jewish National and University Library, Jerusalem)

As probably the first European photographer to settle in the region, Bonfils was, from our point of view, a regional traveling photographer, midway between the European traveler and the local photographer. He photographed the entire eastern Mediterranean area and was consequently much closer to the inhabitants of Jerusalem than Frith or Good, for example, although he too visited western Palestine only for short periods.

Bonfils's image of Palestine reached a world-wide audience in a vast range of publications. In the last decades of the century, his photographs were reproduced more often than any others. Because of this his work had an unusually long life. His earliest wet-plate landscape photographs of Jerusalem date back to between 1867 and 1870, and two of these—in addition to an outdoor portrait taken before 1882—were still reprinted sixty years later in 1930. His work, despite or perhaps because of its extent, is an intriguing and incomplete puzzle. For all its popularity, the precise date and authorship of much of the work Bonfils signed and sold have remained a mystery to this day. He and his descendants often renumbered the stock using various mutually exclusive methods;[28] identical portraits were used in his albums and published by others with conflicting captions, and many of his pictures were montages remounted anew from sections of staged studio or landscape photographs. Bonfils's photographs can be found with or without his signature in published books and private collections as original prints and reproductions, as hand-colored prints sold in ornate albums decorated with dried flowers, and as printed photographs in illustrated books and periodicals.

The earliest photograph of Jerusalem attributed to Bonfils—his signature and a number are scratched on the negative—has to have been taken in 1867 or early 1868. It shows a long, one-story building and a windmill and is captioned "Jewish Hospice." This was Mishkenot Sha'ananim, built by Sir Moses Montefiore in 1858–60 as the first Jewish dwelling outside the walls of the Old City. A second building, located between the first and the windmill and built in 1868–69, does not appear. In contrast, all Bonfils's pictures of the Church of the Holy Sepulchre show a restored dome, looking very different from the ruin that had so distressed Salzmann and Frith. These photographs had to have been taken at a later date, as construction on the dome was not completed until 1869. Bonfils evidently preferred finished buildings.

Félix Bonfils began to publicize his wet-collodion photographs of Jerusalem in 1871. A short review of his work in a French *Pilgrim's Society Bulletin* in 1873 stated that his collection included seventy-eight photographs of Jerusalem, Bethlehem, Hebron, Jaffa, Tiberias, Nazareth, St. John of Acre, Carmel, Nablus, and Ramleh, and 137 stereoscopic views of Palestine available in Paris.[29] His work reached its

peak in 1877 with the publication of his four lavish albums, *Souvenirs d'Orient*, each subtitled *Picturesque Album of the Most Remarkable Sites, Cities and Ruins of the Holy Land*.[30] The third and fourth volumes contained sixty large, beautifully executed albumen prints of Jerusalem and western Palestine showing architecture and landscapes. These were published in Alais, France, by Bonfils himself. In 1878 a smaller version of the album appeared, and in the same year Bonfils was awarded a medal at the Universal Exposition in Paris, which shows that his work had won recognition in circles far beyond his basic market of tourists and pilgrims to the Near East. He received a similar award in Brussels in 1883.[31] Félix Bonfils died in 1885, but his successors continued the business in Beirut for at least another decade.

The only detailed reference to all Bonfils's pictures is his catalogue of 1876.[32] The catalogue probably referred to the photographs and stereoscopic views already mentioned in the *Pilgrim's Society Bulletin* of 1873, as the numbers were strikingly similar. The catalogue introduced portraits, a novel twist, under the heading "Costumes Stereoscopes," which depicted figures in oriental apparel or in characteristic oriental settings. None of these has survived. Some were probably taken on location in Palestine; some were photographed elsewhere in the Near East; others were staged in Bonfils's studio or courtyard in Beirut. Some of the portraits were also listed as "views," that is, large-dimensioned, single photographs.

Bonfils the landscapist, like Bonfils the portraitist, saw his subjects through a traveler's eye. Some of his views of ancient Jerusalem in his 1877 *Souvenirs* are very similar to those of Robertson and Beato taken in 1857. Bonfils preferred the impressive—city gates, mosques, churches, tombs, and historical places. His use of light enhanced the architecture, and his technical execution was excellent.

Some of the differences between his work and that of earlier photographers were due mainly to the passage of time. The 1860s was a period of construction and repair in Jerusalem. Bonfils's work shows none of the desolation that characterized the photographs of Frith and Salzmann. Sites marred by poverty and debris in Frith's photographs look clean and shining in scenes taken by Bonfils from the same angle. Ruins and deserted sites, which lent the views of Bonfils's predecessors an aura of sadness and melancholy, often look attractive and urban in Bonfils's work. The city had not changed that much, but Bonfils knew what his clients appreciated and what views to avoid. His Jerusalem, with its restored Church of the Holy Sepulchre, was a well-kept medieval castle. With its chapels and churches, it was a Christian town in the midst of magnificent oriental architecture. Palestine of the *Souvenirs* was more a settled Mediterranean country than an eastern rural region. That is to say, it was more for tourists than for archeologists, more for pilgrims than for nature lovers. Apart from subjective influences on his selection of sites and angles, Bonfils was responding to the spirit of the age.

Félix Bonfils (ca. 1870), albumen print. Jerusalem. David's Tower. (Jewish National and versity Library, Jerusalem)

A detailed comparison between Good's and Bonfils's collections reveals a difference in nuance in terms of subject matter and composition. This distinction, in fact, can be traced back to the days of the daguerreotypists. In retrospect, the work of Keith, Wheelhouse, Bridges, Frith, Bedford, and Good—all British—constitutes a tradition of landscape-oriented photography; Goupil-Fesquet, de Prangey, Du Camp, Salzmann, de Clercq, and Bonfils, in contrast, constitute a French line that exhibited a stronger interest in architecture. To be sure, we are speaking of nuances. The countryside does feature in French photography, and buildings and towns appear in British collections. Still, even in their pictures of architecture, British photographers generally included more of the surrounding natural environment than their French counterparts. This difference in composition suggests that they were not conscious of their emphases.

The difference in nuance is also discernible in exploratory photography. Though McDonald, Phillips, and Kitchener constitute a separate category of photographers in comparison to Bedford and Good,

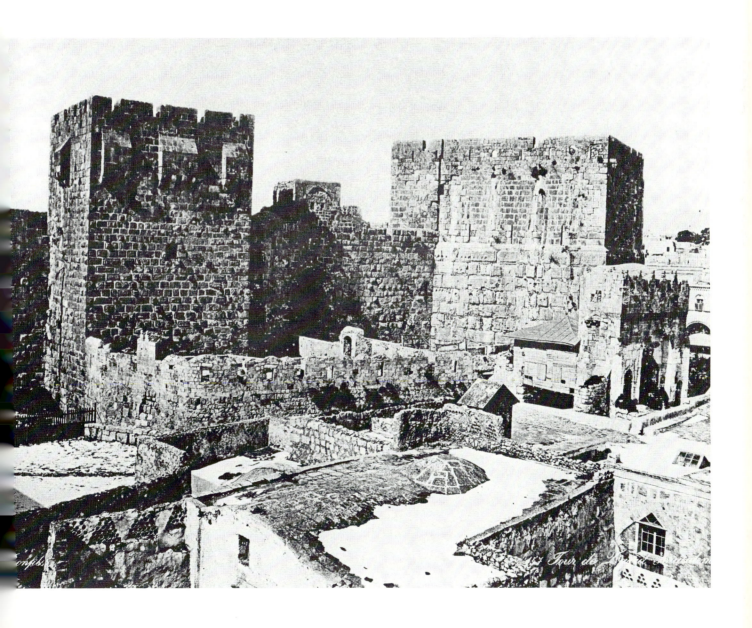

ABOVE: *Félix Bonfils (ca. 1870), albumen print. "Capharnaum." (Jewish National and U\[ni\]versity Library, Jerusalem)*

RIGHT: *Frank Mason Good (1874), woodburytype reproduction. "Site of Capernaum." (\[E\]pin Library, Department of Archeology, Hebrew University, Jerusalem)*

nevertheless their work is close to Bridges's and Frith's matter-of-fact approach; in contrast, de Prangey and Salzmann, precursors of exploratory photography, relate more closely to the French tradition.

True, sponsorship influenced priorities: French institutions were more interested in the photographic exploration of historical landmarks in the Holy Land, while British institutions supported general surveyance; however, we find these priorities overlapping with those of independent photographers. French interest in the photography of historical landmarks in France emerged soon after the invention of the daguerreotype, whereas the British did not consider photographing their own historical sites until more than a decade later. Moreover, there seems to be evidence of two artistic traditions unrelated to the Holy Land. Lady Eastlake, an important figure in Victorian photography, points to this in a casual remark in one of her articles describing the universal appeal of photography: "the best landscape photographs at the Exposition des Beaux Arts are English, the best architectural specimens in the London Exhibitions are French."[33] Her statement reads as if she were reviewing Good and Bonfils. However subjective this judgment may be, it supports the assumption that differences in emphasis in Holy Land photography had roots in overseas traditions.

It is clear that in the context of the Holy Land the classical definitions of landscape versus architec-

tural photography all too narrowly refer to these genres by the physical nature of the photographed objects alone. They do not really encompass the complexity of the subject, the more so since both embody romantic connotations and pictorial values attractive to photographers. In the Holy Land, nature and structures alike hold significance beyond that of landscape and architecture. The Mount of Olives was not merely a landscape, the Temple Esplanade not just a piece of architecture; they were also religious symbols.

From this point of view, the symbols of Christianity in the Holy Land can be sorted into two distinct categories: (1) relatively untouched landscapes in which biblical events occurred, and (2) man-made sites, mostly edifices of a commemorative nature. The prominence given to either of these two categories of subject matter in a given photographer's collection may be due to his religious values and heritage. The British influence may be rooted in the rather negative Protestant attitude toward religious art and decor and in the prominent place of the Bible in Anglican Protestant culture, which has no counterpart in the French Catholic religious tradition.[34] The French influence may be rooted in the emphasis placed on artistic representation in Catholic religious practice. Early Holy Land photography was affected by these two cultural influences. The country was revealed to the Western world by photographers who perceived it differently and who often intuitively represented different values and beliefs related to it.

These differences are also reflected in the personal backgrounds of some of the photographers who worked in the Holy Land. It is perhaps more than a coincidence that Bridges and the lesser-known Isaacs were ministers; that George Skene Keith worked for his father, a theologian and clergyman; and that, in clear contradistinction, Goupil-Fesquet was an artist and art teacher, Girault de Prangey an aristocrat and art historian, and Salzmann a painter. Although this list is not exhaustive, it points to a direct influence of Protestantism in British Holy Land photography and only to an indirect influence of Catholicism in French photography.

There are indications that photographers from other countries were similarly influenced. The dividing line appears to distinguish not only between British and French photographers, but also between Catholics and Protestants. The little-known calotypes of (Catholic?) Irishman John Smith-Shaw, though few in number, fit the Catholic pattern, as does the published work of (Catholic) Italian Pierotti. That Italy's first Holy Land explorer was a civil engineer and that his album was based on photographs of architecture may be of significance. The album of Dr. Lorent, the single German work, also belongs to this category. However, whether he came from a Protestant or a Catholic environment is not known.

Examined from this perspective, the Robertson and Beato album constitutes a dilemma. Were both companions visiting the Holy Land—and taking photographs? And what was each individual's share in deciding upon subjects and composition?

Unfortunately, there were no Catholic British photographers whose work would have helped to check this hypothesis further. There were, on the other hand, French photographers who might have been Huguenots. There was a pastor in the Bonfils family, and a "Protestant" streak discernible in the voluminous Salzmann album may be hypothetically linked to his unknown origins. It was not the photographer's personal link to a specific denomination that was the influential factor, but the broader framework of the general culture in which he lived, was educated, and worked.

Late-century photographic work in the Holy Land, not as predominantly British and French as early photography, seems to corroborate the conclusion concerning the importance of Protestant and Catholic influences (see chap. 8). An extended study of twentieth-century Holy Land photography may indicate whether these influences continued to hold.

The nuances found in early Holy Land photography may link Protestant and Catholic interests in the country to the medium's two faces: its direct relationship to nature and unembellished reality and its affinity to creative representation and art. It is exciting to think that this relationship may also be found in environments uncharged with religious beliefs and may reveal deeply rooted influences of Protestantism and Catholicism on photography in general.

PHOTOGRAPHY Part Two AND LOCAL SOCIETY

Early Local Photographers and the Second Commandment, 1859–1876 ⁵

Except for the intermittent presence and work of traveling photographers, nothing paved the way for the acceptance and use of photography in the Holy Land. Compared to Western Europe where the introduction of photography had been an organic part of overall scientific development, photography was introduced in the Holy Land from outside into a closed, traditionalist and economically backward society.[1]

It was not until twenty years after its invention that a local photographer practicing in the Holy Land was first mentioned. Dr. William Turner of Petersburg, Virginia, in his book *El-Khuds, the Holy: or Glimpses in the Orient*, tells of having his picture taken by a local photographer named Deniss during his visit to Jerusalem in early 1859. His comments provide insight into the environment in which Deniss and other local photographers began their work:

Mr. S——tt and myself strolled off in search of Deniss the photographer, recommended to us by Dr. Barclay. He is the ONLY one in Jerusalem; and I say RECOMMENDED, because Dr. Barclay, learning our desires in regard to having views taken, etc., unasked, gave Mr. Deniss a GOOD NAME—a fortune possessed by very few, according to my observations, by "Jew or Gentile," in THIS country. After numerous adventures, we at length found the house of which we were in search; but our friend the photographer was not in. His wife was kind enough to show us specimens of her husband's art—and, really, I must say they were superb. I have seen photography in New York, London, Paris, Rome, etc., yet I have never seen any to EXCEL that of Deniss.

It seems a little singular that Deniss—in plain PARLANCE—can AFFORD to live here by the fruits of his profession. I understand the natives never avail themselves of his craft; so he must live by selling ABROAD his views of Holy Land scenery, and by the encouragement he received from visiting HADJIS like ourselves. He is a Russian; converses well in several languages; is a very handsome, easy, and accomplished fellow, and is a Protestant.[2]

On his last day in Jerusalem, March 14, 1859, Dr. Turner described what it was like to have his picture taken, showing photography from the tourist's point of view:

In company with Mr. Deniss . . . we proceeded at his suggestion to St. Stephen's gate, thence to the sacred Garden of Gethsemane. From our position on the high bluffs, just outside the gate, we had a fine view of the beautiful slope of Mt. Scopus. . . . We finally reached the locked and bolted door of the Garden of Gethsemane; but here it seemed as if further progress was denied. We beat and banged, and hallooed until our hands and throats were sore from exertion. Finally Deniss, by almost superhuman efforts, brought some one to the opposite side of the gate, whither WE were so persistently endeavoring to get. A long parley, held between Deniss and the inside unseen, in some heathenish dialect, resulted in the large gate slowly moving back. Revealed to our gaze, was a most miserable-appearing Latin priest, who, from the tattered condition of his garb, and the haggard careworn expression of his countenance, looked as if he might have been doing penance all his life. He was the custodian of the sanctity of this sacred spot!

I cannot well describe the many emotions of my mind as I stood fairly within the limits of the divine enclosure, and recollected that here once echoed the voice of Him in agonizing prayer! . . . This then is a genuine holy place, a place so holy that the most flinty-hearted cannot enter it without feelings of awe and veneration, or without emotions akin to them. . . .

This, then—the sacred Garden of Gethsemane—was the spot chosen by Mr. Deniss, on which to take the view of our party. A photograph of my humble self in the sacred Garden of Gethsemane! What a thought! After much trouble and several impertinent interruptions from some Swedes, we were presented with a good negative view of our party, with the noble branches of the aged olives waving over us. We cannot get the pictures in time to take with us tomorrow, but Deniss will arrange the matter so that we can get them in Jaffa, on our return down the coast to Alexandria.[3]

Dr. Turner's book is the only source to mention Deniss the photographer, whose work is unknown. His identification as a "Russian Protestant" remains enigmatic, although it surely indicates that Deniss was not a native inhabitant or a Moslem or Jew. Perhaps he was a converted Jew.

There is another reference to a local photographer dating from about a year later. At the British consulate in Palestine in 1860 Scottish photographer John Cramb met "a Jew resident who had for some time practiced as a professional photographer. He took pretty fair pictures, and had done a considerable number of views."[4] This was most likely Peter Bergheim, a converted Jew, educated at the Anglican Mission in Jerusalem. Apparently his studio had not been as well known as Deniss's the previous year or perhaps it had not yet opened. A third photographer, emerging on the local scene at about the same time, was Yessayi Garabedian, an Armenian priest.

The major difference between these local photographers and their foreign counterparts was that they resided in the Holy Land, made their living in the trade, and were subject to the economic and cultural constraints of the country. In contrast to conditions in industrialized Europe, the economic structure of the Holy Land provided no local market for photography and no springboard from which indigenous artisans could easily switch to such a profession. France's early photographers were former painters, min-

iaturists, and engravers. Many others came from the milieu of "proletarian intellectuals," that is, Bohemians. They, as well as other professionals without artistic backgrounds, were able and ready to learn the trade. Moreover, there was a technological infrastructure available, including chemical and optical workshops and plants.[5] In Britain, photography was "the scientific amusement of the higher classes," and it had a popular "branch" in rapidly multiplying studios where a great volume of photographs was produced; "every little town would have its own photographer."[6] Even the "little towns" of Great Britain were a far cry from their Palestinian counterparts in the 1850s and 1860s, which in comparison were underdeveloped rural environments, as can be seen from the photographs printed in this book.

Indeed, the uses of photography in the Holy Land and in Europe were very different; in the Holy Land it was an extension of the manufacture of *objets de piété* commonly sold to travelers. With it the visitor could be included in his or her own souvenir (as in Dr. Turner's case). Local photographers thus differed not only from their traveling counterparts but also from the temporary resident photographers, Barclay and Graham. What they had in common with the latter was that they were Christians, belonging to a numerically marginal community, and that they continued to cater to the taste of foreign audiences. Descriptions of the life stories of these early practitioners shed light on the social status of photography as a profession in the country. That these local photographers were Christians demonstrates how distant photography was from the indigenous Moslem and Jewish populations, both of whose traditions included anti-iconic elements. The degree to which religion influenced the late emergence of Moslem and Jewish photographers in Palestine is therefore a major question.

CHRISTIANS IN EARLY LOCAL PHOTOGRAPHY

The earliest surviving work produced by a photographer known to have stayed in the Holy Land for a relatively extended period was that of James Graham, an Englishman who lived in Jerusalem between 1853 and 1856. The earliest evidence of his photography was Thomas Seddon's painting *Jerusalem and the Valley of Jehoshaphat*, exhibited in London in 1854. Critics contended that the painting was "simply a photograph with colour." Modern research has shown that it was, in fact, based on a photograph attributed to Graham.[7] Original photographs by Graham are rare; most are known only through reproductions.[8] Four of the reproductions are views of provincial towns off the beaten track, subjects new to Holy Land photography of the early 1850s. His access to these sites may be explained by his position as secretary of the Anglican Mission in Jerusalem, officially known as the London Society for Promoting

Christianity Amongst the Jews, or the London Jews' Society (L.J.S.), which, in fact, had brought him to Jerusalem. The mission had stations in Jaffa and in far-off Safed, which he probably visited.

Graham's photographs also served as the basis for the work of his friend, Holman Hunt, another well-known painter who spent some time in Jerusalem. In the annals of the L.J.S. in Jerusalem their names are linked in connection with their public attack on the "inefficiency and immorality" of the mission's school, established by Bishop Gobat in the hope of attracting Jewish children. This controversy may have cut short Graham's stay in Jerusalem as secretary of the L.J.S.[9]

Graham did not work for any local customers, nor did he make his living in the trade. He is important to local photography in that he introduced it to the Anglican Mission; he probably taught it to Bergheim, who was educated there. At the end of the century, photography played an important role in L.J.S. publications (see chap. 9). In fact, Christian institutions (technically more advanced than indigenous ones because of their relation with industrial countries and parties of pilgrims, travelers, and explorers) became a focal point of local photography, and their role in its development is of primary importance. Christian residents found in photography a field that offered them a relative advantage over local Jews and Moslems.

Photographers associated with the missions in Jerusalem also played an important role in the acculturation of local people to photography. In the 1850s cameras were not small boxes hung from travelers' shoulders but large wooden ones, transported along with darkroom tents on animals. The inhabitants of Jerusalem could not ignore the fact that people who lived in the city and were known to them were walking around, year in and year out, taking pictures with their cumbersome cameras. The practice gradually became part of the local scene.

Peter Bergheim's father, Paul, a German Jew who converted to Christianity, had worked on the L.J.S. medical staff as a pharmacist since 1839.[10] His son was the first of several converted Jews connected with the mission to find his way into photography. As the son of a pharmacist he had no difficulty in learning how to handle chemicals, and as a convert he was not inhibited by traditions forbidding the making of images.

As part of the Anglican community, Bergheim would naturally have had contact with the Royal Engineer exploration parties, which is probably why three of his photographs were published in the *Ordnance Survey* of 1865. Two were taken at the Wailing Wall and the third slightly to the south of it on the Temple Mount enclosure. Of interest is the one captioned "Detail of Masonry at the Wailing

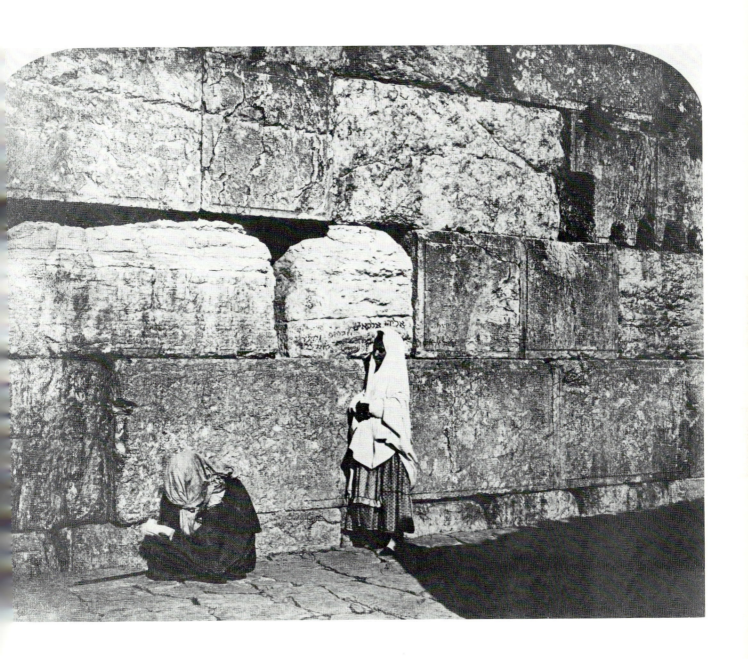

Peter Bergheim (prior to 1865), albumen print. "Detail of Masonry at Wailing Place." Caption
by publisher (Ordnance Survey). (Israel Department of Antiquities and Museums)

Peter Bergheim (186?), albumen print. "Ruins of Samaria." (Israel Museum, Jerusalem)

Wall," and, when Warren reprinted it in his *Underground Jerusalem* in 1876, "Jews Praying at the Wailing Wall." Unlike the reproductions published by Barclay and other photographs in the *Ordnance Survey*, this picture did not investigate details of masonry. Bergheim's picture was of two women. One, whose entire face was hidden behind a veil, sat with a book near the wall; the other was standing, unveiled and better dressed, and looked as if she were posing for a typical souvenir photograph of the kind Dr. Turner had described having taken in the Garden of Gethsemane. This is possibly the earliest extant souvenir photograph to be taken by a local photographer. Its survival may be attributed to the fact that it was purchased and published by the Ordnance Survey. The taking of such photographs was obviously part of Bergheim's daily routine as a local photographer; the son of a convert known for his links with a mission, he certainly had no privileged access to the Wailing Wall on religious grounds.

Other evidence of Bergheim's photographic activity is found in a report of 1867 by Captain Warren of the Palestine Exploration Fund, mentioning that he had met "Mr. P. Bergheim just returning from Petra, where he had been successfully photographing" on the shores of the Dead Sea.[11] Samuel Manning's popular book *Those Holy Fields*, published in 1874, was also illustrated with some engravings based on Bergheim's photographs, among others.[12] A small undated album entitled *Palestine and Syria*, including photographs signed "P. Bergheim" and glued on cardboard (most likely assembled by a buyer) is also extant, as is a private collection of loose prints.

On the whole, Bergheim's work is technically inferior to that of his foreign contemporaries. His subject matter is conventional, and nothing points to an "insider's" point of view. There is one possible example of an innovation. A surviving undated albumen print with the signature "P. Bergheim" on the negative portrays a shop near the Church of the Holy Sepulchre in which two figures are sitting. If it can be dated to the early 1860s, this photograph may point to Bergheim as the first to portray everyday life.

A contemporary of Bergheim involved in photography emerged from an indigenous Christian community in Jerusalem, that of the Armenians, centered in the Armenian Convent. In 1860 the Armenians numbered perhaps five or six hundred among the city's population of 19,000. Marginal in size, this community was not connected to the European Christian institutions, but it had a rich pictorial tradition.

By time-hallowed custom, portraits of the Armenian patriarchs of Jerusalem were painted during their tenure in office. However, in 1860 Patriarch Hovhannes died before his portrait could be painted. According to oral tradition, one of the priests, Yessayi Garabedian, asked to halt the funeral service and

take a photograph of the dead patriarch before his body was put in the coffin. The service was, so the story goes, indeed halted, the corpse seated on a chair, and his picture taken. The portrait of Hovhannes now on view at the patriarchate was painted from Yessayi's photograph.

No written account of the event exists, and this legend can be substantiated today only by a photograph found in the Armenian Convent. It shows an old Armenian dignitary, sitting in a quite unnatural manner on a chair, perhaps sleeping, perhaps dead. The figure is very faded and has been cut away from its background.[13] At the very least, the story indicates that the priest Yessayi was taking photographs at that time, that he is remembered as a central figure of early Armenian Convent photography, and that photography itself is believed to have been held in high enough esteem to bring a funeral ceremony to a halt. A glass negative taken at the convent's photographic studio at the turn of the century depicts a scene almost identical to the legend. It shows a funeral crowd at the entrance to the Armenian compound, exhibiting the dead body of a dignitary on a stretcher before a photographer. If it does not confirm the early date of the legend, at least it indicates the existence of the custom.

It is not surprising that the Armenians were among the first to produce a photographer or that they figured prominently among the earliest local practitioners of photography in Jerusalem. Indeed, Armenian names were common among nineteenth-century photographers all over the Near East. A present-day Armenian photographer, Mr. Berberian of Amman, Jordan, believes that Armenians were attracted to photography for three reasons: first, they could acquire technical training in Turkey; second, they were Christians having "no worries about pictures"; and third, as a persecuted people, they valued "skills [that] cannot be robbed."[14]

Perhaps of greater significance was the Armenian culture, which encouraged pictorial expression and flourished in Jerusalem. The Armenian cathedral of St. James, traditionally one of the five principal sites of Christian pilgrimage in the Holy City, was one of the largest and most elegant churches in Jerusalem in the nineteenth century. The convent's manuscript library has the largest collection of ancient Armenian manuscripts in the world outside Soviet Armenia, some 4,000 in number. Decorations inside the cathedral and other buildings in the compound are ample testimony of the richness of the Armenian artistic tradition. The nineteenth-century marriage register of this community lists the occupation of seven bridegrooms as *badgerahan*, "makers of pictures," which included painters and possibly photographers.[15] Other members of the community were in urban professions and crafts, including the operation of the city's first printing press.

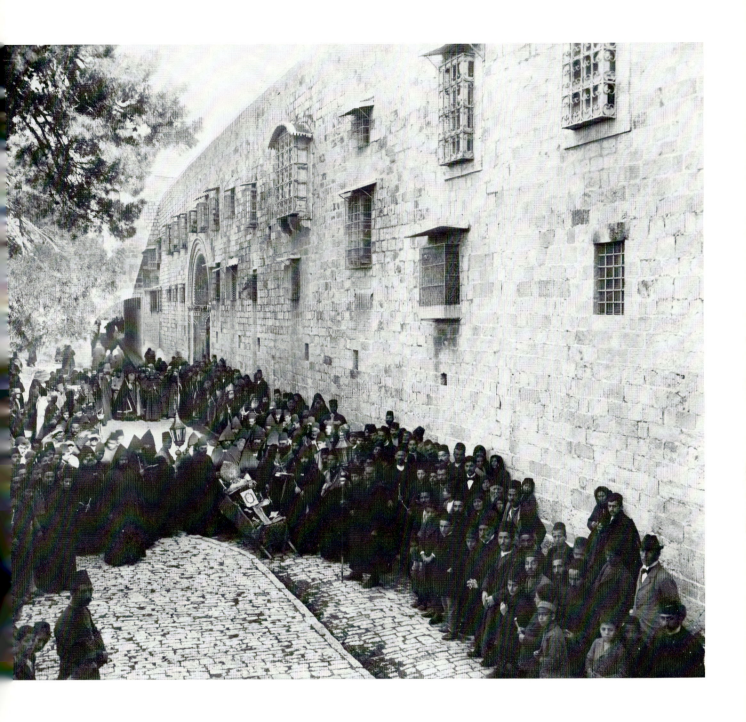

Photographer unknown (1910), dry-gelatin glass negative, modern print. Burial ceremony of Patriarch Haroutioun Vehabedian. (Armenian Patriarchy, Jerusalem)

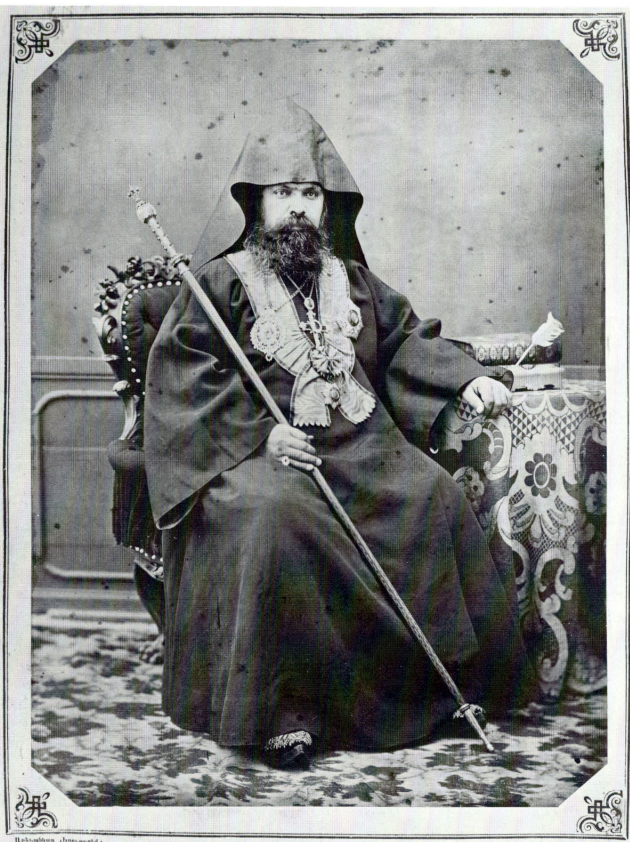

Արուեստաւոր յերուսաղեմ.

Ի ձեռս Մ. Յակոբելեանց.

Տ. ՆԵՐՍԷՍ Ա. ՊԱՏՐԻԱՐՔ Ս. ԵՐՈՒՍԱՂԵՄԻ

The beginnings of photography in the Armenian community are linked to Yessayi Garabedian. According to Kevork Hintlian, author of the *History of the Armenians in the Holy Land*,

Yessayi Garabedian [was] born in 1825 at Talas, Kayseria (Turkey), [and] spent his youth in Istanbul. He arrived in 1844 in Jerusalem, became a student at the seminary, and stayed in Jerusalem until 1859, during which time he engaged in photography. In 1859 he left for four months for Istanbul where he improved his techniques of photography. He was patronized by wealthy Armenians. He was back in Jerusalem the same year. In 1863 he left for Europe, visited Manchester, London and Paris, in each place picking up something new for his passion—photography.[16]

Yessayi's signature appears on three photographs found at the convent dated 1860 and 1861. These depict the façade of the convent itself with some figures on the balconies and roofs, the Church of the Holy Sepulchre, and the Fountain of the Virgin Mary in the Valley of Jehoshaphat. Assuming that these dates are authentic, we can imagine Yessayi standing on the roof of one of the Armenian buildings with de Clercq in December 1859, when the latter photographed the synagogue, the citadel, and the Protestant church from this direction.

When Yessayi Garabedian became patriarch in 1865, he energetically encouraged printing, arts and crafts, and modern technology, as well as photography. (Among other things he set up a small galvanizing plant.) Baedecker's 1876 guide to Palestine, which mentions Bergheim's enterprise as a "shop" located in the Christian quarter of Jerusalem, lists the photographic studio at the Armenian Convent as the "only one in town."[17] Melchior de Vogüé, the renowned Holy Land explorer who was involved in publishing Vignes's photographs, described Yessayi in a book published the same year: "The [Armenian] Patriarch of Jerusalem is a young, intelligent man of giant stature and noble physique . . . it is hard to believe he was a student of Law in Paris, where he learned photography at which he is successful."[18] Jules Hoche, another French traveler, wrote in 1884 that "in his studio in an attic at the Patriarchate, Yessayi initiated into photography a number of young local Armenians and some others from various provinces of the Ottoman Empire."[19]

Yessayi's diary, preserved in the convent's manuscript library, contains some handwritten, detailed references to his early photographic work. In it he refers to contacts in 1863 with the Austrian consul and their discussion of the collodion process. Correspondence with a certain T. Abdullahian of Constantinople on similar subjects is also alluded to, and an 1873 entry refers to stereoscopes, enlargement, gilding of photographs, and other photographic processes.[20]

ɔuted to Garabed Krikorian (ca. 1865), albumen print. "Yessayi Garabedian as Patriarch."
ɔunder of photography at the Armenian Convent. (Armenian Patriarchy, Jerusalem)

During Yessayi's tenure as patriarch (1865–85), photography continued to flourish at the convent. Many photographs taken by him and his assistants, Father Yezekiel Kevork and Deacon Garabed Krikorian, were of the *carte-de-visite* type. These miniature portraits of individuals facing the photographer or looking upward in three-quarter profile, standing or seated in conventional poses before a curtain backdrop, were the brainchild of Parisian photographer A. A. Disdéri and were introduced in the late 1850s. A specially designed professional studio camera was needed for these, and it is unlikely that Yessayi learned the technique from the Austrian consul or photographers who visited Jerusalem. The traveling photographers had no use for it in their landscape work. Yessayi probably acquired this skill during his trip to Europe in 1863. Both the quality and the format of the Armenian Convent photographic studio resembled typical European studio work. Nothing in the settings or poses in these photographs suggested the region in which they were taken or were different in any way from European productions. Yessayi and his staff assimilated photography as a Western custom and genre, as a part of the modern world. It was a source of income, a trade, a service offered to a clientele of Armenian pilgrims. No specifically local modes of representation of the country and of its population were created here.

The portraits show rather well-dressed pilgrims visiting the St. James Cathedral: merchants, ecclesiastics, and Ottoman officers, mostly male, often distinguishable only by headgear from any other middle-class European pilgrim group. Handwritten greetings in the white space around the edges indicate that some of the photographs were meant to be gifts to relatives and friends. Some were inscribed to local religious dignitaries and some to the photographers themselves. The dates were recorded in Armenian calligraphy.

Apparently it was customary for the client to dedicate a photograph to the photographer and distribute others among friends and dignitaries as a memento of the pilgrimage. (There was also a photograph of Yessayi dedicated to him as "a gift from Garabed the photographer, on January 27, 1866.") All the photographs now extant from the 1860s and 1870s made at the compound were *carte-de-visite* pictures or *cabinet* portraits about the size of today's postcards. Among them was found an ambrotype photograph of an Armenian pilgrim and a dry-collodion glass negative of a religious dignitary, both undated. No landscape photographs other than those taken by Yessayi in the early 1860s have been found. Stereoscopic photographs of Jerusalem landscapes and sites were also produced by the studio, but the photographer and the dates are unknown.

Photographer unknown (ca. 1865), dry-collodion negative, modern print (contact). Arm Convent, religious dignitary. (Armenian Patriarchy, Jerusalem)

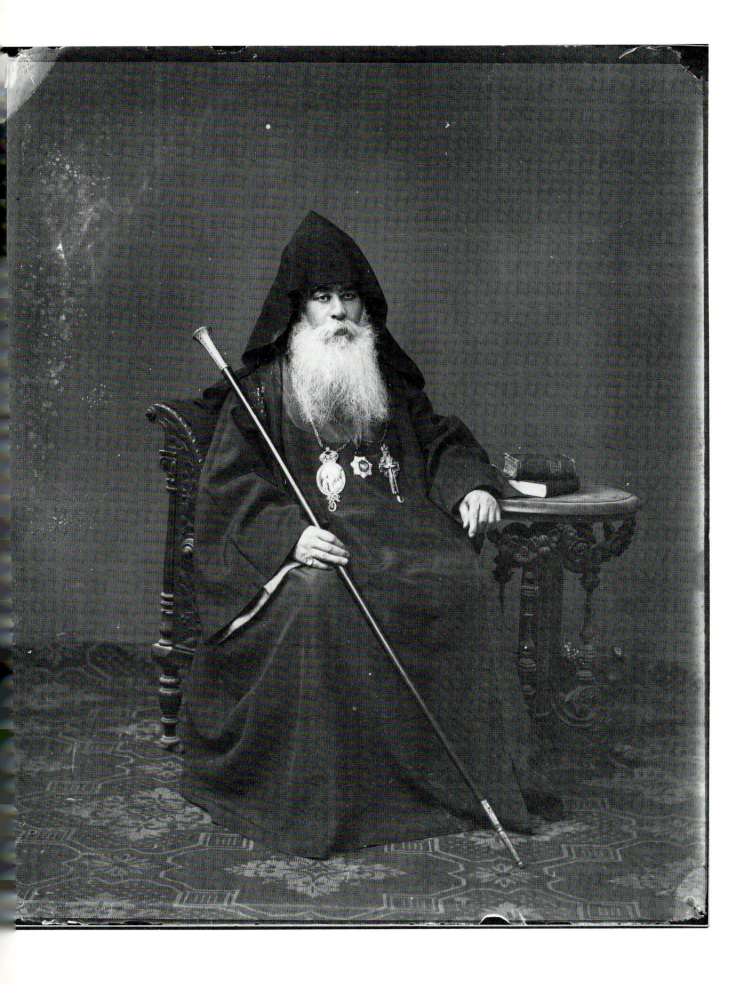

Unknown photographer at the Armenian Convent (prior to 1884). Young Garabed Krikorian. (A. Aboushar, Jerusalem)

Two of Yessayi's pupils, Garabed Krikorian and Kevork, continued his work in the Armenian compound. Each had a different printed insignia on the reverse side of his photographs. Krikorian used the French title "Photographie du Convent Armenien," while Kevork's pictures bore the Armenian inscription "Sun Pictures, Kevork, Jerusalem, Armenian Convent." It is not clear whether Krikorian continued to operate the photographic studio of the Armenian Convent while Kevork ran his own enterprise elsewhere in the compound. Their photographs were of similar quality, but Krikorian's pictures were mounted on much more expensive cardboard, and the printing of his insignia was superior to that of Kevork.

An orphan from Constantinople, Garabed Krikorian came to Jerusalem in his early teens. A *carte-*

RIGHT: *Garabed Krikorian (prior to 1914), cabinet portrait. The photographer's niece friend from Germany in local dresses kept at the studio for customers. (Armenian Patria Jerusalem)*

FAR RIGHT: *Unknown photographer at the Armenian Convent (prior to 1914), dry-gelatin negative, modern print. Unknown female tourist in male Bedouin dress with accessories. Aboushar, Jerusalem)*

de-visite photograph taken at the convent shows him as a young priest. He later became Yessayi's assistant and disciple, but in 1885 he decided to marry. Krikorian left both the convent and the priesthood, converting to Protestantism, and opened his own photographic studio outside the walls of the Old City near the Jaffa Gate. He continued to specialize in individual and group portraits, and in 1898, during the visit of the German Kaiser Wilhelm II, he took outdoor photographs of the event, crediting himself as "the Prussian Emperor's Court Photographer." He also produced landscape photographs, and with Mitry, his partner at the time,[21] he began selling supplies to amateurs. Krikorian specialized in studio portraits: his shop was equipped with characteristic backdrops and costumes for the clientele, which was mainly tourists and pilgrims but also included a few local people. The customer composed a fancy costume for the portrait without undue concern about its authenticity, often combining clothes and accessories of several different ethnic groups or local traditions.[22]

Krikorian's studio became the training ground for many budding photographers, and his willingness to associate with non-Armenians, though atypical at the time, is not surprising for a man who had

already left the confines of the priesthood and the Armenian compound. It was he who provided the link with the beginnings of photography in the Christian, Arab, and Jewish communities. Those who worked and later competed with him included Chalil Raad, Dawid Sabounji of Jaffa, Savvides of the Greek Orthodox community, and, after 1900, Yaacov Ben Dov, one of Jerusalem's early Jewish photographers.

Two other Armenians were engaged in photography during this period: Mardikian in Jerusalem and Hallaidjan in Haifa. Very few samples of their work, which resembled the portrait and tourist work of Krikorian, have as yet been found.[23] A. Guiragossian, who worked at the famous Bonfils studios in Beirut, came from Palestine; it is possible that he was trained by Krikorian.[24]

The Armenian Convent's main clientele consisted of Armenian pilgrims from all over the Ottoman Empire. These pilgrimages were tragically terminated during World War I, when the Armenians were victims of the first genocide of the twentieth century, and no important photography was done in the convent studio after that.

ISLAM, JUDAISM, AND LOCAL PHOTOGRAPHERS

Information on local photographers in Jerusalem is found in a census of shops in the Jerusalem market taken in 1867 by Charles Warren, head of the Palestine Exploration Fund party.[25] He lists four photographers—three Greeks and one Protestant. The one Protestant may have been Peter Bergheim, with whom Warren was personally acquainted and whom he would not have omitted. He listed no Armenians, apparently because their studio was at the convent rather than in the markets.

Who the Greeks were remains enigmatic. To be sure, they were Greek Orthodox, either local Arabs or immigrants. (Was Deniss one of them, and was Turner's description of him as "Russian" and "Protestant" inaccurate? The Greek community's European "protector" was the czar's Russia.) No traces of their work survive. Perhaps they were merely sellers of photographs. The first locally printed book to include a reproduction of a photograph was published by the press of the Greek Orthodox community in 1876.[26] The first known Greek photographer was Savvides, who opened his studio only at the turn of the century.

Warren lists no Jews or Moslems. His table has been quoted by both Israeli historian-geographer Yehoshua Ben-Arieh and Arab historian Aref-el-Aref, present-day authorities on nineteenth-century Jerusalem.[27] Since Aref-el-Aref had a thorough knowledge of the Arab community, a Moslem active in the profession would not have escaped his attention. The same applies to Ben-Arieh and the Jewish

professionals. We can therefore conclude that photography did not exist as a profession among Moslems and Jews during that period. The first local Jewish photographer appeared in the last decade of the century. Of the Arab local photographers who emerged in that decade, there were probably none of Moslem faith.

The lack of broader local photographic activity can be attributed partly to anti-iconic traditions stemming from religious prohibitions. Scholars of Islam trace their tradition, like the similar early Christian one, to Judaism.

According to the Islamic holy scripture, the Qur'an (Sura 59, v. 24), Allah alone

. . . is the God, the Creator
The Evolver
The Bestower of Forms
(Or Colors . . .).

The making of images, therefore, may be considered tantamount to idolatry. In the prophet Muhammad's war against idolatry in Mecca, the holiest Moslem city, he had cursed the painter and drawer of men and animals, and consequently they were held unlawful.[28] Prohibitions against image making were not, however, strictly followed. While abstract forms of the highest level were achieved in Islamic art, figures of animals and humans were not totally absent. For example, seventh- and eighth-century Moslem buildings in Jordan (eastern Palestine) displayed figures, and illuminated manuscripts produced over the centuries included many drawings of human figures.[29]

Traditions and laws as explained to me by authorities in Jerusalem—among them Sir Sa'ad Ed-din El-Alami, mufti of Jerusalem, the highest religious authority and head of the Shariac court—do not seem to have been the main influence. Basing his opinion on a theological text he remembers from the early 1920s, El-Alami believes that the religious authorities saw no justification for continuing to forbid the figurative arts. Idolatry was an outdated rival; nobody prayed to pictures, and there was no point in prohibiting photography. If Moslems of the late nineteenth century resented being photographed and did not take pictures themselves, it was rooted more in popular tradition, habit, and distrust of strangers than in religious conviction. The general population was not aware of the religious texts, and traditional reluctance, if any, had in his opinion been dwindling for a long time. Individual and family portraits, as well as photographs of landscapes or property, were simply of no interest to the Arab population.[30]

Texts published in Egypt between 1908 and the 1930s support El-Alami's view of the gradual disappearance of the traditional prohibition, although they place this development into the twentieth century. In a text published in 1908, photography was still outlawed, as can be seen in the following quotation, which uses the traditional question-and-answer form of Moslem religious rhetoric:

Question [by photographer] . . . Is the difference real or not between a picture made by hand and a picture made by a camera? And what is your opinion of one who claims that the picture made by a camera does not create [human] form, but rather only preserves form, like the preservation of form in a mirror, and thus it is not forbidden. But it is forbidden to put this picture in one's home due to the resemblance between it and idols. Is this statement correct or not?

Answer: The maker of pictures is a photographer if he made the picture by hand or by camera. The picture of a given thing is the same picture if produced by hand or by instrument. It is the same both according to law and to social custom. The statement claiming that it is forbidden to put pictures in one's home due to their similarity to idols is based on a valid principle, which states that the reason for prohibiting painting and photography is to prohibit those pagan ceremonies or the cherishing and worshipping of pictures.[31]

Later texts openly permitted two-dimensional photographs, applying the prohibition only to "images casting shadows," that is, three-dimensional sculpture.[32] Moreover, as El-Alami suggests, the largely illiterate Moslem population of Palestine and most of the local Moslem clergy were unaware of the theological texts and interpretations.

The absence of landscape and architectural photographs collected or produced by Moslems in nineteenth-century Palestine seems to point to a general lack of interest in photography. Moslem architecture and nonfigurative decorations are among the most beautiful and rich ever produced, yet no Moslems in Palestine saw fit to take pictures of them, despite their popularity in the local market.

Photography was not unknown to the Moslems in the nineteenth-century Ottoman Empire. Even the sultans in Constantinople employed court photographers, as is attested to by recently uncovered Turkish records.[33] These photographers, the Abdullah brothers, were Armenians.[34] Significantly, they converted to Islam after having received the appointment. The timing of their conversion indicates that the sultans—not only heads of state but also heads of the religion—and their religious advisers saw nothing wrong in a Moslem taking photographs. If the Ottoman court had wanted to employ Christian photographers to prevent a Moslem from transgressing religious law, the Armenian photographers would probably have chosen to remain Christian precisely in order to maintain their position. Their conversion is unequivocal evidence of the absence of prohibition even by high Moslem authorities.[35]

In Constantinople, the capital of the Ottoman Empire, enough upper-class customers existed for photographers to earn their living. In this context, the lack of development of local photography would have clearly pointed to religious restrictions as the single decisive factor. This situation is quite different from that of nineteenth-century Palestine, where religious prohibitions were not an isolated variable but were interwoven with economic, social, and cultural constraints.

If nothing expressly prohibited the making of images of any kind in the Holy Land, apparently nothing motivated or promoted it either. No cultural, social, or economic tradition prepared local Arab society for the advent of photography. There was no practice of portrayal or figurative printing for religious or social usage. To this day places of worship do not display figures depicting the basic story of Islam or any portraits of its main protagonists, in total contrast to Christian liturgic art. Portraits for secular use generally belong to an indoor social life, whereas most secular centers of social life and communication in the Holy Land were, to use a Western term, outdoors—Bedouin sheikhs' tents or village fountains. Moreover, the notion that portraits or other photographs could add to one's worth or prestige was unknown. Prestigious familial and social links were appreciated and conserved in oral tradition. Family links were immediate, and there was no need for visual records. Literacy was extremely limited, and Moslem society strongly resisted modernization. There were no Arabic-language publications in Palestine that might offer an outlet for photographers' work. Secular education was nonexistent, and in the 1870s there were only seven small religious schools, *kutabs*. The *rushidia* schools, which eventually led to secular education, were not started until 1891.

Lacking a tradition of portrait making, lacking a need for private or public pictorial documentation, and with no knowledge or experience in figurative arts and crafts, Moslem society in Palestine did not seek access to photography, either culturally or socially.

The absence of cultural predispositions was matched by economic and technological conditions in the area. Surplus income was limited to a few families, so that no market for photographs could develop. No modern industry or agricultural methods provided broader familiarity with chemicals and optical apparatus.

Probably a few members of the upper class were introduced to and practiced photography before the end of the century. Many of the rich Palestinian landowners lived in Damascus, the area's capital and metropolis, and may have become familiar with photography there. Evidence of a photograph by a Moslem amateur earlier than 1895 is to be found in a Jerusalem photographer's report of having seen photo-

graphs of Petra made "by the son of the Waly of Damascus."[36] There is no evidence of photographs taken by Jerusalem Moslems at that time.

There are two points of similarity between the Moslem and Jewish populations of Palestine regarding the development of local photography. First, the economic conditions in Jewish society were not favorable for the development of a domestic market. No photographer could make his living by selling photographs to the Jews, who were exceedingly poor. The Jerusalem Jews, though the largest community in the city, did not have their own photographers until the last decade of the century.

Second, the Jewish religion includes anti-iconic elements. The attitude formulated in the Second Commandment, "Thou shall not make unto thee any graven image, or any likeness of any thing . . ." was fundamental in the early struggle of the ancient Israelite culture against paganism and idolatry. However, Jewish authorities throughout the ages, including Maimonides, the most renowned of commentators, have permitted two-dimensional images. Religious texts were often illuminated; for example, popular Passover Haggadahs have for centuries depicted human figures.

In rabbinical literature, photography is mentioned only once, in a 1901 Lithuanian publication. The author, Rabbi Malkiel Zvi Halevy, limited its use to strictly practical purposes, and restricted it to only a portion of the person. One was "not to show the feet of an individual or a person sitting behind a table and the like."[37] The human image should not be a source of admiration and joy, he said, and it should be removed as far as possible from the complete, forbidden three-dimensional image. Hence a photograph of a bust or the face of a person was acceptable, even authorized when needed. A later text written by a highly respected authority, Rabbi Abraham Isaac Hacohen Kook, opposed only complete sculptures.[38] Rabbi Kook, who was to become the chief rabbi of the Holy Land in 1921, wrote in 1906 to the board of directors of the newly founded Jerusalem art academy, Bezalel, that sculpture of the complete human body was the only kind of art the Jewish cultural heritage prohibited, and suggested that this be excluded from the academic program. In 1927 he specifically permitted photography but, like Malkiel Halevy though differently motivated, he recommended photographing only the upper part of the body, which embodied "the highest glorification of the spiritual character of man." Rabbi Ovadia Yosef, former Sephardic chief rabbi of Israel and a most erudite authority, recently stated that photography does not contravene the Second Commandment. In a comprehensive review of rabbinical literature citing all relevant authors on the subject from the Middle Ages up to today, he mentions only one who opposed photography.[39]

By curious coincidence, a story about a Hungarian rabbi is very similar to the story of the Armenian patriarch in Jerusalem, and is dated only six years later:

The great admiration which Hungarian Jewry felt for the blessed personality of Rabbi Judah Aszod found expression on the day in which he was called to the Academy on High, the 23rd day of Sivan, 1866. Within several hours, twenty-two outstanding rabbis gathered to mourn him. For he had been a pillar of strength for Jews and Judaism. On that day, the question of preserving the picture of this saintly man for future generations was placed well before the scholars who came to his funeral. Rabbi Aszod's well-known objection of having his photograph taken during his lifetime presented a difficulty. But there was nothing his disciples and admirers wanted more than to possess his image. After lengthy discussion, having given consideration to every facet of this problem, the rabbis decided to permit it. The body of Rabbi Aszod was dressed in Sabbath clothes, seated on a chair, and his photograph taken for reproduction. Bought by Jews throughout Hungary, some twelve hundred florins were realized, sufficient to provide for adequate nuptials of his younger daughter.[40]

What this story, in comparison to Yessayi's, fails to mention, however, is the photographer. No reference is made to his religious origin, an important issue in our context. Still, the account, even if it refers to European Jewry, shows that religious Jews did not consider photography sacrilegious. The Jewish attitude in Jerusalem, Hebron, Tiberias, and Safed may not have been very different. Photographs of rabbis from Jerusalem and other Palestinian towns dating back to the 1870s and 1880s are known. Names of the photographers cannot be traced, but the garb of the subjects confirms that at least some of the pictures were taken in Jerusalem.

Generally there was no opposition to Christians taking portraits of Jews. On the contrary, if a Jew had to have his photograph taken, he was expected to let a non-Jewish photographer depict him. Most Jews of Palestine did not encourage their sons to enter the field just as they did not encourage them to get a secular education and enter the modern professions. If there was opposition, it was motivated not only by religious tradition but also by opposition to change in the prevailing socioeconomic structure and the cultural expression of that change.

The advent of professional Jewish photographers in Jerusalem and the smaller towns of the Holy Land occurred late and on a limited scale not only for reasons of religious prohibitions related to images. Jewish tradition neither opposed nor promoted the figurative arts. Palestinian Jewish craftsmen and draftsmen of the nineteenth century illustrated private and religious documents and even produced pictures of the human image. But synagogues were not decorated as churches were, and the figurative arts lacked prestige. Moreover and foremost, the "Old Settlement," the indigenous Jewish population of the

country, was extremely poor. Jewish communities in Jerusalem, Safed, Tiberias, and Hebron were supported by a collection-and-distribution system called the *Haloukah*. Some Jews were, of course, professionals and artisans; Warren's survey of 1867 cites 503 in the market shops, among them carpenters, smiths, and shoemakers. Some craftsmen also had contacts with Europe. Stonecutter Mordekhai Schnitzer exhibited his products at the Great Exhibition in London in 1851 and carpenter Haim Yaacov received a medal for his olive-wood work at the 1867 World Exhibition in Paris.[41] The main source of income, however, remained the *Haloukah*, collected abroad among Jewish communities whose members saw the dwellers in the Holy Land as their spiritual emissaries. The Jews so supported devoted their lives to Jewish scholarship and religious practice; this was the raison d'être of their presence in the Holy Land.

Social, cultural, and religious traditions were powerful and interwoven, and innovations of various types, including the profession of photography, threatened to subvert the structure of the community. In 1856 the first secular school for boys in Jerusalem was opened by Austrian Jews against strong resistance from local orthodox circles. In 1860 the first school for girls was opened at the initiative of a member of the Rothschild family, again accompanied by cries of protest. New construction outside the city walls was regarded with equal suspicion. In 1860, facing the city walls not far from the Jaffa Gate, the hospice Mishkenot Sha'ananim, with a windmill built to help introduce economic innovations, was inaugurated by Moses Montefiore against similar opposition. In the economic and sociocultural context of Jewish Palestine prior to indigenous modernization and Zionism, the lack of a market for photography as well as opposition to secular education and industrial development can be considered at least as influential in the late adoption of photography as a profession as the direct effect of explicit religious prohibitions.

Nevertheless, changes beginning in the 1860s laid the ground for the emergence of local Jewish photographers in the 1890s. In 1867, 1869, and 1874 new quarters were established outside the city walls through local initiative. In 1878, a group of Safed Jews founded the first agricultural settlement, Rosh Pina, in the Galilee, and Jerusalem Jews founded Petach Tikva, near Jaffa. The structure of the Old Settlement began to change, and at least one of the photographers active in the 1900s emerged from it.

In conclusion, the history of nineteenth-century photography in the Holy Land (and perhaps the entire Third World) can be subdivided into three stages: first, the penetration of the country by foreign traveling photographers; second, the introduction of photography as a local practice by foreign residents uninvolved in the indigenous society; third, its development into a local profession by foreign-born im-

migrants producing for the tourist market. Not only did local photography emerge late, but its earliest practitioners—Deniss, Bergheim, Yessayi, and later Krikorian and his apprentices—were born outside the country and, as Christians, were not in the mainstream of society. As immigrants lacking roots in the local economy, they were more likely to adopt a new imported profession that was free of indigenous competition.

Early local photographic work in the Holy Land (and perhaps in other countries of similar socioeconomic structure) was not an authentic expression of indigenous cultural and artistic influences. The first local photographers did not bring fresh insights and perceptions unaffected by Western photographic conventions. Photography was not only an imported technology; it was practiced by people who were only partly closer to the local culture and society than their traveling predecessors.

Early Portrayal
of Local Inhabitants:
The View from Outside, 1867–

6

Work produced during the first quarter century of Holy Land photography shows the country as down-trodden and uninhabited. No human figures enliven the fields and streets; no portraits break the stream of landscape and architectural views that fill the well-known albums of Du Camp, Salzmann, Frith, and Bedford. These works, as well as those of the lesser-known Bridges, Robertson and Beato, and de Clercq, limited themselves to the evocation of the past through historical edifices, hills, and valleys. Only exceptional pictures included people, seen from a distance. It is during the second quarter century of photography that the human image of the country emerged, an image that was partially distorted.

Several factors may have been responsible for the absence of portraits in the earlier period and the tendency toward unrealistic representations in the second. First, traveling photographers perceived their work as photographing landscapes. Second, local inhabitants may have been opposed to having their photographs taken (see chap. 7). Third, there was a relative lack of interest on the part of publishers, sponsors, and buyers in the country's inhabitants. The commercial constraint is described by Scottish photographer John Cramb, who visited Bethlehem in 1860 and shared Frith's enthusiasm for its women (perhaps a predisposition common to Christian travelers, who may have associated the women of Beth-lehem and Nazareth with the Madonna):

Sincerely did I regret the arrangement that denies me the pleasure of bringing home witnesses to the correctness of my judgment on this point. But I was not expected to spend my time on such subjects, though I now think it a pity that I was so scrupulous in the discharge of my duty.[1]

It seems as if early photographers thought their buyers would resent having albums of beautiful and impressive historic sites "marred" by the inclusion of Turkish soldiers, "picturesque" Arabs, and wretched-

looking Hassidic Jews. That the most beautiful buildings on the Temple Mount represented postbiblical Moslem architecture and that the authenticity of the Church of the Holy Sepulchre was doubted by many apparently did not detract from the biblical and holy status ascribed to them. Ancient edifices spoke of ancient glory; contemporary portraits could not but destroy this discourse. Had nineteenth-century inhabitants been prominent in photographs of biblical landmarks, the connotation would move from the past to the present. One also wonders if the Western perception of the Orient as a land to be conquered was at play as well.

There is also more pertinent, though indirect, evidence to show the power of the commercial factor. The earliest portraits of local inhabitants were taken by a photographer who worked outside the commercial circuit: he was a member of an exploration party. Moreover, when commercial photographers began to depict local people, they found it necessary or advantageous to make them appealing to Western tastes. Consequently, the representation of local life was distorted in various ways to suit European Christian attitudes.

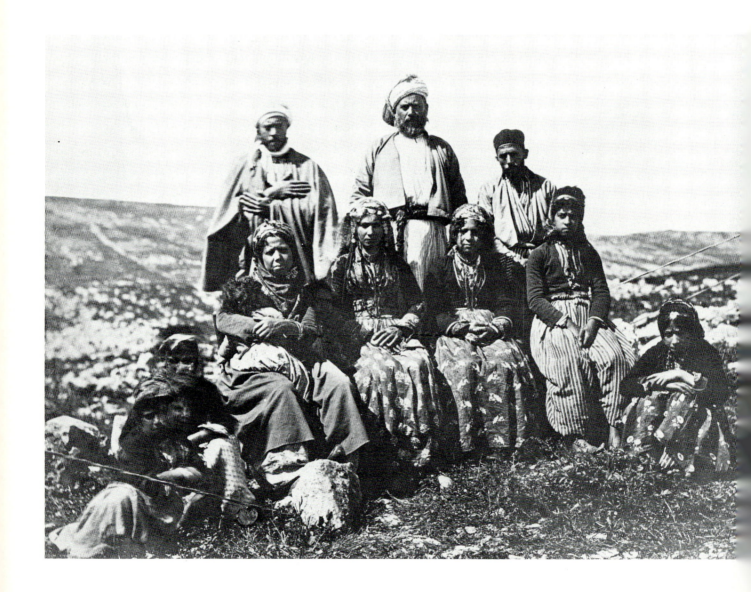

It was nearly three decades after the invention of photography before the first portraits from the Holy Land reached Europe. The first photographer to produce a series of such pictures was Sergeant Phillips of the Palestine Exploration Fund expedition in 1867. For the first time portraits showed people and their costumes and hinted at their way of life. Entitled "Manners and Customs",[2] Phillips's series included twenty-seven photographs, most of which were of Samaritans in groups and at prayer or of Armenian priests; there were also a few portraits of "Polish" Jews, Russian pilgrims, Arabs in Jerusalem, and Ta'amira Bedouins. There was one picture of Lieutenant Warren with the leader of the Samaritan community. There were also pictures of a village, irrigation equipment, women grinding corn, a threshing floor, and another Bedouin camp. This work was a remarkable achievement, the first of its kind, and yet the pictures did not represent the majority of the local population. As a survey, Phillips's work was limited in scope, being more an inventory of ethnic groups than of "manners and customs." Furthermore, it was biased toward minorities. A full third of the pictures portrayed two of the smallest communities in the Holy Land, the Samaritans of Nablus and the Armenians of Jerusalem.

The Samaritans of Nablus, an old indigenous community of perhaps 150 members, were an age-old sect that obeyed the Pentateuch but rejected the later Scriptures. Bedford and many others photographed their Bible, an ancient scroll. Their Passover ritual, on nearby Mount Gerizim, later became a favorite subject. The Samaritans were literate and worked as clerks and scribes. Their culture and status explain why traveling photographers found them both interesting and accessible. Isolated among Moslems, the Samaritans of Nablus welcomed contacts with foreigners who were interested in their faith and were far more open to them than the other townspeople. Their orientation to the earliest biblical sources, which, of course, includes the Second Commandment, did not deter them from posing for photographers.

The Armenian quarter in Jerusalem, a tiny enclave of some 500–600 Christians, was situated halfway between the Jaffa Gate, the main entrance to Jerusalem, and the Temple Mount, the main subject of the P.E.F. excavations to which Phillips was assigned. The Armenians were therefore easily accessible to Phillips, the more so because of their own involvement in photography. The Armenian priests must have welcomed Phillips, who took their portraits indoors in seated poses. Phillips arranged them and the Samaritans as an individual or a group in Europe might pose. The photographs of Armenians and Samaritans show no ethnographic element other than Armenian priestly robes and the Samaritan dress.

The extensive coverage of these small communities is in sharp contrast to the few pictures taken of the overwhelming majority of the population. Phillips's six photographs of Arabs do not depict a system-

...illips (1867), albumen print. "A group of Samaritans." (Jewish National and University ...y, Jerusalem)

atic cross-section of that society's "manners and customs." Though they constitute a beginning, they were in no sense a representative sample. His portraits include an "Arab Kawass" (a uniformed clerk of a European consulate), a picturesque "Bedouin Horseman," and the "Ta'amira Bedouin." The territory of the Ta'amira included the routes most frequented by travelers, that is, Jerusalem-Jericho-Ein Geddi-Bethlehem. The tribe was partly urbanized, often dressed like townsfolk, and worked in the tourist trade.[3] Half of Phillips's Arab subjects hence belonged to those segments of the population that were the most acculturated to photography because they were most exposed to Western "manners and customs." The more accessible these subjects were, the less typical they were of peasants in the hill country and the majority of the Moslem townspeople.

The caption of one of the more characteristic Phillips photographs of Arabs, "Two Women Grinding Corn," listed in a P.E.F. catalogue, was followed in small letters by a biblical reference: "Illustrating the prophecy: 'Two women shall be grinding at the mill; the one shall be taken, the other left.' The corn is still ground in the manner shown, as in former days."[4] This photograph was not included in the published portfolios. If the text was written by Phillips or his superiors in 1867, it has to be considered a precedent, an interpretation that became current in the photography of later decades.

Only two portraits are of Jews, the same seven models appearing in each with different coats and positioned differently. As with his other portraits, Phillips arranged his sitters as a family photographer would have. His apparent intent was to show the two types of coats in use among Jerusalem Jews. A numbered hanger on the wall in the background suggests that the photograph was taken outside their own environment, most likely in a European institution—perhaps the P.E.F. exploration party's lodgings or the headquarters of the Anglican Mission, the L.J.S. The Jews may have been suppliers to the expedition, patients at the L.J.S. hospital, or at least people acquainted with the explorers or the missionaries. At any rate, the double use of the same subjects and setting points to the limited availability of models.

In Jerusalem, the largest town in the Holy Land, the majority of the population was Jewish, about 11,000 out of 19,000 in 1860. To make wider Jewish contacts, as well as wider Moslem and Christian ones—about 4,000 Jerusalemites were non-Armenian Christians—Phillips would have needed more time and perhaps more interest than he had. It was not by design or accident that most of his subjects were ethnically and socially marginal groups. The common denominator was access and availability for interaction rather than representativeness. This series was not yet a systematically conceived work.

Still, Phillips's portraits were innovative. Up to the time of Good and Bonfils, Victorian commercial

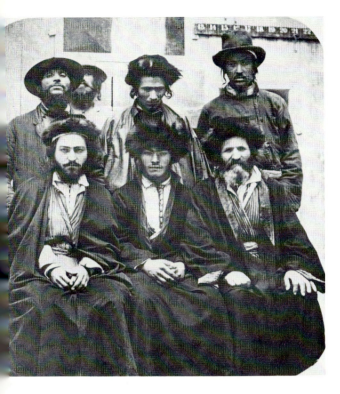

H. Phillips (1867), albumen prints. "Polish Jews, Group of (Jerusalem)." Nos. 245 and 246 in the Palestine Exploration Fund catalogue. (Jewish National and University Library, Jerusalem)

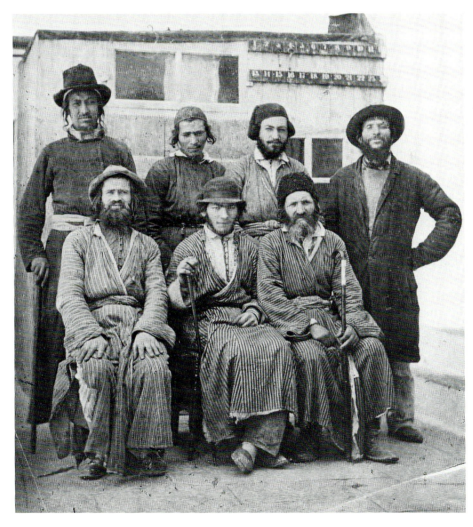

photographers apparently viewed their equipment, their profession, their publishers' needs, and the public taste only in terms of landscape photography. Phillips, liberated from the constraints of the market, could probably "waste" his time and materials on subjects that commercial photographers considered nonrewarding. The very fact that the Palestine Exploration Fund had designated "manners and customs" as an area for a future survey may have given him both the idea and the courage to make a modest start in this direction, even if his immediate superiors had not requested such pictures at the time.

In *Underground Jerusalem*, Phillips's superior, Lieutenant Warren, described the trip on which some of these portraits were possibly made:

March 18, 1867 . . . Corporal Phillips and I went over to Mar Saba to take photographs . . . March 19. Visiting a Ta'amira camp at the foot of the Frank Mountain, near Bethlehem, I went on the top of the mountain with Corporal Phillips and settled about photographs of the Wilderness of Judaea, which turned out most excellent.[5]

Since Warren did not refer to Phillips's photographs of the camp inhabitants, one can only conclude that he and possibly Wilson before him usually came to an agreement with Phillips regarding photographs of landscape and archeology directly relevant to their work and that Phillips took the portraits on his own. Maybe they were simply a working photographer's hobby, done in his spare time out of personal interest. It is also possible that at least some of the pictures were made under the direction of the officer in charge. One photograph, of a group of Samaritans in Nablus, was published in Wilson's and Warren's portfolio, and two other group portraits—one of Jews and one of Samaritans—were used to illustrate Warren's book. This suggests that the new venture had their blessing, and the existence of a portrait including Warren himself certainly indicates his cooperation.

Whatever Phillips's motivation, his primacy in ethnographic photography points first of all to the importance of accessibility to models and locations, of channels open to a photographer operating outside his own culture. Phillips was the most advantaged of his Victorian colleagues in this respect, although even he did not and possibly could not provide a cross-section of the local population and reflect its manners and customs authentically. While his social contact with local people was deeper and of longer duration than that of any of the other landscape photographers, it was still limited.

That Phillips was the first to produce a series of portraits also points to his advantage over commercial photographers. The P.E.F. distribution network provided a noncommercial, highly interested audience for photographs of the population. The buyers were subscribers to the fund, not procurers of impressive albums on the open market: Phillips, or rather the P.E.F., had direct contact with a special audience.

In short, the relationship between the P.E.F. party and specific groups of local inhabitants, on the one hand, and the P.E.F. and its supporters, on the other, was an exception in Palestine and in England. Of all wet-plate photographers, only Phillips had the advantage of both.

The only other wet-plate photographers known to have taken portraits in the Holy Land were Frank Mason Good and Félix Bonfils, commercial photographers and contemporaries of Phillips. Kitchener, the P.E.F. explorer-photographer who succeeded Phillips, did not attempt ethnographic portrayal.

Good and Bonfils were the last traveling commercial photographers to be hindered by the constraints of the wet-plate technique (i.e., long exposure time, cumbersome equipment). They solved the problem of selling portraits on the open market by introducing special genres that became popular in the last decades of the century.

THE TOURIST GUIDE GENRE

The local traveler's guide or "dragoman"; the "kawass," the consulary guardian who accompanied official visitors; and guardians of holy places figured highly on the list of Holy Land portraits. Not only were they most accessible; they were also of colorful appearance. A kawass appears in Phillips's series. Among the work of the commercial photographers, Good's portrait of 1874, captioned "Jacob's Well," was perhaps the first to include a guide. Taken at the well near Nablus, it shows a group of Arabs and Samaritans at the site, revered as the location where Christ spoke with the Samaritan woman. The presence of men near wells, generally the domain of women, is unusual. Since the well was a biblical site on the pilgrim's itinerary, it is most likely that these men were Good's guides and guardians of the site.

A similar photograph was taken at Jacob's well by American writer-photographer E. L. Wilson, who stated: "My old Samaritan guide, Jacob es-Shellaby, sat by the old broken arch which covers the well while the photographs were made."[6]

British photographer Cecil V. Shadbolt took a portrait a few years after Good showing four Arabs posing under an arch. The accompanying text by A. H. Harper explained the picture:

A bodyguard for the journey to Jericho. The two Arabs shown in the engraving are well known. They are sons of the sheykh who lives at Abou Dis—a village on the right hand across the gorge after leaving Bethany. To this skeykh the Turkish government has given the right—for a consideration—to protect travellers in the Jordan Valley. Some years ago this duty was more necessary than now. Times change, and Mr. Shadbolt seems to only have required two, for the other men are his own camp followers. The one seated with the hooked pipe in hand is a well-known dragoman; the other, probably the cook, a most necessary individual in camp life.[7]

The two "protectors" were also depicted in a well-known and often-reproduced Bonfils portrait of three entitled "Sheiks of Abou-Dis." Two studio portraits by Bonfils show a dragoman; in one he sits facing the camera, and in the other he stands with his back to it (this particular "dragoman" happened to be Rolla Floyd, an American from Maine).[8]

Dragomen made easily available subjects. Picturesquely dressed, armed with guns, pistols, and knives, they were presented to the armchair traveler as typical inhabitants of the Holy Land; in studio portraits the outdoor figure associated with the hardships of travel became a mannequin, displaying his dress and weapons. On similar grounds, the consulary guardian, the kawass already depicted by Phillips, became a star of Holy Land photography and also eventually entered the studio. This entrance into the studio was the last step in the process of conventionalizing a nonrepresentative image.

Portraits of beggars and lepers were an extension of the tourist guide genre. The first albums to reproduce such pictures were Lortet's *Syria Today* of 1884 and the Thévoz albums *La Palestine Illustrée* of

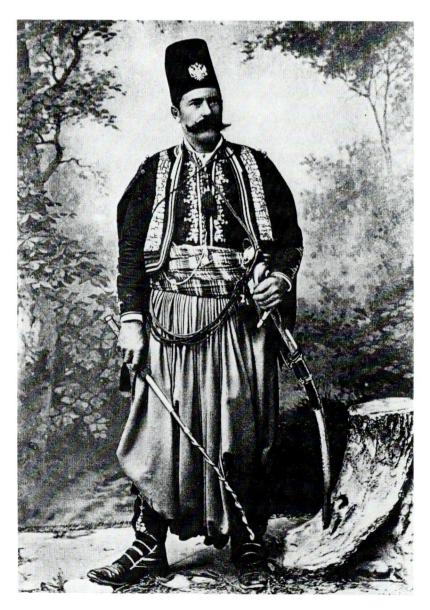

American Colony Jerusalem (prior to 1914), postcard. "Russian kawass." (Private collection)

1889 (see chap. 8).[9] Both beggars and lepers were easily accessible to photographers. Beggars were part of the pilgrim scene, making their living, so to speak, at the entrances of churches and holy places along tourist routes. (Girault de Prangey's attempt in 1844 to portray a beggar comes to mind.) Lepers' quarters were also on the tourist's itinerary. They were readily available models, eager to pose and be paid. According to the Bonfils family oral history, Félix's son Adrien, who had taken some photographs of hired lepers in an attempt to reconstruct biblical events, was threatened by the eldest leper, who said he would "throw himself on Adrien and contaminate him with leprosy" if he did not receive a higher fee.[10] According to the storyteller, "it was only at the point of a revolver that [Adrien] managed to keep them away."

Accessibility, however, was not the only factor to account for the presence of beggars and lepers in photographic collections of the 1880s and later. These subjects are associated with biblical images of the sick and poor, with the "picturesquely primitive Orient," and with Christian compassion and Western

Bonfils Company (prior to 1896), halftone reproduction. "Dragoman." (Sourasky Central Library, Tel Aviv University)

143

paternalism.[11] A universally understandable and graphically strong image, beggars eventually entered Ottoman photographic studios and continued to be photographed both indoors and outdoors after the turn of the century.

THE BIBLICAL ALLEGORY

The genre of portraying outdoor contemporary scenes rich in biblical connotations was introduced by Good. Often the location in which the photograph was taken was related to biblical history. This was true of the picture at Jacob's well (see above) as well as of a photograph of fishermen in "A boat on the lake of Gennesareth, near the supposed site of Bethsaida." The site is connected with the stories of Christ walking on the water and of him feeding the crowds loaves of bread and fishes (Luke 9:12; Mark 6:30; Matt. 14:13). Similar photographs of fishermen at this site appear in late-century albums and books.

Good's fishermen are meant to represent figures of the past and their way of life. In comparison to earlier photographers, who apparently saw local figures as blemishes upon pictures of impressive edifices connoting the past, Good saw the Holy Land through the eyes of biblical figures. Venturing into the timeless countryside, a preferred subject of his landscape work, he was not embarrassed by its present-day inhabitants: he saw both nature and people historically and allegorically, related directly to the Bible. The biblical allegory transformed the portrayed inhabitants into representatives of the past. Theological and literary precedents to this approach were numerous, but Good was the first to use it in photography.[12] Good might also have realized that his predecessors had saturated the market with conventional views and had the wisdom to offer subjects which earlier had seemed marginal or less attractive. Allusions to biblical figures represented by present-day inhabitants did no harm to sales. Later photographic portrayal of local people expanded upon Good's modest start.

The Bonfils establishment, which had become the major supplier of studio and outdoor portraits of individuals and groups, photographed only two biblical allegories. One was of Lazarus's tomb, traditionally linked to the story of Christ in Bethany, near Jerusalem. According to the Gospel, "On his arrival, Jesus found that Lazarus had already been four days in the tomb. . . . Then he raised his voice in a great cry: 'Lazarus, come forth.' The dead man come out, . . ." (John 11:17, 43). There are two versions of this photograph. In both, a figure in the entranceway of a house supposedly at the site of the tomb seems to be playing the role of Lazarus. Other figures surround the entrance; perhaps they are the customary

Adrien(?) Bonfils (prior to 1896), halftone reproduction. "Ruth and Boaz." (Sourasky Central Library, Tel Aviv University)

guardians or local passersby. Rather than looking at the "resurrected Lazarus" or any other figure in the scene, they gaze at the photographer. No women play the roles of Martha or Mary, other characters in the story. Though the scene is not a full reconstruction, this is one of the extremely rare nineteenth-century photographs in which a local inhabitant appears to represent a New Testament character.

In contrast, Bonfils's photograph of "Ruth and Boaz," an Old Testament story, closely reconstructs the biblical scene in which Boaz, the rich landowner, speaks to Ruth, the Moabite maiden.[13] This time the outdoor setting is neutral and nothing indicates the proximity of Bethlehem where the original story took place. The picture might have been staged near Bonfils's studio in Beirut or elsewhere in the region. More direct than an allegory, this is a *tableau vivant* or "living picture," exceptional to the Bonfils style and most likely taken by his son, Adrien.[14] It is also an exception to all nineteenth-century Holy Land photography.

Photographs produced within the biblical allegory genre seem to have followed well-defined lines. Outdoor portraits and snapshots that represented important biblical personalities were always of Old Testament characters, while unidentified background figures were used to allude to the New Testament.

Thus, there were only Good Samaritans or shepherds rather than depictions of the Virgin Mary, John the Baptist, or St. Veronica. Apparently there was a stronger reticence toward and awe of these latter figures, who were perhaps too holy to be captured in all-too-real photographs. It was only the remote past that made the actorlike portrayal of specific biblical roles acceptable. Apostles remained in the more imaginary sphere of painting and sculpture. Moreover, biblical scenes were always staged outdoors. To construct a biblical scene in a studio would have been tantamount to removing its only authentic ingredient, the biblical landscape.

In the 1890s, the genre became richer, although the basic patterns were followed. Travelers of this decade, enabled by new improvements in photographic processes to take snapshots, often depicted passersby as biblical figures. An American author reports a photographer as saying, "Stand up, young David! and let me have your picture," when "a clean-looking boy with a certain careless grace and beauty came

Lars Larsson, American Colony Jerusalem (prior to 1914), dry-gelatin glass negative, modern print. "Shepherd's Sling." (Library of Congress, Matson Collection)

by their encampment and stopped to stare at the strangers."[15] Describing a similar situation, she relates that "in a momentary pause due to the sudden sight of an approaching cavalcade the kodak had eternalized him as 'Joseph of Today.'" "Joseph" was, of course, "a shepherd lad in a scarf of many colors."[16] In Nazareth, however, the author refrained from naming names: "A lad stands just within the threshold of a carpenter's shop. His tunic was blue serge with a red sash at the waist. At the sight of the levelled kodak, he laughs and his hands chafe one another nervously."[17]

None of the models who portrayed biblical scenes was a Palestinian Jew; all figures named Abraham, Joseph, or David were represented by Arabs. Photographers preferred the graphic Eastern and archaic appearance to the historical or cultural link. Jews evoked very different associations. The same author who saw "Davids" and "Josephs" in young Arabs saw Jewish inhabitants as "something little better than a beggar," "a villainous looking tramp (he is one of their priests)," as stated in the captions.[18] Prejudices were not left home; they traveled with the photographer.

It was to the photographers and not the models themselves that the biblical allegory was meaningful. In general, the photographers were overwhelmed by what they considered a direct reflection of biblical life. Only one traveling author-photographer distinguished between modern and biblical elements in his picture: "Apart from the pipe protruding from the mouth of the modern skeikh, the analogy [to Abraham] would be perfect and the photograph he allowed us to take of his person and camp could illustrate a biblical landscape."[19] Yet, even the idea of the analogy could not have occurred to the sheikh. It was the photographers who sought resemblances to images from Bible stories. Thus, their perceptions of contemporary local life were all but innocent of predispositions and prejudices. They interpreted unstaged reality in terms adapted to the onlookers' culture. Obviously, the more archaic forms of life occupied center stage. Other patterns proper to nineteenth-century Moslem and Jewish society remained mostly undocumented in early photography even after portraits became common.

STUDIO PORTRAITS

The popularity of the biblical allegory in Holy Land photography was only matched by portraits, which placed exotic Oriental costumes into the Western bourgeois studio environment. The greatest producers of such portraits were Félix Bonfils and his family and successors, operating out of the studio in Beirut. Entitled "costume views," they were reproduced more often than any other portrayals, were used to illus-

trate books published in various countries, and were diffused all over the world. Paradoxically, although studio conditions allowed Bonfils the most complete control over his subject, his costume views were perhaps the least accurate in transmitting a truthful image of the Holy Land population.

Several factors contributed to the distortion of this image: imprecise captions, the employment of paid models, the inauthentic usage of costumes, the artificiality and inaccuracy of studio props and backdrops, and the mounting of pictures from two or more negatives.

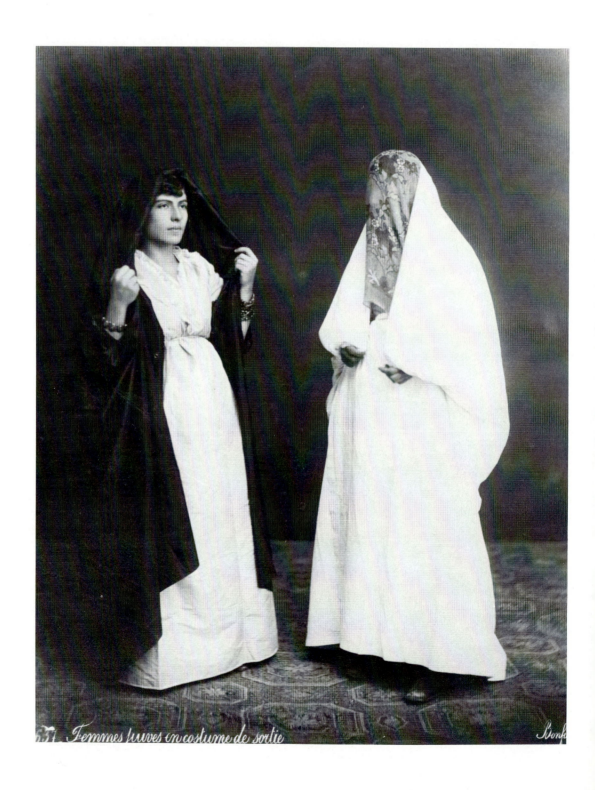

651. Femmes juives en costume de sortie

The errors in and misuse of captions can be traced in general to the repeated printings of Bonfils's photographs by not entirely scrupulous publishers. "A Jew from Beyrouth," one of the earliest published engraved reproductions of a Bonfils studio portrait, appearing in Lortet's widely known *Syria Today*, is a good example. It showed a squatting Jew holding an implement for carding cotton. The head of the same person, now captioned "Polish Jew," appeared as an engraving in a London magazine in 1885 together with three others on a plate captioned "Types of Palestine." A year later the same magazine published an engraving of the same figure, holding the tool, as "Jew of Algiers." (The Jerusalem cotton carder, *hallaj* in Arabic, was often a Jew of Algerian or Moroccan origin.) F. and M. Thévoz selected the same photograph for their albums in 1887 and reprinted it, in phototype—one of the early photomechanical printing processes—in 1889. They entitled the picture "A Jew of Jerusalem" (see pp. 14–17). A halftone reproduction—using the printing process still in use today—of the same person without the carder, entitled "A Jew of Jerusalem," was published in a Viennese book in 1892. Beirut, Algiers, or Jerusalem? A cotton cleaner or a Bonfils model? The tool was certainly in use in Jerusalem, but also in the entire Near East and North Africa. The fur cap and black coat are authentically and unmistakably the apparel of Eastern European Jews. The striped robe beneath the coat was worn in Jerusalem; both coat and robe appear in Phillips's pair of photographs of Jews. Beard and sidelocks look authentically Jewish. The portrait itself is of professional quality and pose: the man displaying the tool (which looks like, and was often thought to be, a musical instrument) is isolated from his true environment. He stands against a neutral studio backdrop, as if the photographer intended to facilitate multiple use. There are other similar cases. The portrait of "Jewish Women in Street Costumes," so entitled by Bonfils on the negative, was later used as "Christian Women" and even "Moslem Women." Numerous uncredited reprintings with contradictory captions—due to error or purposeful misuse—are no less typical of the period and of the uses to which Bonfils's photographs were put than of his photographic style itself.

In producing these and similar studio portraits, Bonfils selected appropriate paid models, mostly Arabs. A writer-photographer, Abbé Raboisson, noted in his diary: "Sunday, 23 April 1882. I have to take a group of natives in Bonfils' atelier which will allow me to acquaint our readers with the Moslem models procured for me by Madame Bonfils."[20] No doubt this was a professional enterprise. The models were posed according to European conventions of studio photography. Eyes were on the photographer or, more often, raised toward a point beside and above him to display a three-quarter profile. This pose was unnatural and had to be learned.

Bonfils (ca. 1880), albumen print. "Jewish women in street costume." (Harvard Semitic
um)

In the Bonfils studio models were not necessarily photographed in their own clothing. The studio accumulated numerous costumes that could be recognized easily as belonging to the region and sometimes to a particular town or country, although they were not always worn according to local conventions. Often figures were overloaded with parts of costumes and decorations. A "Young Woman from Nablus" would hardly have decorated her headcovering with flowers (and with jewels usually worn as pendants) as she appeared in a Bonfils photograph. The women of Nablus, a small and fiercely religious town, certainly followed its severe Moslem code. It is likely that the woman was a tourist who had assembled her costume from the studio's wardrobe. This would explain her painted fingernails, a custom more likely to be practiced in a harbor city like Beirut than in inland Nablus. An engraving made after a similar photograph entitled "Lady from Beyrouth" appears in Lortet's *Syria Today*.[21] While it is true that Lortet inexplicably recaptioned Bonfils's "Jew of Jerusalem" as "Jew of Beyrouth," in this case it is likely that the woman had, in fact, been photographed in the Bonfils studio and was a model. Another example is a Bonfils view of a "Young Jewess of Tiberias." Judging by the costume, she might have been living in any town in the Ottoman Empire and also might have been chosen from among his Moslem models in Beirut.

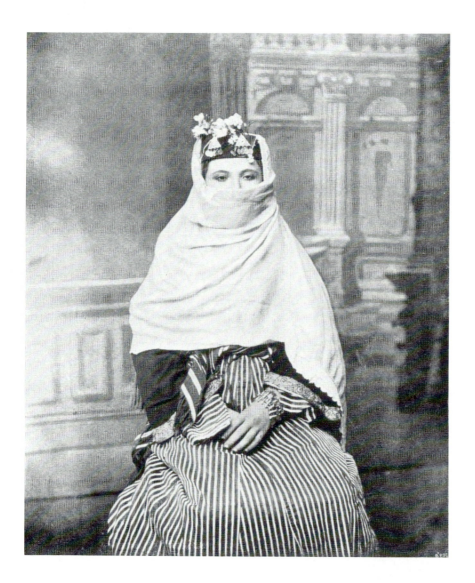

Bonfils Company (prior to 1896 or even 1884), halftone reproduction. "Young woman from Nablus." (Jewish National and University Library, Jerusalem)

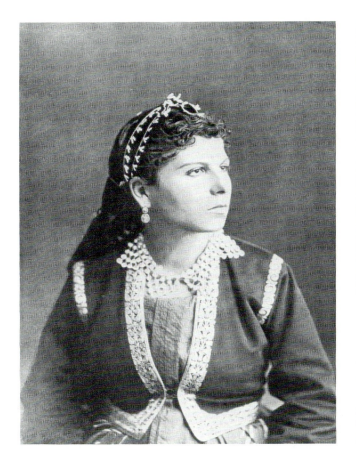 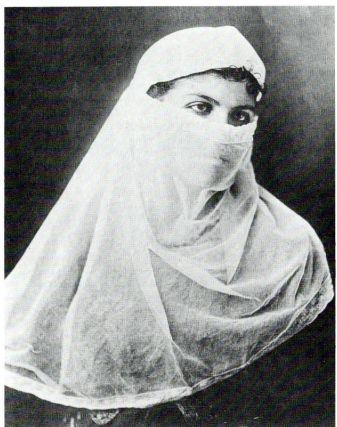

Sometimes an authentic costume is worn incorrectly. For example, the charming black locks that peek out of a "Turkish Woman's" headcovering, making her face more coquettish, are quite in opposition to the Moslem rule requiring the headcovering to cover the hair. Although there is some ethnographic truth in Bonfils's "costume views," certainly it is not the whole truth, and often it is more than the truth.

Even in portraits that were relatively accurate the photographers in Bonfils's studio had their viewers in mind. In a studio scene a group of unveiled Bedouin women, facing the camera, clap to accompany a musician; one of the women, holding a baby in her arms, displays a breast.[22] While such behavior was not in violation of the Moslem code (as Mark Twain reported in his inimitable style in 1867, ". . . women in Beirut cover their faces with dark-colored or black veils, so that they look like mummies, and then

ABOVE LEFT: *Bonfils Company (prior to 1896), halftone reproduction. "Young Jewess of Tiberias." (Jewish National and University Library, Jerusalem)*

ABOVE RIGHT: *Attributed to Félix Bonfils (prior to 1887), phototype reproduction. "Turkish Woman." (Jewish National and University Library, Jerusalem)*

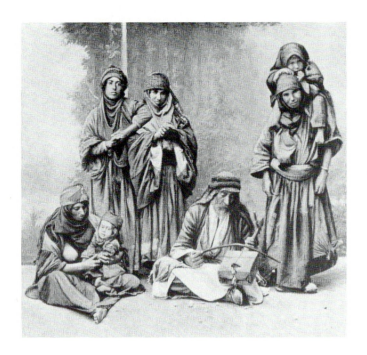

Bonfils Company (prior to 1894), halftone reproduction. "Group of Bedouins." (Jewish National and University Library, Jerusalem)

expose their breasts to the public"),[23] it could only be perceived by Westerners, unfamiliar with both the custom and the code, as "primitiveness," provoking amusement, titillation, and condescension. Lortet's book included similar portraits of single women, with and without babies. They represent one of the photographers' many little voyeuristic sins—local color being only a pretext in an exploitive mode of photography.

The Bonfils photographers skillfully applied the tricks of their trade to make the "exotically" dressed native both attractive and acceptable to the Western buyer. They used neutral or romantically decorated European backdrops, their oriental models often appearing against a background of birches—trees unknown in the region—or salons of decidedly European design. Sometimes the negative was retouched to disguise too familiar backdrops, but their European character was retained. And from time to time there were added props: papier-mâché stones, plants in hidden pots, mounted props from other negatives, even painted-in props. Conventional portraits were aimed not at local sitters but at the Western traveler—not excluding the occasional traveling photographer or writer who used the studio's services—and the publisher. Bonfils and his successors offered well-made and well-packaged merchandise. The strange but

F. and M. Thévoz (1887), phototype, uncredited (attributed to Bonfils Company). "S Fellah." (Jewish National and University Library, Jerusalem)

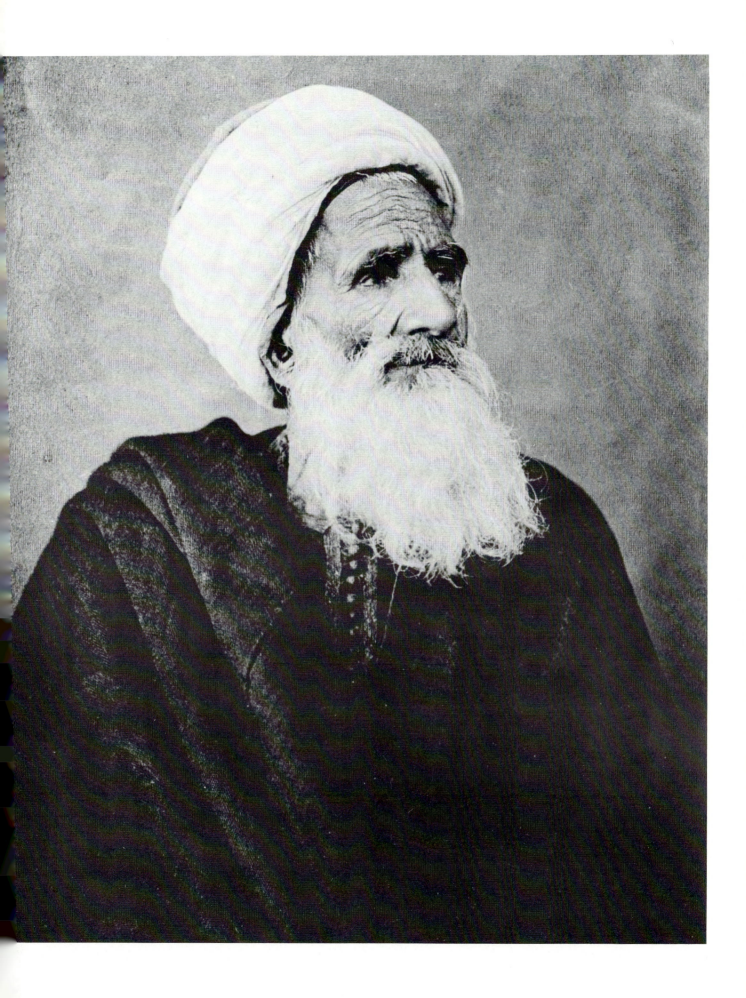

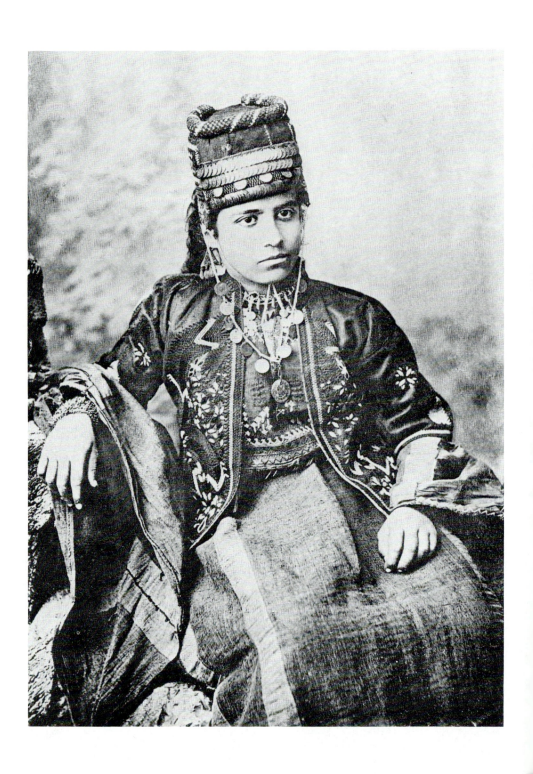

ABOVE: *Bonfils Company (ca. 1880), phototype reproduction. "Bethlehem Woman." ()
National and University Library, Jerusalem)*

RIGHT: *Bonfils Company (prior to 1896), halftone reproduction. "Bethlehem Beads Se
(Jewish National and University Library, Jerusalem)*

ostensibly typical costumes and tools were picturesquely displayed in an obviously professional establishment in the fashionable styles of *carte-de-visite* and *cabinet* portraits, a curious mixture of the unknown and the familiar.

In only one respect did the Bonfils photographers flout European bourgeois portrait conventions: they consistently neglected to use the chair or table or the characteristic small column against which the sitter (or stander) generally rested during the exposure.[24] This was no accident, and it was not characteristic of other studios in the region. The photographers at the Armenian Convent, only a few hundred yards from Bonfils's shop near the Jaffa Gate, used columns and comfortable chairs in *carte-de-visite* portraits from the 1860s on. True, there are numerous studio portraits from the Bonfils establishment in which a rich, decorated sofa or similar piece of furniture was not only used but emphatically displayed, but these were supposed to depict people in cities like Beirut or Damascus. In contrast, figures representing Palestine were usually standing. At other times they sat on invisible stools or papier-mâché stones; a "Bethlehem Woman" sat on these stones as if they were a love seat. "Bethlehem Bead Sellers," with

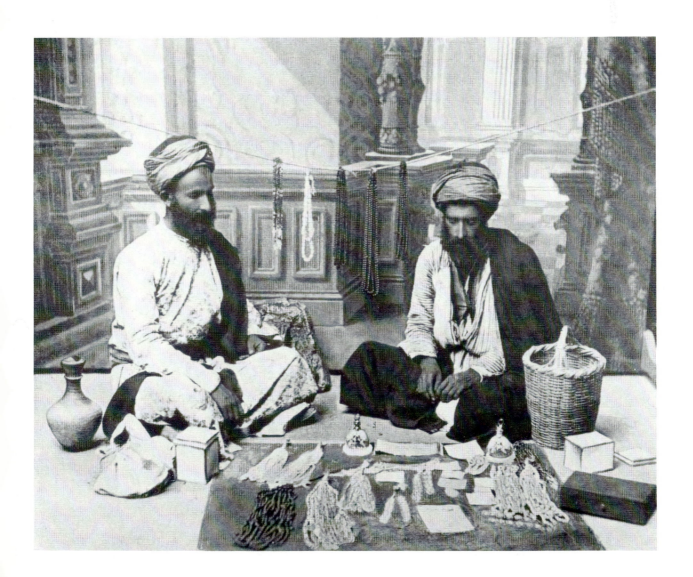

merchandise painted in, sat on the floor, the same salon backdrop of decidedly European design behind them as had been used in the photograph of the "Young Woman from Nablus."

Some Bonfils portraits (as well as landscapes) were mounted from two or more negatives to create entirely new pictures, combinations of figures and backgrounds. True, montages were also made for technical reasons, such as improvement of lighting or emphasis, but often nothing was left of the original setting. So ingenious were the Bonfils montages that in some cases only the different direction of the light falling on two different figures, or on a figure and its background, revealed the splice. Buyers confirmed that more was better; the more picturesque elements a picture offered, the more often it was bought.

Characteristic of Bonfils's commercial aptitude, he used none of the costume views in his own *Souvenirs d'Orient*, which included only landscapes. This was not for lack of material, since his catalogue of 1876 mentions costume views, and the two volumes of *Souvenirs* were published in 1877 and 1878. It is Lortet's book of 1884 that provides the earliest visual documentation of Bonfils's portraits. Lortet purchased these either in Beirut during his tour of the region (1875–80) or after returning home to Paris.

The Bonfils studio work has two composite layers, one reflecting aspects of reality, the other conforming to Western and "orientalist" conventions. Costumes, headcoverings, and tools represent local figures and scenes as any traveler might have perceived them, although in an exaggerated decorative style. The conventions of the photographic studio gave a more "civilized" look to the picture. Studio portraits obviously had to have some authentic ingredients in order to be realistic enough to be believed, but they also had to conform to the reader's preconceptions about the Orient and about respectable bourgeois photography. While familiar European settings modified the true coloring of the country, they enabled Western audiences to accept the exciting and strange foreignness of the subjects. Bonfils did not work for scrupulous ethnographers or for anticolonialists of later times sensitive to distortions in records depicting Eastern societies. He offered condescension and titillation, verisimilitude and overdecoration, codes of behavior and their transgression, the recognizable and the strange: a perfect mixture.

Thus studio photography, the modern, middle-class imaging technique with its conventions built upon pictorial traditions, provided the viewer who looked at unknown and perhaps threatening strangers with security and reassurance. The studio portrait and pose isolated the Oriental from his own environment and tamed his image to suit the Occident.

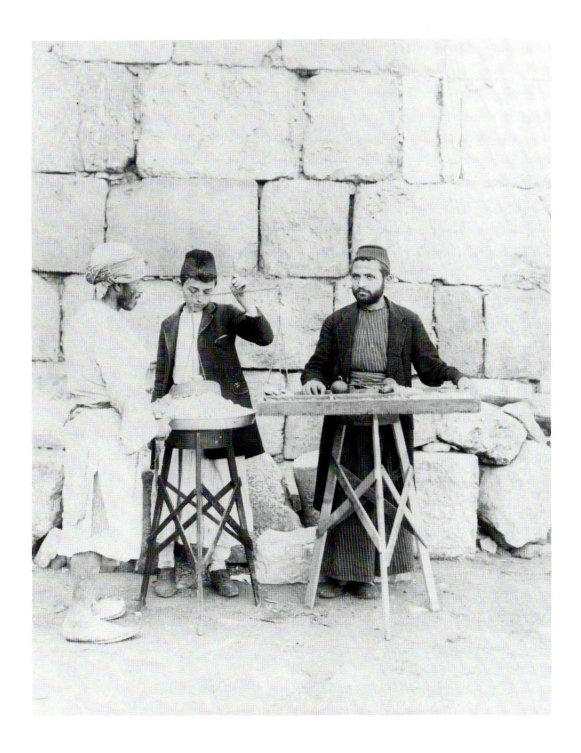

Félix Bonfils (ca. 1880), albumen print. "Street Merchants in Jerusalem." (Harvard Semitic Museum)

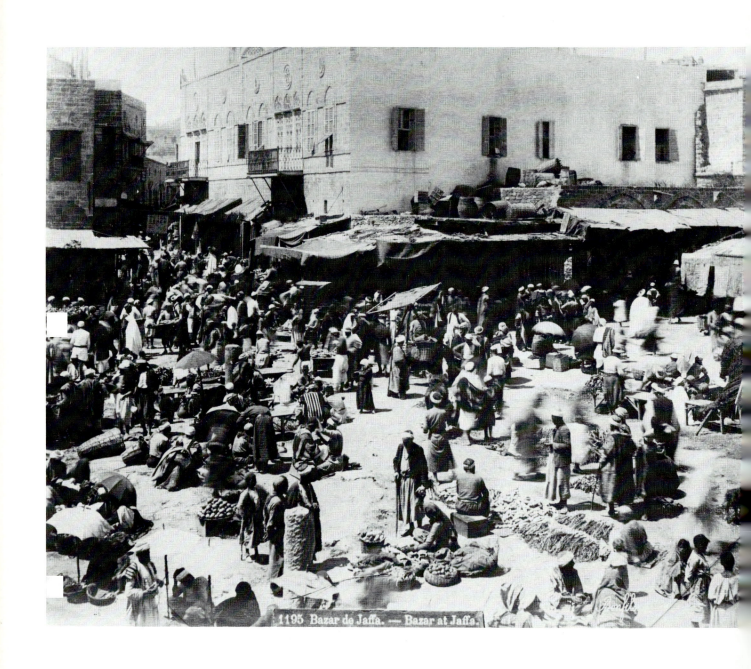

1195 Bazar de Jaffa. — Bazar at Jaffa.

Bonfils Company (ca. 1890), albumen print. "Bazar at Jaffa." (G. Lévy, Paris)

The popularity of Bonfils's staged and mounted costume genre with publishers contrasts with the lack of interest in his straightforward photographs of local inhabitants on location, that is, in fields and streets, taken between 1876 and 1890. A collection of original Bonfils photographs acquired by the Harvard Semitic Museum in 1890 includes unpublished examples of this type of photograph. The simpler and more authentic the photograph, the less often it was published.

Interesting evidence of the authenticity of such photographs is given by a Swiss writer who visited Palestine in the 1890s. He recognized some of his local acquaintances from a village in upper Galilee "in the beautiful collection of photographs of Palestine in the Bonfils house in Beirut No. 729 under the caption 'Group of Metaouilis' showing our people from Hounin, among them the Moukhtar with his long pipe and at his left our friend Oakid."[25] This picture was never reproduced or published.

Most of the Bonfils outdoor portraits did not show villagers from far-off places; generally the subjects were inhabitants with whom tourists came in contact, such as traveling merchants, camel drivers, and sellers in markets. The earliest example was probably "Street Merchants in Jerusalem,"[26] which was not published until the 1890s, and then, in contrast to the many reproductions of less authentic portraits, only twice. Yet even this picture was staged. It shows a young boy holding a scale but not really weighing anything. The time of the snapshot, which technically would have allowed a nonposed picture, had not yet arrived.

Some outdoor photographs with human figures were landscape scenes taken from a distance that included people moving about in marketplaces, busy city streets, or squares with fountains—the very same sites that had been photographed without people by early landscape photographers as "architectural views" or "town landscapes." By comparison, the earlier pictures resemble ghost towns. Bonfils and his successors generally photographed such scenes in the vicinity of landmarks that pilgrims and tourists frequented: the market in Bethlehem, the Virgin's well in Nazareth, the road to Jericho, the Jaffa Market, David Street leading to the Jaffa Gate in Jerusalem. The local life portrayed was still not representative of the majority of the indigenous population.

The figures in the Bonfils street portraits were authentic, but their poses were often unnatural. A portrait of three bearded Jews, two sitting and one standing, shows them uninvolved in any activity but posing. The caption on the negative refers to them as "Jews discussing the Talmud." These figures, as

almost all other Jews in Bonfils photographs, were grey-haired Eastern European types. The Jewish women (appearing in studio portraits), unlike the men, were young and wore oriental dress.

Bonfils portraits kept to the most graphic patterns and culturally embedded and commercially valued stereotypes, conforming to the buyer's biases.

The photographic image conveyed to the West of the local Holy Land population was distorted. The subjects chosen were those who were most available to the photographer and to whom European audiences could relate. Thus, insignificant minorities with whom photographers could more easily interact were cast in the main roles and shaped according to Western bourgeois modes of representation. While some straightforward pictures of local rural and urban inhabitants (including Christian clergymen, merchants, passersby, and peasants) were published, the proportion of portraits taken of marginal elements was exceedingly high. This fact is probably due to the predominance of outsiders among local photographers. To a large degree, both models and practitioners were close to the tourist trade and unrepresentative of the majority of the local population and its culture. Photography remained a Western medium.

The relative prominence of marginal elements in photographs appears more pronounced since there are no portraits of local persons of higher social status or townspeople. None of the Royal Engineers photographed a Turkish officer. No traveling photographer, himself an aristocrat or a middle-class professional, took pictures of a local notable or clerk, an owner of a hotel, a landowner, or the like. The bias was toward figures and scenes that were romantically picturesque, condescendingly depicting the archaic and the poor. These figures were indeed present in the Holy Land, and photographs often showed, their "biblical" captions notwithstanding, true aspects of local life. But, as with the Bonfils portraits, there was truth and more than the truth. Nineteenth-century photographers captured mirror images of the West's spiritual past and bourgeois present. Both the biblical and the costume genres matched the photographers' and the buyers' culture. The remoteness of the Holy Land merged with historical associations and Western social conventions to unite the extraordinary and the associative in digestible ways. Photography did not create an authentic "bridge between cultures." The image of the local population communicated to the West through photography was overlaid with Western visual and cultural conventions.

Bonfils Company (prior to 1896), halftone reproduction. "Jews discussing the Talmud." (S asky Central Library, Tel Aviv University)

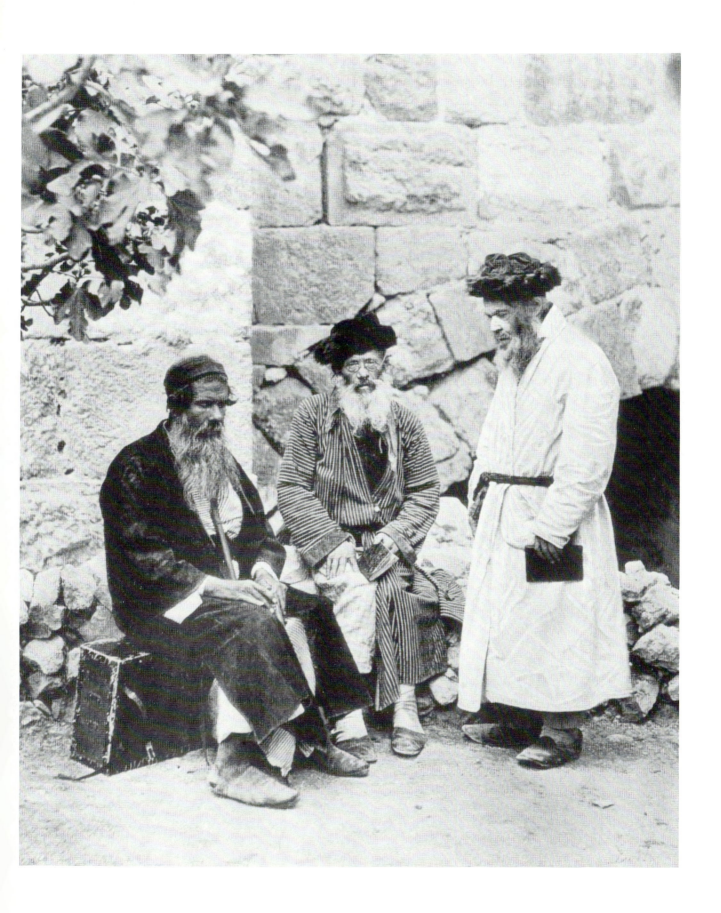

Native Attitudes 7

As opposed to the West, where photography was generally received with enthusiasm, people in other parts of the world sometimes refused to have their photographs taken. It is commonly assumed that this opposition was generated by superstition, taboos, or religious prohibitions. Such attitudes are known even today (e.g., among the Hopi Indians of the southwestern U.S.). Orthodox Jews and Moslems are believed to extend religious prohibitions against image making to passive cooperation with photographers, that is, they refuse to have their pictures taken. Photographers in Jerusalem's ultraorthodox Jewish neighborhoods find to this day that passersby sometimes cover their faces when cameras are pointed at them. Photographers sometimes also are opposed by guardians of the Temple Esplanade, who prohibit the photographing of Moslems there on holidays (this being a recent policy). Such instances invite one to project these negative attitudes toward photography into the past and to generalize them to include the majority of the population. When compared to the many volumes of landscape photographs, the small number of nineteenth-century portraits of Holy Land inhabitants may be perceived as a consequence of the strict application of biblical and koranic law.

Indeed, the travel accounts of several nineteenth-century Holy Land photographers indicate that they met with local resistance; sometimes religious factors were evoked as the cause. In contrast, stories related by other photographers indicate a willingness to pose on the part of the indigenous population. No information from local sources exists to corroborate these reports or to testify to more detailed and nuanced attitudes toward photography. Stories told by photographers are the only available sources for the study of these attitudes. With the aid of these stories, a picture of the local population's negative and positive attitudes can be partially reconstructed. The history of photography has not yet been studied from this perspective, especially in cases in which "natives" were the camera's subjects.

Analysis of this material shows that opposition to being photographed was not general, nor was it related to a single factor. Moreover, there are indications that Western photographers may have occasionally misinterpreted resistance and even caused it themselves. In addition, attitudes changed with time. Indeed, the way the local population related to the camera ranged from ignorance of the camera's function and suspicion of strangers to the acceptance of and acculturation to photography and successful interaction between photographer and subject.

The first stories of some relevance date from the beginning of photography. (In fact, Catherwood's story, quoted in the introduction, preceded photography by six years.) On November 7, 1839, Goupil-Fesquet and Vernet demonstrated the daguerreotype to Muhammad Ali, viceroy of Egypt, then temporarily governing the Holy Land. The viceroy, though otherwise an ardent proponent of modernization, branded the new invention "the work of Satan."[1] Well known and quoted by historians of photography, his declaration does not point to Islamic iconoclasm as its specific source of inspiration. Nor should it be considered an exclusively "oriental" attitude. At least one European source, the German newspaper *Leipziger Stadt Anzeiger*, reacted to Daguerre's new process in precisely the same terms, as "an invention of the devil."[2] Muhammad Ali and his German counterparts probably were expressing fear of an innovation that seemed to possess the power of magic.

In contrast, Goupil-Fesquet encountered a family of wealthy local Jews in Damascus who were willing to allow him the use of their home to photograph the neighboring mountains of Lebanon. According to the photographer, his hosts were "enchanted with the camera."[3]

Goupil-Fesquet reported a somewhat different reaction in Jerusalem:

Whilst I am completely absorbed in my daguerreotype an unpleasant breeze upsets my equipment and will no doubt blur my print. And to top it all two Jews stroll up and down past the lens and I cannot make them understand that they are in the way. They approach me and I wave them away but to no avail. One of them starts laughing and deliberately stands in front of my lens to annoy me.[4]

Of course, these people had never seen a camera before. They had no way of knowing what the daguerreotypist was doing and why their presence in front of the lens annoyed him. Goupil-Fesquet was probably unable or unwilling to explain it to them.

A decade later, calotypist Bridges also mentioned a local Jewish contact whom he met at Rachel's Tomb, a traditional site on the way from Jerusalem to Bethlehem. The Jew was praying next to an opening in the wall made for non-Moslems, to whom entrance was prohibited.

A venerable native Israelite, robed and turbaned as usual, with beard as white as snow, and a ponderous brass-bound volume under his arms, was stopping to offer his prayer through the privileged aperture, when he was startled by the sudden sound of footsteps, and the apparition of a Frank traveller planting the tripod for his mysterious camera immediately behind him. The timid Jew, haunted by visions of oppression, naturally imagined it to be a destructive engine of war. Soon, however, was he assured of the harmless intentions of the stranger. . . . The incident produced a lasting intimacy, profitable to the intruder—who eventually obtained, not only much information, frequently imparted in his dark and dusty study, well stored, apparently, with very ancient manuscripts of indescribable form and figure; but in the end, after much solicitation, the rare and confidential gift of a set of genuine "*Phylacteries*," with the "*Mezuzah*," "*Tallith*," and "*Tsitsith*;"—and, ere he left Jerusalem, was admitted to the privilege of passing "The Feast of Tabernacles" with him and his family under the rude but ornamented tent erected upon the terraced roof of his house in the very heart of the city of his fathers. . . . He proved to be the Chief or Elder Rabbi in Jerusalem.[5]

Bridges did not attribute the "Elder Rabbi's" reticence to the Second Commandment—a reason he would not have failed to note, being an ecclesiastic himself—but to fear. There is no reason to doubt his interpretation, particularly since the two apparently engaged in extended conversation. It should be noted, moreover, that at the time of Goupil-Fesquet and even Bridges the function of photography was unknown, and local Jews could not have been relating to the camera as a picture-making device.

The 1850s and early 1860s did not produce a single written line on this subject. However, Jews praying at the Wailing Wall first captured by Robertson and Beato in 1857 obviously had no objections; they were one of the perennial subjects of Holy Land photography. This photograph, together with a picture taken by Frith in Ramle in 1858, suggests that local people did not shy away from the camera at that time. Francis Bedford's collection of 1862 includes a photograph of two guardians of a mosque; the picture required their full cooperation since it was taken indoors, requiring a lengthy pose. There is no mention of these pictures—or even an oblique reference—either in Frith's writings or, in Bedford's case, in Thompson's book about the Prince of Wales's tour.

In 1864 well-known researcher Rev. H. B. Tristram provided further clues to the absence of opposition, reporting his own photographer's encounter with local people. When, near Jericho, Bowman was taking "a good photograph of 'Hiram's Tomb' . . . a party of Arabs came up during the photographic operation and watched us without expressing either wonder or suspicion."[6] Of course, here there is no mention of portraits. In contrast, in Beirut, the most cosmopolitan city in the region, Tristram and Bowman "had a favourable opportunity of judging Syrian belles as the photographic apparatus . . . was in much request at Mrs. Thomson's schools, where we collected many, both married and single, Greek, Druze, Jewess and Maronite."[7] (No doubt Bonfils, settling there a few years later, found a favorable

environment from which to recruit his models.) That there was no mention of Moslems may be significant.

Disparate, few, and inconclusive as the earliest pieces of evidence are—no other author discusses local attitudes until the 1880s—they do not indicate the existence of generalized opposition. Photographers of the 1880s and 1890s provide us with a general idea of the gamut of local attitudes. People reacted to the approach of a photographer sometimes by opposition and evasion, sometimes with curiosity and even hospitality, and rarely with animosity. A look at these varied reactions and their underlying causes reveals yet another facet of the history of photography, one to which Western-centered research has paid little attention. This aspect is of prime importance in the context of the Holy Land.

The Holy Land is one area in which, by and large, portrait photography was not an outgrowth of the art of portraiture. Here painted portraits could be seen only in a few churches, entered by a small minority of the population, and these, of course, represented traditional Christian figures, not local persons. The interaction between picture maker and subject was unknown. Moreover, of all the visual arts, photography was the first in which the portrayed or "captured" person and group provided the image maker with a more finally elaborated expression for the final product; thus, unlike the painter's sitters, photographed persons participated in the shaping of their own portraits in unprecedented ways and to an unprecedented degree. Their faces, gestures, and actions were not only sources of inspiration to an artist, but also components of the resulting pictures. The advent of portrait photography thus required local people to acculturate to a totally new pattern of behavior.

To the nineteenth-century Holy Land native, photography was an experience to which one was asked to submit, that is, to be subjected to a stranger's gaze. Unlike Americans and Europeans, who generally had their pictures taken for personal use, Holy Land inhabitants served merely as passive models. While a European customer could accept or reject the recorded image, select and collect photographs that were most pleasing, and enjoy looking at the finished product, people in nineteenth-century Palestine rarely saw the pictures of themselves taken by travelers. In fact, they hardly knew what a photograph looked like. Photographs—positive prints—were rarely executed in the Holy Land, and in the 1890s, when portraits were taken in quantities, even the negatives were not developed on the spot. Most sitters and posers in villages and oases had only a vague idea, if any, of how they looked in photographs, although they gradually learned what a camera was for. This situation was probably typical of all colonized native populations, to whom photography generally meant being an object of the camera for other people's uses.

We can think of their images as a cheap "natural resource" that could be exported to metropolitan areas, where it would be processed into cultural goods for (Western) consumption. The process fit the classical pattern of colonial exploitation.

At the same time, portrait photography in the Holy Land provided a new experience for the photographers, who were now faced with animate objects rather than landscapes, people whose reactions to their requests to pose differed sharply from those of their Parisian or London friends and customers. Most photographers were ill-prepared to approach the local people they wanted to depict. Until time and experience taught them to interact more successfully, they ignored the codes of behavior, languages, and traditions of the indigenous population. To overlook the part this played in the shaping of negative responses and unfriendly attitudes is to give but a partial and condescending picture of the situation. The history of photographic portrayal involved a learning process that took place on both sides of the camera lens.

NEGATIVE ATTITUDES

In the Holy Land, nineteenth-century photographers encountered attitudes to which they were unaccustomed, given their mostly urban European environment. Du Camp, Frith, Phillips, and Kitchener were subject to attack or robbery. Goupil-Fesquet and Bridges relate misunderstandings by local contacts. Bedford had his own military escort, evidence of a lack of security. In none of the early accounts is hostility specifically attributed to photography; only a few late-century reports include such elements. Despite their disparity, all reports can serve as indicators of the sources of opposition to photography.

Difficulties created by the Ottoman authorities are first mentioned in Pastor Bridel's introduction to *La Palestine Illustrée*, published in Lausanne, Switzerland, in 1888–90 (see chap. 8). In addition to noting that stones occasionally were thrown at the two photographers who took the pictures for the album and that local people even tried to set fire to their luggage, he emphasized the opposition of the Turkish authorities:

The main difficulties they encountered were with the Turkish government—either because the Turks wanted to get baksheesh [bribes] out of them or because of their crazy fear of spy-rings or in line with the religious revulsion of all Muslims toward pictures. In many places the authorities officially prohibited their work and on more than one occasion they had to resort to taking advantage of the dawn so as to photograph before anyone was awake. They

were even imprisoned in . . . Caesarea accused of having mined the sea and of having directed cannons at the houses. Only by dismantling their camera into parts could they prove their peaceful intentions and so regain their freedom.[8]

Although Bridel gives three possible reasons, in addition to the general hostility, for the difficulties experienced by his photographers, it is clear that security was most important. As the story concerns landscape photography and not portraiture, the reference to "religious revulsion" can be seen as no more than an unsupported supposition.

Another photographer to experience difficulties of this type was Lucien Gautier, also of Switzerland. While visiting Safed in upper Galilee, he was informed by a Turkish officer that photography within this fortified city was strictly forbidden. In the author's own slightly mocking text, this was "dictated by major strategic considerations. The Turks imagine to have in Safed as well as in Acre a fortress of first importance, and they do not want to have its secrets unveiled."[9]

Political and military considerations may explain why the Royal Engineers in the 1860s and 1870s and later British or French photographers refrained from portraying Turkish soldiers in spite of their 1853–56 alliance and common victory in the Crimea. During the period surveyed, only one photographer published a portrait of a Turkish soldier, a "Bashi-Bazouk" (an irregular), in 1892.[10] The photographer was G. R. Lees, a local resident, teacher at a missionary school. His colleague, J. Hanauer, ran into difficulties in 1905 when Turkey was allied with Germany. In that year, Bedouin tribes in Yemen revolted against the Ottoman power, and a Jerusalem detachment of the Turkish reserve forces ("redifs") was sent to quell it. Hanauer described how he attempted to photograph the soldiers marching past the Garden of Gethsemane: "I went out with my camera, hoping to get a picture for your magazine but the curses I heard were so numerous that I had to content myself with the small illustration which I am sending. It gives a distant glimpse of the people who turned out to see the 'redifs'. . . ."[11]

While the story suggests opposition to picture taking per se, the main reason for Hanauer's reaction may have been that he was recognized as a member of the British missionary society and thought to be a spy. To be sure, historical events were to justify the Turkish military's suspicions of the West, to which they lost their empire in 1918.

Photography was not the only Western import to be suspected by authorities. English explorer Catherwood experienced his share of danger in 1833 when using a camera lucida on the Temple Esplanade in Jerusalem. Lieutenant Warren of the P.E.F. had difficulties bringing in theodolites and sextants in 1867.

These were pronounced warlike stores in the customs house and escaped seizure only upon the vice-consul's guarantee of their peaceful nature. In short, Europeans with research equipment, including cameras, were feared. Negotiations accompanied by "baksheesh" bribes were necessary and sometimes had to take place in advance. In 1893 a French-Algerian photographer, Gervais-Courtellemont, obtained the "protection" of Turkish soldiers who accompanied him (in Jerusalem!) "to defend him and his equipment."[12] A year later an American photographic team considered it advantageous or necessary to carry introductory letters from the highest American authorities, including the president of the United States.[13] Yet, the existence of photographs proves that difficulties could in fact be coped with, by bribery, diplomatic intervention, or both.

While the opposition of military authorities is documented in the writings of late-century photographers, there is no direct evidence of opposition by religious authorities. The absence of portraits of Moslem religious personalities may be considered indirect evidence of opposition. Indeed, Pastor Bridel took this opposition for granted, apologizing for the inclusion of an engraving—the only one in an album of some two hundred photographs—of "muezzins," religious functionaries who summon the population to prayer:

We couldn't fail to show our readers this scene, which is one of the most characteristic in Palestine today, but as it was impossible to take it live, a photograph of an accurate engraving will have to satisfy us. One sees here some minarets with muezzins and in the lower section some men praying on the veranda of their houses.[14]

While the true setting for the engraving is Cairo, the reasoning was applied to Palestine. On the other hand, the story of an American traveler, E. L. Wilson, visiting the Holy Land less than three years later, indicates that it was possible to take such photographs. During a storm in the Judaean hills, Wilson found shelter in a mosque. "When the sun came back, the custodian who also airs the hour of prayer took his place in the minaret and permitted the camera to include him."[15] This story invalidates Bridel's assumption. It also suggests that actual religious functionaries, rather than models, appeared as the two muezzins shown on the minaret of a mosque in a photograph included in *Album de la Terre Sainte* (published in the 1890s).

In the absence of expressed opposition by religious dignitaries, the attitudes of laymen should also be considered. It can be assumed that religious holidays generate an atmosphere in which even the not very religious would insist upon respecting religious precepts not strictly observed in daily life. In such situa-

tions European travelers often experienced the awkwardness of their presence among the crowds. The prohibition of picture taking on such occasions might therefore be seen as evidence of the power of religious proscriptions. Close reading of relevant travelers' stories, however, reveals that even here religious factors were not the primary source of local resistance to foreign photographers.

A. H. Harper, writer and painter, relates an unpleasant experience he had in the 1870s that throws some light on the subject:

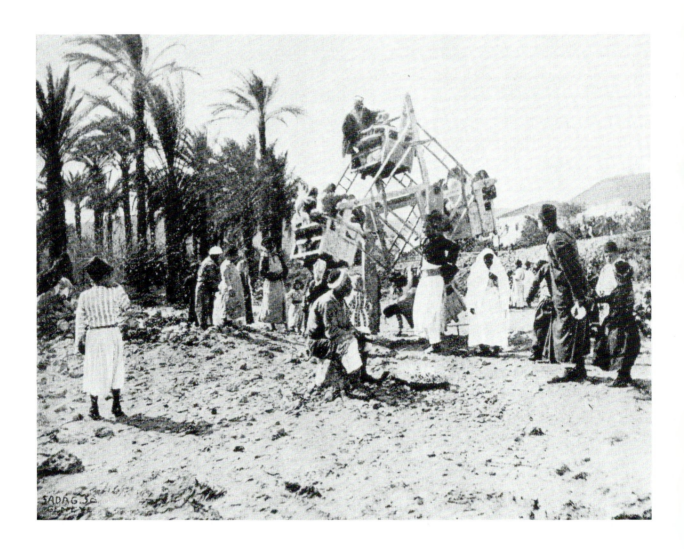

Madame Lucien Gautier (1894), halftone reproduction. The Bairam holiday, after the Fast of Ramadan, Haifa. (Jewish National and University Library, Jerusalem)

On a hot spring day, the time when Moslem pilgrims were about to start for the so-called Tomb of Moses in the Desert of Judea . . . the writer, with a friend, had determined to see all that was possible, but had been told it was dangerous for a European to mingle with these devout Moslems. . . . The array of pilgrims streamed past us down to the steep slope and they skirted the foot of Olivet. The women, in their gayest attire, were seated in groups under the trees or collected in knots on the broken ground. I, struck by the picturesque site of the pilgrim host, from that point of view, happened to stroll up to one of the groups, sketchbook in hand. Immediately I was most bitterly assailed by one woman, who accused me of most improper and indecent conduct, and when in amazement I asked what I had done, a chorus of reproach burst out from the group. My friend some distance away was laughing at my dismay and beckoned to me and then told me that my very impropriety had consisted in standing near the group of women, a crime no Easterner would ever be guilty of.[16]

The event described here—the "Nebi Mousa" festivity—is indeed one of heightened religious fervor. However, while a cursory glance may point to the religious atmosphere as the single source of opposition to Harper's sketching (an obvious parallel to taking a photograph), a closer look at his description indicates that the root of the conflict was ignorance of a social code: the improper conduct of a (foreign) man approaching (local) women.

By contrast, the Gautiers, a husband and wife team from Switzerland, were well informed and exhibited an understanding of local customs. Visiting Haifa and Acre in April 1894 during the traditional Bairam festivities that follow the month-long Ramadan fast, the Gautiers were aware of the inflammable nature of the holiday that they were witnessing: "A popular festivity always brings with it a certain animation, even an overexcitation, and we were warned in Haifa against the inconveniences we might meet at this focus of Moslem fanaticism called Acre. We promised to make ourselves small, to pass if possible unremarked. . . ."[17] Indeed, Gautier does not mention photographing people while in Acre. In Haifa, however, which he apparently considered less "fanatical," Madame Gautier was able to photograph a "vertical caroussel" typically used at the Bairam festival, and the picture was printed in their book. That a foreigner, and a woman no less, could get close enough to take this picture during a Moslem holiday is evidence of a diminishing cultural gap. True, it also testifies to the increasing swiftness of the camera shutter, but no matter how unobtrusive and fastworking her camera, her mere presence could not have gone unnoticed. That Mr. Gautier, who was an Islamic scholar,[18] could speak Arabic explains the ease of his interaction with the revelers. He could respect their feelings and communicate his understanding.

There are no other references to direct contacts between photographers and Moslem religious personnel, or Moslems on religious occasions. None of the quoted texts can be interpreted as supporting

Pastor Bridel's supposition about "religious revulsions" as related to the work and presence of foreign photographers (note that Bridel, who did not visit Palestine himself, did not speak from firsthand experience).

Heightened awareness of religious laws and traditions may also be salient in a Jewish religious atmosphere. As in the Moslem environment, opposition to photography might be more clearly expressed on such occasions than in everyday life.

Only one photographer related a story describing Jewish opposition. The scene was of a crowd at the Jewish cemetery on the Mount of Olives, and the story is told by Hanauer, the above-mentioned missionary who was also unable to photograph the Turkish soldiers that same day:

As I was going down to Siloam to my usual work, accompanied by an American friend interested in our mission, we suddenly, on turning a corner, met a funeral procession which was formed of hundreds, I might say without exaggeration, thousands of Jews. The encounter was quite unintentional on either side. I had my camera with me, and on seeing me and the instrument within a few yards of the corpse of the dead rabbi, many of the Jews uttered a cry of consternation and begged me not to photograph. I, of course, respected their request. . . .[19]

This is a strong and clearly written report. A funeral is an event charged with religious feelings, and this time the opposition to photography as such was communicated with clarity. However, there may have been several different reasons for the reaction. One may simply have been grief. On the other hand, a plea for discretion is sometimes unconnected to religious beliefs. In Jewish funereal practice, the body or face of the deceased is never publicly exposed, and in the Holy Land the corpse is not carried in a coffin to a cemetery but is covered with a special white cloth, through which the outline of the body is perceptible. In addition to all this, Hanauer was a missionary from the London Jews' Society, a despised outsider and the son of a convert, and he was not invited. These circumstances may have carried more weight than direct application of the Second Commandment. In different circumstances photography of the dead was not totally absent from the Jewish environment. The story of Rabbi Aszod's posthumous photograph (see chap. 5, p. 131) is a case in point.

Another example of such an incident in which photography of the dead was not prohibited is illustrated in a photograph by Tsadok Bassan (see p. 243). This photograph, with day and month but no year indicated, shows the inmates of an almshouse who were hired, according to old custom, to say prayers at the Wailing Wall in memory of a dead person. The caption, doubtless distributed with the photograph,

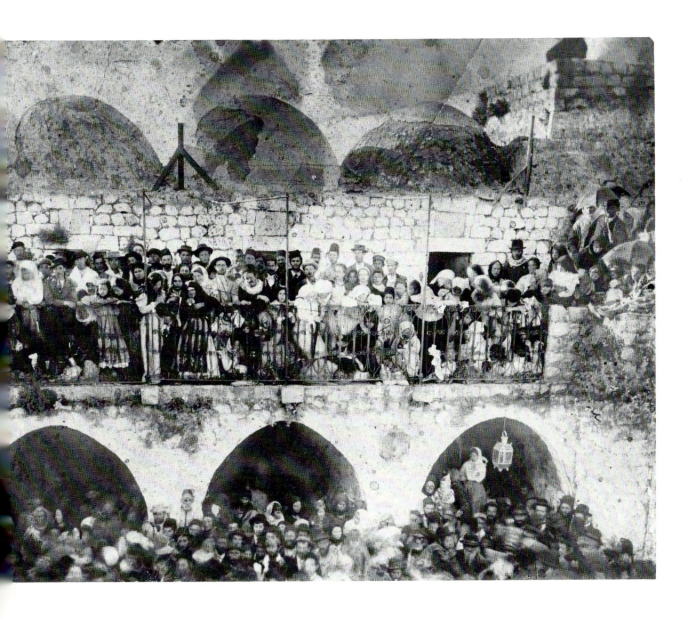

Photographer unknown (ca. 1885), albumen print. Lag Ba'omer festivities at the Tomb of Rabbi Shimon Bar Yohai, Meron. (Zikhron Yaacov Archives)

states in Hebrew that the payment was made by the dead woman's daughter. A complementing caption in Russian gives the address of the Rabbis Dayan and Levy of the "General Kitchen" for the poor, established by Rabbi Salant in Jerusalem. This photograph was made both for the daughter and for distribution, to indicate the existence of the custom and the possibility of hiring poor people for this prayer. The hiring of professional mourners and the offering of charity at funerals are age-old customs, and no taboo or religious ban seems to have prevented the taking of photographs. The picture itself is neither a snapshot of the praying mourners nor a formal portrait. Some of the mourners are praying, others face the

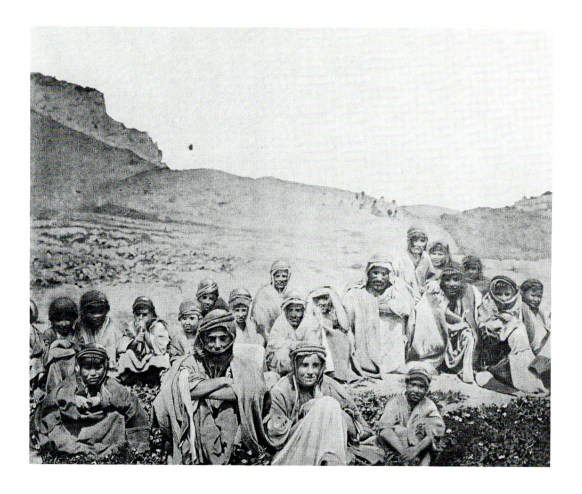

Abbé Raboisson (1882), phototype reproduction. El Hawara (note group of women in background). (Jewish National and University Library, Jerusalem)

photographer. Neither the mourners nor the photographer make any attempt to strike a conventional pose, and no one hides his face.

While Western perceptions of local opposition were generally connected to the well-known Jewish and Moslem prohibitions of image making, the stories related here as well as the photographs taken and published indicate that this restriction was not generally applied. When opposition to photography did occur, it was usually associated with violations of social and cultural codes, particularly those involving Moslem women. Opposition to the portrayal of Moslem women was reported by three different photographers of varied backgrounds, interests, and approaches to the local population. That their stories relate to different years, places, and circumstances suggests that such opposition motivated by tradition existed.

The earliest story is told by Abbé Raboisson, a French writer and photographer who traveled in the Holy Land in 1882. In El Hawarah, a village between Jerusalem and Nablus, Raboisson underwent an experience similar to Harper's of a few years before, and this incident took place in a completely secular environment. It was lunchtime and Raboisson and his fellow travelers were sitting down to eat in a barren field. As they did so, the village men gathered a few steps away to watch them, "as one goes to the zoo to see the animals eating." Raboisson's friends were embarrassed, but he asked them to suffer the stares with patience.

They make such a nice group. In a moment when we finish our lunch I will photograph them. There are among them beautiful Semitic types . . . at the same time the village women grouped themselves some twenty-five feet away . . . I am nourishing the hope of taking the risk of also photographing the second group. . . . Lunch over and I am at work. Everything goes fine for the first group, which I can present to readers as "View No. 103". For the second group—the weaker sex—everything begins well. The Fellahin of three generations have arranged themselves admirably. My head is under the black veil, the eyes on the ground glass—I am focusing at what I will take in a few seconds when all of a sudden all of them escape like a flock of startled sparrows. They put themselves beyond the scope of my lens. Hornstein, the guide, informs me of what happened—one of the male models of the preceding picture sneakily approached the female group and told them in a low voice: "Aren't you ashamed to let yourselves be viewed by the Frandjis (strangers)?" These words together with a menacing look were sufficient to cause the flight. Our young guide, annoyed by this episode, reproached the Bedouin who had made the remark and lashed out at his face with his whip until he drew blood. Hornstein is uneasy—were it not for the blood he would have beat him half to death and it would not have been serious. But the blood in the Orient has to be "redeemed." The guide then appeals to the women to return to their original place. . . . His whip and his proud attitude compel respect. However, the young women are not influenced. Only an old woman and some young girls pose before the lens. Without doubt the village woman was a widow free from fear of revenge from which others would have not been able to escape. I take the group even though it did not seem to offer enough interest for my readers. In the meantime whilst I was busy with the second photograph Hornstein offered his victim two francs, which were accepted. The blood money had been paid; the incident was closed.[20]

Notwithstanding the guide's brutal conduct and the villagers' submission,[21] the key words here are "the weaker sex" and "Frandjis" (strangers). The male villagers were perfectly willing to pose for the "frandji" photographer provided he did not approach the women.

That women were expected to stay away from "frandji" photographers—male or female—is corroborated by Gautier. En route to Gaza from Beer Sheba, in a deserted region rarely visited by tourists, his caravan met a small group of Bedouins near a well. The man in the group "stood immobile as he faced the camera, while the women in his company . . . deposited their pitchers and hurriedly moved aside. . . ."[22] Gautier guessed that they were afraid. The camera was in his wife's hands, and she was able to "snap" a picture anyway.

An American writer and photographer who visited the country in the 1890s, Marion Harland (pseudonym), tells a slightly different story on the same subject. At Mar Saba, the convent in the desert near Bethlehem, a well-trodden Ta'amira region, the visitors stood "among youngsters who asked vigorously for baksheesh." Here is Harland's description of the scene, including the ever-present dragoman guide:

The girl, who must be about sixteen, withdraws modestly, putting a corner of her coarse linen veil over her mouth at the sight of two men, one young and pale-skinned. . . . All David's tact is brought into play to distract her attention and her mother's suspicion from the tell-tale kodak while this end is secured. She is actually in flight, arrested upon the half-step by the dragoman's call—an untamed creature as timid and wild as one of the hares we frightened out of a hollow yesterday. Her brothers and father are easily persuaded to stand for their portraits. . . .[23]

There is a complex stratagem and interaction described: distraction, the intervention of the dragoman, the snapshot. In clear contrast, the men are quite willing to pose.

In all three stories—of Raboisson, Gautier, and Harland—men agreed to pose and women refused, immediately or subsequent to male pressure. The underlying cause of the opposition was the Moslem rule prohibiting women from exposing themselves to strangers, as well as fear of the punishment their husbands would inflict if they disobeyed. The rule itself was related to the inferior status of Moslem women, who were considered male property and kept isolated from (mostly male) strangers.[24] That portraits of Jewish women are rare may similarly be related to their social status.

The negative responses of both men and women were described at the very end of the century by F. M. Deverell, a tourist from Great Britain. Though part of a group, Deverell took some photographs on his own in the far north of the country without the help of a guide or other knowledgeable person:

At Ain Balatah a company of natives came round us, poor wretched people, glad to receive our leavings, the crumbs which fell from the rich man's table; not that the "crumbs" were bad: I, for example, gave one an egg. . . . Some of the young people here were very shy at first; but they gradually gained confidence; one young girl carrying a baby in a bag or pouch on her back seemed terrified. I dare say it was the baby that so strongly roused this instinct of preservation; and perhaps my camera had something to do with it, for I tried to get a picture of her and the baby.[25]

Deverell was able to photograph the girls and the baby, as is attested to by the picture captioned "Native Girls" published in his book. The girls were shown standing on the border of a field, some of them veiled, from close range. Deverell must have literally stuck his camera in their faces. No wonder the young girl with the baby was frightened. Another photograph, entitled "Natives," which shows men and women squatting by the same field at some distance, drew no comment from the photographer.

One might suppose that widespread fears and superstitions played an important role in this and other stories. Only one author, writing in 1907, points to this as a possible source of opposition to photography, however.

Fear or evil spirits, or more specifically, of the evil eye, is an ever-present dread. It seems to arise from the notion that too much property, health, pleasure or any good thing (may cause harm). . . . Blue beads and blue tattoo marks on the face are utilized to avert the evil eye. The evil eye may be in the steady gaze or stare of a stranger, or in his photographic camera, which the more ignorant dodge fearsomely.[26]

Here the opposition is restricted to the "more ignorant." Gautier also mentioned fear (as did Bridges long before him). There is no general agreement about the influence of the "evil eye" superstition.[27]

Deverell's experience with the young girl and her baby, however, may also be explained by his unsuccessful interaction with his subjects. The story behind a third picture taken at Ain Balatah, "A Ploughing Scene," points to a clash between Deverell and one of the men:

A little way off from the fountain ploughing was going on; and, following the example of a companion, I went out to take a photograph of the scene. There were two men, each with a plough and a yoke of oxen, and I wished to take the two in one view, one behind the other, as a picture of Eastern ploughing, and also as, to some extent, an illustration of the ploughing scene in the history of Elisha (First Kings xix:19) . . . and after waiting about for some time I made sure of a picture of one man at plough; but I did not manage to get a view of the two together. The man came out to me, and wanted to see my camera; I allowed him to look in, keeping hold of it myself; but I soon found that what he meant was to get possession of it; and I had to take firm measures, and literally force it from him, or I would have lost my camera.[28]

Did this man believe the camera to be but another "crumb" off the "rich man's table?" Was he trying to prevent the photographer from taking his picture? Did he want to steal the camera? Or was he disturbed by the photographer's waiting and watching? Deverell's description does not disclose the reasons for the suspicions of the local people. The elements that apparently provoked the clash were both the novelty of the camera and the insistence of the rich man. To the villagers of Ain Balatah, Deverell was probably no more than an arrogant intruder.

Villagers in general were not enthusiastic about photography, even in Europe. For example, photography did not penetrate French villages until the turn of the century. French rural dwellers felt that photography was opposed to their values.[29] The attitude of the inhabitants of Ain Balatah and other Palestinian villages may have had similar roots.

POSITIVE ATTITUDES

This is not to say that all reactions to the camera were negative. Successful interactions between foreign photographers and local inhabitants were not uncommon. Even Deverell himself noted a pleasant experience: "In Samaria I photographed the scholars as they were sitting on the floor. And the school-master wrote his name and address in my pocket-book in Arabic."[30] In the photograph some of the youngsters turned their heads away from the teacher and smiled to the photographer, who obviously amused them more. These children were accustomed to travelers bearing cameras, since the school adjoined a mosque that was the former Church of St. John, a site frequently photographed ever since Bedford's visit in 1862. The existence of such photographs, together with a number of other stories indicating a willingness to be photographed, shows that portrayal of local people was indeed possible. In fact, with time it became so common as to be routinized and conventionalized.

Throughout the first sixty years of Holy Land photography it was those local inhabitants in greatest contact with Westerners who were most willing to pose before the camera. Guardians of holy places and dragoman guides, who began to be portrayed in the 1860s, were the first to discover that their presence was sometimes sought in front of the camera; in earlier years, apparently, they were requested to remain outside its range. From the 1880s, however, knowledge of the tourist's desire to photograph local people

began to spread along the main pilgrimage routes. The travelers' local servants were the first to take advantage of the situation.

The stories behind two photographs taken by Abbé Raboisson in 1882 indicate his staff's willingness to pose and even their desire to be portrayed. In the region of Jerusalem Raboisson took a snapshot of "our young sheikh [and] his cousin . . . I took them together with my camera obscura and lodged them in one of my boxes";[31] the "young sheikh" was his guide. A few months later while visiting the Bonfils studio in Beirut for the purpose of photographing the "Moslem models," he was asked (!) by his cook, Youssouf, to take a portrait of him and his son. Raboisson published both photographs in his book. In 1894 American photographer R. E. M. Bain also published a picture of his staff: "eight men, among them dragoman, cook and waiter . . . our caravan, during a pause on the road."[32] Guides, staff members, and sellers of souvenirs were interested in pleasing their customers, and often considered posing for photographs as a part of their duties. In some cases they may have seen it as another service for which the traveler had to pay. American photographer Wilson described such a situation:

The picturesque figures of these rascally Arabs, with their flowing robes and long lances, were of course very desirable "accessories" to the pictures of Petra; but they wanted heavier pay for "sitting" than any professional models. I had to pay thirty dollars for the privilege of making my picture of the six scoundrels on their horses.[33]

On another occasion, in Akaba, Wilson took a snapshot without paying: "One day I caught the rascals with my camera."[34]

By posing for the traveling photographers they guided, the dragomans served both as a buffer and a catalyst. The availability of dragomans may have kept travelers from seeking out less accessible and perhaps more representative local subjects. On the other hand, they were a part of the growing tourist trade, became well acquainted with photography, and played the important role of mediating between photographers and the local population, acting as translators or otherwise persuading local people to pose. Hornstein's violent intervention, as related by Raboisson, and the dragoman's distracting call to the Bedouin girl, as described by Harland, fulfilled just this function (see pp. 175–76). But in general, mediation occurred without recourse to violence or trickery.

In the last decade of the century, hundreds of tourists and pilgrims, cameras in hand, visited villages, oases, and townships where photographers and cameras probably had never been seen before. As local inhabitants became more and more accustomed to having their pictures taken, they came to be less

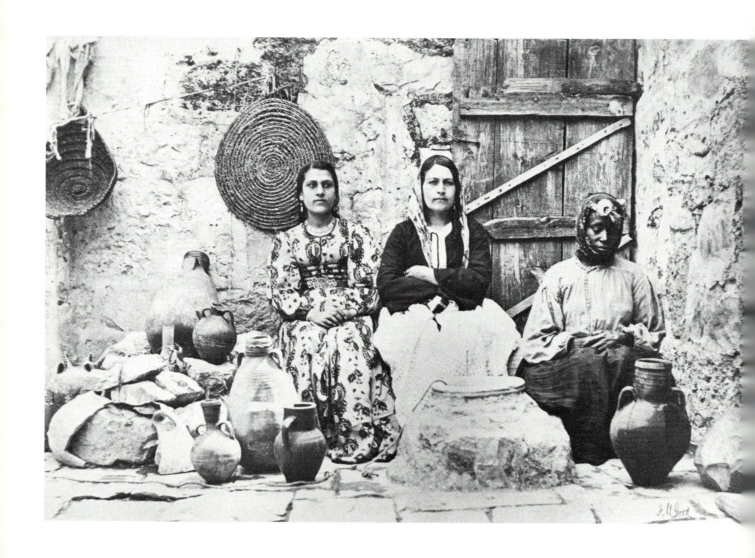

ABOVE: *Frank Mason Good (1874), woodburytype. "Group of Native Women." Also en[titled?]* "Christian Oil Sellers." *(Jewish National and University Library, Jerusalem)*

RIGHT: *R. E. M. Bain (1894), halftone reproduction. "Travelling in Galilee (Mark 3:7[...] As they travel to-day, they have always traveled, and there is no doubt that our Saviour [wit]nessed many just such scenes as the one here photographed. A couple of boxes are strapp[ed ...] the back of a mule or donkey so that one box balances the other." (Jewish National and Un[iver]sity Library, Jerusalem)*

suspicious of photographers and more cooperative. They quickly learned that posing could be a paid service providing welcome added income.

In the 1880s and the 1890s, villagers (fellahin) and nomads (Bedouin) living along the most frequented routes were photographed frequently. Bain took a picture of peasants plowing in the Plain of Esdraelon. Unlike Deverell, Bain knew how to persuade local inhabitants to pose: "When the people you see plowing . . . were asked to stop long enough to let us take their picture, they promised to do so on condition of receiving baksheesh and for this favor they thought a shilling a proper compensation."[35] There was obviously a learning process taking place on both sides of the camera. People learned to charge for a pose, and travelers learned that a fee was expected as for any other service rendered.

The learning process even affected Moslem women, who had less contact with strangers. In Bethany, close to Jerusalem, Harland had two women "bribed with a few 'metalliks' [pennies] to stand upon the platform of their house to be photographed [as] representative matrons."[36] Money, which clarified the purpose of the act, made the relationship between photographer and subject acceptable to local inhabi-

tants, even when they were women. It was part of the Moslem woman's traditional duties to take care of income, and this role apparently overruled codes that forbade her being photographed. In a Bedouin camp near Bethany, women even exhibited an understanding of the technicalities of photography. Harland wrote:

There are twelve children, handsome with merry black eyes. We begged to be allowed to photograph a group drawn up in unconscious effectiveness across the open tent of the "reception room", and it was pleasant to see the sheikh's son persuading them to stand still. Our diffident petition to be allowed to execute pictures of the village and its inhabitants meets with ready assent; the women (unaided by the men, we notice) eagerly looking, draw back the western curtain to let in a stream of light on an interior, that even thus shows obscurely upon the developed film.[37]

Here the learning process was already in an advanced state.

Willingness to be portrayed was motivated not only by monetary reward but also by the positive interaction between traveler and native that may have preceded the actual photographing. Once the presence of a stranger was no longer considered menacing or obtrusive, his desire to take photographs ceased to invite opposition and even evoked interest. Gautier tells the story of Bedouins near the Dead Sea who

examined with interest my photographic operations and were enchanted by my "viewfinder," uttering joyful exclamations of surprise when they detected their next of kin reproduced in a small glass square. I observed with some astonishment that the women mixed freely with the men, who also permitted them to take a peep into the small mysterious gadget of the European traveller.[38]

Gautier took several unobtrusive snapshots of the Bedouins here, who, according to his report, did not object. It should be mentioned again that Gautier spoke Arabic and most likely knew how to introduce himself and his "gadget" to his hosts. Moreover, tourists were not a novelty among the Bedouins of this region.

Gautier's most outstanding story concerns Hounin, a northern Galilee village inhabited by Shi'ite Moslems, the Metaouili. The story has two aspects, the first of which is Gautier's ability to interact. The Gautiers developed a close relationship with their hosts because strong rains forced them to extend their stay. Their prolonged visit allowed Gautier to enter into long conversations with the villagers to the point of his qualifying their relation as "almost intimate." He and his wife were particularly impressed by one of the men, Oakid, whom Madame Gautier photographed with his two small sons. Another of her photo-

graphs showed the house of the village elder (Moukhtar) with three young men standing in the foreground. Again the villagers did not object to being photographed by a foreign woman.

The Gautiers' experiences suggest that when the stranger was accepted or spoke the local language, his requests for poses were also respected. There was little or no opposition as long as no local codes or customs were transgressed. Ability to communicate and friendly attitude helped the photographer to be admitted, to gain his host's trust, to move and photograph freely. There was no mention of baksheesh money.

The second aspect of Gautier's story involves the local inhabitants' understanding of the image-making process. Although Gautier recognized the Moukhtar and Oakid as having appeared in one of Bonfils's photographs (see chap. 6, p. 159), it was his opinion that the Hounin Metaouili had not yet had the occasion "to have even the superficial contact with modern civilization which other inhabitants of the Holy Land have had. So many things are still new and unknown" to these people, Gautier wrote, and he added in a surprising footnote:

I tried to show them photographs, including photographs of some of those present. They stared at the image and, unable to enravel the similarity, they resorted to conjectures that seemed to them plausible, supposing that these were without doubt photographs of "the Sultan" or "the Priest."[39]

The Moukhtar and Oakid faced a camera twice and yet the function of photography remained obscure to them.

That the Hounin villagers could refer to pictures of the sultan and the priest shows not only that such pictures existed but also that they were known in quite remote parts of the Ottoman Empire. The priest in this region might have been of the Shi'ite branch of Islam that did not prohibit portrayal; however, the sultan could be none other than the Sunni Moslem ruler of Constantinople, Abdul Hamid II. Oakid and the Moukhtar apparently identified their own portraits with the only ones they knew, probably from a visit to a Metaouili township. To them, a portrait connoted a ruler or a notable, someone of superior social status. This connotation was strong enough to overshadow the perception of the referential link between a portrait and its subject, between the action of the camera and its result.

Generalizing further, it is possible to infer that many local inhabitants posed for photographers without considering the result of the process, simply to fulfill a guest's request. The fact that Gautier's hosts did not recognize themselves suggests that in many places photography was an entirely one-sided

affair. Consent to pose did not necessarily indicate knowledge of photography as an image-making technique, at least in the early period of portrait photography. Complementarily, opposition to photography sometimes may have had little to do with traditional opposition to images.

The story of the acceptance of photography can be graphically schematized by a system of concentric spheres. If we locate the photographers in its center, the first sphere would show their exclusive orientation toward landscape and the local population's ignorance of photography and its function in portrayal. In the second sphere, guides, guardians of holy places, and other people who maintained business contacts with travelers and explorers would be found. The third sphere would then include people living and working along routes frequented by travelers, such as street merchants, beggars, and villagers in the markets and fields, with women sometimes excluded. Moslem women and Orthodox Jews would populate the fourth sphere, exemplifying those strata of the population whose access to photography and other innovations was limited due to sociocultural constraints. Both groups lived in relatively closed environments and refrained from contact with strangers. The boundaries of these spheres might be imagined to be of irregular form, since factors such as remuneration or favorable interaction between photographers and local people may have encouraged particularly rapid acculturation among certain individuals and groups within the more distant spheres.

Frank Hurley, Australian Imperial Force (1918). Colonel Fan and Moslem women. (Australian War Memorial, neg. B–1650)

PHOTOGRAPHY
Part IN
Three
PRINT

Travel and Pilgrimage
Albums and Books
1886–1899

8

By 1880, Holy Land pictures were no longer a novelty in London, Paris, New York, and other metropolitan centers. Photographs of the most popular sites were freely available in the form of loose prints and stereoscopic pictures and in albums. It seemed that nothing could be added to the work done by wet-plate photographers in the earlier decades.

Three important developments altered this situation, although none brought about immediate change: the availability of new subjects, the introduction of dry-plate photography, and the invention of an efficient process of photomechanical reproduction.

Demographic and physical changes occurred in the Holy Land in the 1880s and 1890s. New buildings and quarters, mostly in Jerusalem, were being constructed by the European powers, especially through their ecclesiastic and missionary arms. Colonies sprang up near Jaffa, Haifa, and Jerusalem, settled by the German Templers, a Christian sect that chose Palestine as its home out of deep religious convictions, establishing communities Germanic in style and spirit. New Moslem villages were created as a result of increased immigration, encouraged by Sultan Abdul Hamid II, who had an interest in economic development and was concerned about the growing Christian and Jewish presence. Palestinian Jews continued to create new quarters outside Jerusalem's city walls and even attempted to establish agricultural settlements near Jaffa and Safed. In 1882 the first wave of modern Zionist immigrants arrived, and Jewish settlement activity took on new proportions. These developments furnished late-century photographers with a fresh set of subjects.

At the same time, two important technological improvements made both the taking and reproduction of pictures easier and cheaper, bringing photography closer to what it is today. The dry-gelatin emulsion, invented in 1871 in England by Dr. Richard Maddox, freed the photographer from the cum-

bersome and laborious wet process. The new dry-negative glass plates (and, from 1889, celluloid films) were factory produced well in advance of the actual picture taking and sold ready for use. The photographer had only to insert the plate in the camera, aim, focus, and snap the picture; he could have the negative developed after returning home. The new emulsion was significantly faster and responded to exposures in split seconds. Because the ready-made dry plates were easier to transport than a complete set of darkroom equipment, remote sites became more accessible. Moreover, shorter exposures meant the possibility of photographing everyday life less obtrusively.

The earliest evidence of the use of dry-plate photography in the Holy Land is a story related by Abbé Raboisson, the first to encounter a problem the wet-plate photographers had been spared. Raboisson had to get his precious boxes of dry-negative glass plates, sensitive to light, through customs undamaged. For the customs office in Alexandria, Egypt, where Raboisson landed on February 8, 1882, the problem was a novelty. Raboisson vividly described his predicament:

What will they do with my packages at the customs? My two boxes of prepared glass plates concern me very much. If these savages demand to see their contents, will I be able to explain that these objects are lost from the moment they see the light? If they persist, will I be able to get their permission to open them only in the red light of the laboratory of a local photographer? And if they disagree! and if they use force to see—a story of this profession's curiosity! here, my lost glass plates! and my brilliant photographic hopes totally ruined!

Finally the director of customs, who spoke excellent French and understood the problem, allowed Raboisson to keep his boxes closed.[1]

A decade after the introduction of dry-plate photography, a second invention of even greater consequence became available: a highly efficient process of reproduction was introduced by S. H. Horgan in America and by George Meisenbach in Germany. Known as the halftone printing process, it made possible the direct reproduction and multiplication of photographs by ordinary letterpress printing presses on ordinary paper. Publishers could print photographs—immediately recognizable as such—on the same pages and with the same machines as the text. The original picture was rephotographed on a metal plate through a fine screen that divided the image into dots—black surfaces into larger dots, bright surfaces into smaller ones—which, etched and covered with ink, reproduced the original photograph in continuous black, gray, and white surfaces, thanks to the invisibility of the dots to the naked eye. The result was a substantial loss of sharpness, brilliance, and detail compared to the original, but the ease of reproduction and use of ordinary paper made publishing immensely cheaper. Illustrated books and magazines

began to profit from the processes even before newspapers converted to them. The first book so printed concerning the Holy Land was published in Paris in 1887; written by J. T. de Belloc, it was illustrated with reprints of Bonfils's photographs together with some drawings.[2]

Photomechanical reproduction of photographs was not a new idea. It had been practiced on an experimental basis since the time of the daguerreotype. Holy Land photographs were reproduced by the early reproduction processes since the 1870s. Vignes's photographs of Duc de Luynes's exploration party had been photomechanically reproduced by steel engraving in 1876; in 1871 Warren had had some of Phillips's and Bergheim's photographs reproduced by woodburytype, an early and high-quality photomechanical process based on carbon; and all of Good's photographs had been reproduced by this process in 1875 and 1882. Almost all the Holy Land albums and illustrated books published in the 1880s contained reproductions made by photogravure and phototype. From the 1890s the halftone process was used almost exclusively in the publication of photographs from the Holy Land.

In contrast to the 1880s, during which only one major and two minor contributions to Holy Land photography were made, the 1890s witnessed an outburst of photographic activity. The generalized use of dry-plate negatives and the halftone process facilitated the publication of albums and books with hundreds of photographs. The ease of reproduction made it possible to publish large-scale works at popular rates, while reduced prices made it equally practicable to publish for small, specific audiences. The number of photographers, both amateurs and professionals, who could find outlets for their work increased dramatically. These changes also had local repercussions: missionary photography emerged, and the first illustrated magazine to cover the country comprehensively started to use halftone reproductions in 1890 (see chap. 9). Arab and Jewish photographers began to join the ranks, and the first book using the halftone process produced by a local photographer appeared in 1899 (see chap. 10). Holy Land photography reached the threshold of mass communication.

During this period, the publisher, editor, and writer came to have an unprecedented influence upon the photographic image of the Holy Land diffused in the West. Editors and publishers could select photographs from the stock of Holy Land pictures for their albums instead of working with one photographer. Furthermore, productions of low-priced books made use of the work of unpretentious amateur photographers, sometimes the writers themselves. Freed from the need to make their living through the sale of photographs, their results, although technically and aesthetically less satisfying, were sometimes more interesting than those of the professionals.

While a greater proportion of portraits began to appear in photographic albums and books (see chap. 6), the emphasis remained on landscape photography, which saw some formal innovations. The nuance noted earlier, distinguishing between Protestant and Catholic traditions (see chap. 4), continued to hold; the collections of a Swiss and an American team emphasized nature and the open countryside, while two French albums focused on architectural landmarks. A similar trend was perceptible in smaller, less ambitious albums and illustrated books published at this time. Protestant authors, editors, and publishers from various countries preferred photographs in which nature and everyday life played a more pronounced role, while their Catholic colleagues displayed commemorative buildings and ecclesiastical institutions more prominently.

These deep-rooted cultural predispositions sometimes mingled with political propaganda. The 1890s were a period of intensified rivalry among the colonial powers over the Middle East, and this was often expressed in photographs and captions. While conventional sites were not omitted, photographs of establishments built by the respective powers were introduced. Thus, there appeared, along with the Protestant and Catholic Palestines, also a French, a Russian, a German, and an English Palestine (for the last, see chap. 9). In the 1890s Holy Land photography became a channel of religious and political propaganda, meant to reach and influence relatively wide audiences.

LATE-CENTURY LANDSCAPE PHOTOGRAPHERS

Only one comprehensive photographic study of the Holy Land was published during the 1880s, and it appeared at the end of the decade. This was the work of F. and M. Thévoz of Lausanne, Switzerland, who visited the region in 1887. Their twenty-volume series of phototype reproductions, *La Palestine Illustrée*, was published in 1888–90 and included 166 photographs of western Palestine with explanatory texts on opposing pages.[3]

The Thévozes' work included the first innovation in the composition of landscape photographs: an emphasis on foreground elements. Thus, the opening scene in the first volume, *From Jaffa to Jerusalem*, while superficially resembling Bonfils's introductory showpiece, uses a low angle to emphasize round rock formations in the sea off the Jaffa coast. These formations stand out in the foreground in striking contrast to the rectangular houses on the hill in the background. This highlighted the contrast between untouched nature and signs of cultivation, a recurring theme in their album. The following picture, "Gar-

F. and M. Thévoz (1887), phototype. "Hebron." (Jewish National and University Lib Jerusalem)

dens of Jaffa," featured an entirely new stylistic device: the gardens were seen through a dominating black silhouette—the columns and arches of an oriental veranda. Framing the landscape with a decorative pattern, characteristic of the region, gave the picture a local flavor.

The olive tree, rich in biblical allusions, also figures prominently in the foreground of some Thévoz pictures. The Church of the Ascension, on the crest of the Mount of Olives, for example, is seen from behind two impressive ancient olive trees, which embrace the little church from either side, occupying most of the surface of the picture. The balance of foreground and background creates a relationship between the tree and the church. An olive tree also stands almost in the center of a photograph of Hebron, concealing a considerable portion of the town. In these cases, the information content is deliberately sacrificed to the connotative and the aesthetic.

In some views, the pronounced foreground elements were used to represent uncultivated land. In "The Plain of Sharon," a large thorn bush covers almost half of the picture, concealing much of the tilled fields of the plain in the background, to which the title refers. The bush was not beautiful enough to

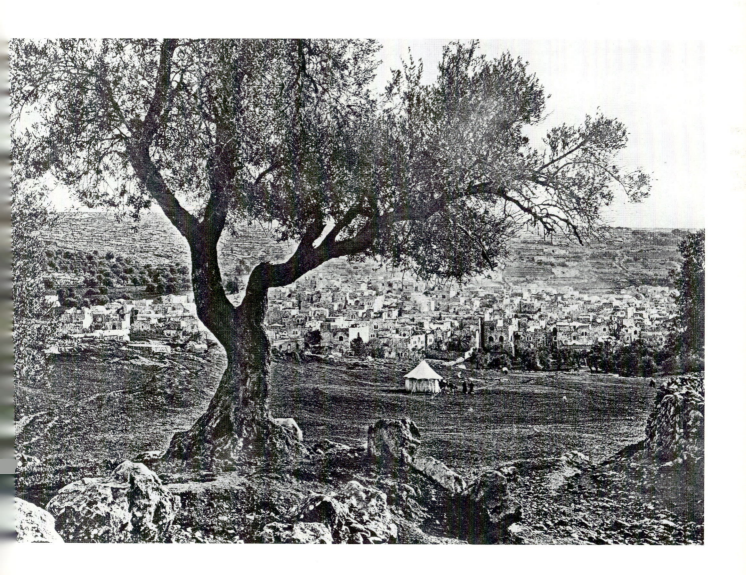

justify the arrangement on aesthetic grounds and was too prominent to be perceived as a purely compositional element, providing a sense of depth. In a picture taken in a hilly area, a heap of rocks in the foreground, brought to prominence through a low angle—as in the view of Jaffa harbor—emphasized the stony look of the fields in the background. The rocky character of the landscape was enhanced by the cold grayish hue in which the photographs were printed.

This representation of the Holy Land was fairly accurate. Indeed, large portions of the plains lay barren; the mountainous areas of the country (in which most biblical events had taken place) were particularly rocky. The houses were built of stone, the Arab villages were integrated into the rocky hills, and the cultivated slopes were terraced with stones.

Earlier photographers had rarely employed this kind of composition. Frith and Bedford used the foreground only in a few cases; in Bonfils's work it occasionally added perspective; Frank Mason Good employed it to a slightly larger degree. In the Thévozes' work, however, it was more prominent and took on new meaning, adding a touch of interpretation.

In addition to their innovations in composition, the Thévozes were the first photographers to respond to the beginnings of modernization. Their picture of the Templer colony of Sarona is the first published photograph to allude to the presence and activities of this twenty-year-old community. Sarona was in no way a holy place or an oriental landscape; it was a European village on the coastal plain, far from the main theater of biblical events. Even the text points to the modern character of the colony, indicating that the windmill in the background of the picture was used to produce electricity. Other contemporary sights include a hotel on the road to Jerusalem and the growing harbor town of Haifa. A picture of a stranded steamer near Gaza might qualify as a modern news report: "Our plate shows a merchant ship wrecked by a storm which indicates the distance one has to keep from the shore to avoid similar accidents." Both geography and topicality may be perceived from these photographs.

Though the Thévozes used ten landscapes for every picture involving people, the very fact that they included five studio portraits, eight outdoor scenes, and a few pictures focusing on dwellings was an innovation.[4] No credit is given, but the five portraits can be attributed to Bonfils—some appeared in albums and books published before the Thévoz trip, while others were used in later books with or without Bonfils's signature. These were of local inhabitants: a Bedouin sheikh, a "fellah" sheikh, a "Turkish Woman in Jerusalem," a "Bethlehem Woman," and a "Jerusalem Jew."

Six photographs in the Thévoz collection, apparently taken by the authors, portrayed people in real-

life settings. The subjects included a group of leper women, a group of Bedouin women grinding corn and making butter, a Bedouin family sitting in front of a hut, a Syrian laborer, and a group of men sitting in a Bethlehem courtyard. The photographic quality of these scenes in terms of overall sharpness, lighting and composition was significantly inferior to the Bonfils studio portraits, and the staging was so artificial that the presence of the photographer was felt throughout. Lack of experience and poor communication with inhabitants apparently prevented the Thévozes from recording more scenes of everyday life.

La Palestine Illustrée represents the first attempt by a commercial publisher to print a large work showing the Holy Land as a geographical unit. While photographs of holy places and historical sites were not forgotten, they lacked the prominence they had enjoyed, for example, in Bonfils's *Souvenirs*, the most recent predecessor of the Thévoz album. The collection, exhibiting the Protestant nuance, was reminiscent of P.E.F exploratory photography.

Six years later, in 1893, a French team composed of a writer and a photographer arrived in Jerusalem. The writer, Charles Lallemand, was also a painter and had visited the area thirty years before.[5] With his photographer, M. Gervais-Courtellemont of Algiers, Lallemand traveled to Egypt and on to Jerusalem, intending to produce a series of art books about the Mediterranean region. The French team worked under favorable conditions. Lallemand tells us that "during our trip, we were often accompanied by soldiers ordered by the Ottoman authorities to protect Courtellemont's work . . . and above all, his equipment. . . ."[6]

French author Pierre Loti, who himself visited the Holy Land, believed that this photographer could capture the "most fugitive aspects."[7] Courtellemont's twenty-four Jerusalem street scenes in his album *Jérusalem-Damas* are indeed the first published snapshots to capture people unobtrusively. Sometimes the subjects face the photographer; at other times they seem unaware of his presence. Most scenes are of busy markets and streets and include passersby and their animals; there are pictures of Turkish soldiers, Greek priests, Arab women with baskets on their heads, Ashkenazic and Sephardic Jews.

Courtellemont dared to get close to people. While Arabic spoken in Algeria, which he probably understood, is different from that in Palestine, the general rules of conduct are similar, and this similarity helped Courtellemont to stroll freely with his camera. The only posed portrait is of a Bethlehem woman, the classic subject.

Courtellemont considered people and buildings as two distinct subjects and photographs of them as two distinct categories. The snapshots are of excellent technique but are small, lack variety, and, to use

the contemporary expression for ethnography, do not depict "manners and customs." True, the photographer took pictures of different ethnic groups, but he limited himself to market scenes and street scenes.

Courtellemont's photographs of Jerusalem are devoted mainly to the city's impressive buildings. Less innovative with his conventional views than with his snapshots, he presented the known places in thirty-three well-composed pictures, many of them covering the length of the page. Gervais-Courtellemont's Jerusalem is a beautiful city of beautiful structures, sometimes framed by trees. This photographer, in line with the French-Catholic tradition, did not depict nature or landscapes outside the town and tended to focus on architectural views.

Gervais-Courtellemont's photographs were laid out carefully, often dissolving softly into the white page. Reproduced in photogravure some street scenes were printed in gray, others and all architectural subjects were in deep green and reddish-pink. Full-page photographs of famous buildings were protected by a semitransparent sheet of paper. This was an art book by a publisher specializing in the field; the author was a painter himself. The result of their collaboration with a highly competent photographer was a pageant of architecture presented in an ornate layout.

An entirely new idea in Holy Land photography was conceived by three Americans: John H. Vincent, founder of the well-known Chautauqua movement of church education; Dr. James W. Lee, a writer; and Robert E. M. Bain, a prize-winning photographer who later became president of the American Outdoor Photographers' Association. The idea was to "bring out a book illustrating the earthly life of Christ and the Apostles" by photographing "the places and objects made sacred by their life . . . accompanied with description from personal observation."[8] Under Vincent's instructions, Lee and Bain visited the region in the spring of 1894 in a grand style:

We passed through the interior of Palestine with a caravan consisting of four tents, five mules, four horses and eight men, including dragoman, cook and waiter. We carried letters of introduction from the Secretary of the Interior, from Dr. W. Harris, Commissioner of Education, and from the President of the United States. We had the best advantages that could be afforded by the courtesy of our Foreign Ministers. A few days after our return the National Photographers' Convention met in the City of St. Louis during the month of July, 1894. Mr. Bain entered a number of the first pictures developed and for super excellence was awarded a medal on them.[9]

The two large-format volumes, entitled *Earthly Footsteps of the Man of Galilee and the Journeys of His Apostles*, contained 384 photographs, about half of them (196) from western Palestine, the Holy Land proper. This apparently was an American enterprise in spirit and in volume, a result of the new

technologies—dry plates and halftone reproduction. It was the first album conceived in advance as a picture-text combination following the New Testament narrative. While the photographs remained the dominant element, the introductions and detailed captions directly oriented the reader toward specific interpretations.

The aim of historical-traditional continuity implied in the title, however, was not realized even in the opening sequence of the first volume. Apparently the authors were unable to follow their original intention, and their work became transformed into a loose and general travelers' account, leaving the burden of associating pictures with biblical references to the text. So, for example, a caption for a street scene in Nazareth reads: "We give a view of the wheat market in Nazareth, the town in which Christ grew up. The scene which we witness above has been one common doubtless in all ages of the town's history." There followed another photograph of a nature scene with shrubs and trees in the foreground and hills in the distance captioned: "The Gardens of Shunem, where Elisha restored the dead child to life." The travelers' tents and caravans, the open countryside around Bethlehem, the English Orphanage, gardens, a steam mill, flowers—all these appeared in the album; in short, Bain and Lee created a decisively new image of the land of the Bible, even while abandoning the no less novel original idea.

Earthly Footsteps not only deviates from the album's declared intentions, but also from the actual itinerary of the team. A photograph of Matariye in Egypt, where Joseph and Mary fled persecution, leads into a series of forty-seven photographs showing contemporary life in Egypt, a military parade, mummies in the National Museum, and pyramids and mosques in Cairo—hardly relevant to Christ's life. The third sequence brings us back to Palestine but is not linked to the Old or New Testament.

The second volume opens with views of the sources of the Jordan in the far north of the country. Its first part contains fifty-seven photographs in no discernible order, including subjects from the first volume photographed from slightly different angles. The reader is then whisked north to Europe and eventually to Rome, but not before seeing pictures of modern Christian institutions in the Holy Land. *Earthly Footsteps* was a tourist guide in the pilgrimage tradition. It presented Egypt, the Holy Land, Turkey, Greece, and Italy in a much expanded version of Bedford's Mediterranean tour.

Despite Lee's stress on originality in his introduction, only a few of the photographs were actually signed by Bain, and only two-thirds of the unsigned ones were obviously his. While all of the photographs of everyday urban and rural life and of nature, and most of the landscapes, can clearly be ascribed to him, seven others bear the partly erased signature of Zangaki, a Greek photographer working in the region,

and four are Bonfils productions. Other unsigned photographs may safely be attributed to these two.

Of the 196 photographs of the Holy Land, about 100 were of popular historical sites, 50 dealt with contemporary life, and 40 were of nature and open landscape. Though these numbers are similar to the Thévozes' subdivision of themes, they do not tell the whole story. Rock and stone figured in less than a third of Bain's nature scenes and his pictures of everyday life were clearly not Bonfils studio portraits.

Bain's treatment of the landscape bestowed a fresher, lusher look, making the structures and ruins seem much less severe than in the work of Frith, MacDonald, Bonfils, and the Thévozes. Bain's Palestine was the Land of Milk and Honey.

Many times nature itself was the main subject of his photographs. For both writer and photographer nature held transcendental as well as pictorial value. Lee described their mood in the introduction: "We stood amid the scenes of His prayer, tears, sermons and wonderful works, and transferred them, with the blush and bloom of Palestine, to the delicate, sensitive surface of our glass plate." One caption is especially laudatory: "The wild flowers of Judea [Matt. 6:28]—No more appropriate place can be found for calling attention to flowers than in Palestine."

F. and M. Thévoz (1887), phototype. "Tel al Foul." (Jewish National and University
ry, Jerusalem)

E: R. E. M. Bain (1894), halftone reproduction. "Tiberias." (Jewish National and Uni-
y Library, Jerusalem)

Bain sometimes obtained his effects by photographing nature scenes from a close range, emphasizing a stream, a bush, or branches of trees. On the other hand, he obtained large panoramas of hills, fields, or rocky terrain by taking long-range pictures in which he showed only the outline of the landscape, without detail. While photographing walls and buildings, he chose angles suitable for including plants or leafy branches in the foreground. Thus, Jerusalem's walls and gates were shown with foliage, the Temple Esplanade was softened by trees and bushes, and pictures of ruins in Tiberias were alternated with those of palm trees. Bain's only photograph from the shores of the Dead Sea brought life to the region by including a person, a hut, and a boat. Further enhancing the sense of a closeness to nature, both text and pictures in *Footsteps* were printed in gray-green ink.

Bain did not choose or stage his pictures to illustrate Bible stories literally; he alluded to the scriptures through nature and landscape. His interpretation was loose, his human subjects emerging as part of their natural environment. It was Lee's text that provided the biblical references. For example, a Bain view taken in Dothan showing open pastures with sheep and a shepherd in the distance is captioned: "Flocks near the pit into which Joseph was thrown by his brethren. We see the flocks feeding on the hills of Dothan and the young shepherd we see watching them has on his coat of many colors very much like that which excited the envy of Joseph's brethren." Sometimes Lee had to make a great effort to link the site to the Bible or find a suitable biblical reference:

Jesus Christ was brought up in Galilee and often travelled through it. This scene is one common to the country. Every day one is likely to meet families travelling just as is here shown. Things never change in Palestine. As they travel today, they have always traveled, and there is no doubt that our Saviour witnessed many just such scenes as the one here photographed.

While Bain did not go so far as to use portraits of Palestinian Jews to represent biblical imagery, the following caption for a landscape does, in a rare instance, identify a Jewish settlement as built by descendants of Abraham:

Roshpina—near where Joshua conquered Jabin, King of Hazor ("Sojourn in this land, and I will be with thee, and will bless thee; for unto thee, and unto thy seed, I will give all these countries, and I will perform the oath which I sware unto Abraham thy father." [Genesis, 26 v.3–1]. Nearly four thousand years from the time these words were spoken to Isaac, we find a village as shown above, built by the Rothschilds, descendants of Abraham in Palestine; the country that was promised to Abraham and built as a place of residence for the Jews. It is a striking and interesting commentary upon the covenant between Heaven and these ancient people, that we find in these last days of the nineteenth century, a disposition on the part of the Jews, which liberal and fortunate men of their race

are helping them carry out, to go back and possess the land of their fathers. Roshpina stands near the waters of Merom.

There are grounds for assuming that Bain's image of the Holy Land was to a great extent molded by his American background and the values generally cherished by his countrymen at that time. The appreciation of beauty, greenery, flocks, farm work, and modernization were all part of what one would expect of an American from the Midwest at the turn of the century.

No other Holy Land photographer produced work of the quality or scale of the Thévozes, Gervais-Courtellemont, or Bain during the last decades of the century.[10]

PUBLISHERS' PERSPECTIVES

The French counterpart to *Earthly Footsteps* was *Album de la Terre Sainte*.[11] It was at once a souvenir album, a guide for pilgrims and tourists, and an inventory of French institutions in the Holy Land. Like *Earthly Footsteps*, the *Album* was produced in a large format with large photographs and short captions printed on the same page.

No photographer seems to have influenced the selection of pictures for the *Album*. Chosen by the publisher and editor, their function, like that of the accompanying text, was to create an image of the Holy Land as a French and Catholic sphere of interest. It was a huge but unsystematic work of compilation, containing 492 pictures, some 300 of which were of western Palestine, mostly work from the Bonfils studio. In many cases it is difficult to trace the origins and dates of pictures, since photographs were furnished by several agencies that also erased the photographers' signatures.[12] Many of the church interiors were taken by Zangaki, whose partly erased signature is recognizable. The sheer quantity of pictures makes it difficult to compare this album with earlier ones. There are fifty times as many photographs as Du Camp took, about ten times as many as in Bedford's or Frith's collections, and almost twice as many pictures as in the Thévozes' and Bain's work. The halftone reproductions were of high quality, printed in a reddish sepia tone that made them resemble original albumen prints. The sepia tone also suited the stone buildings and interior decorations, which abounded in this work. This extraordinary collection appeared as a monthly series (beginning in January 1896), as a three-volume set, and finally as one monumental album. There were versions published in French, French-English, French-Dutch, and possibly in other languages.

Subtitled *Itinerary, from Day to Day, of our Pilgrimage to the Holy Places*, the album was "pilgrim-inspired" and of a decidedly religious character. Its aims were expressed in Abbé Dr. Eugene Bossard's introduction in terms that connote a special blend of religious and political ideology:

In this land, where for centuries there were only ruins, rehabilitation and transformation is under way, and before long the monuments and the land visited by Pierre the Ermit and Bonaparte will be nothing more than memories. Who will not regret it? Who would not like, before the transformation is consummated, to visit these places glorified by the ancient Jews, the first Christians, the Crusaders and our present-day armies? . . . The Maison de la Bonne Presse Publishing House offers the public in response to the needs outlined above the possibility of making the pilgrimage in their thoughts and seeing with their own eyes what our fathers could have done only after long travel with sword in hand. The album, which is highly successful, is a tribute to good taste, religion and patriotism: the Holy Land in fact is not a foreign country to each Christian—it is the country of his ancestors, his fathers; it is his homeland.

Indeed, the album, which displayed a wide array of subjects, had a decidedly political flavor. Following the usual pilgrim's itinerary in Jerusalem, it opened with four photographs of pilgrim institutions in France. Dozens of new Holy Land photographs showed church interiors, mainly of new Catholic establishments, and exteriors of churches and convents, with special emphasis on French property. About a dozen showed new French buildings. The range of French-oriented photographs was considerable, from the French consulate in Jerusalem to a memorial service in the French cemetery on Mount Carmel, where Napoleon's soldiers who had been wounded at St. John of Acre and "massacred in the Mount Carmel Convent by Moslems" were buried. Pictures of French property—the Chapel of St. Anne, convents, hospitals, and pilgrim institutions—usually had a French flag on the roof that had been painted onto the photograph. The audience could have easily concluded that almost all the modern buildings in the Holy Land were French and Catholic.

The already quite numerous English, Scottish, and Austrian institutions were disregarded, the buildings belonging to the massive Russian pilgrim movement were covered in only four photographs, and the flourishing German Templer colonies and other establishments were allotted one picture, of the colony at Haifa. The Jewish presence in the Holy Land and in Jerusalem was largely ignored. Only five photographs—the Wailing Wall, the tomb of Rabbi Meir Baal Haness near Tiberias, and three of the Bonfils "Jewish portraits"—stood for what was in 1896 the great majority of Jerusalem's population, as well as a significant minority in a number of other towns, not to mention the Jewish rural settlements.

A few captions sharpened the message by pointing out particular elements within the pictures. A

fair example is the view of "Old Lydda," in which the ruins of the quite-distant Crusader's Church of St. George are dominated by a mosque with high tower; the caption, however, refers only to the church. Political rivalry even inspired the editor to use overtly propagandistic rhetoric in one of the captions for the four photographs showing Russian establishments, referring to the "immense sacrifices made by the Russians to entrench themselves in the Holy Land."

The *Album de la Terre Sainte* was not, however, an overt expression of French interests. Above all, this was a pilgrim's album taking the reader along mostly familiar tourist routes, and French institutions appeared as an integral part of the itinerary. About a hundred of the photographs used the perennial motifs of earlier collections. In addition, there were pictures of railway stations and the shops near the Jaffa Gate, newer views of towns and villages, and photographs of the desert in the region of the Dead Sea. Desolate landscapes, like those of the Thévozes, or flourishing ones, like Bain's, were rare. This album's Holy Land was primarily a Mediterranean country of small towns, historical sites, churches, and villages. The Bonfils townscapes were well suited to the publisher's purpose—to appeal to the tourist and his armchair twin.

The publisher used pre-1876 landscape photographs of the Bonfils studio, including some that had appeared in *Souvenirs d'Orient* in 1877–78, to show the country as it had been before modernization. He also used, with no indication of the passage of time, photographs from the early 1890s. No dates were indicated and the order was not chronological. So, for example, a careful reader would discover a view of Nazareth strikingly similar to Frith's photograph of 1858, with the tower of the Church of the Annunciation under construction, followed by a more recent photograph with the white tower shining brightly in the center of the picture. Today an editor would probably use such a pairing only for a "before and after" study. In 1896, Old and New Palestine, like the oriental and the European Holy Land, coexisted without explanation in the pages of this collection.

The *Album* is even less accurate in ethnographic terms. Here is a collection of some sixty portraits and outdoor scenes pretending to represent the country's population. None of the pictures shows a craftsman, although in the late 1890s there were dozens of such photographs available, and only one photograph depicts a peasant at work. Even the already traditional picture of two women grinding corn is absent. Fishermen in the Sea of Galilee were there, of course, depicted by Bonfils, but they were static and posed. Notwithstanding a few straightforward photographs of the village population and of Bedouins with antiquated guns and in tent camps, the album relies on genre photographs, mostly Bonfils studio portraits.

If "orientalism" in visual, graphic terms is equivalent to arches, ancient walls, deserts, a few young women in embroidered robes, old shabbily dressed, bearded Jews, and "exotically" dressed "wild" nomads, this is the most orientalist album of the decade, if not the century. At the same time, it is the album that covers most extensively newly decorated church interiors and French institutions, reflecting European presence.

While the *Album* was the largest work of compilation, it was not the only one. Before the century was over, George Newness of London published *The Way of the Cross: A Pictural Pilgrimage from Bethlehem to Calvary*.[13] Although identical to the French album in terms of conception and layout, it was considerably smaller and technically inferior. Like his French counterpart, Newness included pictures from the Bonfils collection, as well as others from unidentified sources. The work contained a total of 240 photographs, including sixteen taken in Egypt and Syria. It opened with several views of Nazareth and Bethlehem, showing their churches, and closed with (Bonfils) photographs of the Via Dolorosa. There were a few pictures of renovated churches or those newly erected on a traditional site, a choice of subject typical of the Catholic nuance perceptible in the French album. Nevertheless, Newness's selection contained more photographs of the open countryside, including such views as dirt roads, hills, and ruins. There were no portraits; in fact, people seldom appeared at all, and the selection displayed no political or national nuances. If the French *Album* was Catholic in tone, then *The Way of the Cross* was the Protestant pilgrim's album of the Holy Land.

An American work of compilation was *Photo-Gravures of the Holy Land*, published in 1891 by Charles M. Stuart.[14] Stuart credited Professor A. J. Marks as having selected photographs "taken by an eminent Oriental artist [Bonfils] during his recent tour through Palestine"; Marks was studying biblical history and geography. In comparison to the *Album*, Marks's and Stuart's fifty photographs show fewer buildings and churches and more open landscapes. There are no portraits or street scenes, and no political overtones are discernible. The printing ink is gray; there is almost no text.

Viewing the compilation albums of the 1890s as a whole, one finds that the Protestant nuance apparent in early Holy Land photography (1844–78) is also found in the *Way of the Cross* and *Photo-Gravures*, while the early Catholic nuance reappears in the *Album de la Terre Sainte* (and in the *Album Missioni Terrae Sanctae*, published in Italy; see chap. 9).

The persistence of this distinction between Catholic and Protestant nuances is also perceptible in Holy Land books produced in a variety of countries, in which photography served merely to illustrate the

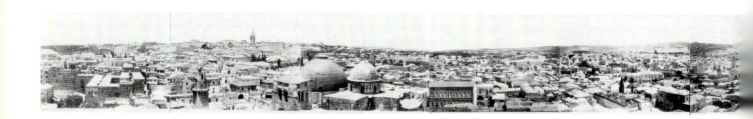

text. This distinction is evident notwithstanding the greater quantity of such books produced by Protestant authors and the varying number of photographs used in each book, ranging from a dozen to more than one hundred. A comparative study of the photographs made by writers, publishers, and editors of various nationalities reveals that their orientation coincided with that of the dominant religious cultures within which these books were produced.

The Protestant nuance is perceptible in a book by Finnish pastor Hilden, published in Helsingfors.[15] It contained photographs from the Beirut collections of Frenchmen Bonfils and Dumas, with an accent on landscape photography. The selection of Dutch preacher J. Krayenbelt is a typical concise portrayal of a Protestant Holy Land.[16] Reverend Boddy illustrated his *Days in Galilee* with photographs taken for the most part by the "American Colony" photographer Elijah Meyers (see chap. 10) in a decidedly "Protestant" manner.[17] Similar selections were made by Swiss pastors Lucien Gautier and Théophile Roller, and by Danish author Edvard Blaumüller.[18]

The Austro-Hungarian Habsburg monarchy, which included many Slavic provinces, was no less Catholic than France. The illustrations in the books on the Holy Land published under the Habsburgs had a strong Catholic tone, although they differed widely one from another. *Palästina, ein Sommerausflug*, by Friedrich Freiherr von Dahlberg, included mostly Bonfils photographs reproduced in halftones and engravings.[19] The more modest *Jeruzalemski Romar*, by Yugoslavian pilgrim Dr. Francisek Lampe, was made up of engravings of his own and Bonfils's photographs and halftone reproductions of photographs by A. Beer.[20] The selection was "Catholic" in both cases.

Both Catholic and Protestant emphases are observable in the German cultural environment, as exemplified by two books, similar in format, published in 1899. Bishop Keppler's 140 illustrations in *Wanderfahrten und Wallfahrten im Orient* are Catholic in tone, while Pastor Tiesmeyer's 166 photographs in *Aus der Heilands Heimat* are in the Protestant vein.[21]

One exception was the Protestant nuance evident in illustrations for *The Holy Bible*, translated from the Latin Vulgate and published with the approbation of the archbishop of Baltimore.[22] This departure from the rule may have been inspired by the American environment in which the book was produced.

In another exceptional case, Abbé Raboisson's selection of Bonfils views and his own photographs for *En Orient* is in keeping with the Protestant nuance, even though the publishing house (and author) was Catholic. This may be explained by Raboisson's professional interest in geography and botany. There are similar Protestant accents in a booklet published by French pastor Théophile Calas, illustrated with

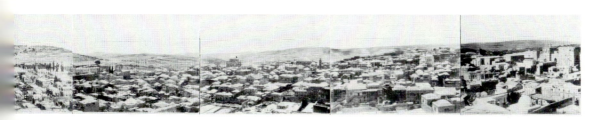

*Panorama
of Jerusalem
pp. 206–11*

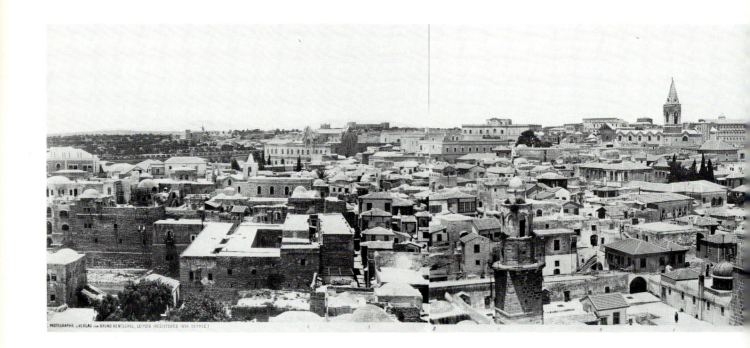

PHOTOGRAPHIE u.VERLAG von BRUNO HENTSCHEL, LEIPZIG (REGISTERED 1899. DEPOSE.)

his own amateur photographs and several others taken perhaps by a friend.[23] Apparently, the author's Protestant background had a greater impact than the French (Catholic) cultural environment in which he lived.

There is one case in which Catholic subjects are favored by a Protestant author. A booklet produced by Reverend James Smith and published in Scotland is decidedly Catholic in tone despite the use of some photographs by Bain and the P.E.F.[24]

The preferences of publishers and writers were expressed not only in terms of Catholic and Protestant nuances but also with respect to their national backgrounds. In this period, in which the powers were already heading toward a worldwide confrontation, photographs were used to display each country's strongholds. As in the case of the *Album de la Terre Sainte*, German publications, such as those of Bishop Keppler and Pastor Tiesmeyer, supplemented descriptions of the Holy Land with pictures of their own institutions, carefully omitting those of their rivals. Pastor Ludwig Schneller, related to the founder of the Syrian Orphanage in Jerusalem, also published a book illustrated by photographs in which German

Bruno Hentschel, panorama of Jerusalem (1898). Taken from the tower of Redeemer Church inside the Old City at the time of its inauguration by Emperor Wilhelm II of Germany. (The tower is visible with its triangular white roof in Ruffier's photograph of Jerusalem, p. 38.) (White Fathers, St. Anne's Convent, Jerusalem)

Left to right: in foreground, Pool of Hezekiah; on the horizon, the windmill today near Kings Hotel (west Jerusalem); Latin Patriarchy and the Ratisbonne Convent.

Franciscan Convent of St. Savior, center rear.

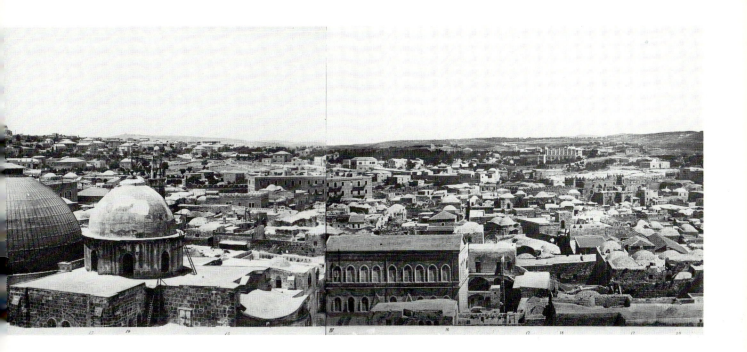

(and Protestant) subjects prevailed.[25] An obvious German subject was the visit of Kaiser Wilhelm II in 1898, which itself occasioned the publication of three German books illustrated by photographs.[26]

A similar emphasis is apparent in Russian productions and photographic collections, although a detailed study of the scanty Russian material does not seem justified. Russian activity is exceptional in that it consisted solely of compilations of photographs, primarily from non-Russian sources. Almost no Russian photographers are known to have visited the country, and only a few pictures taken by Russians were reproduced. There were no Russian illustrated books; all productions were portfolios reproduced in phototype or booklets with engraved reproductions and short captions.[27]

AMATEUR PHOTOGRAPHY

Late-century photography saw the emergence of "amateurs"—Raboisson, for example, "learned the secrets and practices of the new photographic process" from a friend in five or six lessons during the month

Left foreground, Domes of the Church of the Holy Sepulchre; left, on the horizon, the Abyssinian Church; center, Nebi Samuel overlooking the road to Jaffa, today the highway to Tel Aviv; right, the new quarters outside the walls (Mea Shearim, etc.).

Foreground, inside the walls: the Christian quarter; outside the walls, place of Tomb of the Kings and St. Stephen's Convent; to the right of center, Damascus Gate (seen from outside the walls in McDonald's panorama, pp. 91–94).

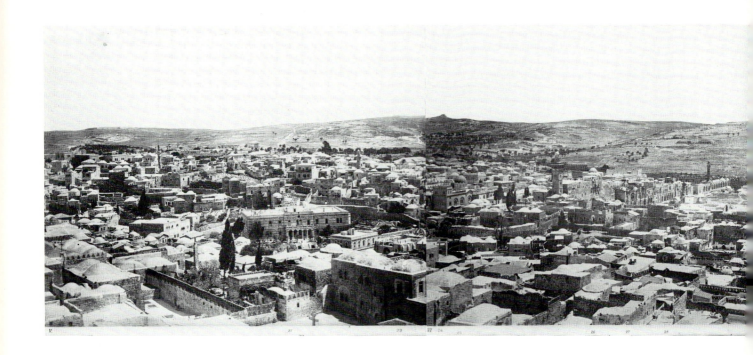

before he left for the Near East.[28] In the 1890s the Kodak camera and similar simple equipment were introduced. The voluminous number of high-quality photographs taken by professionals left amateurs to treat subjects that were perhaps less attractive commercially: rarely visited sites and regions, everyday life, "unpicturesque" people, in short, the country as it was. Though technically inferior, the amateurs' photographs were often fresh and realistic. The lack of commercial constraints and artistic ambitions lent them the same advantage that exploratory photographers had had in the 1860s.

In contrast to Goupil-Fesquet, Bridges, and Frith, who wrote texts to accompany their images, amateurs took pictures to supplement their texts. Many authors used their own pictures or those taken by their friends, along with (or even without) purchased perennial views. Some books included photographs taken by the authors' wives, who accompanied them in their travels. Mrs. Gray Hill,[29] Madame Lucien Gautier (significantly not identified by their own first names), and possibly Marion Harland (pseudonym for Mary Terhune) were the first women photographers to arrive in the country. The German empress followed them in 1898 (see also chap. 7).

The Moslem quarter; right of center, the Austrian Hospice on the Via Dolorosa.

In the background, Mount Scopus and the Mount of Olives; middleground left, Convent of the Sisters of Zion and Compound of St. Anne on the Via Dolorosa; middleground right, Temple Esplanade; foreground, Moslem quarter.

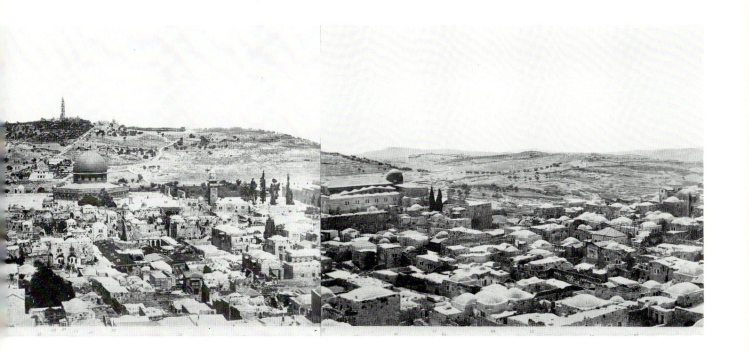

Perhaps the most interesting amateur photography was taken by the Gautiers. *Autour de la Mer Morte* (1901) contains thirty-four illustrations made by Gautier himself, and *Souvenirs de la Terre Sainte* (1899), describing their visit to western Palestine in 1894, was illustrated with fifty-nine photographs taken by his wife. The second book covered the country as a whole, but from a completely new angle. Not a single picture of Jerusalem or any of the well-known historical sites is included, though the title implies no such restriction. Out of the four hundred or so photographs they had taken by the end of their travels, they preferred "to reproduce those landscapes generally neglected by the professional photographers."[30] Gautier specifically mentioned the Thévozes' *La Palestine Illustrée* (which had the same Lausanne publisher) and the Bonfils collection and was no doubt aware of the work of other contemporary photographers. When selecting pictures for publication, he must have taken these works into account. The familiar Palestine scenes photographed by his wife were discarded. The novelty was in her unposed snapshot portraits matched by unpretentious landscapes, simply showing the country along the route she and her husband had traveled, mostly in out-of-the-way places not generally visited. She photographed

Background center, Mount of Olives, the Russian Tower of Kefr-a-Tour; center, Dome of the Rock (see Bedford's photograph, p. 74); background right, the Jewish cemetery on the Mount of Olives.

Far left, Mosque of El Aksa; below it, top of the Wailing Wall.

open spaces without any special landmarks, natural or otherwise, as well as villages and hills without foliage—places where, as her husband put it, "nothing was of interest." In comparison with previous photographs, these views were characterized by a less structured composition, which gave the landscapes an accent of simplicity and lack of embellishment. One has the impression that this is the way the country looked: the bright light, the flat, dusty countryside, dull but real.

There were also amateur photographers who followed the paths beaten by the professionals, producing carelessly snapped, mediocre photographs whose only merit was to have been taken by the traveler himself.

The work of amateur photographers whose originality deserves mention includes Boddy's pictures of himself bicycling along Jerusalem's city walls, geologist Max Blankenhorn's photographs of the area around the Dead Sea, and Professor Gustav Dalman's ethnographic photographs first taken and collected in 1899 and 1900.[31] Dalman's use of photography essentially belongs to the twentieth century.

The large late-century albums—*La Palestine Illustrée, Jérusalem-Damas, Earthly Footsteps,* and *Al-*

The Jewish quarter; left, the synagogue Nissan Bak; right, the synagogue Hurva (see de Clercq's calotype, p. 59).

Left rear, city wall, Zion Gate, and upper part of Jewish quarter; right, Armenian quarter with St. James cathedral, rear, far right.

bum de la Terre Sainte—and the numerous travel and pilgrimage books illustrated by photographs close a period of Holy Land photography.[32] No other albums of this stature were produced until after the fall of the Ottoman Empire in 1918, and the number of photographs in books declined in the early 1900s. Moreover, the turn of the century witnessed a significant change in style. While the last traveling photographers of the nineteenth century were still primarily preoccupied by their subject, the first twentieth-century traveling photographer to visit the country in 1901, Dwight L. Elmendorf, was by far more aware of the formal possibilities afforded by photography.[33] He was the first traveling photographer to depart from the subject-dominated approach of the previous century, shared by professionals and amateurs alike. He favored instead a more form-consciousness approach, of which the Thévozes in 1887 were the precursors (Ben Dov and Larsson, local photographers active in the 1900s, shared this new approach). The first years of the twentieth century ushered in a new period in Holy Land photography.

Left to right, *in background, Christ Church, windmill of Mishkenot Shaananim, David's Tower, and Citadel.*

Missionary Photography and Photojournalism, 1885–1899

9

The new photographic technologies of the 1890s that made picture taking and reproduction easy and inexpensive led to their wide use in the Holy Land by missionaries and missionary societies. In general, missionaries were suited for practicing photography. They were economically independent, knew the countries in which they served, and were eager and well-trained communicators. Some were even active journalists.[1] The need to maintain contact with their institutional bases back home and to inform the membership and sponsors of their activities and achievements drew them to publishing. Missionaries all over the world were known to be "tireless diarists and letter writers. A large number of their published books about their experience were eagerly taken up by those hordes of well-wishers at home, who were always avid for news from the mission field, and a confirmation that the cause which they supported was a just and godly one."[2]

Missionaries in the Holy Land not only wrote for publications but also added illustrations to their reports. Photographs could provide convincing evidence of their successes, although this was not their sole purpose, given the special status of the land in the eyes of their audiences. The connection between photography and missions in the Holy Land was not new; the first resident photographers in Jerusalem had been associated with the missions. Now in the 1890s a large number of interesting photographs of the city and country emerged from that framework.

The most innovative of the missionary photographers were members of the branches of the London Jews' Society. These were amateur photographers working professionally as teachers, doctors, and missionaries. The work produced by them had a unique stimulus: London headquarters published a monthly magazine, the *Jewish Missionary Intelligence*, in which photographs were used as illustrations. This pro-

vided an outlet for photographic reporting from the Holy Land on a regular basis, the first of its kind. In fact, the *JMI* was one of the earliest monthlies in the world to be illustrated by halftone reproductions of photographs. Apparently, missionaries were among the first to grasp the potential of photography as used in the press. In addition it was on the L.J.S. premises that the first book of photographs was locally produced from beginning to end.

Although the published L.J.S. work in the Holy Land is unique, photography practiced at other missions offers interesting contrasts. The Franciscans published an album; Father Jules Ruffier, a Greek-Catholic Melchite missionary from France, left an impressive collection of glass negatives; and Dr. Herbert Torrance, of the Scottish Seaman's Medical Mission, photographed Tiberias and its surroundings.

The intensity of the L.J.S. photographic work can be explained by the society's far-reaching goals. Founded in 1809, it was originally conceived as an Anglican mission aiming to convert London's Jews. For many years the L.J.S. was the most popular of the many gospel societies of the time. Its motto, "To the Jew First," alluded to the claim of the Apostles that the Jews were to be proselytized prior to members of other faiths because "the world would be evangelized through the Jews."[3] Study of the Old Testament had convinced the society's leaders of the Jews' imminent return to Palestine, leading them to plan the establishment of a church there aimed at fulfilling their missionary goals on a grand scale.[4]

The L.J.S. evangelical approach to Palestinian Jews was paralleled by political considerations: the interests of church and empire were strongly intertwined. The British government wished to increase its influence in the Ottoman Empire. Because missionary work among the Moslems was strictly forbidden by the Ottoman authorities, proselytization of the Jews through the Anglican mission appeared to be a way of gaining a foothold in the region. In conformity with its overall theological and political strategy, missions were established in Jerusalem in 1823, in Safed in 1843, and in Jaffa in 1845.[5] The inauguration in 1849 of the mission church in Jerusalem—photographed shortly thereafter by Wheelhouse and by Bridges—was a landmark in L.J.S. history.

Attempts at proselytization of the Jews in the 1850s and 1860s seem to have been an uphill battle. The Arab historian A. L. Tibawi, probably the best informed and most objective writer on the subject, states that in the "weaker" decades of L.J.S. activity, "literate Jews who ventured to acquire literature in the face of the anathema from their rabbis must have been very few considering the small number of individuals who actually converted."[6] Moreover, almost all Jews refrained from using L.J.S. medical services.[7] However, "the desultory condition of the L.J.S in Jerusalem temporarily changed in the 1880s

with the influx of Russian Jews into Palestine."[8] Activities increased in the 1890s, and it was at that time that photography came to play a significant role.

The uses of Holy Land photography by the L.J.S. and its Palestinian members have to be considered from several perspectives: as an expression of L.J.S. ideology; with respect to the editorial policy that evolved for the *Jewish Missionary Intelligence*; and as the work of individual photographers, particularly G. Robinson Lees and C. A. Hornstein.

In 1893 the first book of photographs published in the country was produced on the L.J.S. premises in Jerusalem. Unlike the lavish productions commonly made for commercial purposes, *Bible Scenes in the Holy Land* was a very modest booklet in which the text pages slightly outnumbered the poorly made, tipped-in photographs.[9] Both text and photographs were by Reverend G. Robinson Lees, headmaster of the L.J.S. Boys' School in Jerusalem from 1888 to 1894. All the technical stages of composition, printing, and binding were carried out in the L.J.S.'s own print shop, the "House of Industry," in which converts and potential converts learned various trades.

Bible Scenes differed from other photographic collections in that it was then the most systematic, albeit short, survey of everyday Arab life in Jerusalem and nearby villages. Some of Lees's photographs exhibited successive phases of agricultural work. Plowing, sowing, reaping, and threshing were followed by a picture of the produce being transported by caravans of donkeys, loaded with boxes and sacks, to the market in Jerusalem and another showing goods being cleared through customs. Lees paid special attention to local customs—the beds people slept on, water poured for handwashing, daily greetings, mealtime, and prayer time.

Lees was able to take some of these photographs close to his residence, since many of the scenes took place near the L.J.S compound. Located near the Citadel, of which David's Tower was a part and which served as the local police station, and near the Jaffa Gate, close to the market, the compound was an ideal spot from which to record the various people who passed through the area. Against the background of the gate to the Citadel and the market near Jaffa Gate, Lees photographed porters, laborers, soldiers, beggars, housewives, and even a convicted murderer. Some of these street scenes were captured unobtrusively; others, and most pictures of village life, were posed.

Every one of Lees's pictures in *Bible Scenes* had two captions; one gave details of the photographed subject while the other quoted the scriptures, relating current local customs to biblical life in an attempt to confirm the credibility of the biblical narrative. The result was a mixture of ethnographic documen-

tation and the biblical allegory genre. Lees's introduction to the first edition of *Bible Scenes* makes his dual approach clear: "[The photographs] are selected from the very many illustrations of eastern life that may be seen daily. And though few in number they will show how faithfully the Bible narrative represents the life of the people in the land in which it was written."

Bible Scenes was so successful that an enlarged edition entitled *Village Life in Palestine* (twenty-six photographs with text) was published in 1897 and later editions.[10] That both books containing a very similar selection of photographs could bear different titles shows that Lees used his pictures for both ethnographic and polemical ends.

Whereas fifty years earlier Keith had used landscapes to verify the scriptures, Lees used scenes of daily life for the same purpose. Equipped with a more dynamic medium than Keith's, Lees was able to capture local social patterns. As he elaborated in his preface to the 1905 edition of *Village Life in Palestine*, "At a time when the Bible is the object of severe textual criticism I hope it will not be thought inopportune to urge for consideration the confirmatory evidence of the truth of the Bible supplied by the life of the people in the land of the Bible."

Like other photographers, Lees did not seek the spiritual or ancestral relationship of the Jews to the Bible, although it was a point stressed in the L.J.S. ideology. Lees published only two photographs of Jewish subjects. "The Wailing Wall" and "Tabernacles." One would expect more from a staff member of a mission to Jews, but it may well have been for precisely that reason he was alienated from the Jewish population, which was hostile to all L.J.S. activity.

The ethnographic aspect of Lees's work came to the fore in later editions. In fact, his attempt to depict local life comprehensively and authentically was at the expense of aesthetic considerations. For example, a landscape photograph captioned "The Centre of the Village" was composed to include several features in one frame; the composition was poor, but the picture was packed with information. An "oven made of clay" is in the lower middle, on the left is the "guest chamber," the typical inn of the village, and at the right is a "corn bin on the roof." In the second and later editions of *Village Life*, Lees used small captions and arrows printed around the picture to guide the reader to these main points of interest.

After his return to England in 1894, Lees lectured widely on his experiences and published revised editions of his books.[11] In 1909 he published two others on eastern Palestine,[12] both based on his own pre-1894 photographs and supplemented with some by Charles Alexander Hornstein, his assistant and

successor as headmaster of the mission school, who accompanied him and "secured some very fine pictures of camp life."[13]

Charles Alexander Hornstein's signature first appears in 1895 in the only article in his name ever published in the *Jewish Missionary Intelligence*.[14] The article describes the mission schools in Jerusalem, including his own. The five photographs accompanying the piece were uncredited; they may very well have been his own work.

A series of thirteen photographs taken by Hornstein in 1895 appeared three years later in the *Palestine Exploration Fund Quarterly Statement*, accompanying his article, "A Visit to Kerak and Petra." These were the first photographs signed by and credited to him. During his visit Hornstein was most impressed by "the oleander bushes, through which we had in several places to force our way," and by "the temple . . . cut out of the solid rock."[15] His photographs of the Nabatean Shrine at Petra, a site of exquisite beauty hewn out of solid rose rock, compare favorably with the best of any of the professional landscape photographs.

It can be inferred from Hornstein's article that by the time of his visit to Petra in 1895, he had a reputation as a photographer from whom good work could be expected. His host, a Mr. Forder, and the governor of Kerak went out of their way to help him:

In September, 1895, I was invited by Mr. Forder (Christian Missionary Society, Kerak), to spend a few days at Kerak. I had often wished to visit this very interesting city, and was glad of the opportunity now afforded me. The following day we drove down to the Dead Sea. In the evening, Mr. Forder and I went to pay our respects to the Governor, Helmy Bey Effendi. He received us very courteously and showed us a number of views that the son of the Waly of Damascus had taken; amongst them were three of Petra. . . . I asked him if it was necessary to get a special permit from Constantinople to visit the ruins of Petra, as I had heard that he had refused to let some travellers go who had applied to him. He said that up to the present he had not allowed any travellers to visit the place, but if I wished to go he would give me permission and provide me with an escort. This was quite unexpected, and an offer not to be refused, so I thankfully accepted. . . . I had brought only one dozen plates with my camera, so Mr. Forder suggested sending a messenger to Jerusalem for some more. We found a man willing to undertake the journey for three medjiedies, promising to be back in five days' time.[16]

In the same year the *JMI* published six photographs that can be attributed to Hornstein, although they do not carry his name.[17] Accompanying an article on the new quarters outside the Jerusalem city walls, their quality exceeds all of Lees's extant photographs and reproductions. These photographs are exceptional in that no one before Hornstein, and none after him for many years, expressed interest in

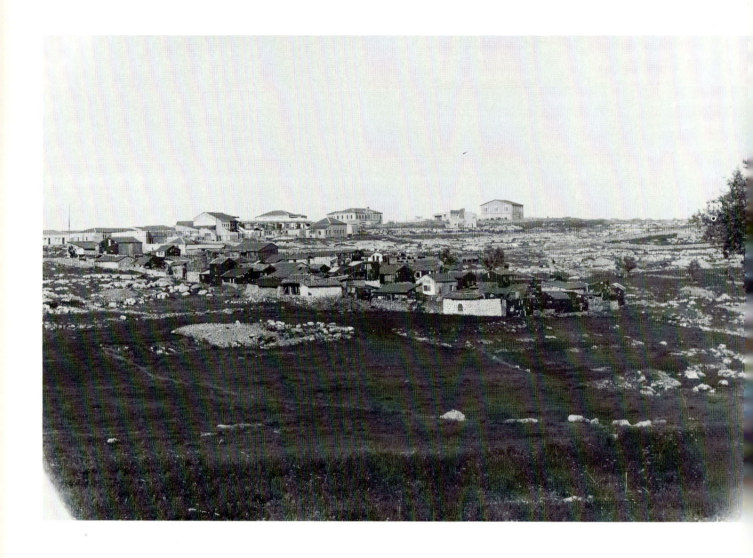

the nucleus of New Jerusalem. Hornstein, in fact, may have been specifically requested to take these views for the *JMI*, since landscapes figure less frequently than local life in his work.

Portraits by Hornstein were credited to him in G. R. Lees's 1905 introduction to *Village Life in Palestine*, where two of his photographs appear. The first shows an Arab woman seated beside a goatskin butter churn hanging on a nearby tripod. Taken in a courtyard, it technically equaled the best of the Bonfils studio portraits and was by far the best picture in Lees's book. What makes it special is that the

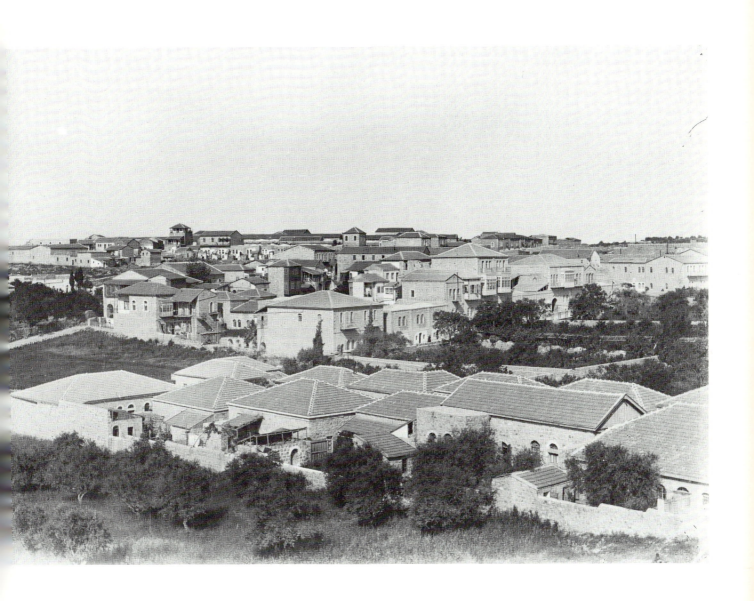

C. A. Hornstein (prior to 1895), dry-gelatin glass negative, modern print. "Bird's eye view of
several Jewish colonies as seen from the roof of the new German Hospital." At far left, corner
of Jaffa Road and Even Israel Lane, next to the liveliest center of today's downtown Jerusalem.
(Israel Trust of the Anglican Church, Jerusalem)

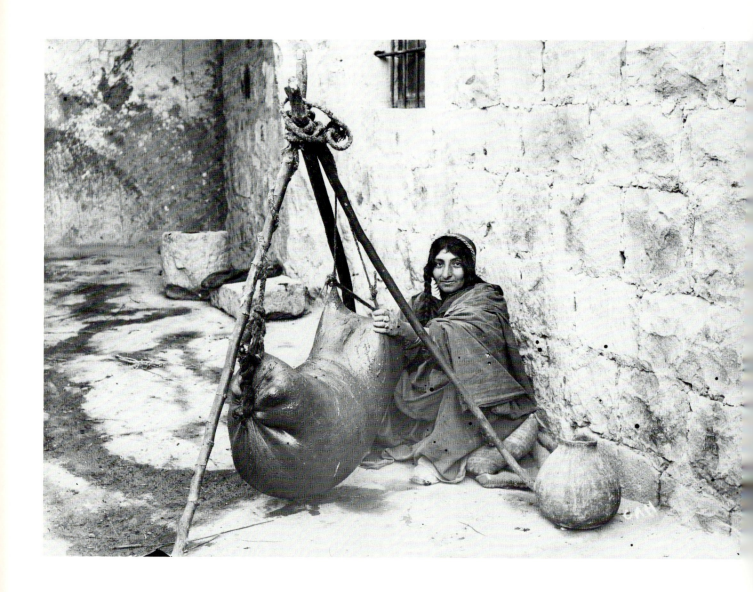

C. A. Hornstein (prior to 1905), dry-gelatin glass negative, modern print. Making butter. (Israel Trust of the Anglican Church, Jerusalem)

woman is looking into the camera and smiling. This depicts a new relationship between subject and photographer. While a smile and a relaxed posture in the presence of a photographer seem natural today, they were less so at the time. Unlike Bonfils's models, the woman's posture was unstaged. The photograph projects an aura of familiarity; perhaps the woman was a maid in Hornstein's home or at the mission. The photograph, which was used as an ethnographic document, in fact looked like a picture of a friend or acquaintance. A similar sense of familiarity between Hornstein and his subjects is felt in many of his photographs that are also, without doubt, ethnographic studies. The second of Hornstein's photographs in Lees's book shows a woman facing the camera with a relaxed attitude and some curiosity. Though she is not smiling, she too completely lacks the affected posture of the Bonfils models. Hornstein portrayed people as they were, not dressed up in costumes or posing as biblical figures. He photographed people whose way of life he was familiar with and who were already acquainted with a camera; at least some of them appear to have known him personally.

Many of Hornstein's negatives—dry-gelatin glass plates made in France in the 1890s—were discovered at the L.J.S. premises in Jerusalem. They testify to his continuous efforts and to his subjects' willing-

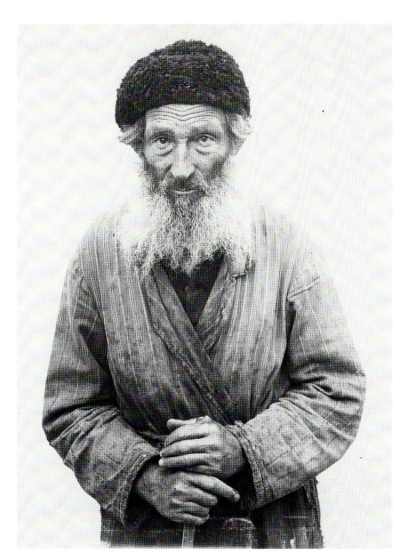

C. A. Hornstein (prior to 1908). A Jew in Jerusalem. (Israel Trust of the Anglican Church, Jerusalem)

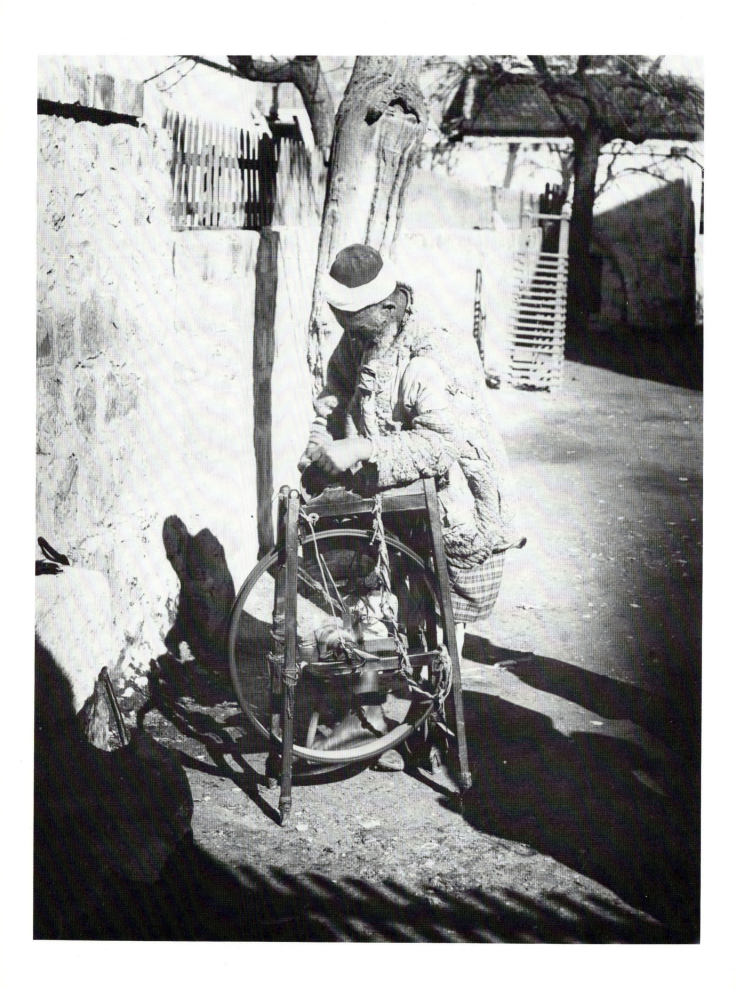

ness to pose. There are typical figures in the streets: water carriers, maids, a cotton carder, a scissors sharpener, passersby, villagers, and Bedouins, both in the desert and in town. There were even Bedouin women at work photographed from close up, a feat rarely achieved before him. Hornstein's approach was direct and unstaged; there is a feeling of immediacy and of interaction.

Hornstein's intimate feeling toward the people and landscape of the country may be explained by the fact that he was born and raised there. He was the rare, and most probably the first, native Holy Land photographer. According to L.J.S. files, Hornstein was born in February 1870 in Jerusalem to a "Hebrew-Christian" (that is, converted) father and a "gentile" mother. Private correspondence with his son indicates that Hornstein's father was a well-educated German convert and that his mother was a Scottish relative of the British Consul James Finn; both parents worked at the L.J.S. hospital in Jerusalem. The Hornstein family ran the Mediterranean Hotel in Jerusalem (the guide named Hornstein whom Raboisson hired and who violently intervened in the El Hawara incident—see chap. 7—may have been Charles Alexander's older brother or uncle). That a photographer's family was in the tourist business was certainly no novelty. According to the L.J.S. files Hornstein spoke Arabic and some European languages, which obviously enabled him to converse directly with the local population. According to his son, he had no special teaching qualifications other than having been educated at the mission school himself. Hornstein did not visit England until after he had become headmaster; by then he was already a proficient photographer. This means that he acquired his approach to photography in Jerusalem.

An amateur photographer born in the country and fluent in Arabic, with little training in conventional studio techniques, might well look at his subjects in quite a different way from traveling photographers and local commercial photographers. Models and audience alike would sense the difference.

That Hornstein's training in photography was acquired solely in Jerusalem points to the intensity of the photographic work done in the city in general and by the L.J.S. in particular at that time. This was no doubt largely due to the availability of a regular, if noncommercial, outlet in the L.J.S. monthly magazine, founded in 1835. In 1885 the *Jewish Missionary Intelligence* enlarged its format and began to carry engravings made after photographs. Four years later it published its first halftone reproduction.[18] In the following year its first three photographs from the Holy Land, of the mission's premises in Jerusalem, were printed. The mission's activity was and remained the monthly's most obvious subject. There was a constant growth of the photographic coverage both in terms of quantity and of scope. At its peak in 1904 seventy-three photographs from Palestine were published alone, forty-three of which did not depict the

A. Hornstein (ca. 1900), dry-gelatin glass negative, modern print. Jewish scissor sharpener.
el Trust of the Anglican Church, Jerusalem)

mission's activities. In later years the richness and originality of the photographic coverage gradually declined, and it was substantially reduced in 1912.

During its best years, the Palestine coverage in the *Intelligence* was the result of a group effort of Lees, Hornstein, J. A. Hanauer (who specialized almost exclusively in archeological subjects), and P. Wheeler, among others. The photographers remained anonymous except for an occasional casual acknowledgment in the accompanying article. Also uncredited were photographs purchased from professionals who can easily be identified as Bonfils, Krikorian, or American Colony photographers.

The *Intelligence* was not only the first of its kind in the Holy Land but also among the earliest magazines in the world to carry photographs. Photographs that usually did not find their way into books because of their topicality found a framework that suited and even encouraged their publication. A significant part of the monthly's photographic reporting was of a general nature and was not restricted to the mission's activity. Moreover, the link to the L.J.S. point of view is not apparent at first glance. These pictures nevertheless express the missionary "image" of the country and of its Jewish population, as well as the photographers' and editors' own biases. With the J.M.I. early photojournalism emerged, although other periodicals were perhaps in existence at that time.

The *Intelligence* followed a clearly established editorial policy, with the aim of justifying L.J.S. activity among Jews. It seems that this policy was intuitively transferred to the selection of photographs. Many illustrated articles were devoted to proving the well-foundedness of the society's strategy. So, for example, the December 1891 issue included a series of four photographs—the first ever published—of a Zionist settlement. Captioned pictures of Lake Merom (Huleh), a few houses, and irrigated fields spread over two pages, illustrating the one-and-a-half page article, "A Jewish Colony in Galilee," written by the L.J.S. missionary in Safed. The text described the settlement at Isbeid ("Yessod Hama'ala") established in 1885 near Lake Merom. The somewhat ambiguous text shows the missionaries' positive attitude toward the settlers, their reservations, and, in sum, the L.J.S. ideological basis:

In 1885 seven Jewish families from Warsaw in Russian Poland, after having endured much persecution from the Government there, managed to sell all their property and arrived in Palestine with a considerable sum of money. Soon after their arrival they succeeded, in spite of innumerable difficulties put in their way by the Turkish Government, in buying 2,400 dunam of land close by the Waters of Merom. . . . The first settlers of Isbeid were bigoted Jews and very little mission work could be done among them. . . . The spiritual observer cannot fail to see in this wonderful movement [i.e., Zionism] the great Guide and Leader of Israel controlling and overruling all things, even the very wrath of men, to His own praise and glory. By the hand of the persecutor the people of Israel are driven to seek a home in the land of their fathers.[19]

In 1898, photographs of Zionist settlements, purchased from photographer Leon Katz of Jaffa, appeared upon the monthly's pages, accompanying texts of a similar nature. The editors considered the settlements and the Zionist movement in general the concrete fulfillment of the L.J.S. prognosis for Palestine and the Jews, even though prospects for successful proselytization seemed dim.

The *Intelligence* maintained basically the same editorial policy with respect to the new Jewish quarters of Jerusalem. A good example is the publication of the six photographs of the quarters attributed to Hornstein, illustrating the article "Jerusalem Outside the Walls" (1895). No Jewish or Zionist publications carried such photographs. There was a bird's-eye view of the buildings along both sides of Jaffa Road at what is close to today's King George and Strauss streets, the liveliest crossing in downtown Jerusalem; the Montefiore quarters of Mishkenot Sha'ananim and Yemin Moshe; views of the poor suburbs Beit Yaacov and Beit Israel; and two pictures of the ultraorthodox quarter Mea Shearim. These are the earliest photographs of the new parts of the city ever published and perhaps ever taken. The author, Dr. E. W. G. Masterman, thought it important to document the hitherto ignored development outside the city walls:

Pictures of Jerusalem [the Old City] are so familiar to all and descriptions of it so common that it would require an apology to write of it again. But of the suburbs round Jerusalem forming as they do now in many ways the more important part of the city, little or nothing has been written and few if any pictures published. Recent books on the Holy City pass it by as completely as does the traveller to Palestine. . . . A traveller usually passes by these groups of modern Jewish houses with complete indifference as he proceeds to the many centres of interest within the walls. Few indeed ever enter the colonies themselves unless especially interested in the Jews, or wishing to attend as guests their annual Passover. And yet, are they not of interest? of more interest perhaps than most of what is to be seen within the walls. Here we have not dry bones of antiquity but a living people. A people who believe this land is bound to be theirs, and who in the strength of that faith have landed in the country after infinite difficulty, have built houses after every possible opposition, and are there today, counting it their greatest privilege to live in the poorest quarters, if in their Holy City.[20]

One has to read it in the original yellowing pages of 1895 to believe that this passage, paralleled by so many similar ones in classical Zionist writings, came from the pen of an Anglican missionary.

Masterman's conclusion is even more startling. "It is a part of the city quite sure to grow into more and more importance as Jerusalem becomes of increasing prominence in the affairs of modern politics," he wrote, "as those who know it best are sure it will, and therefore well worth a little attention from thoughtful minds."[21]

Masterman published a more detailed article on the same subject in 1904, accompanied by twenty-four photographs. Neither Hornstein in 1895 nor the anonymous photographer of 1904 followed Master-

man's advice to the letter; they did not depict the Jewish quarters from inside. Photographs of people first appeared in another context in November 1901. Five pictures taken inside the new quarters were part of the article "Visitation of the Sick in Jerusalem," by P. Wheeler, chief doctor of the mission hospital. Four of them display extremely poor housing, a few destitute inhabitants, and a group of residents posing in the street. One photograph was related directly to the work of missionary doctors in the Jewish quarters. It showed Wheeler on his donkey accompanied "by the out-patients' man," charged to find out where the patients live.

Wheeler's text described the plight of the ailing, the local superstitions that missionary doctors had to combat, the poor living conditions, and the effects of the *cherem*, the ban of excommunication on Jews who accepted treatment in the mission hospital. His introduction was obviously addressed to L.J.S. sponsors:

Sometime ago I sent an account of the work of our Outpatients' Department; now perhaps, our friends would like to know something about our visitation of Jewish homes. The visiting of patients in their own homes is an important part of our work, and one which is very much appreciated by the Jews, especially the poorer sort. It is not only a great boon to them, but gives the missionary also a good opportunity of visiting among the people and becoming known to them.[22]

A close look at one of Wheeler's captions discloses that even an "objective" photograph is intended to show both local conditions and the mission's involvement in local life:

Photograph No. 2. Part of Colony of Yemen Jews. This was a wretched quarter, very squalid. We have many patients here. The large house belongs to an Ashkenaz Jew. Several families live in one house.[23]

Another caption, with a "social documentary" air about it, does not allude to the mission at all.

Photograph No. 3—a portion of the "Box Colony"—so called from its houses being built mainly of petroleum boxes and tins. The people were turned out of the Montefiore houses and had to erect these sheds, where they have since remained. The poor of all kinds of Jews live here—Persian, Baghdad, Koorje, Sephardim, Yemen, Aleppo, Mugrabim, etc.[24]

These photographs no doubt appealed to the readers' sense of compassion, an obvious aim for a missionary monthly and for a photographer interested in social issues.

Another 1901 article presented the society as a force inspiring the development of the city. It was a double-page feature on Jewish hospitals in Jerusalem written by Reverend J. E. Hanauer, with postcardlike photographs taken by his son. The symmetrical layout wove pictures and text. The author presented the photographs as a report; only single sentences reveal his true motives:

From the roof my son took a photograph of the Jewish hospital "Mizgav Ladach." This hospital was opened by Rothschild in 1854 in opposition to the work of our Society. Ten years later, finding that our Society's Medical Mission not only held its own, but was winning the hearts of the Jewish population, another hospital, "Bikour Cholim", was opened in premises adjoining that of the L.J.S. . . . All the Jewish hospitals, schools, etc. now existing in Jerusalem, owe their existence to the influence of our Society; and we rejoice in their having been called into being even though in opposition to us.[25]

The *Intelligence* also carried "news" photographs that were indirectly connected to the L.J.S. For example, in November 1897 it published Hanauer's photograph of a bridge over the Musrara River, near Jaffa, that had collapsed. Judging solely by the picture, it was a typical journalistic treatment of a disaster. The text, however, mentioned the washed-out bridge as an aside. It referred to attendance at Jaffa L.J.S. activities, which was

very encouraging considering the remarkably heavy rain which fell during the month and which made it very unpleasant to be out of doors. The Wady Musrara (a tributary of the Anjeh) rose to such a height that the floods destroyed the western pier supporting the great iron bridge, built at great cost three years ago.[26]

Again, Hanauer had his sponsors in mind.

Another news photograph taken in 1897, this time by Hornstein, was of a subject of political relevance; it was captioned "The ships of H. M. Mediterranean Squadron in the port of Jaffa." A year later, photographs of the imperial visit of Wilhelm II of Germany appeared in the magazine. Many news photographs portrayed Jewish religious ceremonies and public events: burial of holy scrolls in Jerusalem (1892), Lag Ba'omer festivities in Meron (1899), the burial of the grand rabbi of Jerusalem, arrivals and departures of visiting rabbis, and the like. They are a unique testimony to Jewish life in Palestine of that time. The photographic reporting of Jewish religious ceremonies in a positive light points to the unique situation in which the Anglican missionary work was carried out. Jews were shown as worthy of the L.J.S. efforts.

Significantly absent from the *Intelligence* were scenes of Jewish everyday life and portraits of local inhabitants. During two decades of intensive work, only two portraits of Jews taken by the L.J.S. group were published. The magazine staff was no doubt aware of the delicacy of the subject and the reluctance of Jews to be portrayed by missionaries. Many of the missionaries were converted Jews or sons of converts; traitors, *meshoumeds*, turned active proselytizers, they were more than outsiders. Missionary photographers had very limited access to the mainstream of the Jewish population, made up of artisans, *haloukah* recipients, and religious students. Interaction was almost impossible and was confined to the margins of Jewish society. This explains the many news photographs depicting official events and religious holidays

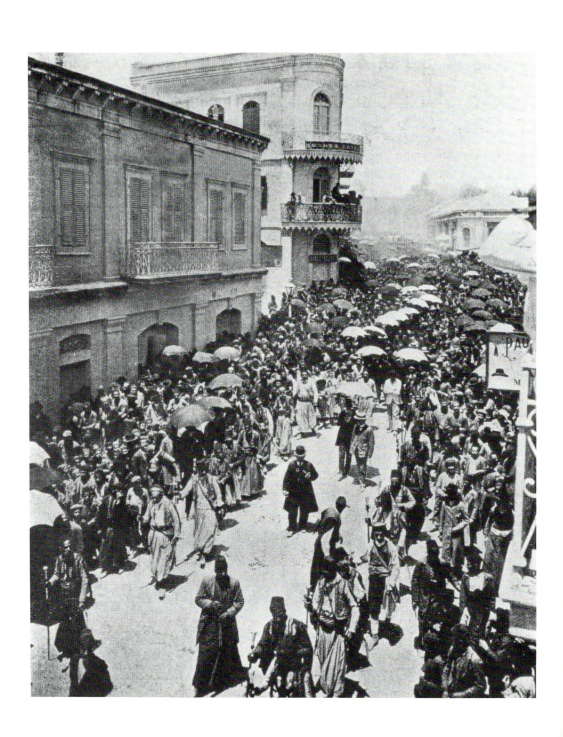

that could be captured by the missionaries themselves from a distance or be purchased from commercial photographers. When in need of portrait-style illustrations for articles about Jews, the magazine published purchased studio portraits of local middle-class Jewish families. The texts generally praised the represented groups. The publication of these pictures implied the (nonexistent) involvement of L.J.S. missionaries in local life.

In one exceptional case, Hornstein succeeded in portraying a rabbi and his family. The pictures appeared in a 1904 report about Jerusalem's Karaite community, a Jewish sect of about fifty members that the Jewish religious establishment considered heretical. Not recognizing the authority of the Talmud, the Karaite people were considered outside of the mainstream of the population, and this exception clearly reaffirms the rule.

The *Intelligence* featured conventional landscapes of sites and towns but few pictures of Arabs, in contrast to most other publications of that time. This omission could not have been accidental or due to the unavailability of such photographs to the London editors. Even Lees and Hornstein had such photographs, which were published in the former's books. The *JMI* editors most likely considered this subject of no importance to their missionary efforts and L.J.S. aims.

Though the L.J.S. work is without precedent and has no counterpart in Holy Land photography, part of it—the depiction of the society's activities and premises—can be fruitfully compared to the collection of photographs published by the Franciscan Mission in the Holy Land. These appear in partly hand-drawn reproductions in the *Album Missioni Terrae Sanctae*, published in Italy in 1893.[27] No photographer was credited, and except for some pictures that can be attributed easily to Bonfils and a few others credited to A. Beer in Lampe's *Jeruzalemski Romar*, the origins of the photographs are unknown.

With the exception of the *JMI* work, *Album Missioni* is the only extensive collection to represent the activity and ideology of a nineteenth-century mission. The *Album* focuses on two subjects: religious architecture and missionary activity. Entitled *Judaea and Galilaea*, the volume devoted to western Palestine includes no landscapes of Jerusalem, biblical sites in the open countryside, or local life. There are architectural views of the Church of the Holy Sepulchre, of shrines along the Via Dolorosa, and of other Catholic churches. There are, of course, many pictures of the Franciscan Church of the Eternal Saviour, inaugurated in 1884, the center of the mission's activity, and views of the mission's premises in Jerusalem, Jaffa, Nazareth, and a few other locations.

Of the more than one hundred photographs, about half depict the activities of the Franciscan

...ographer unknown (1906), halftone reproduction. "The Funeral of the Chief Rabbi of ...alem." Published in the Jewish Missionary Intelligence. *(Israel Trust of the Anglican ...rch, Jerusalem)*

monks, who are shown providing food to the poor and tending to the sick. There are also pictures of numerous other services provided by them, such as a bakery and a carpenter's shop, and there are photographs of orphanages and schools, with the children in group photographs and at work.

A comparison of the *Album Missioni* with the L.J.S. photographic legacy reveals that both the Franciscans and the Anglicans used pictures to report their activities. Group portraits of pupils and patients look very much alike, of course. However, whereas the *Album* portrays Franciscan missionary activity within a strictly ecclesiastic environment, surrounded by ornate architecture, the Anglican missionary photography seems to have preferred the entire country as its setting. True, the political dimension of the L.J.S. aims may account for this difference. But one is also tempted to consider it an expression of the Catholic and Protestant nuance.

There were Europeans associated with other missions who were also amateur photographers, but lacking an organized publishing apparatus, like that of the L.J.S or the Franciscan album, their work remained unknown.

The French missionary Jules Ruffier des Aimes was a contemporary of both Lees and Hornstein, and his work is comparable to Hornstein's in quality. Born in the province of Savoie in France in 1861, he lived in Jerusalem as a member of the White Fathers' Order between November 9, 1884, and December 13, 1914, when the Turkish authorities expelled French citizens.[28] (One of his negatives shows the White Fathers' personal effects on the benches of the chapel, assembled on the day of their expulsion.) The earliest date on the envelopes of his negatives is 1886. Ruffier's collection consists of several hundred large glass-plate negatives of photographs taken during his stay at the Convent of St. Anne, attached to the White Fathers' Order of the Greek Catholic Melchites.[29] He did not seek publication; a few photographs were published in the 1920s and 1930s, and then Ruffier was forgotten again.

Ruffier's photography expressed personal interests and dealt mainly with two subjects: the mountainous landscape near Jerusalem and throughout the country, and the Convent of St. Anne and its grounds. Ruffier was the rare Catholic photographer who did not focus on architecture. He perceived Jerusalem as part of a hilly countryside rather than a city. Its streets and landmarks interested him much less than the hills around it. Virtually all his city views were taken from surrounding valleys and from elevated points.

His landscapes, including no more than a rocky hill, a few stone houses, a few trees, and stonewalled terraces in an abundance of soft lines and rounded shapes, are unique. These are landscapes taken for their own sake. In many cases, the locations are impossible to identify because they lack any remarkable

Jules Ruffier des Aimes (ca. 1890), dry-gelatin glass negative, modern print. Selouan. Arab village facing Jerusalem. (White Fathers, St. Anne's Convent, Jerusalem)

Jules Ruffier des Aimes (1886), dry-gelatin glass negative, modern print. Anatoth. Mountain village, north of Jerusalem. (White Fathers, St. Anne's Convent, Jerusalem)

feature. One or two of his pupils often sit in one of the corners, almost invisible. Photographs taken with his class on excursions show the pupils from a great distance, barely perceptible in the countryside. Ruffier was a man of open spaces, perhaps a solitary monk who happened to become a missionary teacher. He saw the countryside and the Holy City in terms of mountains, a constant and unchanging space beyond the reach of time. His photography is a beautiful expression of the hill country around Jerusalem.

Ruffier's personal background and childhood may have had the strongest influence on his approach. Born and bred in the mountainous region of southern France, he loved the mountains of the Holy Land, where he led excursions of young seminar students even after he became superior of the small seminar at the convent. We read in his obituary by the Order of the White Fathers: "Often he was the Scout in the exploration of biblical and ancient sites. . . . This Savoyard, with hocks of steel, cruised the mountains and the valleys with the ease of a Chamois."[30]

The Convent of the White Fathers, the Chapel of St. Anne, and adjacent buildings of which he kept a running photographic record were the single architectural subjects to which Ruffier devoted his time. He copied earlier photographs of the convent, one of them captioned "the state of the convent in 1856," and photographed drawings, plans, and engravings. With Father Cebron, his predecessor as superior and another missionary photographer, Ruffier worked on the convent's numismatic collection, participated in excavations near the chapel, and planted trees on the convent's grounds.[31] No doubt he perceived the convent, the chapel, and the nearby excavations differently from the world outside. A self-appointed photographic chronicler of St. Anne, he did not feel a similar engagement with the city as a whole. He saw the compound in terms of its history and its growth, as the story of his own life.

Dr. Herbert Torrance, head of the hospital of the Scottish Seaman's Medical Mission in Tiberias, on the Sea of Galilee, was another amateur photographer. Though the pictures in his collection are not of professional quality, their subject matter is well delineated: the Scottish Mission Hospital in Tiberias, its staff, clientele, and growth; archeological studies of ancient synagogues; regional landscapes; and some local events in Tiberias, especially those related to the development of transportation (the first steamer on the Sea of Galilee, construction of the pier, a tourist caravan, the new Hedjaz Railway). The collection represents the earliest locally made photographic chronicle of Tiberias.[32]

Dr. Torrance came to Palestine in 1884 to look into the possibility of missionary work. Back in Scotland, he reported that "Palestine had become even a more promising field than it was in 1839" (alluding to Keith).[33] It was decided to create The Sea of Galilee Medical Mission in Tiberias, on the

shore of the Lake of Gennesareth. The mission's activity began in 1885, and Torrance's earliest photographs show the town at that time. Torrance's collection ends in 1914, when he, like Ruffier, was forced to leave the country.

Historically, a missionary background assured the photographer of his livelihood and allowed him to take photographs for his own pleasure and interests. This had been true for Barclay and Graham in the 1850s, and it was true of Ruffier and Hornstein, the most talented of the missionary photographers. Ruffier's missionary photography consisted of his concern for the development of the St. Anne compound; his landscape photography was a personal affair. So was Hornstein's gallery of people, mostly Arabs, never published by the *JMI*. Rather than limiting their work, their connection to a mission enabled them to photograph freely subjects of their own choosing. Judged as individuals, they were probably the best photographers of their time.

Looking at L.J.S. photojournalism on the institutional level, one discovers a sophisticated usage of photographs unexpected in a turn-of-the-century periodical as well as a no less surprising positive image of the population whose conversion was attempted. The *JMI* editorial policy regarding photographs can be seen as a product of ideology and historical context. The L.J.S. did not consider the indigenous Jewish population of Ottoman Palestine and the new Zionist settlers as ignorant heathens to be salvaged from paganism. The role assigned to the Jews by the L.J.S. in the overall design of the church (and the empire) was infinitely more prestigious. Their photographic depiction had to foster such an image, the more so as it was not consonant with the image of the Jew held by British society. To insist on the poverty and needs of the Jewish population might have been counterproductive. The pictures of Jewish life printed on the pages of the *JMI* were chosen to evoke compassion toward a disfavored but dignified population and to inspire confidence in its ability to carry out its role in the church's grand design.

Arab, Jewish, and "American Colony" Photography, 1890–1899 10

The most significant development in local photography to follow the appearance of Deniss, Yessayi, and Bergheim around 1860 was the arrival of Arab and Jewish photographers on the scene in the 1890s. In the harbor town of Jaffa, Dawid Sabounji and Leon Katz entered the trade. In Jerusalem, following the example of Armenian Garabed Krikorian, Yeshayahu Raffalovich and Chalil Raad opened independent studios. In 1899 Raffalovich was the first to publish an album of photographs devoted to a modern subject—the Jewish settlements. He was assisted by Elijah Meyers, who in 1898 founded the famous photographic enterprise at the "American Colony," a Jerusalem community of fundamentalists.

The 1890s were a decade of beginnings, starting with the emergence of Arab photographers. While only a few pictures taken prior to the turn of the century have survived, the very existence of their studios is indicative of the penetration of photography into the local environment. This environment was not untouched by developments such as increased European rivalry and the changes that ensued from intensified Jewish immigration. Arab photographers, who had some local Arab customers, also worked for European and Jewish institutions and travelers. Jewish photography emerged mainly in the radically new context of modern Zionist activity, which encompassed immigration, the purchase of rural properties, the creation of agricultural settlements, and renewal of the Hebrew national culture. Jewish photographers—with the exception of Raffalovich—also left few photographs, all of which were related to the change initiated by the Zionist movement. The foundation of the American Colony photography enterprise demonstrated the local potential from a third perspective: American and European publishers and travelers needed a permanent source of modern Holy Land photography because of increased international attention to the Holy Land and the growth of illustrated media. There were, of course, additional sources of local photography, such as Krikorian (chap. 5), the L.J.S. missionaries (chap. 9), and a number of other photographers of various origins whose work is of minor importance.[1]

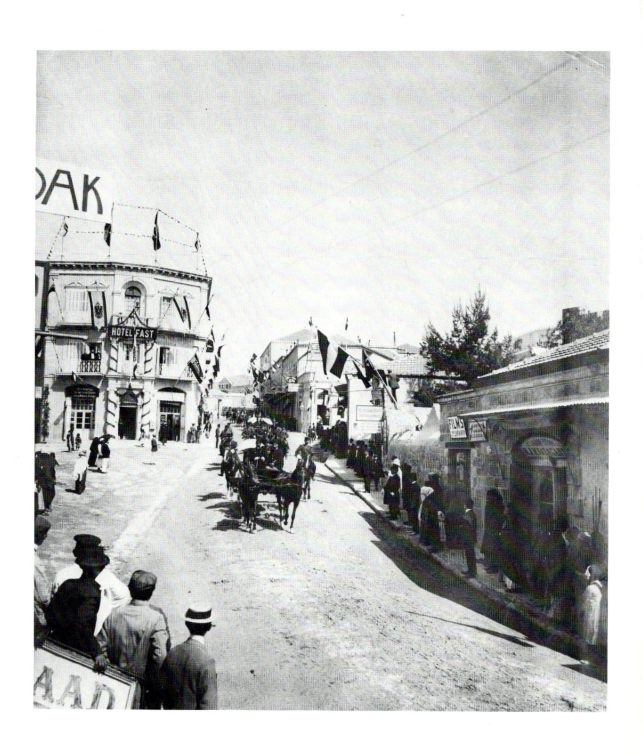

Chalil Raad (1898), dry-gelatin glass negative, modern print. The arrival of Kaiser Wilhelm II of Germany in Jerusalem. At left, Raad's insignia; across the street, Krikorian's and Mitry's. (Central Zionist Archives, Jerusalem)

The emergence of two photographers who could communicate freely with virtually all local inhabitants, who lived in their midst and had a close understanding of the local cultural traditions and social codes, might have been expected to create a new climate for photography. Apparently, however, they had no such ambition. They and their society did not yet feel a need to use photography as a means of social and cultural communication. This was still a rural society, with little or no migration to the towns, in which the family was an immediate, all-embracing, and extended frame of protection and reference. Publishers of local newspapers, periodicals, or books who might want to purchase photographs did not exist, nor was there yet a significant literate readership to justify their existence. The sociocultural context in which a self-image of the Arab population more authentic than biblical allegories and costume genres could develop did not yet exist, and Arab photographers themselves may have had little interest in its creation.

Very little information could be gathered about the earliest Arab photographers and their work. The first known to have practiced photography in the Holy Land was Chalil Raad. Raad, whose first name—unlike his surname—is unmistakably Arabic, was born in 1869 in Bhamdoun, Lebanon, near Beirut on the main route to Damascus. Raad, a Christian, arrived in Jerusalem as a young man and began to work for Garabed Krikorian in 1890. In 1897 he announced the opening of his own studio on Jaffa Road, across from Krikorian's, in the local Hebrew press. His advertisements in the early 1900s are the earliest written evidence of the continuous operation of a local studio by an Arab.

The opening of Raad's studio led to fierce competition between Krikorian and himself, which ensued until 1913 when Krikorian's son Hovhannes returned from studying photography in Germany to manage his father's studio. That year he married Raad's niece, Najla, and she was ever after known in both families as the "bride of peace." The marriage paved the way for a partnership between young Krikorian and Chalil Raad.[2]

Two of Raad's photographs appeared in the official record of Kaiser Wilhelm's visit in 1898. One is of the kaiser's tent camp, the other of the emperor and his guard at the Tomb of David. The professional-quality pictures show that locally trained Raad could handle the camera with as much ease and expertise as any European photographer. None of Raad's photographs other than those related to this event can be given a definite pre-1900 date. His later photographs, many of them widely reprinted in the 1920s and 1930s, depicted landscapes, historical landmarks, and scenes related to Christianity (the most popular shows a nun kneeling in prayer at the Tomb of Christ in the Holy Sepulchre). Some of the outdoor

photographs sold and published as Krikorian's may in fact have been taken by Raad, as both Garabed and Hovhannes concentrated on studio portraits.

The Krikorian-Raad studio housed one of the largest photographic archives in the city. A substantial part of this collection was lost during the heavy fighting in that area in 1948, during Israel's War of Independence. Raad fled to Beirut with part of the collection, and it is not known whether it survived the Lebanese civil war of the 1970s, the Israeli siege of the city in 1982, or the present-day fighting between rival factions. Najla Krikorian, who remained in Jerusalem, has only family portraits and none of the archival material.

The earliest-known photographs by Dawid Sabounji were taken in 1892 at the Mikve Israel agricultural school near Jaffa (the gilded cardboard frames bear his name).[3] The quality of the photographs shows that, like Raad, Sabounji was not inexperienced. It is possible that Sabounji established his studio in Jaffa before or directly after Raad began to work for Krikorian. Sabounji himself was associated with Krikorian in 1898 in connection with the German kaiser's visit. Insignia on the back of some of their photographs show that they used a common label, printed in German.

No personal data about Sabounji are available. His first name gives no hint of his origins, as Dawid could be an Arabic, Jewish, or European name. The use of the *w* in Latin spelling points to the Arabic "Daoud." Sabounji's family name—meaning "soapmaker" in Arabic—suggests a background in manufacture. It also suggests a common family line with Beirut photographer Georges Sabounji. Georges's label appears on the back of a *carte-de-visite* photograph of Garabed Krikorian and his wife, Karina, taken in 1882. Georges Sabounji is also credited with a few landscape photographs of the environs of Jerusalem printed in a 1903 German book.[4] These two dates suggest that his career was continuous. What is perhaps his earliest signature appears in a Bonfils photograph as graffiti in Arabic, together with Bonfils's name, on an ancient Egyptian edifice: "Gergi Sabounji mussawwir shamsi 1875" ("one who makes pictures by the sun," i.e., a photographer).[5] Gergi is the Arabic equivalent for Georges, and it identifies the photographer as a Christian.[6]

Dawid Sabounji may have belonged to the same Christian Arab family of Beirut. Perhaps he had been born there and migrated to Jaffa after having learned the profession of photography in the family business. In the 1890s Jaffa had become a lively and growing little town and presumably attracted him because it was less competitive than Beirut.[7] If this profile of the Jaffa photographer, which is speculative and influenced by what is known of Raad, is accurate, it fits the pattern of local photographers being both Christian and born outside the geographical boundaries of the Holy Land.

Dawid Sabounji (1892), albumen print. "Nursery Plants in Pots." Agricultural School, Israel. (Mikve Israel Agricultural School)

By establishing his studio in Jaffa, Dawid Sabounji also avoided competition in Jerusalem. Though he was far away from most historical and biblical sites, he could attract the business of tourists and pilgrims en route to the Holy City. Almost all travelers bound for Jerusalem entered the country through Jaffa, and the railway line that opened between the two in 1892 reinforced this stream. Still, Sabounji's work for tourists was probably occasional, and he must have been making his living to at least some degree from portraits for local Jews and Arabs.

Sabounji had local customers, both Jewish and Moslem. Some portraits of Jewish employees from the Mikve Israel school have survived, and at least one portrait of an Arab can be attributed to him (the name on the photograph is D. Subounji). According to the British owner of the photograph, the subject, Suleiman Girby—a personal acquaintance from Jaffa—was a Moslem. In the picture Girby wears a shirt

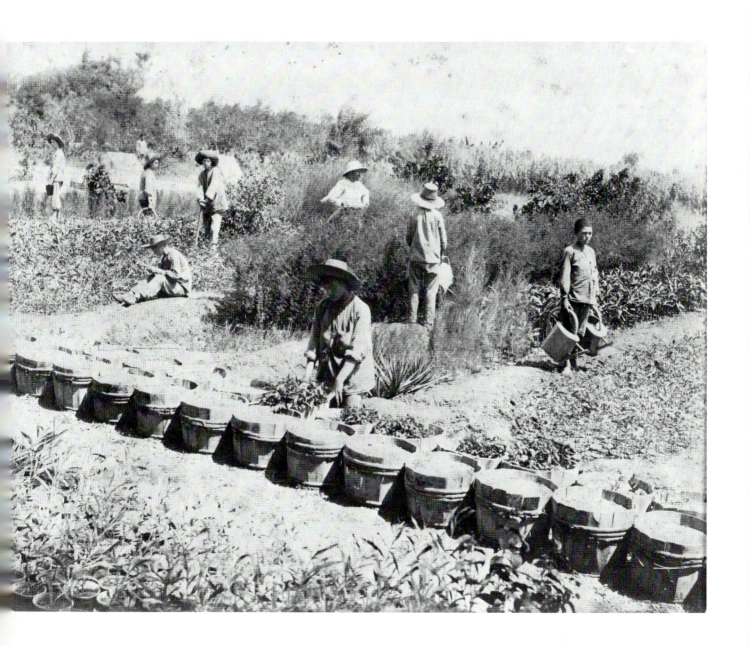

indicating his position as "chief boatman" with Cook's travel company.[8] Portraits of tourist personnel are no novelty in Holy Land photography. The pose is conventional, with Girby standing and facing the camera, as in Bonfils's photographs. Use is made of both a natural prop (thick branches of a bush) and a painted backdrop, the conventional outfit of a studio. The novelty of the picture, of course, lies in the fact that it was taken by a local Arab who had an independent studio.

Sabounji's earliest-known photographs, made for the agricultural school of Mikve Israel, were found in the school (which is still in operation). They show the pupils posing as if working in an orchard, a plant nursery, with geese, in a carriage on the school's yard, and on a threshing floor. The pictures seem to be staged; though the pupils are not arranged in a group, most pose somewhat stiffly, some of them looking at the photographer. There is also a less formal photograph of the pupils bathing in the farm's water cistern. The pictures are lively, modern in spirit, and constitute the earliest photographic report of a farm (or school). The school, founded in 1870 by the French *Alliance Israélite Universelle*, was the first of its kind and a stronghold of secular education.

These photographs serve as historical documents of local photography in two senses. First, they indicate that in 1892 local customers hired a local photographer, perhaps in response to his own offer. Second, their subject matter was new to Holy Land photography. Informal staging at the actual place of work was the closest that photographers in 1892 got to straightforward documentary photography. In fact, in this sense Sabounji's small series resembles the photographs of workshops run by the Franciscan missionaries and reproduced in their *Album Missioni* and L.J.S. photographs showing the Jerusalem mission's House of Industry (see chap. 9). Mikve Israel, like the two missions, was sponsored by a European organization and run by a European staff. The interesting difference between the photographs resides in the prominence that Sabounji generally gives to the pupils.

Two of Sabounji's photographs—work in the plant nursery and on the threshing floor—were reproduced in halftone in *Die Welt*, a biweekly published in Vienna, Austria, by a board of Zionist editors in 1897.[9] No signature appears nor is Mikve Israel mentioned, and captions relate to "settlements" in a general manner. Apparently, Sabounji's photographs had reached Europe and were among the first to represent Jewish agricultural work.

No Arab institution seems to have been interested in photographs. An album of original prints produced for the Ottoman authorities by Krikorian in 1898[10] and the earliest album printed and published by the authorities themselves (in 1916)[11] show only landscapes and architecture. No photographs of Arab

life taken by Raad or Sabounji prior to 1900 are presently known, though German ethnographer Gustav Dalman published some such photographs by Raad in the 1920s. No other local Arab photographers appeared before World War I.

Raad and Sabounji were apparently Lebanese Christians and probably came in touch with photography in Beirut. Beirut was the most westernized place in the area, and its Christian population was socially and economically the closest and most open to modern influences. The city was much closer to Palestine than any of the other urban centers in the Ottoman Empire, from which earlier local photographers Garabedian, Krikorian, and perhaps Deniss migrated to Jerusalem. Raad and Sabounji had roots that were geographically and ethnically closer to the environment to which they migrated. No Moslems born in Palestine are known to have entered the trade. Religious tradition and the economic situation apparently continued to play a part in limiting clientele, thereby discouraging indigenous youth from pursuing photography as a profession.

JEWISH PHOTOGRAPHERS

The Jewish population of the Holy Land, from which local Jewish photographers emerged, was composed of three communities: the Sephardic (Spanish-Mediterranean) and Ashkenazic (Central and East European) communities in the Old Settlement, made up of indigenous inhabitants and established immigrant families, and the group of more recent immigrants who arrived mostly from Eastern Europe.

Jews had immigrated to Ottoman Palestine for centuries and especially during the nineteenth century, often in defiance of Ottoman law. They joined the Old Settlement. Motivations were generally messianic—to live and pray in the Holy Land, to be buried in the ancient cemetery on the Mount of Olives—combined with the need to escape the repression and persecution of medieval and early industrial Europe. The great wave of immigration that began in 1882 was partly similar, partly dissimilar to its predecessors. These immigrants were escaping a particularly violent wave of pogroms—mass killings, rape, and robbery by the Russian population, encouraged by the Czarist regime after the assassination of Alexander II. But they were also Zionists, influenced by the rising national consciousness expressed in the liberation movements in Eastern Europe and aspiring to create a national home in the land of the Bible. Some of the immigrants joined the urban Jewish population; others set up agricultural colonies.

While part of the urban population continued to be supported by the *halouka* system, the number of

Jews engaged in crafts and trades grew constantly. According to a census taken in Jerusalem in 1899, the end of the period surveyed here, there were 2,576 families of craftsmen of both Sephardic and Ashkenazic origin—construction workers, tailors, stonecutters, carpenters, shoemakers, smiths—1,916 families of tradesmen and 615 families dependent on the *halouka* or supported by relatives abroad.[12] The census points to two photographers among the craftsmen, both Ashkenazic; Raffalovich may have been one of them.

Both photographers mentioned in the census must have had a limited clientele; however, since the overall level of income was low, photography may have been a feasible source of income in the Old Settlement. Though no Sephardic photographers are mentioned, the possibility that one existed, perhaps temporarily out of work by the time of the census, cannot be ruled out. The name of Tsadok Bassan, pointing to Sephardic origins, appears on a list of recipients of the *halouka* in 1890. By 1906 he had emerged as an independent photographer.[13]

Photographers had few customers in the new settlements as well. The resources of the settler families were scarce, with no surplus money available for photographic documentation of their pioneering venture for posterity. Even Western European Jewish philanthropists who supported the settlers, particularly the Rothschild family, did not collect photographs documenting their deeds. While Zionist leaders, sponsors, and publishers did not lack historical vision of the Jewish Renaissance in which they were involved— they printed numerous pamphlets, manifestos, and other written publications—they did not see the value of photography as a medium of historical documentation or propaganda. One is tempted to ascribe this to the traditionally literate nature of Jewish expression.

The earliest photographs depicting Jews engaged in agriculture are Sabounji's pictures of Mikve Israel, the L.J.S. photographs of Yessod Hama'ala (see chap. 9), and a few pictures taken in the new villages by B. Warshawski, who was probably a Jewish photographer, perhaps himself an immigrant settler from Russia.

Three engraved reproductions of photographs showing Rechovot, Gedera, and Ekron, which can be attributed to Warshawski, appeared in the first edition of the Hebrew yearbook *Luach Achiassaf*, published in Warsaw in 1893.[14] This was the first time views of the new settlements were ever printed in a Jewish publication. The pictures were used to illustrate a report on the state of the settlements. According to the captions, they were taken in the Hebrew year corresponding to 1891–92. No photographer was credited and no source was mentioned.

Tsadok Bassan (190?), dry-gelatin glass negative, modern print. "The poor of the Ge Kitchen pray on the anniversary of death for the deceased Fruma Rasha being endowed b daughter." (Central Zionist Archives, Jerusalem)

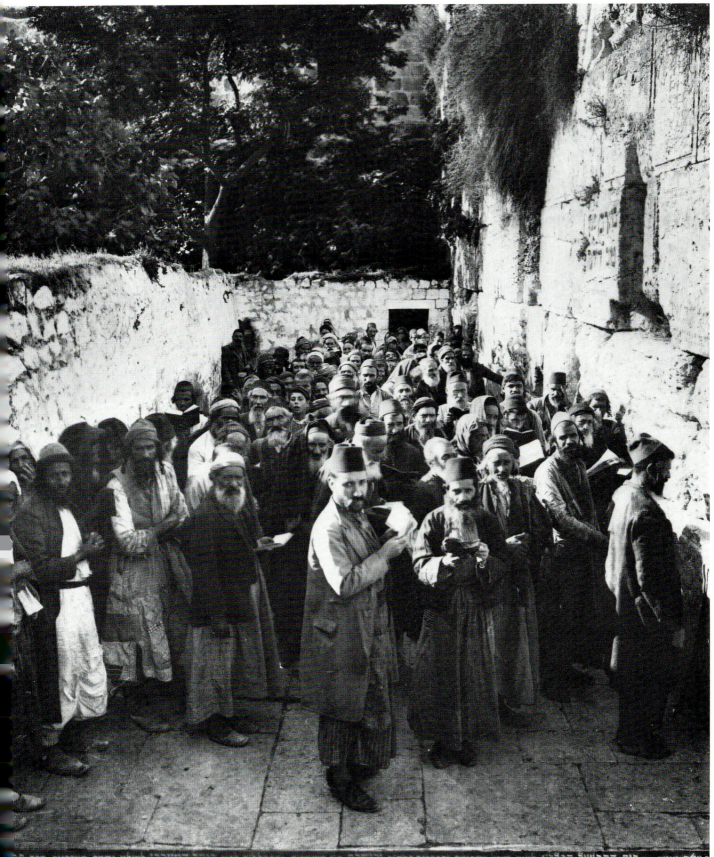

Gedera (1893). Engraving made after photograph, published in Luach Achiassaf, Warsaw. (Jewish National and University Library, Jerusalem)

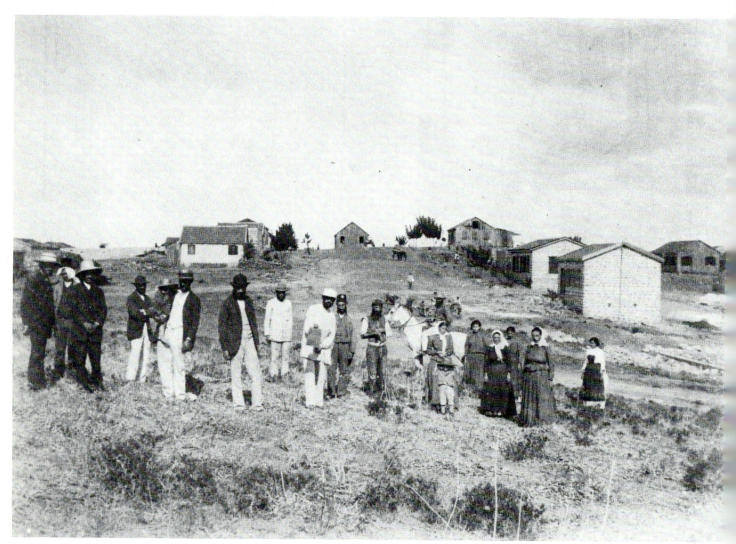

The identity of the photographer was discovered on the cardboard base of the original photographs found in a private collection in Jerusalem. The signature reads "B. Warshawski, Poltawa" [Russia]. Since his only known work is of the Jewish settlements—no photographs published by the Russian Orthodox institutions were taken by a photographer of that name—it is reasonable to assume that he was Jewish. No additional information about him is available and no other pictures of his have been published.

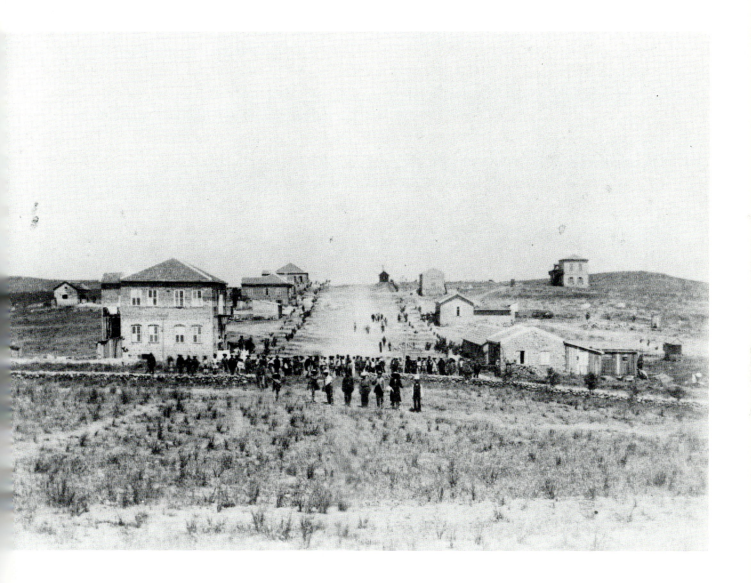

: B. Warshawski (1891/2), albumen print. "Gedera." (Y. Lehman, Jerusalem)

ᴇ: B. Warshawski (1891/2), albumen print. "Rechovoth." (Y. Lehman, Jerusalem)

Warshawski was probably the first Jewish photographer to have worked in the country. He might have been among the many Jewish immigrants from Russia who arrived after 1881. He may have resided in Palestine for a few years and then left the country for Europe or America, as did some other immigrants, or perhaps he came for only a brief stay and sent his photographs to the Warsaw publisher upon his return to Poltawa.

The three photographs published in the *Luach Achiassaf* share certain formal features. The camera faced the center of each settlement's "main street." Two rows of small stone houses, together with newly planted saplings, border the street in each village. The view of Ekron shows a few people and mainly two reaping machines, the pride of the settlement. In the view of Rechovot dozens of settlers—probably the entire population—form a long line facing the photographer while eight figures—probably the settlers' committee or administrators—stand before them in a shorter row. One of the figures in a white shirt holds a hoe as if working—a symbolic gesture, since the men stand in a barren field with the sole intent of posing for the picture. The village itself is seen in the background. The view of Gedera is similarly structured, but in this case the photographer was closer to the village and the people; there are about twenty men, women, and children, all in European dress. One man holds a child on his arm. Another man clad in white suit and hat again holds a hoe as if working (and the Warsaw engraver "helped" him raise it higher).

Two unpublished Warshawski photographs are, like Sabounji's, of Mikve Israel. One shows its wine cellar, the other a group of settlers with many youngsters wearing the school's typical straw hat. Instead of houses in the background, as in other Warshawski pictures, there are fields, and the group is much closer to the photographer. Two well-dressed gentlemen are probably administrators or teachers. The pupils hold tools; six of them raise hoes up high. Two figures, bearded and mustachioed, add an amusing touch to the photograph; one holds a flute, another a violin.

Though Warshawski's work was technically poor, it seems to represent faithfully his own as well as the settlers' attitudes toward work in the fields. The settlers actively participated in conveying the message. This was a proud display of rural labor and common goals directed toward a distant audience. In contrast, Sabounji's Mikve Israel subjects were more passive. Warshawski and the settlers with their symbolic hoes introduced a new genre.

In 1896 two halftone reproductions reminiscent of Warshawski's pictures in *Achiassaf* appeared in the *Hovevei Zion Quarterly*, published in London.[15] Both views were of Rechovot. One, captioned "Jacob

Street," shows the landscape from a vantage point similar to Warshawski's, although there were only a few very distant figures. The trees had grown taller in the meantime. The second view, of "Benjamin Street," recalls Warshawski's view of Gedera. The two photographs accompanied a travel account, "Palestine of the Present Day," translated from a German text written by Willy Bambus. Bambus, a German Zionist, published his more complete travel account in Berlin in 1898.[16] The few halftone reproductions in the book show the settlements of Rishon Le Zion and Rosh Pina; a view of Zichron Yaacov in the northern part of the country; the view of "Benjamin Street" in Rechovot; and two Bonfils views of Jerusalem—the Citadel and Jaffa Gate (interestingly enough, not the Wailing Wall or any other Jewish theme). The writer visited the country in the fall of 1895. The photographer, who is not mentioned, may well be the author himself.

Rechovot was depicted from a similar vantage point a third time by Jaffa photographer Leon Katz.[17] The height of the trees indicates that Katz was there after Warshawski and before Bambus. Katz also produced the earliest extant photograph of Petach Tikva, one of the first Jewish villages. A series of his (uncredited) photographs of various settlements was published in the *Jewish Missionary Intelligence* in 1898.[18] They were taken from a distance and show fields and houses. No other details about this photographer or his work are known.

In addition to the JMI and *Luach Achiassaf*, one other periodical published photographs of Jewish Palestine: the Zionist biweekly of Vienna, *Die Welt*, which was first published in 1897. *Die Welt* carried relatively few photographs—less than one per issue; it published two pictures by Sabounji of Mikve Israel, two by Bambus (?) of Rishon Le Zion and Rosh Pina, as well as a few others. At no time was a photographer credited. Unlike the photographic reports combined with texts appearing in the *Intelligence*, *Die Welt* used pictures as general illustrations of Zionist activity in Palestine. Apparently, the publishers of *Die Welt* did not consider photographs important documents warranting a detailed explanation.

The few photographs by Warshawski, Bambus, and Katz provide the first glimpses of the Holy Land as perceived by Jewish photographers. It was a country of fields, modest houses, distant groups of people, and gestures symbolizing work. Conspicuously absent in their work and in other photographs published in the later 1890s in *Die Welt* and the *Achiassaf* yearbook are photographs of the Wailing Wall and other historical sites. Even the new quarters of Jerusalem, displayed on the pages of the *Intelligence* in 1895 and later, did not attract Jewish photographers or Zionist publishers. The earliest photographs of Palestine taken by Jews focused solely on the new settlements.

The dominance of new subjects in the pictures of Warshawski, Bambus, and Katz calls for an explanation, the more so since their approach seems reinforced by the editorial policy of the Jewish periodicals in which their photographs appeared. As their neglect of traditional landmarks and the Old Settlement shows, Zionism was nothing short of a revolution, a total alteration of Jewish social and cultural values. It represented a new kind of Jewish existence, a secular conception of Judaism, accompanied by the rejection of the old and the established. The perception of the continuous Jewish presence in Jerusalem, Safed, Tiberias, and Hebron as the spiritual representation of the Diaspora was challenged by Zionism. Jewish photographers and publishers of the 1890s shared this approach. For them, Jerusalem's synagogues and even the streets of the new quarters held no implications of national and social renewal. Moreover, Jewish villages, fields, and vineyards in the open countryside connoted the life of the biblical forefathers—the Jewish-Zionist version of the biblical allegory. In Rechovot, Bambus tells us, even the horses that pulled his carriage had biblical names.

Curiously enough, the most important Zionist photographer of the period lived within the Old Settlement. Yeshayahu Raffalovich, an immigrant from Russia, was the main figure in local Jewish photography in the 1890s. He arrived in Jerusalem with his parents in 1882 at the age of twelve. He began his studies at the Etz Hayim Yeshiva rabbinical college, and during a short period in London a decade later, he also studied photography.[19]

For Raffalovich photography was first of all a profession. "I learned the trade of photography to perfection," he wrote,

I knew all the tricks of the trade, but am not ashamed to admit that I was not captivated by its artistic aspect. I did not delude myself into thinking I was an artist. I viewed photography as a useful tool to earn one's living. . . . I decided to learn a profession that would support me, because I longed for my home in Jerusalem, and was captivated by the idea of setting an example for the youth of the Holy City. And so on the advice of a friend I chose a light, clean profession—photography.[20]

The "youth of the Holy City" were, of course, his fellow rabbinical students, and the example he had in mind was to demonstrate how they could enter modern professions and earn a living by their own efforts. In this sense he challenged Old Settlement values. A "clean profession" meant a technically advanced one, as opposed to "blue-collar" small manufacture in Jerusalem and agricultural work in the settlements.

In 1895 an advertisement in *Luach Eretz Israel*, a Hebrew yearbook published in Jerusalem, an-

nounced that "a new photographic studio has been opened by Y. Raffalovich and Abraham Ritowsky close to the city, outside Jaffa Gate in the former Baladia Coffee House."[21] In his autobiography, Raffalovich did not mention the opening, nor did he refer to his partner. He wrote:

After much effort I succeeded in setting up a photography studio outside the Walls of Jerusalem. I was then the only Jewish photographer in the city, and since my work was superior to the Armenian photographer Krikorian, I had at first ample work. However, after a period business slackened. The Jews of Jerusalem saw no need to be photographed and there were certainly those who regarded the very occupation as a peculiarly gentile one. I therefore took to photographing the holy sites and the city's institutions. From the sale of these photographs my income was so limited that I was obliged to accept other work, such as translations from Hebrew into English and vice-versa.[22]

A year later Ritowsky repeatedly advertised the studio in the same yearbook without mention of Raffalovich. No photographs signed by or credited to Ritowsky are known.

Raffalovich did not claim to be the first Jewish photographer in Jerusalem, merely the only one working at the time. At any rate, he was the first local photographer to advertise his studio. One of his studio portraits, taken in April 1896, was published by the L.J.S. It shows the pupils of Mikve Israel returning from a trip to Jordan. Adorned with Arab costumes and holding antiquated guns, probably part of Raffalovich's wardrobe, they posed before a painted backdrop of David's Tower and the Jerusalem city walls—decidedly a novelty.

Raffalovich reproduced this and other portraits, together with landscape photographs, in his most daring photographic enterprise—his book of 1899. Again he was setting an example, carrying out a mission. At the advice of his friend Moshe Eliahu Sachs, who became associated with the project, Raffalovich undertook the publication of the first Jewish photographic album, entitled in its English version *Views of Palestine and Its Jewish Colonies*.[23] Its eighty-six photographs, taken by Raffalovich and Meyers, were printed in halftone and accompanied by Raffalovich's captions.

At the time he decided to publish this work, the newly established Zionist movement was in the midst of a controversy that was to go on for decades: the question of whether priority should be given to political work on the international scene or construction of settlements in Palestine. Raffalovich supported the constructionists, and the purpose of his album was to emphasize the importance of the settlements already established and the need for more.

In the preface to his album, which became his photographic legacy, Raffalovich explained why he had embarked on this formidable enterprise:

The views that are contained in this book show the new conditions under which the Jew lives and works and the change that has taken place in the long neglected country.

They show the farms and cottages, vineyards and wheat-fields, which the Jewish Colonists have called into existence and indicate the new feeling that has been awakened in our ancient race.

No Jew can regard this state of things without a glow of pride, because it shows that the old spirit is still alive and that the people have not through their long exile lost the capacity for agricultural work which characterized them in olden times.

A biblical quotation could not be absent:

And I shall bring back from captivity my people Israel, and they shall build waste cities and inhabit them, and they shall plant vineyards, and drink the wine thereof; they shall also make gardens and eat the fruit; and I shall plant them in their land, and they shall no more be pulled out of the land which I have given them, saith the Lord thy God. [Amos 9:14–15]

Raffalovich's album opens with four pages devoted to the agricultural school at Mikve Israel. There follow six pictures showing the Rishon Le Zion settlement south of Jaffa, with its fields and wine cellar. While it might seem quite natural today to open an album on Palestine (called in the Judaic tradition

Eretz Israel) with an imposing building for wine production and to give prominence to the pupils of a modern agricultural school, at the time it was a novelty. The emphasis was contemporary rather than historical, with the modern style of the building signifying progress. The majority of the photographs that followed were devoted to the agricultural settlements and had a similar tone. The oriental features popular in most Holy Land albums of the period were absent, and the perennial views were relegated to the latter part of the work. The result was a more complete survey of Eretz Israel with an overall shift in perspective.

The album was more a kind of inventory than a photographic achievement. As Raffalovich wanted to show as much of the settlements as possible, including the surrounding fields, he took most of his pictures from afar. The villages themselves generally appear as lines of small houses on a distant crest. Most of the landscapes are static, containing a lone figure in the foreground—possibly Raffalovich or Meyers. The photographs were taken during wintertime, so there are no views of grain or grape harvesting. Winter clothing, muddy fields and yards, together with the European style of the small houses, gave the villages a rather Western appearance.

Aside from a few conventional group portraits—of the Rishon Le Zion orchestra and of pupils in Jerusalem schools—the few settlers captured in villages and fields assumed informal poses. In a photograph of the Rishon Le Zion wine cellar two distant workers wave to the camera, and in an interior view workers are spread out amid the machinery rather than assembled in a formal group picture. Portraits of notables or clerks were absent, and none of the settlers or workers posed alone, apparently befitting the group spirit of their enterprise.

A group portrait taken in the Warshawski vein in Rechovot illustrates the importance the idea of tilling the soil held for the settlers. The picture, of a few figures with tools in hand posing in front of houses, is taken from closer range than usual, enabling an examination of the subjects. Though some figures raise their hoes as if at work, their dress gives them away as the settlement's administrative clerks or the more established landowners. Apparently the pose had become a convention, if not a ritual. Obviously, manual labor was considered worthy of portrayal—so much so that in this case it was the "bosses" who seem to have adopted the gesture. This incongruity is both amusing and enlightening. The posing figures may have been overly eager to display their industry and zeal, or perhaps they were thinking of the possible propagandistic effect of the photograph.

ayahu Raffalovich (1899), halftone reproduction. Jewish colonists. Probably in Rechovot,
vish village in the coastal plain. (Jewish National and University Library, Jerusalem)

At the back of the album appear pictures relating to the Old Settlement and historical sites. There were some perennial views, such as the Wailing Wall, synagogues in Jerusalem and Galilee, and the tombs of Rabbi Meir Baal Haness in Tiberias and Rabbi Shimon Bar Yohai in Meron, traditional Jewish pilgrimage sites. Photographs of families and groups and *carte-de-visite* portraits of individuals in the form of vignettes also appeared. Raffalovich did not ignore the Old Settlement within which he lived and worked, and in whose own renewal he took an active part. Nevertheless, his main emphasis was on the activities of the Zionist settlers.

Not all the photographs were taken by Raffalovich. At least twelve of them can be clearly attributed to Elijah Meyers of the American Colony and at least one to Leon Katz of Jaffa. While credit is not given to them in the album, Meyers is mentioned half a century later in Raffalovich's autobiography:

I set out to tour the land from Gedera [in the south] to Metulla [in the north] together with a friend from the American Colony, Mr. Meyedes [sic], an expert photographer; and we photographed whatever caught our attention.[24]

Raffalovich was not the first author to omit a credit line. Still, the concept behind the album, its production and text, and the efforts at publishing and marketing it were all his own.

In taking on a project of photography to promote the constructionist ideology, Raffalovich was ahead of his time. Photography evoked little interest among European Zionist circles, as a glance at *Luach Achiassaf* and *Die Welt* reveals. This attitude is corroborated by Raffalovich's story of his efforts to find a publisher and a bookseller for his album:

. . . I was charged with the task of going abroad to find a publisher. Since we lacked experience in such matters, it did not occur to us that it might be difficult to find someone to invest money in publishing a book about Palestine. Yet this difficulty was greater than we could possibly have foreseen.
All my acquaintances agreed that the one place to publish such a book was Germany. I therefore went to Frankfurt, though I was a stranger there. . . . I found a Jewish lithographic firm that agreed to publish my book. . . . And since no one there knew how to arrange the Hebrew letters, I myself took care of it. I had learned arranging in my father-in-law's printing house in Jerusalem, and I was an expert not only in arranging the letters but in matters of print in general.
The book came out perfectly splendid, and the printers agreed to wait until I found a bookseller and could pay them in installments. But where was one to find this bookseller?[25]

Raffalovich made his first attempts in Paris, where he engaged the assistance of Zionist leader Bernard Lazare and of well-known French publisher Lévy. The three contacted every publishing house interested

in illustrated books, but in vain. Raffalovich then went to London hoping to enlist the aid of the Hovevei Zion organization. Again, he was disappointed. Not even the Zionist leaders who supported constructionism appreciated the merits of his album. On the other hand, Raffalovich had an unexpected and even undesired success in America. Rafael Mazin, a London bookseller, suggested that he send a copy of the album to New York in the hope of finding a big market there. He sent copies to some American acquaintances, of which he lost track. A recently discovered booklet indicates that they simply reprinted a limited pocketbook edition with Yiddish annotations, without his permission and without credit.[26]

In the meantime, the Zionist movement assembled for its third congress in Basel, Switzerland. But even here Raffalovich found only one person who appreciated the value of the book as a tool for propaganda. Finally, the publisher of the Warsaw *Luach Achiassaf* showed some interest in the diffusion of the book. Realizing that even good sales would not return his investment, Raffalovich sold his share in the album, together with his studio and equipment in Jerusalem, to his friend Moshe Eliahu Sachs, whom he met by chance at the congress. At this point Raffalovich abandoned photography, this time for good.

Raffalovich's career in local photography appears to have been stormy but short. A descendant of a distinguished rabbinical family, he returned to this profession and eventually left the country.

The small number of photographs reproduced by Jewish publishers and Raffalovich's lack of success with Zionist leaders show that they were unaware of the potential of photography as a means of communication. Perhaps a Jewish audience for Holy Land and Zionist photography did not yet exist, either in Europe or in Jerusalem.

"AMERICAN COLONY" PHOTOGRAPHERS

The most famous photographic agency in Jerusalem, first known as American Colony Jerusalem and since 1934 as Matson Photo Service, was founded in 1898. Today only a hotel bears the name American Colony, but at the turn of the century it stood for a many-sided enterprise engaged in hostelry, tourism, and the production of souvenirs and photographs.

The colony had been in existence since September 1881, when a group of pilgrims from Chicago headed by Horatio G. Spafford arrived in Jerusalem and decided to stay. The somewhat eccentric, fundamentalist and utopian community was enlarged by newcomers from America and financed by supporters in Chicago. Controversial from its beginnings, the colony earned the U.S. consulate's enmity,

worsening its already precarious financial position. An influx of Swedish members beginning in 1896, inspired by a Swedish group in Chicago, helped the colony survive by raising animals and growing crops. The Swedes, farmers from Nas, in the Dalekarlia region, came to play an important role in the colony's economy, and two of them—Lars Larsson and G. Eric Matson—later became its best-known photographers.

The photographic activity of the colony seems to have begun in 1898. The daughter of the founder, Bertha Spafford-Vester, relates the story:

In October 1898 Kaiser Wilhelm II of Germany . . . used the opening of the reconstructed Crusader Church . . . the Lutheran Church of the Redeemer which stands almost in the shadow of the Holy Sepulchre . . . as an excuse to visit both Turkey and Palestine. . . . The imperial visit was a great occasion for Palestine. The American Colony had bought an old camera, and in this small way started the Photographic department which later became famous for its large selection of photographs and stereopticon slides. Frederick [Vester], with Elijah Meyers—Brother Elijah, a converted Jewish-Indian who had a partial knowledge of photography—followed the Kaiser and his entourage on the entire Palestine trip.[27]

Evidence provided by G. Eric Matson corroborates Spafford-Vester's story concerning Meyers while providing complementary information. "Elijah Meyers, a Jew from India who accepted the Christian faith, joined the Colony and taught Colony members Furman Baldwin, Lars Larsson and myself to take pictures," he remembered.[28] Matson was ten years old in 1898, but he worked for the photographic department from his early teens and knew its history intimately.

The credit belatedly given to Meyers by Raffalovich also points to Meyers's involvement in the colony's earliest photographic work. The corroboration of independent sources is important, since Meyers did not sign his photographs, instead using the colony's common label, and since his name and work have been overlooked in the twentieth century. It is also important that Raffalovich, who considered his own work superior to Krikorian's, labeled Meyers "an expert photographer." In light of this, Spafford-Vester's reference to an "old camera" and Meyers's "partial knowledge" with respect to the beginnings of American Colony photography may have been a bit romanticized. In fact, Meyers might have had a solid background in the profession; a studio in Bombay, India, was run by a Jewish family by the name of Meyers in the early twentieth century.[29] Perhaps Brother Elijah had been involved in photography even before he converted to Christianity and emigrated to Palestine.

Raffalovich's story also indicates that the tour of the settlements may have preceded the kaiser's visit by many months. Raffalovich mentions that Meyers froze during a snowstorm on their way home; the

American Colony Jerusalem (Elijah Meyers?) (190?), albumen print. Same place as p. 2 reverse view, toward Jaffa Gate. Krikorian, Raad, and Savvides—a Greek photographer—al the main access road used by tourists, pilgrims, travelers, and inhabitants. (Central Zio Archives, Jerusalem)

only snowfall registered during the last years of the century occurred in January-February 1898.[30] Meyers's work in the settlements may have provided additional training for coverage of the kaiser's visit. The superior quality of American Colony photographs of the kaiser's visit suggests that they were taken by an experienced photographer.

The American Colony photographs documenting the kaiser's visit are not inferior to Raad's or Krikorian's or to pictures taken by the no-less-qualified German photographers who accompanied their sovereign. The photographs may be attributed to Meyers, although more than one person was mentioned by eyewitnesses in connection with the early photographic activity at the colony.

Spafford-Vester's story lends itself to an interpretation that may point to Vester as a second photographer (especially since many post-1900 American Colony picture postcards carry his name). But according to his son,[31] Vester was only involved in the sale of photographs. Frederick Vester, the son of a Swiss-German missionary (and later Bertha Spafford's husband), owned a gift shop near the Jaffa Gate, next to

320 View looking down Jaffa Road. Blick auf dem Jaffa-Thor Vue Prise de la Porte de Jaffa

Bonfils's Jerusalem branch. A German national and well acquainted with German Vice-Consul Hess, Vester would have had no difficulty getting permission to follow the kaiser with his photographer. Meyers, too, was on friendly terms with the Hess family even before the imperial visit.[32] A third name that came up in connection with early American Colony photography was Furman Baldwin, mentioned by Matson. No other source points to this colony member as a photographer.

The sole reliable source of pre-1900 American Colony photographs is Reverend Boddy's *Days in Galilee*. Boddy, an English author and amateur photographer, visited Jerusalem and the American Colony in the spring of 1899. Some forty photographs in his book were credited to the American Colony.[33] Of these, twelve, although cropped, can be recognized as identical to views in Raffalovich's album. These pictures clearly can be attributed to Meyers, and by extension it is plausible to assume that all the American Colony photographs published in *Days in Galilee* were his.

The twelve pictures also used in *Views* show the perennial subjects—landscapes, traditional holy places such as Rachel's Tomb, the Wailing Wall, and Tiberias, and some small figures. In addition, *Days in Galilee* contains portraits of veiled women in oriental dress; three poor, bearded Jews holding prayer-books; various landscape views; some church interiors; Bedouins with rifles in the Judaean desert; Bedouin tents; and shepherds tending sheep—conventional Holy Land photography. All photographs were taken outdoors, and there were very few "Catholic" emphases: this was a Protestant book, and so was, perhaps, the selection offered by the photographer.

Boddy not only used American Colony photographs; he also had extended conversations with Furman Baldwin, whom he identified as the head of the colony. Baldwin elucidated the colony's social and religious principles of communal life: "[we] wished to live out the Christ life in unity there," and "[we] lived in community and told one another kindly of each one's faults." Baldwin also told Boddy that

their object in coming to Jerusalem was not, as so many said, to watch for the visible coming of Christ from the wall of the Holy City. They had been led by the Holy Spirit to come to Jerusalem. Christ' Second Coming is primarily in His people. He came the first time through Bethlehem, Galilee, Gethsemane and Golgotha, and he comes again by being born in the Christian, passing through everyday life to a spiritual crucifixion and to resurrection power.[34]

Baldwin and his people had lived together fourteen years in America and Jerusalem.

Boddy did not mention Baldwin as a photographer, and Matson's reference to him as such remains unsubstantiated. However, another statement by Boddy may indicate that Meyers was not the only pho-

Attributed to Elijah Meyers, American Colony Jerusalem (1898/9), albumen print. Jew Abraham's Vineyard. (A. Carmel, Haifa)

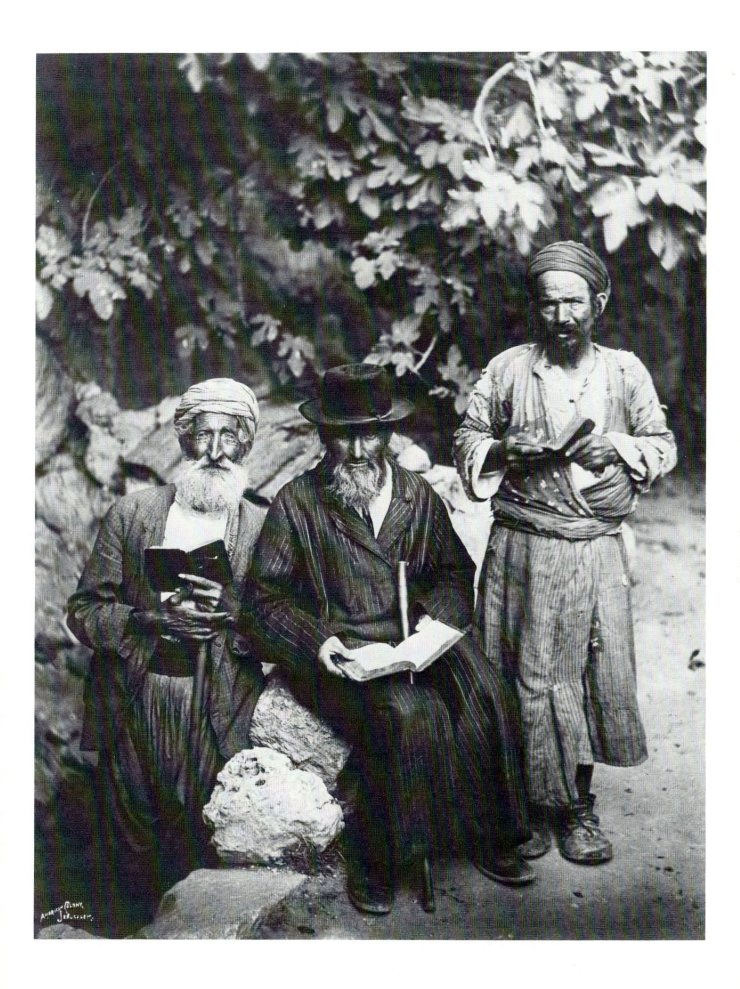

tographer at the colony, even in 1899. Using the plural, Boddy relates that "they gladly gave me permission to reproduce any of the fine photographs which have been taken by members of the community. They make photography one of their professions."[35] Whether the second photographer in 1899 was Baldwin or Larsson remains unknown. Perhaps Boddy, respecting an explicit wish, simply used the plural to signify the collective spirit of the group. This would be in keeping with their use of a common label.

Despite the practice of group credit, Lars Larsson and not Elijah Meyers can be identified with a second period of the colony's photographic work. This period may have begun around 1904, the year in which A. Goodrich Freer's *Inner Jerusalem* appeared, illustrated by new and superior American Colony photographs.[36] There was an unstaged view of Arab village work—a subject treated often by Larsson in his work of the 1910s and 1920s—and in general a greater variety of subjects than in American Colony photographs published earlier. During World War I, Larsson ceased usage of the common label. An album of 1916 and a book of 1918 include many pictures credited to himself;[37] these closely resemble (some are identical to) others carrying the common label published earlier in the *National Geographic Magazine*.[38] In the book of 1918 Larsson is mentioned as the only photographer of the colony.

G. Eric Matson, the young apprentice who came to Jerusalem with his parents in 1896, replaced Larsson and took over the photographic enterprise and collection, beginning to take pictures in the 1930s.[39] My wife and I visited him in 1976, in the Episcopal home for the elderly in Alhambra, California. Alert and in good spirits, his memories fresh, he was happy to have visitors from Jerusalem. He showed us what he was working on: tinting the American Colony's large sepia prints of turn-of-the-century Jerusalem in lively colors. In the dining room of the home, American Colony photographs—landscapes, shepherds, and lambs, carefully accompanied by appropriate verses from the Old and New Testament—adorned the walls.

A year later, this last direct and active witness of nineteenth- and early twentieth-century photography in the Holy Land died. The only survivor from this era is Chalil Raad's niece, Najla Krikorian, the bride of peace.[40]

After the turn of the century, a new style appeared in local photography. Whereas Meyers—as well as Raad, Sabounji, and Krikorian—had been concerned with subject alone, Larsson used light and shadow to dramatize his views and to provide his subjects with a sense of plasticity. In his excellent photographs of Arab life, Larsson, himself of peasant origin, combined a graphic approach with true insight into local village society. The new photographs were published only after 1910.

In a similar vein, the 1910s saw a shift in the work of Jewish photographers, represented by Ben Dov and Soskin. The former favored chiaroscuro compositions both in his landscapes and portraits. Unlike Raffalovich (and Warshawski), his views of Jewish settlers were more informal and realistic. True, there were group poses and work scenes, but no hoes were raised in symbolic gestures. Soskin's views were in this vein too, showing the builders of the new city of Tel Aviv, founded in 1909.

In general, the 1900s were a period of hiatus during which no local photographic publications appeared. The new work and style which Larsson, Ben Dov, and Soskin introduced in the second decade of the twentieth century pointed to a new direction.

A similar hiatus—and a similar shift—was noted in the work produced by foreign visitors. Dwight L. Elmendorf, who photographed the country in 1901, was by far more aware of the formal possibilities afforded by photography than any of his predecessors. His work was published only in 1913 and could not have influenced Larsson or Ben Dov. This delay in publication may have reflected a market flooded with previous productions in the early 1900s. The first new collection of some importance to appear in a book was that of G. E. Franklin, published in 1911. In that same year, the most important Jewish photography yet produced also appeared, the work of Dr. Leo Kann, an active Zionist and president of the Vienna Photoklub. German ethnographer Gustav Dalman, who resided intermittently in the country in the 1900s and used photography extensively in his research, published his work after World War I.

The lack of important new publications in the early 1900s, together with the transition to a new style and approach to subject matter in the photographs appearing in the following decade, signal the close of the first period in the history of Holy Land photography. Over this sixty-year period, stretching from 1839 to 1899, four major forces appear to have shaped photographic production: travel and tourism, biblical traditions and religious-cultural factors, socioeconomic conditions, and photographic technologies.

Photography was introduced to the country by traveling photographers, and priorities in subject matter were strongly influenced throughout the period by the demands of the overseas and tourist market. Biblical-oriental images were created, catering to foreign tastes no less than representing local life. People connected to or employed by the travel trade were among the first local inhabitants to be captured, serving as portrait "models." They also acted as agents of acculturation to broader segments of local society. The interaction between photographers and local models took place around travelers' routes and spread as the numbers of tourists and accessible sites increased. Tourists and pilgrims also largely influenced the products of local photography, which naturally followed this market's tastes.

The role of Christian religious cultures in attracting some of the earliest and most famous traveling photographers to the land of the Bible is obvious. Virtually unknown was their role—and that of the Bible—in shaping genres in portrait photography and nuances in landscape photography. Biblical heritage and religious ideology also played a significant part in the promotion of a persuasive "missionary" image of the country and its population. From a different angle, biblical and Moslem antiiconic traditions contributed to the relatively late local acceptance and development of photography; but this factor has tended to be overstated at the expense of socioeconomic conditions.

The local society, overwhelmingly rural and nomadic, poor and closely knit, was uninterested in keeping pictorial family records—the main source of a photographer's income. Until the end of the nineteenth century, local inhabitants were mostly passive subjects photographed for foreign consumption. Interaction between photographers and their subjects was that of strangers who only gradually learned to communicate with one another. Until the end of the century, apparently local trade photographers— Armenians, Arabs, Jews, and the surprisingly high number of converted Jews—were immigrants from near and far. The degree of their involvement in the local economy was partial, as were their roots in local cultures. The image of the Holy Land and its inhabitants was produced by and large by outsiders for an audience outside the country.

On the whole, the shift in early photographic processes had a negligible effect on the image of the Holy Land in terms of the development of styles. However, the shift to ready-made dry negative plates and to the inexpensive halftone reproduction process that took place in the 1890s led to a democratization of the medium. Growing numbers of photographers, amateurs included, could now seek new subjects and interact more easily with local people; and growing and more diversified audiences could purchase books and other publications illustrating a greater variety of subjects. Local photography was not unaffected by this development.

Looking back upon the first period in the history of Holy Land photography, one wonders whether and to what degree the noted trends were specific to this area. First, photographs of historical edifices and genre portraits published in impressive albums and popular periodicals may have preceded closer-to-life photographic representation in other Third World environments as well. The late-occurring and scarce realistic portrayal of "exotic" peoples in mass-produced publications may have been more a matter of predispositions (that may hold to this day) than a matter of inadequate photographic processes. Second, without denying the special place granted the Holy Land in Western religious traditions, Protestant

(and Catholic) perceptions of the universe may have been a force in photography in other settings. Our story suggests that the history of photography in general should also be considered a history of modes of representation rooted in cultural predispositions and a history of the social interaction between photographers and their subjects, individuals and societies.

NOTES,
BIBLIOGRAPHY,
AND
INDEX

Notes

Introduction

1. Helmut and Alison Gernsheim, *The History of Photography from the Camera Obscura to the Beginning of the Modern Era* (New York: McGraw-Hill, 1969), pp. 75–76.

2. W. H. Bartlett, *Walks about the City and Environs of Jerusalem* (London: Hall, Virtue & Co., 1842), pp. 148–51.

3. Rolf H. Krauss, "Travel Reports and Photography in Early Photographically Illustrated Books," *History of Photography* 3(January 1979):17.

4. F. V. Hayden, introduction to *Portraits of American Indians* (1877), quoted in Ian Jeffrey, *Photography, a Concise History* (New York: Oxford University Press, 1981), p. 56.

5. A relevant example is the highly successful exhibition of photographs, "Family of Man," that toured the world in the 1950s. Of the 503 pictures taken in 68 countries, only 82 had been taken in Asia, Africa, or Latin America, and of those only 6 had been produced by local photographers.

6. A. L. Tibawi, *British Interests in Palestine 1800–1901* (Oxford: Oxford University Press, 1961), p. 184. See also idem, *American Interests in Syria* (Oxford: Clarendon Press, 1966), p. 4.

7. Herbert Hovenkamp, *Science and Religion in America 1800–1860* (Philadelphia: University of Pennsylvania Press, 1978), pp. 147–48.

8. Mark Twain, *The Innocents Abroad* (New York: Harper and Brothers, 1911), p. 243.

9. I am grateful to Mary Heathcote for this information.

10. Twain, *Innocents*, p. 9.

11. Ibid., p. 244.

12. Herman Melville, *Journal of a Visit to Europe and the Levant, October 11, 1856–May 6, 1857*, ed. Howard C. Horsford (Princeton: Princeton University Press, 1955), p. 154.

13. Ibid., p. 137.

14. Ibid., pp. 4–5.

15. Ibid., p. 148.

16. M. de Lamartine, *Un voyage en Orient* (Paris: Gosselin, Furne & Pagnene, 1844), p. 346.

17. Ibid., p. 232.

18. Comte Eugene Melchior de Vogüé, *Syrie, Palestine, Mont Athos, Voyage aux pays du passé* (Paris: Plon, 1887), p. x.

19. Edward W. Said, *Orientalism* (New York: Vintage Books, 1979), pp. 1, 4, 168.

20. Aaron Scharf, *Art and Photography* (London: Pelican Books, 1974), p. 57.

21. *Encyclopedia of World Art*, vol. 12 (London: McGraw-Hill, 1961), p. 569.

22. Rev. Jesse L. Hurlbut, D.D., *Bible Atlas, a Manual of Biblical Geography and History* (Chicago: Rand McNally and Co., 1894), p. 29.

23. Personal communication.

24. Ibid.

25. Shmuel Avitsur, "The Influence of Western Technology on Traditional Society in Nineteenth-Century Palestine," in *Studies on Palestine during the Ottoman Period*, ed. Moshe Ma'oz (Jerusalem: Magnes Press, 1975), pp. 486, 491.

26. Gabriel Baer, "The Impact of Economic Change on Traditional Society in Nineteenth-Century Palestine," in *Studies on Palestine during the Ottoman Period*, ed. Moshe Ma'oz (Jerusalem: Magnes Press, 1975), pp. 495–96.

27. Personal communication.

28. Jacob M. Landau, "The Educational Impact of Western Culture on Traditional Society in Ottoman Palestine," in *Studies on Palestine during the Ottoman Period*, ed. Moshe Ma'oz (Jerusalem: Magnes Press, 1975), pp. 505–6.

29. Ibid.

30. Shimon Shamir, "The Impact of Western Ideas on Traditional Society in Ottoman Palestine," in *Studies on Palestine during the Ottoman Period*, ed. Moshe Ma'oz (Jerusalem: Magnes Press, 1975), p. 507.

31. Ibid., p. 514.

CHAPTER 1.
Art, Propaganda, and "Remarkable Views"

1. Frédéric Goupil-Fesquet, *Voyage d'Horace Vernet en Orient* (Paris: Challamel, 1843), p. 1.

2. *Excursions Daguerriennes—vues et monuments les plus remarquables du globe* (Paris: Lerebours, 1842), n.p.

3. See Helmut and Alison Gernsheim, *The History of Photography from the Camera Obscura to the Beginning of the Modern Era* (New York: McGraw-Hll, 1969), p. 116; Beaumont Newhall, *The History of Photography from 1839 to the Present Day* (New York: Museum of Modern Art, 1964), p. 175. The letter originally appeared in Amédée Durand, *Joseph, Carle et Horace Vernet, correspondance et biographies* (Paris, 1846).

4. Goupil-Fesquet, *Voyage*, p. 1.

5. Ibid., p. 116.

6. Alexander Keith, *The Evidence of Prophecy in Historical Testimony to the Truth of the Bible* (London: Religious Tract Society, 1882), p. xiii.

7. Alexander Keith, *Evidence of the Truth of the Christian Religion* (Edinburgh: W. Whyte, 1847), p. 8.

8. A. A. Bonar and R. M. M'Cheyne, *Narrative of a Mission of Inquiry to the Jews for the Church of Scotland in 1839*, 3d ed. (Philadelphia: Presbyterian Board of Publishers, 1845), p. 100.

9. In 1839 Dr. Andrew Fyfe was president of the College of Surgeons, Edinburgh (see Helmut and Alison Gernsheim, *History*, p. 124). Dr. George Skene Keith became a licentiate of the college in 1841 and subsequently a fellow. His brother, Thomas, a well-known calotypist, also became a licentiate in 1848. This information was recently forwarded to me by Dorothy V. Wardle, librarian, the Royal College of Surgeons, Edinburgh.

10. Helmut and Alison Gernsheim, *History*, p. 86.

11. Joseph Philibert Girault de Prangey, *Monuments arabes d'Egypte, Syrie et Asie Mineure, dessinés et mésurés de 1842 à 1845* (Paris, 1846), n.p. Lithographies are by Fichot and Bichebois. There is no text about Jerusalem or Palestine.

12. Idem, *Monuments et paysages de l'Orient, Lithographies executées en couleur d'apres aquarels* (Paris, 1851).

13. There were some exceptions. The most successful was the process of electrotyping invented by Hippolyte Fizeau. Two reproductions in vol. 2 of *Excursions Daguerriennes*—not those from the Holy Land—were printed by this process (see Helmut and Alison Gernsheim, *History*, p. 540).

14. When in Cairo, Goupil-Fesquet noted: "I obtained four prints of the Sphinx and five prints of the pyramids, having exposed the images for 15 minutes in the sun. (The prints made on the seashore are always more beautiful and require less time than those made inland. In Alexandria, I obtained excellent results after two minutes or even less.)" *Voyage*, p. 123.

15. This view has been reprinted in *Encyclopedia Judaica, Yearbook 1975–76* (Jerusalem: Keter), p. 23, in a portfolio of nineteenth-century photographs from the Holy Land edited by Nachum T. Gidal, the renowned photographer and photohistorian.

16. *Excursions Daguerriennes—vues et monuments les plus remarquables du globe* (Paris: Lerebours, 1842), plate "St. Jean d'Acre."

17. See, for example, Goupil, Frédéric-Auguste-Antoine, or Goupil-Fesquet, *L'Art de dessiner* (1863); *Manuel complet et simplifié de la peinture à l'huile* (1858); *Manuel général de modelage à bas-relief et en ronde-bosse, de la sculpture et du moulage* (1860). He published thirty-four such books, some of them in several editions.

18. *Excursions*, Introduction.

19. Goupil-Fesquet, *Voyage*, pp. 179–80.

20. Written by Alexander Keith (Edinburgh: W. Whyte, 1847).

21. Ibid., 1843 ed., pp. 110–11.

22. These engravings were also published separately in a small album. See *Daguerreotypes of the Holy Land* (Edinburgh: W. Whyte, 1848).

23. Alexander Keith, *Evidence of the Truth*, 1847 ed., p. 8.

24. In 1839 Alexander Keith was asked by his companions what he understood by the expression "I will make Samaria as an heap of the field." He replied that he supposed

"the ancient stones of Samaria would be found not in the forms of a ruin, but gathered into heaps in the same manner as in cleaning a vineyard, or as our farmers at home clear their fields by gathering the stones together. In a little after we found the conjecture to be completely verified" (A. A. Bonar and R. M. M'Cheyne, *Narrative of a Mission of Inquiry to the Jews for the Church of Scotland in 1839*, 3d ed. [Philadelphia: Presbyterian Board of Publishers, 1845], p. 219). In a similar example, while on Mount Zion he and his companions "found [themselves] in the midst of a large field of barley. The crop was very thin, and the stalks very small, but no crop could be more interesting to us. We plucked some of the ears to carry home with us, as proofs addressed to the eye that God had fulfilled his true and faithful word. (Therefore shall Zion for your sake be ploughed as a field) (Mic. 3:12)" (Ibid., p. 133). It was a simple step from the carrying home of physical evidence to the use of photogenic drawings, through which the image of the object was transferred onto paper. The move from photogenic drawings to the use of daguerreotypes as evidence was quick to follow.

25. Alexander Keith, *Evidence of the Truth*, 1843 ed., pp. 164–65.

26. Alexander Keith's writings about the state of the country are based on his own observations made during repeated visits in 1839 and 1844. He also quotes known researchers, mainly Burckhardt, Clarke, and Volney, who preceded him. For a concise survey of nineteenth-century geographical research in the Holy Land, see Yehoshua Ben-Arieh, "The Geographical Exploration of the Holy Land," *Palestine Exploration Fund Quarterly Statement* (July–December 1972), pp. 81–92.

27. Alexander Keith, *Evidence of Prophecy*, p. xix.

28. I am grateful to Helmut Gernsheim, who helped me locate the original plates. Handwritten notes in the wooden boxes in which they were found suggest that the collection had been examined in 1865 and 1880, presumably by Girault de Prangey himself. I found the same handwriting on caption labels adhering to the reverse side of the daguerreotypes. Many of the captions, however, did not refer to the depicted places, and some of the labels had been detached. It was nevertheless possible to identify most of the places. The owner of the plates wants to retain the collection undisturbed and requested anonymity. I greatly appreciate his help and generosity and naturally will respect his wishes.

29. On de Prangey's trip and work, see Comte de Simony,

Une curieuse figure d'artiste, Girault de Prangey, 1804–1892 (Dijon: Academy of Sciences and Fine Arts, 1937), pp. 4–6. This is a short article written by a resident member of the academy who knew of de Prangey's daguerreotypes and his published work and who first brought his colorful personality to the public eye. Beaumont Newhall referred briefly to de Prangey's trip to the Near East (*History*, p. 20), as did the Gernsheims (*History*, p. 116). The latter gave more detail about the collection of daguerreotypes in their book, *L. J. M. Daguerre* (New York: Dover, 1964), pp. 106–7. Neither in Newhall's nor in the Gernsheim's histories were daguerreotypes from the Holy Land reported.

30. He used plates of various dimensions: 24 × 18.6 cm, 18.6 × 12 cm, 11.8 × 9.4 cm, and 9.3 × 7.7 cm. By having the 24 × 18.6 cm plate cut into two, he obtained the unusual dimension of 24 × 9 cm; fifty-two of his best-executed plates were of this size. He even took four pictures of 24 × 4½ cm—two halved plates of 24 × 9—to depict the Mediterranean shores.

31. Maxime du Camp and Francis Bedford took photographs from the same vantage point in 1850 and 1862, respectively. Frederic Catherwood used his camera lucida here as early as 1833.

CHAPTER 2.
Jerusalem in Beautiful Prints

1. Yehoshua Ben-Arieh, "Legislative and Cultural Factors in the Development of Jerusalem 1800–1914," in *Geography in Israel*. A collection of papers offered to the 23rd International Geographical Congress, USSR, July–August 1976 (Jerusalem, 1976), p. 61; idem, "The Population of the Large Towns in Palestine during the First Eighty Years of the Nineteenth Century," in *Studies on Palestine during the Ottoman Period*, ed. Moshe Ma'oz (Jerusalem: Magnes Press, 1975), pp. 49–69.

2. The calotypes of both du Camp and Salzmann were printed and their books published on Blanquart-Evrard's premises.

3. Michel Braive, *L'âge de la photographie* (Brussels: Connaissance, 1965), p. 209.

4. Rev. A. S. Marshall was the author. See Helmut and Alison Gernsheim, *The History of Photography from the Camera Obscura to the Beginning of the Modern Era* (New York: McGraw-Hill, 1969), p. 281.

5. The British calotypists were Bridges, Wheelhouse, and

Isaacs. Rev. A. A. Isaacs had some of his calotypes reproduced as lithographs in H. B. Tristram, *Scenes from the East* (London: Society for Promoting Christian Knowledge, 1870). John Smith-Shaw of Dublin left unpublished calotypes, some of them of Jerusalem and Petra, in his collection of seventy-eight paper negatives, forty calotype positives, and eleven other prints of Europe and the Near and Middle East. The two German calotypists were Wilhelm von Herford, who visited Jerusalem in 1856, and A. J. Lorent.

6. George W. Bridges, *Palestine as It Is: In a Series of Photographic Views by the Rev. George W. Bridges. Illustrating the Bible* (London: J. Hogarth, 1858). Subscriber's copy. This was part of a seven-year tour beginning in 1846, in which he photographed Italy, Malta, Greece, and the Holy Land; Christie's East, *19th Century Photography* (sales catalogue) (New York: May 16, 1980).

7. The unsigned introduction was written in Beachly Parsonage, November 1858.

8. Text to plate 31.

9. Text to plate 52, p. 2.

10. Lord Lincoln wrote a letter of introduction to Roger Fenton, the first semiofficially appointed photographer to depict the British Army in Crimea; see John Hannavy, *Roger Fenton* (Boston: David R. Godine, 1975).

11. C. M. Wheelhouse, "Photographic Sketches from the Shores of the Mediterranean, Calotypes Taken between 1849–1850," private album.

12. Maxime du Camp, *Egypte, Nubie, Palestine et Syrie* (Paris: Gide et Baudry, 1851).

13. Idem, *Orient et Italie, souvenirs de voyages et lectures* (Paris: Librairie Académique, 1868), p. 238.

14. Idem, *Egypte*, p. 55.

15. Gustave Flaubert, *Voyage en Orient (1849–1851)*, Oeuvres complètes illustrées de Gustave Flaubert (Paris: Centenaire, Librairie de France, 1925), p. 147.

16. Idem, letter to Louis Bouilhet of August 20, 1850, *Reisebriefe* (Potsdam: G. Kiepenhauer Verlag, 1921), pp. 213–14.

17. Idem, *Voyage*, p. 155.

18. Auguste Salzmann, *Jérusalem, Etudes et reproductions photographiques de la Ville Sainte depuis l'époque jadaïque jusqu'à nos jours*, 2 vols. (Paris: Gide et Baudry, 1856), 92 pp. text, 180 calotypes (reduced edition, Paris, 1855, 40 calotypes). (The complete edition was bound in three signatures of sixty pages; Braive, *L'age de la photographie*, p. 211.)

19. Salzmann, *Jérusalem*, p. 3.

20. Of all the painful scenes he had witnessed, Salzmann wrote, "nothing equalled the deep distressing pain of two Jewish women who came to the Western Wall one Friday evening to weep after the past. They wept eighteen centuries of maledictions. . . ." And yet, though "these eternal pariahs have only one aim, to dig their graves in the Valley of Jehoshaphat, and to fall asleep in the shadow of their Temple," he felt that, in spite of it all, "this disappeared race lives here, at its cradle, with as much vivacity, as fanatical as any time. . . . Entire nations have disappeared, their language is forgotten; and it is still in Hebrew that the Jew curses his oppressors and prays to his God" (ibid., p. 7). Whether his intense interest in Judaic landmarks was connected solely to de Saulcy's thesis or whether there were other reasons remains unknown.

21. Ibid., abridged ed., p. 59.

22. R. E. J. Rey wrote about de Clercq's participation in his book, *Etude historique et topographique de la tribu de Juda* (Paris: Bertrand, 1863), pp. 17–18.

23. Louis de Clercq, *Voyage en Orient, vues de Jérusalem et des lieux saints en Palestine*, 4 vols. (Paris, 1859–60).

24. W. Baier, "A. J. Lorent," in his *Geschichte der Photographie* (Mosel: Schirmer, 1977).

25. Dr. August Lorent, *Jerusalem und seine Umgebung*, with explanatory captions by Dr. G. Rosen, Prussian consul in Jerusalem (Mannheim, 1865), n.p.

CHAPTER 3.
Early Traveling Landscape Photographers

1. Francis Frith, *Egypt and Palestine* (London: James S. Virtue, 1859).

2. All known photographs of this period have been produced by persons of Western European background, predominantly British. Additional research may uncover other photographs. For example, P. I. Sevastianov, a Russian traveling photographer, was said to have taken 3,500 photographs of ancient manuscripts, miniatures, and various works of art in the Near East in the 1850s (S. Morozov, *Russkie puteshestvenniki-fotografy*, ed. D. I. Schrebakov [Moscow: Soviet Academy of Sciences, 1953], quoted in Albert Parry, "Russia's Early Photography," mimeo). There may be others whose names and photographs have not been mentioned or included in any published works. I refer in this book exclusively to photographs or reproduc-

tions I was able to examine personally, and I consider them an adequate sample of the work done, if not an entirely definitive survey.

3. James Robertson and Felice A. Beato, *Jerusalem* (Constantinople-Leipzig, 1864), n.p. The question of authorship will possibly remain unanswered, as the photographs were conjointly signed. The only evidence I could find to support the assumption is one photograph signed F. Beato, appearing in the album "Egypte et Terre Sainte" (most likely put together by a private collector) that also included seven photographs signed by Ostheim and two others signed Rumine; most were taken in 1860, as indicated on the negative. Photographs signed A. Beato found in albums of later production may either point to Felice Beato's middle initial or to another photographer.

4. Frith's travels in Egypt are well known and documented. See Bill Jay, *Victorian Cameraman: Francis Frith's Views of Rural England* (London: Newton and Abbot, 1973), p. 16; Helmut and Alison Gernsheim, *The History of Photography from the Camera Obscura to the Beginning of the Modern Era* (New York: McGraw-Hill, 1969), pp. 286–87.

5. Francis Frith, *Sinai and Palestine* (London: William Mackenzie, n.d. [1859]), n.p. The photographs were dated 1857 by Frith, but this refers to the beginning of his trip. His description of how he developed his plates in tombs because of the heat and his reference to ripened corn in fields near Tiberias point to the spring of 1858, just before his return to England in May.

6. Quoted from various books of Frith in which pages are sometimes bound differently so that their order is not fixed. See Jay, *Victorian Cameraman*, p. 18.

7. Frith, *Sinai and Palestine*, text to plate "Hebron."

8. Francis Frith, *The Holy Bible* (or *The Queen's Bible*), 2 vols. (London: William Mackenzie, 1862).

9. Frith, *Egypt and Palestine*, text to plate "Bethlehem."

10. Frith, *Sinai and Palestine* (complementary album), text to plate "Gaza, the New Town" (also appears in other albums of Frith's).

11. Frith, *Sinai and Palestine*, text to plate "The Church of Holy Sepulchre, Rear View."

12. Ibid.

13. Frith, *Sinai and Palestine*, text to plate "Tiberias."

14. Ibid.

15. Oliver Wendell Holmes, "The Stereoscope and the Stereograph," *Atlantic Monthly* (June 1859), quoted in Vicky Goldberg, *Photography in Print* (New York: Simon and Schuster, 1981), pp. 109–10. Eyal Onne provides contradictory information on Frith's stereoscopic pictures in the Holy Land (*Photographic Heritage of the Holy Land 1839–1914* [Manchester: Institute of Advanced Studies, Manchester Polytechnic, 1980]). Whereas on p. 10 he states that Frith used one camera, which tallies with Holmes's description, in a reference on p. 100 Onne indicates that Frith used a multiple-lens camera, that is, the standard procedure. The only presently known published series of Frith's stereoscopic pictures is entitled *Egypt, Nubia and Ethiopia*. Only additional research may settle the question.

16. Bill Jay associated Bedford's choice by Queen Victoria to his aristocratic connections. He considered Frith the superior photographer. See "Francis Bedford 1816–1894," *University of New Mexico Art Museum Bulletin* (1973), pp. 16–21.

17. A catalogue of Bedford's photographs was published to facilitate the sale. The introduction to the list advertises Bedford's primacy of access to certain places and appraises his stylistic approach: "The series embraces Views of many highly interesting places never before photographed, also of scenes known indeed but here represented from new and more picturesque points of view. . . ." For the first time ever, views were divided into two categories: "Subjects of special Biblical interest" and "Architectural subjects." General views of the Temple Esplanade belonged to the former category, while closer views of the Moslem architecture there belonged to the latter. The catalogue was published by Day and Son, lithographers to the Queen and the Prince of Wales. Bedford's photographs of biblical places were used to illustrate a small book by Mrs. Mentor Mott entitled *The Stone of Palestine* (London: Seeley, Jackson and Halliday, 1865).

18. See Helmut and Alison Gernsheim, *History*, pp. 287–88.

19. E. A. Finn, *Reminiscences of Mrs. Finn* (London-Edinburgh: Marshall, Morgan and Scott, 1929), plate facing p. 236.

20. Calotypist Lorent's view on the same subject does include some houses of the village, in line with the general spirit of his work.

21. W. M. Thompson, *Egypt, the Holy Land, Constantinople and Athens*, 2d ed. (London: Day and Son, 1867), p. 2.

22. Ibid., p. 5.

CHAPTER 4.
Exploratory Reports and Travelers' Pictures

1. James T. Barclay, *The City of the Great King, or Jerusalem as It Was, as It Is, and as It Is to Be* (Philadelphia: James Chatham, 1857), pp. xvii–xx.

2. Ibid.

3. D. S. Burnet, *The Jerusalem Mission under the Direction of the American Missionary Society* (Cincinnati: American Christian Missionary Society, 1853), p. 7.

4. Ermete Pierotti, *Jerusalem Explored*, 2 vols. (London: Bell and Baldy, 1864). The title page states that Pierotti was "architect-engineer, civil and military, to his Excellency Surraya Pasha of Jerusalem." The illustrated volume includes lithographic reproductions of photographs, ground plans, and sections.

5. Idem, *Customs and Traditions of Palestine Illustrating the Manners of the Ancient Hebrews*, trans. T. G. Bonney (Cambridge, 1864).

6. Duc de Luynes, *Voyage d'exploration à la Mer Morte, à Petra et sur la rive gauche du Jourdan* (Paris: Bertrand, 1874).

7. Helmut and Alison Gernsheim, *The History of Photography from the Camera Obscura to the Beginning of the Modern Era* (New York: McGraw-Hill, 1969), p. 337.

8. H. B. Tristram, *Land of Israel* (London: Society for Promoting Christian Knowledge, 1865).

9. Idem, *Pathways of Palestine* (London: Sampson, Low, Marston, Searle, and Rivington, 1881–82), p. 68.

10. Colonel Sir Charles M. Watson, *The Life of Major-General Sir Charles Wilson, R.E.* (London: J. Murray, 1909). Wilson studied at the Chatham School of the Royal Engineers from 1855 to 1857 (p. 9). The Gernsheims report that photography was taught at this school starting in 1856 (*History*, p. 231). It was probably there that Wilson became acquainted with the possibilities offered by photography in exploration. McDonald and Phillips, his photographers in the Holy Land, may also have studied there.

11. *Catalogue of Photographs and Slides for the Lantern* (London: Palestine Exploration Fund, n.d.). The title page includes an address to which the organization moved in 1890 and remained until 1898.

12. *Ordnance Survey of Jerusalem*, vol. 3. Made with the Sanction of the Right Hon. Earl de Grey and Ripon, Secretary of State for War. By Captain Charles W. Wilson R.E. under the direction of Colonel Sir Henry James. R.E.F.R.S. and Director of the Ordnance Survey. Published by Authority of the Lords Commissioners of Her Majesty's Treasury, 1865. According to the *Survey*, McDonald was both a very good surveyor and a very good photographer (p. 1).

13. McDonald also produced beautiful pictures for three volumes of *Ordnance Survey of Sinai* in 1868 and 1869.

14. Colonel Sir Henry James, *La Triangulation de Jérusalem, Révue des cours Littéraires de la France et de l'Etranger* (1866).

15. Captain Wilson and Lieutenant Warren, *A Selection of Photographs Taken by the Exploratory Parties* (London: Palestine Exploration Fund, 1867). See also *Palestine Exploration Fund Quarterly Statement* (1869), p. 36.

16. Colonel Sir Charles M. Watson, *Fifty Years' Work in the Holy Land, a Record and a Survey 1865–1915* (London: Palestine Exploration Fund, 1909), pp. 33, 37, 51.

17. Charles Warren, *Underground Jerusalem* (London: Bentley, 1876).

18. Letter of Mr. Emanuel Deutsch, *Palestine Exploration Fund Quarterly Statement* (1869), p. 36.

19. Lieut. H. H. Kitchener, R.E., *Photographs of Biblical Sites* (London: Palestine Exploration Fund, n.d.). The complete list of the series of fifty photographs appears in the *Palestine Exploration Fund Quarterly Statement* (1876), pp. 62–63.

20. H. H. Kitchener, "List of Photographs Taken in Galilee, with Description," *Palestine Exploration Fund Quarterly Statement* (1878). These photographs were not included in the 1876 list.

21. "Mr. Frank Mason Good has, during the last two or three years, been rapidly earning a position as one of our first landscape photographers, and the series of stereographs before us will go far to render that position unchallengeable"; *The Photographic News*, London, January 3, 1868. The reviewer mentions views from Nazareth, Jerusalem, Sinai, Lebanon, and Greece. Unlike albums and books, a collection of stereoscopic pictures consists of loose prints and is rarely complete. There is no trace left of a catalogue of Good's stereoscopic pictures. A French catalogue of stereoscopic views was published in 1869 by Andrieu, but the pictures themselves have been lost.

22. "We are glad to hear that Mr. Frank M. Good recently returned from a five months tour in the East. We have no doubt he has brought home with him a further addition to the fine series of photographs we have already from his hands," *The Photographic News* (London), August 20, 1875.

23. Frank Mason Good, *Photo-Pictures of the Holy Land* (London: W. A. Mansell and Co., n.d. [1875]), two volumes of woodburytype reproductions.

24. Tristram, *Pathways*. Though the book states it is illustrated by forty-four permanent photographs, these are, in fact, woodburytypes, early photomechanically printed reproductions that are indistinguishable from photographs. Good's name is not mentioned in Tristram's introduction, although he claims their priority over all extant photographs. Good's signature appears on the negatives of some of the pictures, and other pictures are identical to but smaller than those published in his portfolio.

25. Good is said to have had a possible influence on Frith by the early 1860s (see Weston J. Naef's leaflet, *Early Photographers in Egypt and the Holy Land* [New York: Metropolitan Museum of Art, 1973]), and an even earlier link cannot be ruled out.

26. Carney E. S. Gavin, "Bonfils and the Early Photography of the Near East," *Harvard Library Bulletin* 26(October 1978):458. The earliest reference to Bonfils's work is a letter he wrote to the Société Française de Photographie in 1871.

27. For a more detailed account of Bonfils's work, including photographs, see Carney E. S. Gavin, Elizabeth Carella, and Ingeborg O'Reilly, "The Photographers Bonfils of Beirut and Alès 1867–1916," *Camera*, no. 3 (March 1981).

28. Adam D. Weinberg has noted inaccuracies in Bonfils's numbering systems. See his catalogue, *Majestic Inspirations, Incomparable Souvenirs, 19th Century Photography of the Mediterranean and the Middle East from the Collection of Brandeis University*, 1977.

29. H. Gautier de Claubry, "Vue photographique de l'Orient.—Egypte, Palestine, Syrie, Grèce et stéréoscopes de Palestine par M. Bonfils, photographe à Beyrouth," *Bulletin de l'oeuvre des pélerinages en Terre Sainte* 8(1873):41–43. The stereoscopic views have been lost, although single plates are extant. Twenty photographs of Jerusalem and three of other places in the Holy Land, assumed to date from 1873, are kept in the George Eastman Museum, International House of Photography, Rochester, New York.

30. Photographed and published by Félix Bonfils, *Souvenirs d'Orient, Album pittoresque des sites, villes et ruines les plus remarquables de la Terre Sainte* (Alais [Gard], 1877–78).

31. The two medals appear on the cardboard insignia on the back of a *cabinet* portrait taken in the early 1890s and found in a private collection in Jerusalem.

32. Félix Bonfils, *Catalogue des vues photographiques de l'Orient, Egypte, Palestine (Terre Sainte), Syrie, Grèce & Constantinople* (Alais [Gard]: published by the author, 1876). This catalogue is the only source that can validate those photographs taken by the founder of the company, Félix Bonfils, himself. His landscapes may be verified in his albums, *Souvenirs d'Orient*. All other photographs reproduced and published since 1887 might also be of later production.

33. Lady Elizabeth Eastlake, "Photography," in *Classic Essays on Photography*, ed. Alan Trachtenberg (New Haven, Conn.: Leete's Island Books, 1980), p. 43.

34. Barbara Tuchman, noting that "The England of Lord Shaftesbury's generation was almost as Bible-conscious as the England of Cromwell," indicates that British biologist and advocate of Darwinism Thomas Huxley considered the Bible "the national epic of Britain." See Barbara Tuchman, *Bible and Sword* (London: Paper Mac, 1982), pp. 179, viii. The P.E.F explorations themselves were undertaken for the sake of biblical research.

CHAPTER 5.
Early Local Photographers and the Second Commandment

1. The same was true of other underdeveloped countries. See Ray Desmond, *Photography in India during the Nineteenth Century* (London: India Office Library and Records Report, 1974), pp. 5–36; Dr. A. D. Bensusan, *Silver Images: History of Photography in Africa* (Cape Town: Howard Timmins, 1966), p. 9; Gilberto Ferrez and Weston J. Naef, *Pioneer Photographers of Brazil, 1840–1920* (New York: Center for Inter-American Relations, 1976), p. 17.

2. Wm. Mason Turner, *El-Khuds, the Holy: or Glimpses in the Orient* (Philadelphia: James Challen and Son, 1861), p. 248.

3. Ibid., pp. 319–21.

4. *British Journal of Photography*, July 1, 1861, p. 237, quoted in Eyal Onne, *Photographic Heritage of the Holy Land 1839–1914* (Manchester: Institute of Advanced Studies, Manchester Polytechnic, 1980), p. 14.

5. Gisèle Freund, *Photography and Society* (Boston: David R. Godine, 1980), pp. 35–36, 58.

6. Alan Thomas, *Time in a Frame, Photography and the Nineteenth-Century Mind* (New York: Schocken Books, 1977), pp. 11–12.

7. "During the year the canvas was painted Seddon joined

Holman Hunt and the photographer James Graham in Jerusalem and it is not unlikely that the photograph in question was taken by Graham" (Aaron Scharf, *Art and Photography* [London: Allen Lane, the Penguin Press, Pelican Books, 1974], pp. 103–4).

8. Engravings after Graham's photographs of small towns and of Jerusalem appeared in W. H. Dixon, *The Holy Land* (London: Society for Promoting Christian Knowledge, 1865). Color lithographs appeared in H. B. Tristram, *Scenes in the East* (London: Society for Promoting Christian Knowledge, 1870).

9. A. L. Tibawi, *British Interests in Palestine 1880–1901* (Oxford: Oxford University Press, 1961), pp. 117–21. Scharf (*Art and Photography*, p. 340) quotes evidence of the collaboration between the two: "Graham was to photograph, Sim was to shoot, and I [Hunt] to draw when our destination was reached" (*Pre-Raphaelitism and the Pre-Raphaelite Brotherhood*, vol. 1 [London, 1905], p. 425); Hunt's reference is to an expedition to the Dead Sea in 1854. Pictures by Hunt were identified with Graham's photographs exhibited in 1859 in Paris (Scharf, *Art and Photography*, p. 144).

10. Rev. Francis L. Denman, *History of the Jerusalem Mission* (London: London Jews' Society, 1912), p. 12. Bonar and M'Cheyne refer to the father as a "young gentleman in European dress . . . he proved to be the medical attendant of the Jewish mission at Jerusalem." See A. A. Bonar and R. M. M'Cheyne, *Narrative of a Mission of Inquiry to the Jews for the Church of Scotland in 1839*, 3d ed. (Philadelphia: Presbyterian Board of Publishers, 1845), p. 124.

11. Charles Warren, "Remarks on a Visit to 'Ain Jidy' and the Southern Shores of the Dead Sea in Midsummer 1867," *Palestine Exploration Fund Quarterly Statement* (1869), p. 150.

12. Samuel Manning, *Those Holy Fields* (London: Religious Tract Society, 1874), p. 5.

13. This story—fact or fiction—was related to me in the course of my research by Kevork Hintlian, author of the *History of the Armenians in the Holy Land*. Hintlian had by chance come across a faded copy of a photograph showing an old man seated in a most unusual posture. I double-checked the story independently. I also asked two pathologists to examine the photograph; they could not be sure whether it was of a dead person.

14. Berberian's comments are found in Carney E. S. Gavin, "Bonfils and the Early Photography of the Near East," *Harvard Library Bulletin* 26(October 1978):444.

15. The register also includes the names of seven "best men of marriage" whose occupation was listed as *badgerahan*. While the Armenian word for photographer, *lousangaritch*, does not figure here, *badgerahan*—literally, "a man who brings out pictures"—can refer either to a painter or a photographer. Out of a population of close to four hundred persons, seven is a high figure.

16. Personal communication. The sources Hintlian quoted were Tigran Sawalanian, *History of Jerusalem*, 2 vols. (Jerusalem: St. James Publ. House, 1930), 2:1135; Malachia Ormanian, *History of the Armenians*, 3 vols. (Jerusalem: St. James Publ. House, 1927), 3:4209.

17. Karl Baedeker, *Palästina und Syrien* (Leipzig: K. Baedeker, 1876), p. 36.

18. Eugène Melchior de Vogüé, *Syrie, Palestine, Mont Athos, Voyage aux pays du passé* (Paris: Plon, 1887), p. 182.

19. Jules Hoche, *Le pays de croisades* (Paris: Librairie Illustrée, 1884), p. 221.

20. *Catalogue of the Manuscript Library*, vol. 7, entries 2773 and 2775 of 1863, and 2777 of 1873.

21. Mitry's name appears together with Krikorian's on their shop in a 1898 photograph, taken from across Jaffa Road.

22. Mrs. Alice Aboushar, daughter of Hovhannes Krikorian, informed me that costumes were always available in her father's and her grandfather's studio for any customer who wished to be photographed in them. She herself appeared in several family photographs in different costumes and with different props, as was customary.

23. *Carte-de-visite* and *cabinet* portraits taken by Haroutoun Mardikian were found at the Armenian Convent in Jerusalem bearing dedications from 1896. A photograph taken by Hallaidjan was dedicated in the same way in 1906. Three of Hallaidjan's photographs were published in Philip J. Baldensperger, *The Immovable East, Studies of the People and Customs of Palestine* (London, 1913).

24. Guiragossian came to Bonfils from Palestine; see Thomas Ritchie, "Bonfils & Son, Egypt, Greece and the Levant; 1867–1894," *History of Photography* 3(January 1979):33–46.

25. Charles Warren, *Underground Jerusalem* (London: Bentley, 1876), pp. 491–92.

26. Beniamin Joannidou, *Proskinetarion tis agias gis* ("Itinerary in the Holy Land") (Jerusalem: Greek Orthodox Patriarchate Printing Press, 1876). The photographs were reproduced in Vienna.

27. Yehoshua Ben-Arieh, *Ir berei tkoufa, Yeroushalayim bemea ha-tesha-esre* ("City in the Mirror of Time, Jerusalem in

the Nineteenth Century") (Jerusalem: Ben Zvi Institute, 1977), pp. 64–66; Aref-el-Aref, *Al-mufassal fi tarih al-Quds* ("The Detailed History of Jerusalem") (Jerusalem: Dar el Maarif, 1961), pp. 348–50.

28. Hussein al-Baghawi, *Mishkat*, book 12, chap. 1, pt. 1, and book 20, chap. 5. See also T. P. Hughes, *A Dictionary of Islam* (Clifton, N.J.: Reference Book Publishers, 1965).

29. Richard Ettinghausen, "The Man-Made Setting," in *Islam and the Arab World*, ed. B. Lewis (London-New York: A. A. Knopf, 1976), p. 62. Ettinghausen mentions a *hadith* that elaborated on the prohibition. For a detailed consideration of images in Islam, see Oleg Grabar, *The Formation of Islamic Art* (New Haven: Yale University Press, 1973), pp. 76, 82–88.

30. Personal communication. The text was Al-Ghawl al Shaff's (Great Mufti of Egypt) *Fi ilahat al-taswir al futugrafii*.

31. "Hukm suwar al-yad wa'l suwar al-shamsiya," fatwa of Muhammad Rashid Rida, in *Al Manor* 11(1908–9):277–78.

32. Fatwas, *Madjallat-al-Azhar* 6(1936):171; 7(1937):327; 11(1940):163–64.

33. Gavin, "Bonfils," p. 444.

34. Indeed Yessayi of Jerusalem corresponded with a photographer from Constantinople named Abdullahian, the suffix of which is Armenian. This might have been one of the brothers, who might have abandoned the suffix upon conversion.

35. Compare the case of the emir of Turkestan who intervened in favor of foreign photographers. These two examples show that rulers, who certainly were better informed about religious law, were not opposed to photography.

36. C. A. Hornstein, "A Visit to Kerak and Petra," *Palestine Exploration Fund Quarterly Statement* (1898), p. 110. This is the earliest written reference to a Moslem photographer, an amateur from Damascus. See also chap. 9.

37. Malkiel Zvi Halevy, *Sefer sheelot ve-tshuvot, divrei Malkiel*, vol. 3 (Vilna, Lithuania, 1901), n.p.

38. Abraham Itshak Hacohen Kook, *Igarot Hareia*, vol. 1 (Jerusalem: Mossad Ha-rav Kook, 1907–8).

39. Ovadia Yosef, *Or Tora*, vol. 2 (Jerusalem: Agudat Or Tora, 1977–78).

40. Leo Jung, *Men of Spirit* (New York: Kymson, 1964), p. 329.

41. Mordechai Eliav, *Eretz-Israel ve-yishuva be-mea ha-tesha-esre 1777–1917* (Jerusalem: Keter, 1978), pp. 205–6.

CHAPTER 6.
Early Portrayal of Local Inhabitants

1. *British Journal of Photography*, July 1, 1861, p. 238, quoted in Eyal Onne, *Photographic Heritage of the Holy land 1839–1914* (Manchester: Institute of Advanced Studies, Manchester Polytechnic, 1980), p. 17.

2. In *Catalogue of Photographs and Slides for the Lantern*, pp. 39–40.

3. According to H. B. Tristram, "the Ta'amira dress more like townsmen" and "[t]he whole country south of the road from Jerusalem to Jericho, as far south as Ein Gedi and east of Bethlehem and Frank Mountain is considered to be the property of the Ta'amira." See H. B. Tristram, *Pathways of Palestine* (London: Sampson, Low, Marston, Searle and Rivington, 1881–82), p. 89.

4. *Catalogue of Photographs and Slides for the Lantern*, p. 39.

5. Charles Warren, *Underground Jerusalem* (London: Bentley, 1876), p. 120. Warren lets us understand that the P.E.F. party had strong and exclusive ties with the Ta'amira Bedouins: "It appears that Mr. Bergheim was just returning from Petra (where he had been successfully photographing) and, suspecting that we were with the Ta'amira, succeeded in restraining his party from coming to close quarters with us." This remark implies that access to the Ta'amira was still limited. See idem, "Remarks," p. 150.

6. E. L. Wilson, *In Scripture Lands* (New York: C. Scribner's Sons, 1890), p. 259. Warren was photographed in Nablus with a Yakub Es-Shellaby (picture 229 in the P.E.F. catalogue), perhaps the same person or certainly from the same family.

7. A. H. Harper, *Walks in Palestine* (London: Religious Tract Society, 1888), pp. 9–10.

8. Carney E. S. Gavin, *The Image of the East: Nineteenth-Century Near Eastern Photographs by Bonfils from the Collections of the Harvard Semitic Museum*, comp. and ed. Ingeborg Endter O'Reilly (Chicago: University of Chicago Press, 1982).

9. See Paul Lortet, *La Syrie Aujourd'hui* (Paris: Librairie Hachette, 1884), and F. and M. Thévoz, *La Palestine Illustrée* (Lausanne: G. Bridel, 1888–90).

10. Thomas Ritchie, "Bonfils & Son, Egypt, Greece and the Levant; 1867–1894," *History of Photography* 3(January 1979):45.

11. Of the three (!) pictures used to illustrate a little book by the Frenchman de Vogüé, who considered Orientals "re-

tarded races," one was of lepers. See Eugène Melchior de Vogüé, *Journal des voyages en Syrie* (Paris: Plon, 1875).

12. Not all of Good's portrait work was formally and technically innovative. His "Group of Native Women" (1874), for example, represents Phillips's photograph of the Ta'amira women in that it is taken from close range, most likely in a natural environment. A drawing made after this photograph became quite popular; entitled—probably correctly—"Christian Oil Sellers," it was published in several books in the 1880s. Another photograph, showing small, distant figures, captioned "Pilgrims Bathing in the Jordan Near Jericho," recalls Robertson's and Beato's 1857 photograph taken at the Wailing Wall. Here, too, is a scene of a ritual in a holy place and not a biblical allegory.

13. "Do not go and glean in any other field, and do not look any further, but keep close to my girls. Watch where the men reap, and follow the gleaners; I have given them orders not to molest you" (Ruth 1:2). The photograph shows a rich landowner talking to a poor girl who holds wheat stalks; women working in the background wear the better Bethlehem dress (used also in Bonfils's studio portrait of "Women of Bethlehem").

14. The photograph was not published before 1896, when the volumes of *Album de la Terre Sainte* started to appear. Moreover, Adrien attempted to produce a collection or album entitled *Nouveau Testament*, with the intention of reusing many of his father's photographs retitled as biblical illustrations. The firm of F. Gutekunst in Philadelphia prepared lithographs from these pictures in 1898, but the book was never published. This was the single attempt of a French photographer to closely follow this genre. If the attempt is significant, so is the failure.

15. Marion Harland, *Under the Flag of the Orient* (Philadelphia: Historical Publishing Company, 1897), p. 209. Marion Harland was a pseudonym for May Virginia Ternune. The fictional name given to the photographer is Alcides.

16. Ibid., pp. 167–68.

17. Ibid., p. 130.

18. Ibid., pp. 288, 290, 292. A photograph published on p. 212 was captioned "listens with downcast eyes." The text gives the following interpretation: "One of the most prosperous listens with downcast eyes to David's talk of crops and weather, cunningly drawn while Alcides retires to a ledge far enough away to focus the modern Martha of Bethany." This is a rare reference to a New Testament figure.

19. Lucien Gautier, *Souvenirs de la Terre Sainte* (Lausanne: G. Bridel, 1899), p. 161.

20. L'Abbé Raboisson, *En Orient* (Paris: Librairie Catholique de l'Oeuvre de St. Paul, 1886–87), 2:308.

21. Lortet, *La Syrie d'Aujourd'hui* (364 engravings, 275 of which were made from photographs).

22. Dr. Adnan Hadidi, director general of Antiquities, Jordan, and Khaled Moaz of Damascus, with whom I consulted, confirmed that Moslem women normally would not pose for a photographer uncovered. This was also the sole photograph in which Bedouin women were depicted in the company of a man.

23. Mark Twain, *The Innocents Abroad* (New York: Harper and Brothers, 1911), p. 153.

24. Bonfils had a small column in his studio. It appears in a photograph of a dragoman, but he does not lean on it.

25. Gautier, *Souvenirs*, p. 333.

26. The title "Street Merchants in Jerusalem" appears in Bonfils's catalogue of 1876; there is no way to confirm whether the catalogue refers to the extant pictures. The earliest outdoor photograph of people taken by Bonfils to which a date can be ascribed is of three Jews on a Jerusalem street. It was purchased by the party of the Prince of Wales, later King George V, during a tour of the Near East in 1880–82. This too was published only twice, once in the 1890s and once, cut in two, in 1930.

CHAPTER 7.
Native Attitudes

1. "The camera-obscura is directed towards a natural object and the reflected image is shown to the astonished onlookers, who are particularly bewildered by the reverse image of the sentry, parading before the palace gate who, though his head is upside down, doesn't topple over. The ioded plate replaces the ground glass and the whole operation is over within two minutes. At this juncture Muhammad Ali's countenance reveals heightened interest: the agitation and disquiet in his eyes are somewhat intensified at the moment of darkness as the plate is passed through the mercury. His brilliant pupils twirl with surprising speed . . . the impatience of His Highness gives way to marked surprise and admiration, but despite the well-produced camera-image he exclaims—'It is the work of Satan' and turns away."
(Frédéric Goupil-Fesquet, *Voyage d'Horace Vernet en Orient* [Paris: Challamel, 1843], pp. 33–34.)

2. "Was it possible," the newspaper asked, "that God should

have abandoned His eternal principles and permitted a Frenchman in Paris to give the world an invention of the devil?" (Helmut and Alison Gernsheim, *The History of Photography from the Camera Obscura to the Beginning of the Modern Era* [New York: McGraw-Hill, 1969], p. 72.)

3. Goupil-Fesquet, *Voyage*, p. 215.

4. Ibid., pp. 180–81.

5. George W. Bridges, *Palestine as It Is: In a Series of Photographic Views* (London: J. Hogarth, 1858), text to Plate 18. The word *rabbi* is misleading: "Rabbi is a very familiar title among the Jews in Jerusalem. How many are deserving enough to have it applied to them is a question. In most instances, it is simply used as a term of respect." E. S. Wallace, *Jerusalem, the Holy* (Edinburgh-London: Oliphant, Anderson & Farrar, 1898), p. 298.

6. H. B. Tristram, *Land of Israel* (London: Society for Promoting Christian Knowledge, 1865), pp. 56–57.

7. Ibid., p. 25.

8. F. and M. Thévoz, *La Palestine Illustrée* (Lausanne: G. Bridel, 1888–90), p. 2.

9. Lucien Gautier, *Souvenirs de la Terre Sainte* (Lausanne: G. Bridel, 1899), p. 282. He did, however, publish a picture of Safed, explaining that "the photograph of the bazaar . . . is, if nothing else, a rarity, the result of an unintentional violation of an established rule" (ibid.).

10. The photograph was published in *The Jewish Missionary Intelligence*, December 1892.

11. Ibid., August 1905.

12. Charles Lallemand, *Jérusalem-Damas*, Collection Courtellemont (Alger-Paris: Ancienne Maison Quantin, 1894), p. 4. Photographs by Gervais-Courtellemont.

13. R. E. M. Bain, *Earthly Footsteps of the Man of Galilee and the Journeys of His Apostles*, introductions and text by James E. Lee and John H. Vincent (London: A. M. Gardner, 1894). Letter of introduction mentioned by Lee.

14. F. and M. Thévoz, *La Palestine Illustrée*, picture no. 44.

15. E. L. Wilson, *In Scripture Lands* (New York: C. Scribner's Sons, 1890), p. 211.

16. A. H. Harper, *Walks in Palestine* (London: Religious Tract Society, 1888), p. 31.

17. Gautier, *Souvenirs*, p. 255. Gautier and his wife, who took the photographs, spent five and one half months in the Holy Land during 1893–94.

18. Gautier's doctoral dissertation, published in Leipzig in 1871, dealt with a famous Islamic text, Ghazali's *Addourra Al Fakhira* (The Precious Pearl).

19. *Jewish Missionary Intelligence*, August 1905.

20. L'Abbé Raboisson, *En Orient* (Paris: Librairie Catholique de l'Ouevre de St. Paul, 1886–87), 2:225–26.

21. Apparently this was characteristic behavior; it was the duty of dragomans to protect their charges and they apparently held the status of semiofficial security personnel. Their conduct was not different from that of officials; Catherwood's story comes to mind. In 1850 Gustave Flaubert, while visiting the Church of the Holy Sepulchre with Maxime du Camp, witnessed "our janissary Turk chasing the beggars with big strokes of his stick . . .[and giving] a first stroke to a blind one." The reference is probably to a soldier hired by the two (Gustave Flaubert, *Voyage en Orient [1849–1851]* [Paris: Centenaire, Librairie de France, 1925], p. 135).

22. Lucien Gautier, *Autour de la Mer Morte* (Geneva: Ch. Eggimann & Cie, 1901), pp. 148–49.

23. Marion Harland, *Under the Flag of the Orient* (Philadelphia: Historical Publishing Co., 1897), p. 322.

24. In 1973, in the course of directing a television documentary on the effects of traditional and modern medicine on Bedouins in the Sinai, I was forced to gain the permission of the husbands of several Bedouin women who had undergone eye surgery before their wives would agree to remove their veils before the camera. Moslem women who do not have their pictures taken for religious or traditional reasons are the only Israelis exempt by law from the requirement to submit photographs for the purpose of acquiring identity cards.

25. F. M. Deverell, *My Tour in Palestine and Syria* (London: Eyre and Spottiswood, 1899), pp. 179–80.

26. Rev. Elihu Grant, *The Peasantry of Palestine* (New York: The Pilgrim Press, 1907), pp. 116–17.

27. Mr. Soubhi Abou Gosh, a high executive in the Israeli Islamic judiciary administration, attributes suspicion of photography to fear of modern instruments rather than to superstition (personal communication).

28. Deverell, *My Tour*, pp. 181–82.

29. Pierre Bourdieu et al., *Un art moyen, essai sur les usages sociaux de la photographie* (Paris: Minuit, 1965), pp. 40, 42, 46. Even in the early twentieth century, when photography became accepted in French villages, it was used solely for weddings, and the photographer himself was a town dweller.

30. Deverell, *My Tour*, p. 113.

31. Raboisson, *En Orient* 2:77, 158.

32. Bain, *Earthly Footsteps*, photograph taken near Dothan.

33. Wilson, *In Scripture Lands*, p. 98.

34. Ibid., p. 101.
35. Bain, *Earthly Footsteps*, photograph taken in the Valley of Esdraelon.
36. Harland, *Under the Flag*, p. 208.
37. Ibid., pp. 180–81.
38. Gautier, *Souvenirs*, pp. 53–57.
39. Ibid., p. 334.

CHAPTER 8.
Travel and Pilgrimage Albums and Books

1. L'Abbé Raboisson, *En Orient* (Paris: Librairie Catholique de l'Oeuvre de St. Paul, 1886–87), 1:117.
2. J. T. de Belloc, *Souvenirs d'un voyage en Terre Sainte*, 2d ed. (Paris: Société Générale de Librairie Catholique, 1887).
3. Some photographs by the Thévozes not published in their series appear in Cunningham Geikie, *The Holy Land and the Bible* (London: Cassell, 1897); and in Théophile Roller, *La Tour d'Orient* (Lausanne: G. Bridel, 1891).
4. A photograph entitled "Fishermen in the Sea of Galilee" appears in Geikie, *The Holy Land*.
5. Lallemand published *La Syrie, costumes, voyages, paysages*, illustrated by his own colored plates, in 1865 and 1866. It included a few pictures of Palestine.
6. Charles Lallemand, *Jérusalem-Damas*, Collection Courtellemont (Alger-Paris: Ancienne Maison Quantin, 1894), p. 11. The book is part of a series, *D'Alger à Constantinople*, published by J. Gervais-Courtellemont, a publisher of art books. Although the name of the photographer is not indicated on the title page, both the introduction to the volume *Cairo* and the text of *Jérusalem-Damas* refer to M. Gervais-Courtellemont as the photographer. He was probably the publisher's brother or son.
7. Introduction to *Cairo*, Collection Courtellemont (Alger-Paris: Ancienne Maison Quantin, 1894).
8. R. E. M. Bain and James W. Lee, *Earthly Footsteps of the Man of Galilee and the Journeys of His Apostles* (London: A. M. Gardner, 1894), unpaginated. The collection of photographs was again drawn upon for the *New Self-Interpreting Bible Library* (St. Louis: Bible Educational Society, 1914). The four volumes included 448 engravings and the introductions from *Earthly Footsteps*. Bain was credited here as the late president of American Outdoor Photographers' Association.
9. There were two introductions, one by Lee, the other by Vincent. Lack of pagination makes references difficult.
10. One small collection of quality was Cecil V. Shadbolt's, reproduced in photoengravings and published in 1888 by painter A. H. Harper in his *Walks of Palestine*. Shadbolt was probably introduced to photography by well-known photographer George Shadbolt. The date of Cecil's visit to the Holy Land is unknown. He died in a ballooning accident in 1892. American Edward L. Wilson, founder, editor, and publisher of *The Philadelphia Photographer* and permanent secretary of the National Photographic Association, published *In Scripture Lands* in 1890, which he wrote and illustrated with engravings and a few halftone reproductions of his own photographs. Most of Wilson's illustrations are landscapes.
11. *Album de la Terre Sainte* (Paris: Maison de la Bonne Presse, 1896), 492 photographs. The first installment was published on January 1, 1896.
12. Most came from the Parisian agency J. Kuhn, 220 rue de Rivoli, Paris. Views of Petra and the surrounding deserts were imprinted as the "Frith Series," an enigmatic mark.
13. George Newness, *The Way of the Cross: A Pictorial Pilgrimage from Bethlehem to Calvary* (London: George Newness Ltd., [1893?]).
14. Rev. Ch. M. Stuart, *Photo-Gravures of the Holy Land, embracing fifty prominent views illustrating the Bible History and Scenes in the Life of our Lord* (Cincinnati: Cranston & Stowe, 1891).
15. Pastor K. Aug. Hilden, *Palestina, Reseanteckningar* (Helsingfors, Finland: D. C. Frenckell and Son, 1891).
16. J. Krayenbelt, *Het Heilige Land* (Rotterdam: Wenk & Brikhof, 1895).
17. Rev. Alexander A. Boddy, *Days in Galilee and Scenes in Judea, with some account of a solitary cycling journey in southern Palestine* (London: Gay & Bird, 1900).
18. Lucien Gautier, *Souvenirs de la Terre Sainte* (Lausanne: G. Bridel, 1899); idem, *Autour de la Mer Morte* (Geneva: Ch. Eggimann & Cie, 1901); Théophile Roller, *La Tour d'Orient* (Lausanne: G. Bridel, 1891); Edvard Blaumüller, *Hellig Jord* (Copenhagen: Gyldendalske-Boghandets, 1898).
19. Friedrich Freiherr von Dahlberg, *Palästina, ein Sommerausflug* (Vienna: Leo Wolf, 1892).
20. Dr. Francisek Lampe, *Jeruzalemski Romar* (Celovec, Yugoslavia: Druzba Sv. Mohorja, 1892).
21. Paul Wilhelm von Keppler, *Wanderfahrten und Wallfahrten im Orient*, 3d ed. (Freiburg im Breisgau: Herdersche Verlagshandlung, 1899); L. Tiesmeyer, *Aus der Heilands Heimat* (Bielefeld-Leipzig: Velhagen und Klassing, 1899).
22. *The Holy Bible*, Rheims and Douay Version (Baltimore:

John Murphy, 1899), published with the approbation of James Cardinal Gibbons.

23. Théophile Calas, *En Terre Désolée* (Paris: Librairie Fischbacher, 1900).

24. Rev. James Smith, *A Pilgrimage to Palestine* (Aberdeen: n.p., 1895).

25. Ludwig Schneller, *Aus meiner Reisetasche* (Leipzig: Wallmann, 1901).

26. Felix Mühlmann, *Das deutsche Kaiserpaar im Heiligen Lande im Herbst 1898* (Berlin: E. S. Mitten und Sohn, 1899); Ludwig Schneller, *Die Kaiserfahrt im Heiligen Lande* (Leipzig: Wallmann, 1899). The third publication (untitled) consists solely of pictures taken by Empress Augusta Victoria.

27. The earliest possible visit of a Russian photographer dates back to the 1850s, when an expedition to the Near East by P. I. Sevastianov brought back to Russia more than 3,500 photographs of ancient manuscripts, miniatures, and various works of art. Whether this collection includes photographs from the Holy Land is at present not known. Some unpublished photographs are part of a private journal of one P. P. Melnikow dated 1869 (see Reinhold Röhricht, *Bibliotheca Geographica Palaestinae* [Berlin: H. Reuther, 1890], p. 547). Whether Melnikow was the photographer is not known. In the 1890s the Russian Imperial Pravoslav Palestine Society published booklets, such as *Vidi Sviatoi Zemli* (Views of the Holy Land), containing engravings made after photographs, and portfolios of Nazareth, Jerusalem, and Bethlehem with phototype reproductions of photographs credited to Bonfils, Dumas, Fiorillo, Zangaki, Barshchevskoy (Russian), and Timon (possibly Russian). Original photographs carrying the signature "F. M. Timon" appeared in a single album produced by the Russian Spiritual Mission in Jerusalem at the turn of the century. It depicted Russian churches, towers, and buildings in Jerusalem. Some original photographs assembled in a small album that probably dates from the 1900s depict the staff of the Russian consulate in Jerusalem in various official and nonofficial poses.

28. Raboisson, *En Orient* 1:24.

29. Gray Hill credited his wife with the few photographs published in his book, *With the Bedouins, a Narrative of Journeys and Adventures in Unfrequented Parts of Syria* (London: Unwin, 1891). Only two of the photographs were of Palestine. The couple toured the region in the 1880s.

30. Gautier, *Souvenirs*, p. vi.

31. Boddy, *Days in Galilee*; Dr. Max Blankenhorn, *Das tote Meer und der Untergang von Sodom und Gomorrha* (Berlin: Reimer, 1898); Gustav Dalman, *Arbeit und Sitte in Palästina*, 7 vols. (Gütersloh: C. Bertelsmann, 1927–42). Dalman made use of his own photographs—the earliest that he published had been taken in 1899 and 1900—as well as those of his own staff, of Bonfils, Raad, and the "American Colony" (see chap. 10).

32. Stereoscopic pictures produced during the period surveyed in this chapter have not been discussed. One collection, produced by the American company Underwood and Underwood, can be ascribed to the late 1890s; the series is catalogued in Jesse L. Hurlbut, *Traveling in the Holy Land through the Stereoscope* (New York: Underwood and Underwood, 1900). However, there is little point in conducting a serious study of these stereoscopes as long as almost all earlier collections (such as Good's and Bonfils's) are virtually unavailable. Stereoscopes (and lantern slides) rarely survive in complete sets, and catalogues do not provide a complete picture of the photographer's work and approach.

33. Dwight L. Elmendorf, *A Camera Crusade through the Holy Land* (London: John Murray, 1913), 100 illustrations from photographs by the author.

CHAPTER 9.
Missionary Photography and Photojournalism

1. A. A. Bennett III, "Missionary Journalism in Nineteenth-Century China: Young J. Allen and the Early Wan-Kuo-Kung-peo, 1868–1883," Ph.D. dissertation, University of Southern California, 1971.

2. Geoffrey Moorhouse, *The Missionaries* (London: Eyre Methuen, 1973), pp. 170–71.

3. Originally the society was interdenominational, but from 1815 onward it was almost exclusively an Anglican organization. The slogan "To the Jew First" was repeatedly emphasized in the society's literature. One example is found in Rev. C. Rumfitt's *Subscription to Missions to the Jews*: "God's plan for the evangelization of the world in this dispensation requires that the gospel be preached 'to the Jews first.'"

4. Dr. Alexander Keith (see chap. 1) was a precursor of the L.J.S. approach. During his 1939 visit in Jerusalem he met with the well-known Jewish philanthropist Sir Moses Montefiore. "Dr. Keith suggested that [Palestine Jews] might be employed in making roads through the land, as materials were abundant and that it might be the beginning of the fulfillment of the prophecy. . . ." A. A. Bonar

and R. M. M'Cheyne, *Narrative of a Mission of Inquiry to the Jews for the Church of Scotland in 1839*, 3d ed. (Philadelphia: Presbyterian Board of Publishers, 1845), p. 143.

5. W. T. Gidney, *Mission to the Jews*, 11th ed. (London: London Jews' Society, 1914), p. 66.

6. A. L. Tibawi, *British Interests in Palestine 1880–1901* (Oxford: Oxford University Press, 1961), pp. 76–77.

7. Ibid., p. 206.

8. Ibid., p. 210.

9. G. R. Lees, *Bible Scenes in the Holy Land* (Jerusalem: London Jews' Society, 1893), unpaginated.

10. *Village Life in Palestine* (London: Elliot Stock, 1897; Longmans, 1905, 1907).

11. Aside from the later printings of *Village Life*, Lees published a revised edition of *Bible Scenes* entitled *Scenes in the Holy Land* (Cambridge: Cambridge University Press, 1911). He also used a similar selection of photographs in his *Jerusalem Illustrated* (Newcastle on Tyne: Mawson, Swan and Morgan, 1893), and in *Jerusalem and its People* (London: James Townsend, 1897).

12. G. R. Lees, *The Witness of Wilderness, the Bedawi of the Desert* (London: Longmans, Green & Co., 1909); idem, *Life and Adventure beyond the Jordan* (London: Ch. H. Kelly, 1909).

13. Lees, *Life and Adventure*, p. 48.

14. C. A. Hornstein, "Jerusalem Boys' School," *Jewish Missionary Intelligence*, 1895.

15. C. A. Hornstein, "A Visit to Kerak and Petra," *Jewish Missionary Intelligence*, 1898, p. 95.

16. Ibid.

17. E. W. G. Masterman, "Jerusalem Outside the Walls," *Jewish Missionary Intelligence*, 1895, pp. 192–95. The negatives of four of these pictures were found in wooden boxes at the L.J.S. mission in Jerusalem (known today as the Church's Ministry to the Jews) together with Hornstein's signed negatives and others Lees had credited to him. While at least one negative can be attributed to Lees and others are of a quality inferior to Hornstein's work, the four of the new quarters are on a par with his output.

18. The L.J.S. headquarters apparently kept in step with the most modern developments of communication media. It produced several periodicals and, in the early days of the movies, possessed a large stock of cinematographic films at the society's house.

19. B. Z. Friedmann, "A Jewish Colony in Galilee," *Jewish Missionary Intelligence*, December 1891, pp. 184–85.

20. Masterman, "Jerusalem Outside the Walls," pp. 194–95.

21. Ibid.

22. P. Wheeler, "Visitation of the Sick in Jerusalem," *Jewish Missionary Intelligence*, November 1901, p. 168.

23. Ibid., p. 169.

24. Ibid.

25. J. E. Hanauer, "Jewish Hospitals in Jerusalem," *Jewish Missionary Intelligence*, 1901, pp. 22–23.

26. Idem, *Jewish Missionary Intelligence*, November 1897, p. 162.

27. *Album Missioni Terrae Sanctae* (Milan: Gualassimi e Bartarelli, 1893), vol. 1, *Judaea et Galilaea*. The coordinator of the production was Father Luigi Michieli.

28. Ruffier returned to Jerusalem on December 25, 1918, remaining until October 20, 1926. He died in Algeria in 1948. Biographical data on Father Ruffier appear in the *Liste Générale des Pères et Frères Blancs de Sainte Anne 1878–1932* (n.p., 1932).

29. Ruffier's collection was mentioned in Monsignor Philippe Gorra, *Sainte-Anne de Jérusalem* (Antioch, 1932), p. 76.

30. Ibid., p. 241.

31. Ibid., p. 76. Father Cebron's photographs remain unknown.

32. There is no way of knowing which of the later photographs were taken by Dr. Torrance himself, which by his son, which by Dr. James Cohen, a doctor at the mission hospital, and which by others at the mission. Only one is signed by Torrance himself. The prints are of various sizes. There are no snapshots of the streets of Tiberias, and its inhabitants appear only as hospital patients. The landscape photographs are probably mementos of mission excursions. There is a view of the tomb of Rabbi Meir Baal Haness, a simple pilgrimage photograph; and a rare photograph of the tomb of Rabbi Yeshayahu Halevi Hurwitz, who came to Tiberias from Prague in the sixteenth century and authored the *Shelach*, a book known in Jewish scholarly circles.

33. W. P. Livingstone, *A Galilee Doctor* (London: Hodder & Stoughton, 1926), pp. 31–32.

CHAPTER 10.
Arab, Jewish, and "American Colony" Photography

1. Such were, for example, Germans Grossman and Schumacher, a few American friends of the U.S. consul in Jerusalem, and two local Jews. Grossman started as an amateur taking pictures of the hotel his family built in Tiberias while under construction in 1894. Grossman,

who was not Jewish, later sold landscape scenes of the new Jewish settlements in the lower Galilee as well as posed portraits of Arabs. Dr. Schumacher, a resident explorer and engineer, was an amateur photographer. Friedrich Imberger, of the German Templer Colony in Jerusalem, who published an album of his own photographs in 1903, may also have been active before then. A few photographs taken by Americans E. S. Wallace, U.S. consul in Jerusalem; T. J. Alley, a consulary employee; Reverend Putnam Cady; and E. Warren Clark were published in Wallace's book, *Jerusalem the Holy* (Edinburgh-London: Oliphant, Anderson & Farrer, 1898). The social background of these local and resident photographers is strikingly similar to that of their counterparts in the 1850s. No doubt, consulary employees, explorers, and people involved in hostelry (as well as missionaries) were the rare local inhabitants who had both a financial basis to pursue photography and contact with the tourist environment, of which photography was a part. Details about the work of Ritowsky and Edelstein, local Jews involved in photography, are unavailable.

2. Personal data on Chalil Raad were gleaned from private conversations with his niece, Mrs. Najla Krikorian.

3. One picture of the series shows a building completed in 1892 while still under construction.

4. C. Ninck, *Auf Biblischen Pfaden* (Berlin-Leipzig: Deutsche Kinderfreunde, 1903).

5. Carney E. S. Gavin, *The Image of the East: Nineteenth-Century Near Eastern Photographs by Bonfils from the Collections of the Harvard Semitic Museum*, comp. and ed. Ingeborg Endter O'Reilly (Chicago: University of Chicago Press, 1982), p. 26.

6. Similarly, it can be assumed that the initials "J. P." (Jean-Pierre? Jean-Paul?) of Cairo photographer Sebah point to his having been baptized. His name, with these first initials, appears on the title page of his *Catalogue général de la collection des vues de la haute et basse Egypte et de la Nubie* (Cairo-Constantinople, 1868).

7. Beirut was, of course, the home of the Bonfils studio. In addition, Frenchman Tancrède Dumas settled there, producing landscapes and portraits of the region and its people. A Dumas studio portrait showing the head of a Maronite priest was included in the Lebanese section of the Thévozes' *La Palestine Illustrée*. A series of *cabinet* portraits of Palestinian inhabitants (and, of course, of a dragoman!) with his signature was taken in 1882. His panoramas of Jerusalem were published in books of the

1890s. Bonfils and Dumas alone were substantial competition, and there may have been others, not the least of which was Georges Sabounji.

8. The owner's inscription is on the back of the photograph.

9. *Die Welt*, no. 20, p. 7; no. 13, p. 9 (1897).

10. Jacob M. Landau, *Abdul Hamid's Palestine* (Jerusalem: Carta, 1979), p. 3.

11. *Alte Denkmäler aus Syrien, Palästina und Westarabien*, published by the order of Ahmed Djemal Pasha (governor of Palestine) (Berlin: G. Reimer, 1916).

12. Abraham Moses Luncz, *Luach Eretz Israel* (1898–99), 2:163–68.

13. The list was published in Jerusalem in 1890–91, in vol. 11 of *Sefer Shimush Tsedaka Me-vaad Haklali* ("Record of Charity Allocations from the General Committee"). A 1906 photograph with his signature shows a group of tourists at the Tomb of the Kings. A 1908 Bassan photograph, "Group Portrait of Most of the Pupils and Many of Their Teachers in the 'Ets-Haim' Talmud Tora School," is a class picture mounted with several smaller ones, including a portrait of Shmuel Salant, chief rabbi of Jerusalem and head of the school. One caption indicates that the pictures were made for the exclusive use of this institution. If ever there was a prohibition or inhibition related to photography of the human figure, it was overcome long before these pictures were taken and used.

Another photograph by Bassan depicts the inhabitants of an almshouse who were hired to say prayers at the Wailing Wall in memory of a deceased loved one. The caption on the negative states in Hebrew that payment was made by the deceased woman's daughter. A complementing caption in Russian gives the address of the Rabbis Dayan and Levy of the "General Kitchen" for the poor, established by Rabbi Salant in Jerusalem. This photograph was made both for the charitable daughter and for distribution to indicate the existence of the custom and the possibility of hiring poor people for this prayer. The hiring of professional mourners and the offering of charity at funerals are age-old customs, and no taboo or religious ban seems to have prevented the taking of such photographs.

14. *Luach Achiassaf*, "A Popular Calendar, literary and practical, with pictures and drawings" (Warsaw: Achiassaf, 1893–94), pp. 138, 144, 156.

15. Willy Bambus, "Palestine of the Present Day," *Hovevei Zion Quarterly*, September 1896. Hovevei Zion—the lovers of Zion—was a Jewish organization connected with the "First Aliyah," the 1882 wave of immigration.

16. Willy Bambus, *Palästina, Land und Leute* (Berlin: S. Cronbach, 1898). See also idem, *Die jüdischen Dörfer in Palästina* (Berlin: S. Cronbach, 1896).

17. The name of the village is inscribed on the negative, as was Katz's practice. The insignia "Leon Katz Jaffa" and "L. Katz Jaffa" is printed on the cardboard base of his photographs.

18. The photographer can be identified through the inscribed name of the settlement appearing on the pictures.

19. See Godfrey E. Silverman, "Three Lovers of Zion," *Niv Hamidrashiyah* (Tel Aviv, 1970), pp. 74–81. See also entry in *Encyclopedia Judaica* (Jerusalem: Keter, 1971), 13:1,511.

20. Yeshayahu Raffalovich, *Tsiunim Vetamrurim* (Tel Aviv: Achiassaf, 1952), pp. 57–58.

21. Luncz, *Luach Eretz Israel* (1895–96).

22. Raffalovich, *Tsiunim Vetamrurim*, p. 61.

23. Yeshayahu Raffalovich and Moshe Eliahu Sachs, *Views of Palestine and Its Jewish Colonies* (n.p., [Raffalovich], 1899), unpaginated.

24. Raffalovich, *Tsiunim Vetamrurim*, p. 69. A typographical error in the phonetic Hebrew spelling transformed the *r* into a *d*.

25. Ibid., p. 74.

26. *Eretz Israel Album* (New York: Meir Chimsky, n.d.). See also *Eretz Israel Album* (Newark: The Hebrew Publication Company, n.d.).

27. Bertha Spafford-Vester, *Our Jerusalem* (London: Evans Brothers, 1951), p. 197.

28. Personal communication with Mr. Matson.

29. A newspaper photograph taken in the 1920s in Bombay and showing "Jewish Soldiers gathered together for the Passover in Bombay with the Chief Rabbi of Baghdad" was credited to Meyers Bros. The photograph was found in a private collection.

30. The information, from the Israeli Meteorological Service, was given to me by Dr. Dov Gavish.

31. Personal communication.

32. "Sometimes, not frequently, the Hesses came to call at the American Colony. Whenever they did, they brought their young son with them. He was a terrific nuisance. . . . We always delegated one of our members, Brother Elijah, to keep Rudolph in charge. . . . He had his hands full trying to entertain the nervous, mischievous boy who was to become the sinister Rudolf Hess—mysterious visitor to England and notorious prisoner of World War II" (Spafford-Vester, *Our Jerusalem*, p. 196).

33. Some of the photographs were also published in Ludwig Schneller, *Aus meiner Reisetasche* (Leipzig: Wallmann, 1901). Some of the pictures appearing in Boddy's book were apparently cropped and separated from their backgrounds, as the same figures appear in Schneller's book as part of a larger photograph. Similarly, a view of Haifa in Boddy's book is found as the center section of a picture in Raffalovich's *Views*.

34. Rev. Alexander A. Boddy, *Days in Galilee and Scenes in Judea, with some account of a solitary cycling journey in southern Palestine* (London: Gay & Bird, 1900), p. 156.

35. Ibid., p. 155.

36. A. Goodrich Freer, *Inner Jerusalem* (London: Constable, 1904). Evidence about the exact beginning of Larsson's photographic work is unavailable. Since his work is superior to that of Meyers published in Raffalovich, Boddy, and Schneller, it might be assumed that he was responsible for the pictures of the kaiser's visit as well. But Larsson had arrived in Jerusalem two years earlier as a simple farmer from Sweden and had to be taught photography, perhaps by Meyers.

37. See *Alte Denkmäler*; Sven Hedin, *Jerusalem* (Leipzig: Brockhaus, 1918). The latter included a portrait of an old bearded Jew credited to Larsson. The same photograph had appeared in Freer's *Inner Jerusalem* fourteen years earlier.

38. *National Geographic Magazine*, vols. 24 (January 1913), 25 (March 1914), and 26 (March 1915).

39. See George S. Hobart, "The Matson Collection—A Half-Century of Photography in the Middle East," *The Quarterly Journal of the Library of Congress* 30(January 1973):19–43.

40. Najla Krikorian, a wonderful woman, passed away before this book went to press.

BIBLIOGRAPHY

I. Nineteenth-century photographic work in the Holy Land: chronology of publications of original photographs and early reproductions.

1842 *Excursions Daguerriennes—vues et monuments les plus remarquables du globe.* Paris: Lerebours. Engravings made after daguerreotypes by Goupil-Fesquet.

1846 Girault de Prangey, Joseph Philibert. *Monuments arabes d'Egypte, Syrie et Asie Mineure, dessinés et mésurés de 1842 à 1845.* Paris. Engraving probably made after daguerreotype by author.

1847 Keith, Alexander. *Evidence of the Truth of the Christian Religion.* Edinburgh: W. Whyte. Engravings after daguerreotypes by George Skene Keith.

1848 *Daguerreotypes of the Holy Land.* Edinburgh: W. Whyte. Engravings after daguerreotypes by George Skene Keith.

1850 Wheelhouse, C. M. "Photographic Sketches from the Shores of the Mediterranean." Private album. Calotypes by author.

1851 Du Camp, Maxime. *Egypte, Nubie, Palestine et Syrie.* Paris: Gide et Baudry. Calotypes by author.

ca. 1852 *Scenes in the Holy Land.* London: Society for Promoting Christian Knowledge. Illustrations after photographs. Details unavailable (mentioned in Röhricht; see bibliography, section II).

1856 Salzmann, Auguste. *Jérusalem: Etudes et reproductions photographiques de la Ville Sainte depuis l'époque judaïque jusqu'à nos jours.* Paris: Gide et Baudry. Calotypes by author.

 von Adelsfried, Edmund Wörndle. *Bilder aus dem Heiligen Lande.* Vienna: Universitätsverein. Photographs of original drawings.

1857 Barclay, J. T. *The City of the Great King.* Philadelphia: James Chatham. Engravings and drawings made after photographs by author and by James Graham.

 Stewart, R. W. *The Tent and the Khan, A Journey to Sinai and Palestine.* Edinburgh: W. Oliphant & Sons. Engraving after photograph by James Graham.

1858 Bridges, George W. *Palestine as It Is: In a Series of Photographic Views by the Rev. George W. Bridges. Illustrating the Bible.* London: J. Hogarth. Calotypes by author.

 Lays of the Holy Land. London: James Nisbett. Illustrations after photographs. Details unavailable (mentioned in Röhricht; see bibliography, Section II).

1858–59 Frith, Francis. *Egypt and Palestine*. 2 vols. London: James S. Virtue. Albumen prints by author.

1859 Frith, Francis. *Sinai and Palestine*. 2 vols. London: William Mackenzie. Albumen prints by author.
[1862?]

1859–60 de Clercq, Louis. *Voyage en Orient, vues de Jérusalem et des lieux saints en Palestine*. 4 vols. Paris. Calotypes by author.

1860 Buchanan, Rev. Robert. *Jerusalem in 1860*. Glasgow: William Collins. Albumen prints by John Cramb.

 Frith, Francis. *Egypt, Sinai, and Palestine*. London: William Mackenzie. Albumen prints by author.

1860–61 Poole, Sophia and Reginald. *Cairo, Sinai, Jerusalem and the Pyramids of Egypt*. Albumen prints by Francis Frith.

1861 *City of our Lord*. London: R. Griffin. Albumen prints by John Anthony.

1862 Frith, Francis. *Egypt, Sinai and Palestine* (supplementary volume). London: William Mackenzie. Albumen prints by author.

 The Holy Bible (The Queens Bible). London: William Mackenzie. Albumen prints by Francis Frith.

1863 Bedford, Francis. *Egypt, Sinai and Jerusalem*. 4 vols. London: Day and Son. Albumen prints by author.

1864 Pierotti, Ermete. *Jerusalem Explored*. 2 vols. London: Bell and Baldy. Lithographs made after photographs, perhaps by author.

 Robertson, James, and Felice Beato. *Jerusalem*. Constantinople-Leipzig. Albumen prints signed by authors.

1865 Dixon, W. H. *The Holy Land*. London: Society for Promoting Christian Knowledge. Engravings after photographs by James Graham.

 Gallerie Universelle des Peuples. Paintings by Lallemand, photographs by Hart. Views from Germany, Switzerland, Egypt, Palestine, etc. Details unavailable (mentioned in Röhricht; see bibliography, section II).

 Lorent, August J. *Jerusalem und seine Umgebung*. Mannheim. Calotypes by author.

 Newton, C. T. *Travels and Discoveries in the Levant*. London. Details unavailable (mentioned in Röhricht; see bibliography, section II).

 Tristram, H. B. *Land of Israel*. London: Society for Promoting Christian Knowledge. Some engravings after photographs by H. Bowman.

 Werner, C. *Photographs from Original Drawings of the Holy Places*. Leipzig: Schmid.

 Wilson, Charles W. *Ordnance Survey of Jerusalem*. London: Authority of the Lords Commissioners of Her Majesty's Treasury. Albumen prints by James McDonald and a few by Peter Bergheim.

1866 James, Colonel Sir Henry. *La Triangulation de Jérusalem, Révue des cours Littéraires de la France et de l'Etranger*. Paris. Albumen prints of single stereoscopic pictures by James McDonald.

 Payer, Aloys. *Album von Jerusalem*. Vienna: Literatur-und-Art Anstalt. After original photographs. Details unavailable (mentioned in Röhricht; see bibliography, section II).

 Thompson, W. M. *Egypt, the Holy Land, Constantinople and Athens*. 2d ed., 1867. London: Day and Son. Albumen prints by Francis Bedford.

1867 Wilson, Captain, and Lieutenant Warren. *A Selection of Photographs Taken by the Exploratory Parties*. London: Palestine Exploration Fund. Albumen prints by Sgt. H. Phillips.

1869 Melnikow, Paul P. "Diary of a Travel to the Orient." Manuscript in Russian with album of photographs. Details unavailable (mentioned in Röhricht; see bibliography, section II).

1870 Holland, Rev. F. W. *Sinai and Jerusalem, or Scenes from Bible Lands*. London: Society for Promoting Christian Knowledge. Color lithographs made after colored photographs (partly calotypes) by Rev. A. A. Isaacs and others.

 Tristram, H. B. *Scenes in the East*. London: Society for Promoting Christian Knowledge. Colored photographic views reproduced in lithography, after photographs and calotypes by Isaacs, Bridges, Cramb, Frith, Graham.

1874 Duc de Luynes. *Voyage d'exploration à la Mer Morte à Petra et sur la rive gauche du Jourdan*. Paris: Bertrand. Steel engravings by Charles Nègre after photographs by L. Vignes.

 Manning, Samuel. *Those Holy Fields*. London: Religious Tract Society. Engravings made after photographs by Bergheim, Bonfils, and Phillips (P.E.F.).

1875 Good, Frank Mason. *Photo-Pictures of the Holy Land*. London: W. A. Mansell and Co. Two portfolios of woodburytype reproductions after photographs by author.

 Kitchener, Lieut. H. H. *Photographs of Biblical Sites*. London: Palestine Exploration Fund. Portfolio of albumen prints by author.

 de Vogüé, Eugène Melchior. *Journal des voyages en Syrie*. Paris: Plon. Three anonymous albumen prints.

1876 Warren, Charles. *Underground Jerusalem*. London: Bentley. Woodburytypes after photographs by Phillips and Bergheim.

1877 Bonfils, Félix. *Souvenirs d'Orient, Album pittoresque des sites, villes et ruines les plus remarquables de la Terre Sainte*. Vol. 3: *La Terre Sainte*. Alais (Gard): published by author. Albumen prints by author.

 Joannidou, Beniamin. *Proskinetarion tis agias gis*. Jerusalem: Greek Orthodox Patriarchate Printing Press. Phototype reproduction produced in Vienna. Photographer unknown.

1878 Bonfils, Félix. *Souvenirs d'Orient, Album pittoresque des sites, villes et ruines les plus remarquables de la Terre Sainte*. Alais (Gard): published by author. Albumen prints of single stereoscopic views by author.

1881–82 Tristram, H. B. *Pathways of Palestine*. London: Sampson, Low, Marston, Searle and Rivington. Woodburytype reproductions of photographs by Frank Mason Good.

1884 Lortet, Paul. *La Syrie d'Aujourd'hui, Voyages dans la Phénicie le Liban et la Judée 1875–1880*. Paris: Librairie Hachette et Cie. Engravings after photographs, mostly attributed to Bonfils.

1886–87 Raboisson, L'Abbé. *En Orient*. 2 vols. Paris: Librairie Catholique de l'Oeuvre de St. Paul. Phototype reproductions of photographs by author and by Bonfils.

1887 de Belloc, J. T. *Souvenirs d'un voyage en Terre Sainte*. 2d ed. Paris: Société Générale de Librairie Catholique. Halftone reproductions of photographs, mostly attributed to Bonfils.

 Porter, J. L. *Jerusalem, Bethany and Bethlehem*. London: T. Nelson and Sons. Engravings after photographs, mostly attributed to Bonfils, previously published by Lortet.

 de Vogüé, Eugène Melchior. *Syrie, Palestine, Mont Athos, Voyage aux pays du passé*. Paris: Plon. Illustrations by J. Petcocq after photographs.

1888 Harper, A. H. *Walks in Palestine*. 2d ed., 1894. London: Religious Tract Society. Photogravure reproductions after photographs by Cecil V. Shadbolt.

1888–90 Thévoz, F. and M. *La Palestine Illustrée*. Lausanne: G. Bridel. Phototype reproductions of photographs by authors.

1890 Wilson, E. L. *In Scripture Lands*. New York: C. Scribner's Sons. Mostly engravings, a few halftone reproductions made after photographs by author.

ca. 1890 *Vidi Sviatoi Zemli.* St. Petersburg: Russian Imperial Pravoslav Palestine Society. Drawings after photographs, some attributed to Bonfils.

1891 Hilden, K. Aug. *Palestina, Reseanteckningar.* Helsingfors, Finland: D. C. Frenckell and Son. Halftone reproductions of photographs, mostly by Bonfils.

Hill, Gray. *With the Bedouins, a Narrative of Journeys and Adventures in Unfrequented Parts of Syria.* London: Unwin. A few halftone reproductions of photographs by author's wife.

Jewish Missionary Intelligence. London: London Society for Promoting of Christianity amongst the Jews & J. Nisbett. Monthly illustrated, since 1885 by engravings made after photographs, and since 1891 by halftone reproductions of photographs, by Bonfils, Krikorian, American Colony, and by Palestine missionaries and missionary staff.

Roller, Théophile. *La Tour d'Orient.* Lausanne: G. Bridel. A few phototype reproductions of photographs by F. and M. Thévoz.

Ross, Rev. D. M. *The Cradle of Christianity.* London: Hodder and Stoughton. A few halftone reproductions of photographs by Bonfils and M. Thomas Dunn.

Stuart, Rev. Ch. M. *Photo-Gravures of the Holy Land, embracing fifty prominent views illustrating the Bible History and Scenes in the Life of our Lord.* Cincinnati: Cranston & Stowe. Halftone reproductions of photographs by Bonfils.

1892 Hall, Birger. *Billeder fra det heilige Land.* Kristiania [Oslo], Norway: I Hoved Komission. Some halftone reproductions of photographs, mostly by Bonfils.

Lampe, Francisek. *Jeruzalemski Romar.* Celovec, Yugoslavia: Druzba Sv. Mohorja. Halftone reproductions of some photographs by A. Beer, engravings after photographs of author and others.

von Dahlberg, Friedrich Freiherr. *Palästina, ein Sommerausflug.* Vienna: Leo Wolf. Halftone reproductions and engravings mostly made after Bonfils photographs, the latter taken from Lortet.

Croix-Mesnil, Comtesse de. *Femmes d'Orient.* Brussels: Crumps. Portfolio of photographs. Details unavailable (mentioned in Thomsen; see bibliography, section II).

1893 Lees, G. R. *Bible Scenes in the Holy Land.* Jerusalem: London Jews' Society House of Industry. Albumen prints by author.

————. *Jerusalem Illustrated.* Newcastle on Tyne: Mawson, Swan and Morgan; London: Gay & Bird. Halftone reproductions of photographs by author.

Luach Achiassaf. Warsaw: Achiassaf. A few engravings made after photographs by B. Warshawski.

Michieli, Luigi, coordinator. *Album Missioni Terrae Sanctae.* Vol. 1, *Judaea et Galilaea.* Milan: Gualassimi e Bartarelli. Manipulated reproductions. A few photographs attributed to Bonfils and A. Beer; most photographs anonymous.

Newness, George. *The Way of the Cross: A Pictural Pilgrimage from Bethlehem to Calvary.* London: G. Newness Ltd. Halftone reproductions of photographs, some attributed to Bonfils.

1894 Bain, R. E. M., and James W. Lee. *Earthly Footsteps of the Man of Galilee and the Journeys of His Apostles.* London: A. M. Gardner. Halftone reproductions of photographs by Bain, others attributed to him, Bonfils, Zangaki, perhaps some by unknown photographers.

Dupuis, L'Abbé J.-F. *Rome et Jérusalem.* Québec. A few halftone reproductions of Bonfils photographs.

Hurlbut, Rev. Jesse L. *Bible Atlas, a Manual of Biblical Geography and History.* Chicago: Rand McNally and Co. A few halftone reproductions of photographs, some attributed to Bonfils.

Lallemand, Charles. *Jérusalem-Damas*. Collection Courtellemont. Alger-Paris: Ancienne Maison Quantin. Halftone reproductions of photographs by Gervais-Courtellemont.

Nazareth I Evo Okresnosti. St. Petersburg: Russian Imperial Pravoslav Palestine Society. Phototype reproductions of photographs by Bonfils, Fiorillo, Timon, Dumas.

Photochrome farbige Photographien von Palästina und Syrien. Zürich: Photochrome. Color reproductions of hand-colored photographs, mostly by Bonfils.

Scrinzi, Gustiniano. *In Oriente*. Schio. A few halftone reproductions of photographs by Ottavio Ronconi.

1895 Klement, František. *Palestyna*. Prague: Beaufort. A few halftone reproductions of photographs by Bonfils.

Krayenbelt, J. *Het Heilige Land*. Rotterdam: Wenk & Brikhof. Halftone reproductions of photographs by Bonfils.

Smith, Rev. James. *A Pilgrimage to Palestine*. Aberdeen, Scotland. Halftone reproductions of photographs by Bonfils, Krikorian, P.E.F., G. R. Lees.

1896 *Album de la Terre Sainte*. Paris: Maison de la Bonne Presse. Halftone reproductions of photographs mostly purchased from the Parisian agency of J. Kuhn. Most photographs are by Bonfils; some by Zangaki, A. Beato (?), and others. Signatures on the negatives partly or entirely erased.

Bambus, Willy. *Die jüdischen Dörfer in Palästina*. Berlin: S. Cronbach. Halftone reproductions of three uncredited photographs.

Briggs, Rev. Charles. *Six Months in Jerusalem*. London: Oxford University Press. A few halftone reproductions of photographs.

Hovevei Zion Quarterly. London. A few halftone reproductions of photographs, perhaps by Bambus.

Lamond, John. *Modern Palestine*. Edinburgh-London: Oliphant, Anderson & Farrer. Halftone reproductions of photographs, some by Bonfils and Leicester.

Llor, Antonio. *La Tierra Santa o Palestina*. Barcelona: Salvador Ribas. A few color lithographs of hand-colored photographs.

Palästina. Ansichten von denkwürdigen Stätten des Heiligen Landes und Dörfern Jüdischer Bauern. Berlin: H. Schildberger. A few halftone reproductions of photographs, some also published in Bambus, *Palästina* (1898).

Sto Vidov Jerusalema I Sviatoi Zemli. St. Petersburg: Russian Imperial Pravoslav Palestine Society. Drawings made after photographs, some by Bonfils.

Vicini, G. *La Mia Valigia*. Saluzzo. A few halftone reproductions of photographs by Zarate.

1897 Geikie, Cunningham. *The Holy Land and the Bible*. London: Cassell. Phototype reproductions of photographs by F. and M. Thévoz.

Harland, Marion [May Virginia Terhune]. *Under the Flag of the Orient*. Philadelphia: Historical Publishing Co. Halftone reproductions of photographs by the author (?) and others attributed to or by Bonfils.

Lees, G. R. *Jerusalem and its People*. London: James Townsend. Halftone reproductions of photographs by the author.

———. *Village Life in Palestine*. London: Elliott Stock. Halftone reproductions of photographs by the author.

Die Welt (biweekly, several issues). Vienna. Halftone reproductions of photographs, some attributed to Sabounji and Bambus.

1898 Bambus, Willy. *Palästina, Land und Leute.* Berlin: S. Cronbach. A few halftone reproductions of photographs, attributed to author (?) and Bonfils.

Blankenhorn, Max. *Das tote Meer und der Untergang von Sodom und Gomorrha.* Berlin: Reimer. Halftone reproductions of photographs by the author.

Blaumüller, Edvard. *Hellig Jord.* Copenhagen: Gyldendalske-Boghandets. Halftone reproductions of photographs, some by Bonfils, most others attributed to Bonfils and author.

Ferreiroa, D. Urbano. *La Terra Sancta.* Valencia: Domenech. A few engravings and color lithographs after photographs, some attributed to Bonfils.

Hentschel, Bruno. *Rundblick vom Turme der Erlöserkirche.* Leipzig: Hentschel. Albumen prints of 360-degree panorama of Jerusalem.

Les Voyages Artistiques: Jérusalem et la Palestine. Paris: Tolra. Halftone reproductions of photographs by and attributed to Bonfils.

Van Puymbrouck, P. Adolphus. *Sint Franciscus in Het Heilige Land.* Gent. A few halftone reproductions and engravings after photographs attributed to Bonfils and others.

Wallace, E. S. *Jerusalem the Holy.* Edinburgh-London: Oliphant, Anderson & Farrar. Halftone reproductions of photographs by T. J. Alley, Rev. Putnam Cady, Krikorian, E. Warren Clark, and the author. (Wallace was the U.S. consul in Jerusalem, and Alley was his employee.)

1899 Deverell, F. M. *My Tour in Palestine and Syria.* London: Eyre and Spottiswood. Halftone reproductions of photographs by author.

Gautier, Lucien. *Souvenirs de la Terre Sainte.* Lausanne: G. Bridel. Halftone reproductions of photographs by author's wife.

von Keppler, Paul Wilhelm. *Wanderfahrten und Wallfahrten im Orient.* Freiburg im Breisgau: Herdersche Verlagshandlung. Halftone reproductions of photographs, some by or attributed to Bonfils.

Mühlmann, Felix. *Das deutsche Kaiserpaar im Heiligen Lande im Herbst 1898.* Berlin: E. S. Mitten und Sohn. Halftone reproductions of photographs by Bonfils, Hentschel, Raad, Anschütz, Juergens, and Empress Augusta Victoria.

Raffalovich, Yeshayahu, and Moshe Eliahu Sachs. *Views of Palestine and Its Jewish Colonies.* Published by Raffalovich. Halftone reproductions of photographs by Raffalovich and by Meyers of the American Colony.

Schneller, Ludwig. *Die Kaiserfahrt im Heiligen Lande.* Leipzig: Wallmann. Halftone reproductions of photographs, some attributed to Bonfils and Meyers.

Stewart, Robert Laird. *The Land of Israel.* New York: F. H. Revell. A few halftone reproductions of photographs by Bonfils, P.E.F., and perhaps others.

Tiesmeyer, L. *Aus der Heilands Heimat.* Bielefeld-Leipzig: Velhagen und Klassing. Halftone reproductions of photographs, some by or attributed to Bonfils.

189? *Album.* Halftone reproductions of photographs, some attributed to Bonfils, Zangaki, and Dumas.

Neil, C. Lang. *Pictorial Palestine, Ancient and Modern.* London: Piles and Miles. Halftone reproductions of photographs by Rev. G. R. Lees.

Photographs and Flowers of the Holy Land. Jerusalem: F. F. Marroum. Hand-colored albumen prints and pressed flowers.

1899? *Eretz Israel Album.* New York: Meir Chimsky. Uncredited halftone reproductions of photographs by

Raffalovich and by Meyers of the American Colony.

1900 Boddy, Rev. Alexander A. *Days in Galilee and Scenes in Judea, with some account of a solitary cycling journey in southern Palestine.* London: Gay & Bird. Halftone reproductions of photographs taken before 1900 by American Colony (attributed to Meyers) and author; some anonymous.

Calas, Théophile. *En Terre Désolée.* Paris: Librairie Fischbacher. Halftone reproductions of photographs taken before 1900 by author and by M. d'Allemagne.

Fulton, John. *Palestine.* New York-London: Merrill and Baker; Philadelphia: H. T. Coates. Most photographs attributed to Bonfils. Some of the anonymous photographs are also in *Way of the Cross* (1893).

1901 Gautier, Lucien. *Autour de la Mer Morte.* Geneva: Ch. Eggimann & Cie. Halftone reproductions of photographs taken before 1900 by the author.

Schneller, Ludwig. *Aus meiner Reisetasche.* Leipzig: Wallmann. Halftone reproductions of photographs, some attributed to Bonfils and some to Meyers of the American Colony.

1903 Ninck, C. *Auf Biblischen Pfaden.* Berlin-Leipzig: Deutsche Kinderfreunde. Halftone reproductions of photographs, a few by Georges Sabounji.

1904 Freer, A. Goodrich. *Inner Jerusalem.* London: Constable.

1927–42 Dalman, Gustav. *Arbeit und Sitte in Palästina.* 7 vols. Gütersloh: C. Bertelsmann. Halftone reproductions of photographs, some taken in 1899 and later by author, some by Bonfils, and others taken in 1900 and later by the American Colony, Dalman's colleagues, and others.

II. Textual sources: nineteenth-century Holy Land photography (items included in section I are not repeated).

Baedeker, Karl. *Palästina und Syrien.* Leipzig: K. Baedeker, 1876.
Bartlett, W. H. *Walks about the City and Environs of Jerusalem.* London: Hall, Virtue & Co., 1842.
Bonar, A. A., and R. M. M'Cheyne. *Narrative of a Mission of Inquiry to the Jews for the Church of Scotland in 1839.* 3d ed. Philadelphia: Presbyterian Board of Publishers, 1845.
Bonfils, Félix. *Catalogue des vues photographiques de l'Orient, Egypte, Palestine (Terre Sainte), Syrie, Grèce & Constantinople.* Alais (Gard): published by the author, 1876.
Burnet, D. S. *The Jerusalem Mission under the Direction of the American Missionary Society.* Cincinnati: American Christian Missionary Society, 1853.
Catalogue of Photographs and Slides for the Lantern. London: Palestine Exploration Fund, n.d.
Denman, Rev. Francis L. *History of the Jerusalem Mission.* London: London Jews' Society, 1912.
Du Camp, Maxime. *Orient et Italie, souvenirs de voyages et lectures.* Paris: Librairie Académique, 1868.
Durand, Amédée. *Joseph, Carle et Horace Vernet, correspondance et biographies.* Paris, 1846.
Encyclopedia of World Art. London: McGraw-Hill, 1961.
Flaubert, Gustave. *Reisebriefe.* Potsdam: G. Kiepenhauer Verlag, 1921.
————. *Voyage en Orient (1849–1851).* Oeuvres complètes illustrées de Gustave Flaubert. Paris: Centenaire, Librairie de France, 1925.
Gautier de Claubry, H. "Vue photographique de l'Orient.—Egypte, Palestine, Syrie, Grèce et stéréoscopes de Palestine par M. Bonfils, photographe à Beyrouth." *Bulletin de l'oeuvre des pélerinages en Terre Sainte* 8(1873):41–43.
Gorra, Philippe. *Sainte-Anne de Jérusalem.* Antioch, 1932.
Goupil-Fesquet, Frédéric. *Voyage d'Horace Vernet en Orient.* Paris: Challamel, 1843.
Grabar, Oleg. *The Formation of Islamic Art.* New Haven: Yale University Press, 1973.
Grant, Rev. Elihu. *The Peasantry of Palestine.* New York: The Pilgrim Press, 1907.

Halevy, Malkiel Zvi. *Sefer Sheelot ve-Tshuvot, Divrei Malkiel.* Vol. 3. Vilna, Lithuania, 1901.

Hedin, Sven. *Jerusalem.* Leipzig: Brockhaus, 1918.

Hoche, Jules. *Le pays de croisades.* Paris: Librairie Illustrée, 1884.

Hughes, T. P. *A Dictionary of Islam.* Clifton, N.J.: Reference Book Publishers, 1965.

Hurlbut, Jesse L. *Traveling in the Holy Land through the Stereoscope.* New York: Underwood and Underwood, 1900.

Keith, Alexander. *The Evidence of Prophecy in Historical Testimony to the Truth of the Bible.* London: Religious Tract Society, 1882.

Kook, Abraham Itshak Hacohen. *Igarot Hareia.* Vol. 1. Jerusalem: Mossad Ha-rav Kook, 1907–8.

Liste Générale des Pères et Frères Blancs de Sainte Anne 1878–1932. 1932.

Livingstone, W. P. *A Galilee Doctor.* London: Hodder & Stoughton, 1926.

Luncz, Abraham Moses. *Luach Eretz Israel 1898–99.* Jerusalem.

Ormanian, Malachia. *History of the Armenians.* 3 vols. Jerusalem: St. James Publ. House, 1927.

Palestine Exploration Fund Quarterly Statement. London: Palestine Exploration Society, 1869–99.

Photographic Pictures of Egypt, the Holy Land, Syria, . . . (Catalogue of Francis Bedford's photographs). London: Day and Son, 1863.

Raffalovich, Yeshayahu. *Tsiunim Vetamrurim* (autobiography). Tel Aviv: Achiassaf, 1952.

Rey, R. E. J. *Etude historique et topographique de la tribu de Juda.* Paris: Bertrand, 1863.

Rida, Muhammad Rashid. "Hukm suwar al-yad wa'l suwar al-shamsiya." *Al Manar* 11(1908–9).

Röhricht, Reinhold. *Bibliotheca Geographica Palaestinae.* Berlin: H. Reuther, 1890; revised ed. by D. Amiran, Jerusalem: University Booksellers, 1963.

Sawalanian, Tigran. *History of Jerusalem.* 2 vols. Jerusalem: St. James Publ. House, 1930.

Sefer Shimush Tsedaka Me-vaad Haklali. Vol. 11. Jerusalem, 1890–91.

Silverman, Godfrey E. "Three Lovers of Zion." *Niv Hamidrashiyah.* Tel Aviv, 1970.

Spafford-Vester, Bertha. *Our Jerusalem.* London: Evans Brothers, 1951.

Thomsen, Peter. *Die Palästina-Literatur.* Vol. A, 1878–94, Berlin: Akademie Verlag, 1960; vol. 1, 1895–1904, Leipzig: J. C. Hinrichs, 1911.

Turner, Wm. Mason. *El-Khuds, the Holy: or Glimpses in the Orient.* Philadelphia: James Challen and Son, 1861.

Watson, Colonel Sir Charles M. *Fifty Years' Work in the Holy Land, a Record and a Survey 1865–1915.* London: Palestine Exploration Fund, 1909.

———. *The Life of Major-General Sir Charles Wilson, R.E.* London: J. Murray, 1909.

III. Nineteenth-century Holy Land.

Aref-el-Aref. *Al-mufassal fi tarih al-Quds.* Jerusalem: Dar el Maarif, 1961.

Ben-Arieh, Yehoshua. *The Rediscovery of the Holy Land in the Nineteenth Century.* Jerusalem: Magnes Press, 1979.

———. *Ir berei tkoufa, Yeroushalayim bemea ha-tesha-esre.* Jerusalem: Ben Zvi Institute, 1977.

———. "Legislative and Cultural Factors in the Development of Jerusalem 1800–1914." In *Geography in Israel,* a collection of papers offered to the 23rd International Geographical Congress, USSR, July-August 1976. Jerusalem, 1976.

———. "The Geographical Exploration of the Holy Land." *Palestine Exploration Fund Quarterly Statement* (July-December 1972).

Eliav, Mordechai. *Eretz-Israel ve-yishuva be-mea ha-tesha-esre, 1777–1917.* Jerusalem: Keter, 1978.

Encyclopedia Judaica. Jerusalem: Keter, 1972.

Gat, Ben Zion. *Ha-yishuv ha-yehudi ba-arets be-shnot 1840–1881.* Jerusalem: Agudat Shoharei Hagymnasia Haivrit, 1963.

Gidney, W. T. *Mission to the Jews.* 11th ed. London: London Jews' Society, 1914.

Hovenkamp, Herbert. *Science and Religion in America 1800–1860*. Philadelphia: University of Pennsylvania Press, 1978.

Lamartine, M. de. *Un voyage en Orient*. Paris: Gosselin, Furne & Pagnene, 1844.

Ma'oz, Moshe, ed. *Studies on Palestine during the Ottoman Period*. Jerusalem: Magnes Press, 1975.

Melville, Herman. *Journal of a Visit to Europe and the Levant, October 11, 1856–May 6, 1857*. Edited by Howard C. Horsford. Princeton: Princeton University Press, 1955.

Said, Edward W. *Orientalism*. New York: Vintage Books, 1979.

Tibawi, A. L. *American Interests in Syria*. Oxford: Clarendon Press, 1966.

———. *British Interests in Palestine 1880–1901*. Oxford: Oxford University Press, 1961.

Tuchman, Barbara. *Bible and Sword*. London: Paper Mac, 1982.

Twain, Mark. *The Innocents Abroad*. New York: Harper and Brothers, 1911.

IV. Sources on history of photography (general and of the Holy Land).

Baier, W. *Geschichte der Photographie*. Mosel: Schirmer, 1977.

Bensusan, A. D. *Silver Images: History of Photography in Africa*. Cape Town: Howard Timmins, 1966.

Bourdieu, Pierre, et al. *Un art moyen, essai sur les usages sociaux de la photographie*. Paris: Minuit, 1965.

Braive, Michel. *L'âge de la photographie*. Brussels: Connaissance, 1965.

Christie's East. *19th Century Photography* (sales catalogue). New York, 1980.

Desmond, Ray. *Photography in India during the Nineteenth Century*. London: India Office Library and Records Report, 1974.

Ferrez, Gilberto, and Weston J. Naef. *Pioneer Photographers of Brazil, 1840–1920*. New York: Center for Inter-American Relations, 1976.

Freund, Gisèle. *Photography and Society*. Boston: David R. Godine, 1980.

Gavin, Carney E. S. "Bonfils and the Early Photography of the Near East." *Harvard Library Bulletin* 26(October 1978).

———. *The Image of the East: Nineteenth-century Near Eastern Photographs by Bonfils from the Collections of the Harvard Semitic Museum*. Compiled and edited by Ingeborg Endter O'Reilly. Chicago: University of Chicago Press, 1982.

Gavin, Carney E. S., Elizabeth Carella, and Ingeborg O'Reilly. "The Photographers Bonfils of Beirut and Alès 1867–1916." *Camera*, no. 3 (March 1981).

Gernsheim, Helmut and Alison. *The History of Photography from the Camera Obscura to the Beginning of the Modern Era*. New York: McGraw-Hill, 1969.

———. *L. J. M. Daguerre*. New York: Dover, 1964.

Goldberg, Vicky. *Photography in Print*. New York: Simon and Schuster, 1981.

Hannavy, John. *Roger Fenton*. Boston: David R. Godine, 1975.

Hobart, George S. "The Matson Collection—A Half-Century of Photography in the Middle East." *The Quarterly Journal of the Library of Congress* 30(January 1937):19–43.

Jay, Bill. *Victorian Cameraman: Francis Frith's Views of Rural England*. London: Newton and Abbot, 1973.

Jeffrey, Ian. *Photography: A Concise History*. New York: Oxford University Press, 1981.

Jung, Leo. *Men of Spirit*. New York: Kymson, 1964.

Krauss, Rolf H. "Travel Reports and Photography in Early Photographically Illustrated Books." *History of Photography* 3(January 1979).

Naef, Weston J. *Early Photographers in Egypt and the Holy Land*. New York: Metropolitan Museum of Art, 1973.

Newhall, Beaumont. *The History of Photography from 1839 to the Present Day*. New York: Museum of Modern Art, 1964.

Onne, Eyal. *Photographic Heritage of the Holy Land 1839–1914.* Manchester: Institute of Advanced Studies, Manchester Polytechnic, 1980.

Ritchie, Thomas. "Bonfils & Son, Egypt, Greece and the Levant; 1867–1894." *History of Photography* 3(January 1979):33–46.

Scharf, Aaron. *Art and Photography.* London: Allen Lane, the Penguin Press, Pelican Books, 1974.

Seely, Gail. "Egypt and the Holy Land as Photographic Subjects 1849–1870: A Comparative Study of Seven Photographers" (bibliography). M.A. thesis, University of Texas at Austin, 1976.

Simony, Comte de. *Une curieuse figure d'artiste, Girault de Prangey, 1804–1892.* Dijon: Academy of Sciences and Fine Arts, 1937.

Sobieszek, R. A., and Carney E. S. Gavin. *Remembrances of the Near East: The Photographs of Bonfils, 1867–1907.* Catalogue of exhibition, International Museum of Photography at George Eastman House and the Harvard Semitic Museum, 1980.

Thomas, Alan. *Time in a Frame, Photography and the Nineteenth-Century Mind.* New York: Schocken Books, 1977.

Trachtenberg, Alan, ed. *Classic Essays on Photography.* New Haven, Conn.: Leete's Island Books, 1980.

University of New Mexico Art Museum Bulletin, 1973.

Weinberg, Adam D. *Majestic Inspirations, Incomparable Souvenirs, 19th Century Photography of the Mediterranean and the Middle East from the Collection of Brandeis University* (catalogue). 1977.

Yosef, Ovadia. *Or Tora.* Vol. 2. Jerusalem: Agudat Or Tora, 1977–78.

V. Late twentieth-century publications with reproductions of nineteenth-century Holy Land photographs (items included in section IV are not repeated).

Avitsur, Shmuel. *Adam ve-amalo; atlas le-toldot klei avoda ve-mitkanei yitsur be-Eretz Israel.* Jerusalem: Carta, 1976.

Comparative Photography: A Century of Change in Egypt and Israel. Introduction by Brian M. Fagan, photographs by Francis Frith and Jane Reese Williams. Carmel, Calif.: The Friends of Photography, 1979.

Gidal, Nachum T. *Eternal Jerusalem.* Lucerne: Bucher, 1982.

———. "The First Settlers." In *Encyclopedia Judaica, Yearbook 1975.* Jerusalem: Keter, 1975.

Graham-Brown, Sarah. *Palestinians and Their Society 1880:–1948: A Photographic Essay.* London: Quartet Books, 1980.

Landau, Jacob M. *Abdul Hamid's Palestine.* Jerusalem: Carta, 1979.

Matson, Eric G. *The Middle East in Pictures: A Photographic History, 1898–1934.* 4 vols. New York: Arno Press, 1980.

Schiller, Ely. *The First Photographs of the Holy Land.* Jerusalem: Ariel, 1979.

Vaczek, Louis, and Gail Buckland. *Travelers in Ancient Lands, Portrait of the Middle East, 1839–1919.* Boston: New York Graphic Society, 1981.

Van Haaften, Julia. *Egypt and the Holy Land in Historic Photographs: 77 Views by Francis Frith.* New York: Dover, 1980.

Addendum

A personal letter written in 1864 and uncovered after this book had been typeset confirms that calotypist Bridges took his Palestine views in 1849 and 1850. In Jerusalem he had instructed the writer of the letter, Mrs. Finn, wife of the British consul, "in the mysteries of what was then Talbot-type." The letter also confirms that James Graham was the one who introduced photography to the local scene; moreover, that he had instructed a "Mr Mendel J. Diness (hebrew Christian) in the art," "Diness" being, of course, "Deniss." Graham had also provided him with a camera. The letter also solves the problem of authorship of the Robertson and Beato album and in part, at least, of Pierotti's album. It was Robertson alone who "came to Jerusalem after the Crimean war." Diness, according to his own words to Mrs. Finn, took him "to all his own best points of view, and at the right time of day, on the express promise that none of Mr. Robertson's Photographs should be sent to Jerusalem for sale." "Diness' points of view," according to the letter, were in fact Graham's. In Mrs. Finn's eyes, there was also a similarity with Pierotti's plates in his *Jerusalem Explored*, including a view of the Wailing Wall in which Diness's likeness appeared. It also appeared in a similar view known to Mrs. Finn that was taken by Graham. The portrait of Pierotti himself appeared in one of six stereoscopic views given to Mrs. Finn by Diness in 1860 before he left Jerusalem.

The comparison of the album signed Robertson and Beato with Pierotti's *Jerusalem Explored* shows that no more than four of the lithographs might resemble Robertson and Beato photographs. Most of Pierotti's plates differ from them and are of interest for architectural details alone. Nevertheless, portraits mentioned by Mrs. Finn support her statement that Pierotti's lithographs were based on photographs taken by Diness/Deniss.

Robertson, unfortunately for Diness/Deniss, did not keep his promise and "consigned quantities of views identical with his own to Mr Bergheim for sale; that Mr Bergheim being a banker, and a near

relation of both the hotel-keepers (Hauser and Rosenthal) could always obtain the first access to travellers, for sale of Photographs, and that he (Diness) could not compete with this"; Diness, who told the story to Mrs. Finn, had to leave Jerusalem. Bergheim, the banker (the former medical assistant at the L.J.S. dispensary), was the father of Peter Bergheim, the photographer. Bergheim Junior had the advantage of his father's relations and therefore, perhaps, survived in the trade for a longer period than Deniss, his predecessor.

The information in this letter, which is valuable as an eyewitness account, confirms the important role played in local photography by Graham, the Anglican Mission, and the Jewish converts—which includes Deniss, the "hebrew Christian." It also confirms the dependence of the new local trade on the tourist market. Last but not least, it shows that a British photographer, Robertson (perhaps partly influenced, via Deniss, by another British photographer), produced an album in the "French-Catholic" vein. His personal background in the arts—as chief engraver of the Imperial Mint in Constantinople—possibly played a certain role in this respect.

Dror Varman, a young Israeli historian who uncovered the letter in a little-known booklet written by G. Williams, entitled *Dr. Pierotti and his assaillants or the defense of "Jerusalem Explored,"* published in London in 1864 (pp. 50–51), was able to establish that Diness was a Russian Jew baptized in Jerusalem by Consul Finn.

Index